T0265970

TABLE OF CONTENTS

SPRING 2023
VOLUME 3, NUMBER 3

EDITOR
LEON WIESELTIER

MANAGING EDITOR
CELESTE MARCUS

PUBLISHER
BILL REICHBLUM

JOURNAL DESIGN
WILLIAM VAN RODEN

WEB DESIGN
BRICK FACTORY

EDITORIAL ASSISTANT
DARIUS RUBIN

Liberties is a publication of the Liberties Journal Foundation, a nonpartisan 501(c)(3) organization based in Washington, D.C. devoted to educating the general public about the history, current trends, and possibilities of culture and politics. The Foundation seeks to inform today's cultural and political leaders, deepen the understanding of citizens, and inspire the next generation to participate in the democratic process and public service.

FOUNDATION BOARD
ALFRED H. MOSES, *Chair*
PETER BASS
BILL REICHBLUM

Engage
To learn more please go to libertiesjournal.com

Subscribe
To subscribe or with any questions about your subscription, please go to libertiesjournal.com

ISBN 979-8-9854302-0-2
ISSN 2692-3904

EDITORIAL OFFICES
1101 30th Street NW, Suite 310
Washington, DC 20007

DIGITAL
@READLIBERTIES
LIBERTIESJOURNAL.COM

Liberties

ANDREW DELBANCO

On Reparations

6 My subject is really three subjects that together constitute a single theme at the heart of American life. First, slavery itself — that form of human relations by which, for more than two centuries, white persons exerted unappeasable power over black persons as if they were tools or livestock. When speaking about this subject, I try to keep in mind an admonition from William Wells Brown, a fugitive from slavery who spoke in the antebellum years to audiences in the North who were eager to hear in lurid detail what he had endured in the South. Most left disappointed. "I would *whisper* to you of slavery," he told them. "Slavery cannot be represented; it can *never* be represented."

Reticence from a man who had known the thing itself should give pause to anyone who presumes to speak of it now.

Second, there was — and is — the aftermath of racial subjugation that long outlasted the institution of slavery. For black Americans, that experience extended in space and time far beyond the Jim Crow South, and even many who have attained prosperity or renown still know it today in the form of condescension or contempt. This, too, is something of which no white person can have more than nominal knowledge.

And finally there is the question of reparations — our shorthand word for the idea that a decent society must accept responsibility in the present for injustices perpetrated in the past. What this would mean in practice raises a host of moral, political, and personal questions — all of them urgent and none of them simple.

What connection should one feel to acts committed or omitted before one was born? How can the cost be calculated of living at the mercy of a person who claims to own you, and of knowing that the same will be true for your children and their children? Even if one could compute the cost, who would fund the reparations, and to whom should they be paid? Would they be subject to means-testing and paid on a graduated scale like a sort of reverse income tax? In a society where identity is increasingly fluid and self-defined, who would decide who qualifies and who does not? Adjudicating these questions — and there are many more — will no doubt open more cracks in our already fractured country. But evading them, as the phrase goes, is not an option.

A good place to begin is with Thomas Jefferson, who was both a fervent democrat and an unrepentant slaveowner. As such, he embodied what some would call the tragic paradox of

early America and others would call bald hypocrisy. In 1775, when news of revolution in the colonies reached the mother country, Samuel Johnson inquired with acid scorn, "How is it we hear the loudest yelps for liberty among the drivers of Negroes?" Jefferson was at the bullseye of that question, and he knew it. "I tremble for my country," he famously wrote, "when I reflect that God is just, and [that] his justice does not sleep forever." His choice of word — "tremble" — tells us that, like many slaveholders, he feared that when justice came, it would come not as reconciliation but as retribution.

Some fifty years later, the editors of *Freedom's Journal*, America's first periodical written and published by black people, agreed with him. "National sins," they wrote, "have always been followed by national calamities." But no one — neither the enslavers nor the enslaved — could foresee when or at what scale the calamity would come. Just before daybreak on April 12, 1861 — not quite thirty-five years after Jefferson's death — it came. That morning, partisans of slavery, feeling both enraged and emboldened by the election to the presidency of a man who had promised to place slavery "in the course of ultimate extinction," launched an artillery assault on Fort Sumter in Charleston harbor. President Lincoln responded by calling up seventy-five thousand volunteers to suppress what he called a "domestic insurrection."

After a three-month lull, the conflict resumed some forty miles from the nation's capital, at Manassas, Virginia. As so often at the outset of war, both sides expected little more than a carnival show with pop guns. In the North, volunteers waved bits of rope with which they promised to lace up the rebels like trussed hogs. In the South, slaveowners boasted that all the blood to be spilled would barely fill a thimble. We know how those predictions turned out. Over four years of slaughter at

places of previously small note — Shiloh, Antietam, Chancel-lorsville, Vicksburg, Gettysburg, Chickamauga — the scale of the calamity revealed itself. Writing about the first on that grisly list, General Grant recalled that the earth at Shiloh was "so covered with dead that it would have been possible to walk . . . in any direction, stepping on dead bodies, without a foot touching the ground." Before the war was over, at least three quarters of a million bodies (equivalent to some eight million today) had been put under the ground, including roughly seventy thousand black soldiers who gave their lives fighting for the Union, not to mention countless formerly enslaved persons who, abandoned by their former masters, died of disease or starvation.

President Lincoln never formally joined any church, but like most Americans of his time he was a believer. In his second inaugural address, delivered on March 4, 1865, on the steps of our recently desecrated Capitol, he quoted Matthew 18 — "woe to that man by whom the offense cometh" — to say that suffering on such a scale could only be due to the righteous wrath of God. And he was careful to identify the provoking sin not as southern slavery but as "American slavery." Then he spoke a terrifying sentence, concluding with a line from Psalm 19: "If God wills that [the war] continue until all the wealth piled by the bondsman's two hundred and fifty years of unrequited toil shall be sunk and until every drop of blood drawn with the lash shall be paid by another drawn with the sword, as was said three thousand years ago so still it must be said 'the judgments of the Lord are true and righteous altogether.'" One could read that famous sentence — and I suspect many people have read it this way — as meaning that the debt owed by white Americans to black Americans had now been paid, in blood. We don't know how Lincoln, had he

9

lived, would have tried to reconstruct the shattered nation; but we do know enough to doubt that he regarded the bloodletting as a full accounting.

Years before the first shots were fired, the black writer and abolitionist Martin Delany already had called for a "national indemnity ... for the unparalleled wrongs, undisguised impositions, and unmitigated oppression" endured by black people since the first enslaved Africans arrived in the seventeenth century. The most egregious wrong, slavery itself, was dealt a blow early in the war by the Confiscation Acts, then was fatally wounded by the Emancipation Proclamation, and was finally killed off by the Thirteenth Amendment. But with slavery destroyed, the nation was left with an unanswered question: in what currency could the indemnity possibly be paid?

Some thought that formerly enslaved persons should be offered what the legal scholar Boris Bittker, drawing fifty years ago on the tort-law concept of compensatory damages, called "pecuniary solace for the past." In fact, there already existed a tradition of paying damages in the context of emancipation. But this tradition stood in obverse, or better to say, perverse, relation to what we think of today as reparations: it was about money flowing not to the formerly enslaved but to their former enslavers. After the American Revolution and the War of 1812, slave owners demanded restitution for human property that had fled to, or been seized by, the British. President Lincoln himself tried to convince the relatively few slaveholders in Delaware to accept payment in exchange for manumission — but they balked. As part of the Emancipation Act abolishing slavery in Washington, DC, Congress

10

appropriated a million dollars (a lot of money in 1862) for compensating slaveholders for their loss.

After the war, some formerly enslaved persons tried to get the money flowing in the other direction — that is, from, rather than to, their former masters. In the summer of 1865, Jourdon Anderson, who had been liberated by the Union army in Tennessee and found refuge in Ohio, received a letter from his former master asking him to come back "home" to help with the autumn harvest. He was assured that this time he would be paid for his labor. Though Tennessee had been one of the few slave states where it was not illegal to teach a slave to read, he was illiterate — so with the help of the man for whom he now worked, he dictated his reply. As in so many writings by fugitives, his resilience is manifest in his humor:

Dayton, Ohio, August 7, 1865

To my old Master, Colonel P. H. Anderson,
Big Spring, Tennessee

Sir:

Although you shot at me twice before I left you, I did not want to hear of your being hurt, and am glad you are still living.

He concluded his letter with a flourish: "P.S. — Say howdy to George Carter, and thank him for taking the pistol from you when you were shooting at me."

In between, no doubt assisted with the numbers by his employer, he gets down to business:

I served you faithfully for thirty-two years, and Mandy [his wife] twenty years. At $25 a month for me, and $2 a week for Mandy, our earnings would amount to $11,680. Add to this the interest for the time our wages have been kept back, and deduct what you paid for our clothing, and three doctor's visits to me, and pulling a tooth for Mandy, and the balance will show what we are in justice entitled to. Please send the money by Adams Express, in care of V. Winters, Esq., Dayton, Ohio.

He knew, of course, that he would never see a cent.

But even as Anderson and many others talked into the wind, the idea of money reparations was evolving into the idea that the federal government should provide formerly enslaved persons with grants of free land. Hope arose — naïve hope, as it turned out — that, in the words of W.E.B. DuBois, "all the chief problems of Emancipation might be settled by establishing the slaves on the forfeited lands of their masters."

That may sound like a radical plan out of Mao's China or Castro's Cuba — but in fact there were precedents in nineteenth-century America. In 1862, on the Sea Islands off the coast of South Carolina, which had been captured by Union forces early in the war, the federal government granted to former slaves free housing, modest wages, and basic rations in exchange for cotton cultivation on small plots of land. Three years later, General William T. Sherman issued Field Order 15, which assigned ownership of hundreds of thousands of abandoned acres along the coast from Charleston to Florida to some forty thousand former slaves.

But those were wartime measures. As soon as peacetime returned, the "poetry" of the idea, DuBois wrote, collided with the "prose" of reality. With the return to power of a federal

administration friendly to the white South, promises to the freedmen were revoked, property returned to former Confederate landowners, and the dream of black homesteads "melted quickly away." Toward the end of his life, Frederick Douglass bitterly remarked that "when the serfs of Russia were emancipated, they were given three acres of ground upon which they could live and make a living. But not so for America's slaves, who were "sent away empty-handed, without money, without friends and without a foot of land upon which to stand."

Land, of course, was not the only essential asset of which black people had been deprived. Education was another. "Let us atone for our sins," wrote the leaders of the American Missionary Association on the eve of the war, "by furnishing schools and the means of improvement for the children, upon whose parents we have inflicted such fearful evils." It was too late for the parents, but perhaps the children might be saved.

But this, too, proved to be a dream deferred. After federal troops withdrew from the South in 1877, black children were subjected to what can only be called a terrorist campaign. Parents who dared send their children to school were fired by their white employers. Teachers and students were beaten. Schools were torched. And even when terror abated, black schools were grossly underfunded. As late as 1912 in Lowndes County, Virginia, for every dollar spent on education for a black child more than thirty dollars were spent for a white child. By 1950, the disparities had narrowed, but they remained enormous. In Mississippi, black public schools received approximately $32.00 of state support per student while white schools received roughly four times as much. When it came to funding education, black Americans got the table scraps. And once the struggle against separate and unequal schools got under way, black children were greeted by police dogs and

13

firehoses in the South, and by obscenities and white flight in the North.

So the debt owed by white America to black Americans continued to accrue. It grew through the sharecropping system that locked agricultural workers into inescapable cycles of debt. It was compounded by the system of convict labor by which black men were snatched off the streets for such putative crimes as "vagrancy," and forced to work unpaid in factories or mines. It persisted into the twentieth century as the United States built the semblance of a welfare state from which millions of African Americans were excluded. The signature program of the New Deal, the Social Security Act of 1935, exempted agricultural and domestic laborers who, in the South, were overwhelmingly black. Black military veterans were excluded, too, not *de jure* but *de facto*, from the Serviceman's Adjustment Act of 1944 (better known as the G.I. Bill). At just the moment when a college degree began to supplant the high school diploma as the minimum credential for entering the middle class, most black veterans, who came overwhelmingly from the South, failed to qualify because their schooling had been negligible, or because, no matter how qualified they might be, most colleges would not admit them.

The larcenies that I have enumerated so far were measurable forms of theft that help to explain why black Americans have owned so little that could be passed on to their children, and why the median wealth of black families today is barely one seventh of that of white families. Yet there is another list of immeasurable injuries: frat boys posing in blackface; black men shoved aside so white women might pass on the sidewalk; beaches segregated to keep black bodies — deemed noxious or sexually enticing — away from white bodies; and, of course, the ghastly regularity of beatings and lynchings. These pathol-

14

ogies haunted black writers such as Richard Wright, who wrote of them with icy rage, and James Baldwin, who wrote of them with sorrow and pity, as when, flying to Atlanta over woodland, he imagined that the "rust-red earth of Georgia . . . acquired its color from the blood that had dripped down from these trees."

In this dark and capacious literature, one recent instance stands out for me. In her book *The Warmth of Other Suns*, Isabel Wilkerson writes of an elderly black man named George Starling, whom she interviewed at his home in Harlem around 1990. Mr. Starling recalled going as a boy some seventy years earlier to the local drugstore in his hometown of Eustis, Florida, with the plan of buying an ice cream cone. The pharmacist liked to greet his black customers by addressing a question to a little terrier he kept with him in the store. "What would you rather do," he would ask the dog, "Be a [n-word] or die?" — at which point the well-trained pet would flip onto its back, shut its eyes, and play dead. For white patrons, this canine comedy act was hilariously entertaining. For black children, there is no fathoming the damage it did to their souls.

This appalling history alone — of which I have given only a minimal sketch — makes the moral case for some form of reparations irrefutable. But it does not answer the political question of whether reparations in any conventional sense are conceivable.

Until recently, most Americans hardly thought about this question at all. Through the nineteenth century and into the mid-twentieth century— from Martin Delany in the 1850s to Queen Mother Audley Moore in the 1950s — black Americans

issued impassioned calls for recompense, even sometimes proposing dollar amounts per person or per family. By and large, these demands were dismissed, ignored, or, as in the case of Callie House, leader of the National Ex-Slave Mutual Relief, Bounty, and Pension Association, silenced by imprisonment.

But around the middle of the last century, propelled by two world-historical events, the reputation of reparations began to change. The first event took place abroad: the campaign to exterminate the Jews of Europe, led by Germany and abetted, acquiesced in, or cheered on by many other nations. This was the blasted world of which Camus said that "only the stones are innocent." The second event took place here in the United States: the movement to secure basic civil rights for millions of black Americans who were still living under a white supremacist regime to which the Nazis had turned for inspiration in devising their own typologies of race.

It is always dangerous to go down the road of analogies, which can lead to a grotesque exercise I heard Leon Wieseltier describe many years ago as "comparative calamitology." There is no ranking system for crimes against humanity. There are no scales by which to weigh the worth of Jews sent by rail to the gas chambers against the worth of Africans sent by sea into oblivion. In thinking about history, differences are always more salient than commonalities. One difference is that for some fraction of the victims of the Nazi crimes, reparations entailed calculating the value of homes lost, businesses seized, art works stolen; whereas the victims of slavery, by definition, owned nothing, including themselves. Slave owners, moreover, had incentive to keep their human chattel alive, whereas the Nazi murderers assessed their success by the efficiency of the killing.

Yet these two crimes, hideously unique as they were, rooted in distinctive traditions of bigotry and hate, one committed largely out of public sight, the other carried out openly while masquerading as a form of benevolence, confront us with a common question: once the horror stopped, what did these societies owe to the survivors and their posterity?

In the wake of the Second World War, when words like "genocide" and "Holocaust" were just entering public discourse as names for the unnamable, the German philosopher Karl Jaspers tried to answer this question. In 1946, at the University of Heidelberg, he delivered a lecture called "The Question of German Guilt," in which he attempted to thread the needle between accusing all Germans of collaboration and urging all Germans to accept that "all are co-responsible" for the way they are governed. All, "without exception," he concluded, "share in the political liability" for "deeds done by their state." And so "all must cooperate in making amends to be brought into legal form."

What Jaspers called "political guilt" turned out to be deep and wide enough in post-war Germany to support restitution of stolen property to some Jewish families, and payments to the nascent state of Israel. These attempts at mitigation — or reparation, as it came to be known — were by no means met with universal approval. Many Germans denied involvement in, or even knowledge of, the satanic work of the Third Reich, while others took private pride in its dashed dreams. As for Israelis, some opposed accepting "contaminated dollars," while others likened the whole business to Esau, in Genesis 25, selling his birthright for a mess of pottage. Still, the fact that a major European nation was trying to own up to its crimes was not lost on those who, in the 1950s, began to press the United States to do the same.

The most celebrated champion of racial justice in midcentury America, Martin Luther King, Jr., is not usually counted among them. As far as I know, he never used the term "reparations." When he did speak about the past, it was with fierce but abbreviated anger, as when he remarked not long before his death that "a society that has done something special *against* the Negro for hundreds of years must now do something special *for* the Negro." Dr. King was as free from recrimination as any justly aggrieved person can be. But he knew that, in the absence of redress, time alone does not erase past injustice. And so, in 1964, we find him writing that "the ancient common law has always provided a remedy for the appropriation of the labor of one human being by another. This law should be made to apply for American Negroes. The payment should be in the form of a massive program by the Government of special, compensatory measures which could be regarded as a settlement in accordance with the accepted practice of common law."

Dr. King was joined in this view by others with whom he is not usually associated, notably Malcolm X, who, around the same time, reopened the land question by demanding a black national homeland, pointing out that a country that provided lavish foreign aid to Europe and Latin America had no excuse for failing to do the same for people whom it treated as foreigners on its own soil. James Forman, speaking in 1969 from the pulpit of Riverside Church in upper Manhattan, called upon white churches and synagogues to put up five hundred million dollars as a kind of jump-start for a national reparations program.

Such a monetary approach was encouraged not only by the German precedent, but also by homegrown efforts in the United States. In 1946, the same year that Jaspers spoke at Heidelberg, Congress created the Indian Claims Commis-

sion as a mediator between Native Americans and the federal government. Since then, from Alaska to North Carolina, several billion dollars have been paid out by federal and state governments in settlement of land claims — a big-sounding number, but in aggregate it amounts to less than a thousand dollars per person. Payments were typically made to tribes or individuals through land trusts that dispensed funds earned by lease or sale. In some cases, land has been transferred to private corporations in which claimants are awarded shares of stock. These arrangements almost always include a provision requiring the beneficiaries to relinquish all further claim for the return of ancient tribal lands.

Another official act of reparation occurred in 1988, when Congress, with bi-partisan support, passed the Civil Liberties Act, by which the United States officially apologized to Americans of Japanese descent who had been thrown into detention camps during World War II. Almost fifty years after the disgraceful internment, payments of twenty thousand dollars — a sum meager in practice but consequential in principle — were authorized for living individuals, but no provision was made for children of deceased internees, much less for what today we would call "descendant communities." As the historian Bruce Weiner writes, "the specter of claims by other groups wronged by the U.S. government loomed in the background of the congressional debates."

As some feared and others hoped, that specter has now moved to the foreground. In fact, much of the world — not just the United States — is teeming with reparations talk. Some of it is cynical, designed to inflame resentment among the suppli-

cants — as in the demand by Poland's ruling nationalist party that Germany compensate Poland to the tune of one trillion dollars for its invasion and occupation eighty years ago. Some of it is sincere, such as Mohammed Hanif's anguished call, in the face of the recent catastrophic floods in Pakistan, that developed nations, which for centuries have poured carbon into the atmosphere, must "pay the communities that they have helped to drown" — just one voice in a growing chorus of demands that the Global North settle its "climate debt" to the Global South. Other variations, so far at least, are mainly talking points among intellectuals, such as Thomas Piketty's call for France to restore to the Haitian government some portion of the staggering sums that nation was forced to pay after independence to indemnify former slaveholders. In our own country, some advocates of reparations propose distributing trillions of dollars to everyone who can demonstrate descent from an enslaved ancestor and who, for some designated period, has identified as black.

Heartfelt as they may be, such purely monetary approaches are doomed, I think, to languish in what the human rights scholar Elazar Barkan, in his book *The Guilt of Nations,* calls "political fantasyland." They face overwhelming obstacles: competing claims by other groups or nations; rivalry and discord among prospective beneficiaries; and the mind-boggling price tag attached to any meaningful attempt to give back what was taken away. It is a cautionary fact that, right now in the United States, public hostility to the very idea of group preferences seems likely soon to kill off affirmative action in college admissions, which for the past fifty years has been a relatively small form of reparations under camouflage.

And yet, inspired in part by a powerful essay by Ta-Nehisi Coates published in *The Atlantic* not quite a decade ago, the

question of slavery reparations has been gaining attention across a swath of American life. Led by black intellectuals, including William Darity and Kirsten Mullen, Randall Kennedy, Adolph Reed, Ruth Simmons, Glenn Loury, Robin Kelley, Mary Bassett, Earl Lewis, and John McWhorter, a vigorous debate is under way over what form, if any, reparations should take. Meanwhile, apologies are flowing from universities, municipalities, and businesses for their complicity not only in slavery but in subsequent forms of racial exploitation. Some elite universities are offering tuition waivers to descendants of enslaved persons — as well as to members of federally designated Native American tribes — and making promises to invest in "descendant communities." In September 2020, the California Assembly established a task force charged with making recommendations for reparations to black Californians. A month later, in Washington, DC, Representatives Clyburn and Moulton introduced a bill, co-sponsored in the upper house by Senator Warnock, that would provide federal loan guarantees and education subsidies to descendants of black World War II veterans who were denied their GI benefits. House Resolution 40, first introduced by Representative Conyers three decades ago and named for General Sherman's promise of forty acres per emancipated person, calls for a commission to design a national reparations plan, and has now garnered more than two hundred co-sponsors. Depending on one's point of view, these are either baby steps or signs that the dam is breaking.

At stake in all these efforts is a fundamental question — we might call it the statutes-of-limitations question — broached by the philosopher Susan Neiman in a book called *Learning from the Germans: Race and the Memory of Evil.* "Do the sins of the fathers contaminate the children?" she asks. "And if so,

for how long?" It is a serious question, but it is also, because it will never yield an actionable answer, an academic question in the pejorative sense of the word. Some readers of the Bible discern an answer in Numbers 14:18, where we find the Lord "visiting the iniquity of the fathers upon the children unto the third and fourth generation." That verse seems to say that sin travels undiminished through time. Other readers, citing Ezekiel 18:20, find that "the son shall not bear the iniquity of the father, neither shall the father bear the iniquity of the son: the righteousness of the righteous shall be upon him, and the wickedness of the wicked shall be upon him." On this view, moral culpability belongs not to families, tribes, or nations but only and always to individuals. Each of these assertions begets objections from advocates of the other because, like the Constitution, the Bible will always be read by readers devoted to mutually canceling convictions.

If one turns to secular texts, one finds writers from Aeschylus and Sophocles to Hawthorne and Faulkner wrestling with the sins-of-the-fathers theme and leaving us with the same conundrum. Edmund Burke, in the wake of the French Revolution, decried the idea of holding individuals responsible for what he called a "pedigree of crimes" committed in the past by some class, party, or sect to which they may belong. But Burke also wrote that society "is a partnership... between those who are living, those who are dead, and those who are to be born." If history confers on people in the present neither credit nor blame for what happened in the past, what kind of partnership exists across time?

Our nation is badly overdue in facing this question. But seeking a consensual answer is like wading into quicksand. I suspect that most people believe both the Nay and the Yay of the matter — that no one living today is to blame for the

sins of the past, but that everyone has a responsibility to help redress them.

In pondering what this might actually mean, I came upon a book, *Reconsidering Reparations*, written recently by Olúfémi O. Táíwò, a young scholar at Georgetown University, who speaks of reparations not as payback or getting even or settling scores, but as what he calls a "construction project." He wants to refocus the debate away from the destructive past and onto a constructive future. "What if building the just world," he asks, "was reparations?" He means, I think, that we must proceed with full awareness that the dire challenges of our time — climate change, disparities in health care and education amplified by the COVID pandemic, gun violence, state violence in the form of bad policing, misused and inequitable incarceration, to name just a few — all have disproportionate effect on persons left vulnerable by history, notably but by no means only black persons. This version of reparations does not gloss over penalties exacted in the past by racial cruelty, but it looks to a future in which human dignity will count for more and more and race will count for less and less.

23

Martin Luther King, Jr. shared this view. Back in the twentieth century, when our politics were positively congenial compared with now, he understood that targeting reparations solely for black Americans was a political impossibility. He correctly predicted that "many white workers whose economic condition is not too far removed from the economic condition of his black brother, will find it difficult to accept a 'Negro Bill of Rights,'" which seeks to give special consideration to the Negro ... and does not take into sufficient

account their plight." But such resistance, with which in fact he sympathized, did not dissuade him from the principle of redress itself. On the contrary, he envisioned something more daring, more ambitious, and more inclusive — an idea of reparations that was not post-racial but cross-racial. "It is a simple matter of justice," he said, "that America, in dealing creatively with the task of raising the Negro from backwardness, should also be rescuing a large stratum of the forgotten white poor."

Today, as we tally up the human consequences of corporate globalism, I hardly need reiterate that a great many white Americans feel as demeaned and discarded as black Americans, and just as forgotten. In the grim metrics of poverty rates, infant mortality, and maternal deaths in childbirth, black Americans and Native Americans continue to hold the lead. But in the distribution of suffering, as measured by other markers such as opioid addiction, alcoholism, and suicide, the racial gap is closing — not so much because black or indigenous people are rising but because a great many white people are falling. They are falling toward what the scholars Anne Case and Angus Deaton, in a harrowing book of the same name, call "deaths of despair."

This multi-racial reality can only be addressed with a multi-racial response — a plan of the sort envisioned by King and his close ally Bayard Rustin, who, as the young historian Timothy Shenk reminds us, urged a "shifting away from race-based initiatives toward universal economic policies whose benefits would, in practice" flow disproportionately to African Americans because they have been disproportionately dispossessed. Beginning with a robust defense of the right to vote, such a response must include subsidized housing for low-income Americans; improved access to

health care; investments in public transportation; expanded child tax credits; pre-school and wrap-around services for all children of the sort that affluent families take for granted. It must include renewed investment in community colleges, historically black colleges and universities, tribal, and regional public colleges, where low-income white students as well as students of color are likely to enroll. At elite private colleges, it should mean less dependence on the blunt instrument of standardized testing, and more bridge programs for recruiting and preparing children from low-asset families, white as well as non-white. I know that all this sounds like a fanciful wish list, and a partial one at that — but it is no departure from the American creed of equal opportunity, in which both parties profess to believe, but which is undercut by structural inequities in American life.

I have no doubt that a racially inclusive approach to repairing our society stands a better chance than any restitutive effort that is racially exclusive. I believe this in part for a positive reason: that despite ferocious resistance, our leadership in politics, culture, and business is slowly but surely becoming less monochrome. I believe it, too, for the negative reason that deprivation and despair observe no racial boundary lines. Politicians have been all too good for all too long at pitting people with small means against one another; but the populist anger emanating today from both left and right presents an opportunity to turn antagonism into alliance. Reparations narrowly conceived will stoke anger and resentment, but reparations broadly imagined can be a force for unity and reconciliation.

Despite our social acerbities, there are hints of progress — if not always under the banner of reparations. There is renewed awareness of historical precedents, such as the federal

settlement in 1974 with victims of the notorious Tuskegee experiment, whereby the U.S. Public Health Service, for forty years, left hundreds of black men with syphilis untreated while studying them as medical specimens; and of compensation authorized in 1994 by the Florida State Legislature for descendants of victims of a white mob that, seventy years earlier, had murdered residents of the black community of Rosewood before burning the town to the ground. The city of Evanston is using a marijuana tax, of all things, to help fund housing grants for black residents whose families were damaged by red-lining or predatory mortgages. Though no reparations have yet been paid to victims of the notorious Indian boarding schools where for centuries children were abused and traumatized, Secretary of the Interior Deb Haaland is pushing for memorialization of the horrors, and for revitalization of the tribal languages and practices whose eradication was the schools' prime purpose.

Meanwhile, individuals descended from slaveowners are seeking out persons whose ancestors were enslaved, and vice-versa, for reconciliation and mutual education. The National Memorial for Peace and Justice in Montgomery, Alabama, conceived by Bryan Stevenson, and the Museum of African-American History and Culture founded by Lonnie Bunch, hold great promise for building an American future that will be less ignorant and more honest.

At the core of all these efforts — civic and local, personal and national — is an idea articulated long ago by Isaiah Berlin in his great essay on liberty:

What oppressed classes or nationalities . . . want is simply recognition (of their class or nation, or color or race) as an independent source of human activity, as an entity with a will of its own (whether it is good or legitimate, or not) and not to be ruled, educated, guided, with however light a hand, as being not quite fully human, and therefore not quite fully free.

I hear him here not as the Olympian Sir Isaiah, but in the voice of his boyhood self, as a child in tsarist and then Bolshevik Russia, where he was mocked and shunned for no reason other than that he was a Jew. What I hear in this passage is the universal craving for recognition that is the precondition of human freedom. It is the same craving that Ta-Nehisi Coates expresses when he defines reparations as "the full acceptance of our collective biography and its consequences." It is the keynote of African-American literature, from the fugitive slave narratives, to Zora Neale Hurston's insistence that the "oldest human longing... is self-revelation," to the opening of Ralph Ellison's *Invisible Man:* "I am an invisible man . . . simply because people refuse to see me." This is a matter on which African Americans have had an authoritative voice.

But not a proprietary voice. We hear the same theme from working-class whites in Louisiana, of whom the sociologist Arlie Hochschild writes: "You are a stranger in your own land. You do not recognize yourself in how others see you. It is a struggle to feel seen and honored." It is the same theme that torments Tommy Orange, who writes in his novel *There, There* about Native Americans "fighting for decades to be recognized as a present-tense people," and the same captured by Arthur Miller in four famous words about a middle-class white man sinking toward the abyss: "Attention must be paid."

Among its most heartbreaking expressions is Dr. King's multicultural masterpiece, *Letter from a Birmingham Jail,* in which he writes of "the degenerating sense of nobodiness" by which black Americans have been purposefully afflicted for so long. He draws in that work on Socrates, Augustine, and Aquinas, then leaps forward to Niebuhr and Tillich via Jefferson and Lincoln; but his real authority is his six-year-old daughter. To the white ministers who have scolded him for what they consider his impatience and inflammatory tactics, he replies that he has had to tell his daughter that the local public amusement park is closed to "colored children." As she tries to grasp what he is saying, he is forced to watch "depressing clouds of inferiority begin to form in her little mental sky," along with an incipient "bitterness toward white people." She is a child of slavery and of the Jim Crow South. In another sense, however, she has no color or ancestry or place of birth. She is just a child who wants to play with other children while her parents look on from near enough to make her feel safe, but far enough to make her feel proud. She is anyone's child — and anyone with a scintilla of conscience cannot abide what is being done to her.

Thinking about that child makes me wonder if reparations — freighted word that it is, all but guaranteed to trigger reproval from proponents and vitriol from opponents — is quite the right word for what we owe to the future. Perhaps the better word is "recognition," whose etymology means to know *again*, to *recognize*, that is, to re-know, re-learn, the truth of human equality, a truth that we all possess in childhood before losing it to someone else's animus or ideology, or to the encroachment of our own prejudice or self-interest.

Whichever word we prefer, it signifies the dream by which Dr. King was possessed: to repair what he called the broken

"network of mutuality" that was, according to his religion, both the origin and destiny of humankind. He set his sight not on the crimes of the past but on what another great dreamer, Herman Melville, called "the prospective precedents of the future." He was engaged, as Professor Táíwò would have it, in the work of construction. The reconstructed world that he imagined — still, for now, a dream world — will be a place where anyone's remediable suffering is an affront to us all.

JAMES KIRCHICK

From Queer to Gay to Queer

I

I am a direct beneficiary of the most successful social movement in American history. I am a gay man. Born in 1983 when a mysterious disease was beginning to decimate an earlier generation of gay men against a backdrop of societal indifference, I now live in a country where gay people can marry, serve openly in the military, and are legally protected from discrimination. Public polling regularly indicates that a large majority of Americans are accepting of their gay and lesbian fellow citizens, a majority that, thanks to the broad-mindedness of younger generations, grows larger every year. Excepting some conservative subcultural redoubts and a few

professional sports leagues, openly gay people can now be found in practically every arena of American life. The presidential candidacy of Pete Buttigieg suggests that the election of an openly gay person to the highest office in the land could happen within my lifetime.

This welcome state of affairs would have been unimaginable to all but the most clairvoyant of gay people (and, for that matter, straight people) born in the middle of the last century. As an historian of the gay experience who came to understand the fact of his own nature around the time that our leaders were busy passing measures aimed at stigmatizing gay people (the military's "Don't Ask, Don't Tell" policy and the paradoxically named Defense of Marriage Act), it was certainly unimaginable to me. For what qualifies the gay movement as more successful than any of the other campaigns for equality waged by American minority groups is both the extent of the transformation that has been achieved (in both law and public attitudes) and the rapidity with which it occurred.

It is increasingly difficult to remember today, but within living memory the homosexual was the most despised figure in the American imagination. Diagnosed as mentally ill by the medical establishment, condemned as heathens from the pulpit of every major religious denomination, their conduct deemed illegal by the state, gay men and women — commonly referred to as "perverts," "sex deviants," and even less pleasant epithets — once occupied a place comparable to that of the dissident in a totalitarian regime. Between 1946 and 1961, the year before Illinois became the first state to decriminalize homosexual acts between consenting adults, state and municipal governments imposed some one million criminal penalties upon gay people for offenses ranging from holding hands to dancing to sex, a legal regime approximating what Christopher Isherwood

31

memorably described as a "heterosexual dictatorship." Indeed, when it came to gay people, the legal system sanctioned illegality, in the form of the "gay panic" defense that enabled assailants to justify their violent, even homicidal assaults on gay men as fits of temporary insanity "provoked" by a homosexual's "indecent advance." The Postal Service impounded gay literary magazines and the FBI spied on gay rights organizations. Declared enemies of the state by leaders of both political parties, gay people were prohibited from working for the federal government until 1975, and barred from holding security clearances for another two decades.

Such was the revulsion that homosexuality aroused among the general public that, in the year I was born, Edwin Edwards, the notoriously corrupt governor of Louisiana, quipped that "the only way I can lose this election is if I'm caught in bed with either a dead girl or a live boy." Edwards might have intended his remark as a joke, but he expressed an important, if rarely acknowledged, axiom about American public life, which was that the only thing as bad as murdering a member of the opposite sex was loving a member of the same one.

In 2004, President George W. Bush won reelection after campaigning for a constitutional amendment to ban same-sex marriage. While that effort failed, over two dozen states eventually adopted anti-gay marriage amendments to their constitutions. But hearts and minds were already beginning to change. The year Bush attempted to enshrine discrimination in our country's founding document, sixty percent of Americans opposed same-sex marriage and only thirty-one percent supported it. Within fifteen years, those figures had reversed, representing the most dramatic shift in public opinion about a social issue in the history of polling. Today Pete Buttigieg serves in the Cabinet, where the greatest contro-

versy surrounding his sexual orientation was the complaint that he took too much paternity leave.

This astonishing metamorphosis in the status of the homosexual from what one elderly gay man once described to me as America's "last lepers" into full and equal members of society has had a profound impact on gay and straight people alike. By coming out of their closets, gay men and women helped the country overcome one of its most deep-seated yet irrational fears, which was ultimately a fear of difference. This national coming out has transformed relationships between friends, colleagues, even strangers. (It is often strangers who threaten gay people most, which is why the quotidian act of holding hands with one's partner in public can be a courageous act.) Most significant is the change that has happened within families, where the revelation of a loved one's homosexuality less frequently leads to the rejection and banishment that used to be the norm.

Acknowledging progress is often difficult for those fighting to achieve it, as doing so can feel like complacency when so much important work remains to be done. If gay rights activists have been hesitant to trumpet their victories, their opponents have demonstrated the opposite tendency, treating each concession to the dignity of gay people as yet another precipitous step in the decline of Western civilization. Decriminalizing homosexuality, they warned, would lead to "special rights" — that is, equal treatment — for homosexuals, which would in turn lead to the recognition of gay marriages, the legalization of polygamy and bestiality, and the rebuilding of Sodom and Gomorrah. When, in 1996, the Supreme Court struck down a constitutional amendment in Colorado that would have prohibited the state from protecting gay people from discrimination, Justice Antonin Scalia prophesied that,

as a consequence of this protection, laws against polygamy would eventually fall. Seven years later, when the Court struck down a Texas law prohibiting private sexual acts between persons of the same sex, Scalia added "state laws against bigamy...adult incest, prostitution, masturbation, adultery, fornication, bestiality and obscenity..." as next on the legal chopping block.

So swift has been the transformation of the legal landscape that conservatives have often been unable to describe it in terms other than the conspiratorial. Reviewing one such tract, a book called *The Homosexual Network,* in *National Review* in the early 1980's, the conservative commentator Joseph Sobran remarked that the book's "most important lesson" is one that "transcends homosexuality." Most worrisome to Sobran was how "a very small number of people, united on behalf of a cause heartily despised by the great majority of others, can, even in a democracy, gain unbelievable leverage." The charge that liberal elites impose their will on conservative majorities has long been a staple of American populist rhetoric, and many conservatives criticize the legal victories for gay equality on the grounds that they were decided by "activist judges." But Sobran's lament about the ability of "despised" homosexuals to "gain unbelievable leverage" over the mass of decent God-fearing Americans "even in a democracy" missed the mark. For whatever one thinks about the aims of the gay rights movement, its undeniable success is not a repudiation of democracy but a vindication of it.

That movement is widely believed to have begun with the Stonewall Uprising of 1969, when the patrons at a gay bar in Greenwich Village fought back against a police raid. (Even the provision of liquor to homosexuals was once illegal.) Over the course of three days and nights, hundreds of angry

homosexuals joined the fray, and the spirit of gay liberation was set free. "Do You Think Homosexuals Are Revolting?" a pamphlet distributed in the exhilarating weeks following the unrest cheekily asked. "You Bet Your Sweet Ass We Are."

The riot in downtown New York, which was reported in newspapers across the country, was without question a pivotal moment in the history of gay America. News of the homosexuals who had, so contrary to type, bravely resisted state oppression made a profound impact on individual gay men and lesbians, helping them come to terms with their sexuality and recognize that they were a part of something much larger than themselves. But while Stonewall was the birthplace of gay liberation, the movement for gay civic equality had begun much earlier. After some fizzling starts in Los Angeles and San Francisco in the early 1950's, the effort found its footing in the more staid precincts of Washington, D.C. The leaders of this cause may not have been "revolting" drag queens, but they were revolutionaries, of a sort.

The central figure was a Harvard-trained astronomer named Franklin E. Kameny. In 1957, Kameny was fired from his job with the Army Map Service on account of his homosexuality. Thousands of people had already been terminated on such grounds, but Kameny was the first to challenge his dismissal, a decision that would, in the words of the legal scholar William Eskridge, eventually make him "the Rosa Parks and the Martin Luther King and the Thurgood Marshall of the gay rights movement.'" In 1960, Kameny appealed to the Supreme Court to restore his job. The petition that he wrote invoked the noblest aspirations of the American founding: life, liberty and the pursuit of happiness. To the government's claim that his firing was justified on account of its right to prohibit those engaged in "immoral" conduct, Kameny

35

replied with what was, for its time, a radical, even scandalous, retort: "Petitioner asserts, flatly, unequivocally, and absolutely uncompromisingly, that homosexuality, whether by mere inclination or by overt act, is not only not immoral, but that, for those choosing voluntarily to engage in homosexual acts, such acts are moral in a real and positive sense, and are good, right, and desirable, socially and personally." He continued: "In their being nothing more than a reflection of ancient primitive, archaic, obsolete taboos and prejudices, the policies are an incongruous, anachronistic relic of the Stone Age carried over into the Space Age — and a harmful relic!"

Inspired by the African-American civil rights movement, Kameny expressed his outrage at being treated as a "second-rate citizen," and like the leaders of that heroic struggle he appealed to America's revolutionary founding document for redress:

> We may commence with the Declaration of Independence, and its affirmation, as an "inalienable right," that of "the pursuit of happiness." Surely a most fundamental, unobjectionable, and unexceptionable element in human happiness is the right to bestow affection upon, and to receive affection from whom one wishes. Yet, upon pain of severe penalty, the government itself would abridge this right for the homosexual.

Kameny's arguments may have been revolutionary, but his goals were not. He had no desire to overturn the American government; he just wanted it to live up to its self-proclaimed principles. When his appeal to the Supreme Court was denied, Kameny founded the first sustained organization in the United States to represent the interests of "homophiles"

(as some gays called themselves at the time), the Mattachine Society of Washington, D.C., in which capacity he led peaceful protests, wrote letters to every member of Congress, and engaged in public awareness campaigns. In 1965 — four years before Stonewall — Kameny organized the first picket for gay rights outside the White House. Men were required to wear jackets and ties; women, blouses and skirts reaching below the knee. "If you're asking for equal employment rights," he instructed his nine comrades, "look employable." Eight years later, he played a crucial role in lobbying the American Psychiatric Association to remove homosexuality from its register of mental disorders.

To the younger and more militant gay liberationists of New York and San Francisco, Kameny's dedication to liberal reform reeked of assimilationism. Many of them came to view Kameny with contempt, speaking of him in the same tones with which black nationalists derided Martin Luther King, Jr. With his fussy dress codes, his carefully typewritten letters, and his veneration of the Constitution, Kameny was a practitioner of dreaded "respectability politics," which for radicals (then and now) has been the great scourge of American liberalism. But Kameny was no conformist. In his petition in 1960, he declared:

> These entire proceedings, from the Civil Service Commission regulation through its administration and the consequent adverse personnel actions, to respondents' courtroom arguments, are a classic, textbook exercise in the imposition of conformity for the sake of nothing else than conformity, and of the rigorous suppression of dissent, difference, and non-conformity. There is no more reason or need for a citizen's sexual

tastes or habits to conform to those of the majority than there is for his gastronomic ones to do so, and there is certainly no rational basis for making his employment, whether private or by the government, contingent upon such conformity.

In 2015 — fifty years after staging his picket outside the White House, and four years after his death at the age of eighty-six — Kameny was vindicated when the very Supreme Court that had refused to hear his case of wrongful termination ruled that the Constitution recognized the right of same-sex couples to marry. *Obergefell v. Hodges* was a momentous victory for the American principle of equality before the law, achieved through the American principles of freedom of expression and freedom of association. (Today it is not uncommon for gay couples to include excerpts from Justice Anthony Kennedy's majority opinion among the readings at their wedding ceremonies). Five years later the Court completed the work of Kameny and his legatees in *Bostock v. Clayton County*, ruling that the Civil Rights Act of 1964 protects gay and transgender people from discrimination in the same way that it does other minority groups. By this point, the court was mainly tying up loose ends, as the private sector had already begun instituting its own nondiscrimination policies. Finally, it seemed, America had put the gay question to rest.

II
One of the most puzzling aspects of our contemporary political debate has been the reemergence of gay rights — or, in the parlance of our times, "LGBTQ rights" — as a subject of fierce public controversy. The major battleground is the public

schools, where, over the past several years, states and munici-
palities across the country have passed laws prohibiting discus-
sion of subjects pertaining to sexual orientation and gender
identity in early grade levels. Some of the rhetoric surround-
ing these efforts (describing schoolteachers as "groomers") has
a distinctly menacing tone, invoking ugly stereotypes of gay
men as pedophiles.

But just as the rhetoric of the anti-gay right harks back to
a darker time, the language of some of those purporting to
speak on behalf of "LGBTQ people" has assumed something of
a retro quality as well. The most visible manifestation of this
development has been the revival of the word represented by
the last letter in that cumbersome acronym: "queer." A decade
ago, the *New York Times* had printed this word — commonly
regarded as a slur — only eighty-five times in the paper's
entire history. In 2022 alone, the *Times* published it well over
six hundred times. (Pamela Paul published these figures in
her *Times* column last October.) Once difficult to find on the
website or in the literature of the country's leading gay rights
organization, the Human Rights Campaign (HRC), "queer"
is rapidly replacing "gay" and "lesbian" in our discourse. Last
year, in a six-and-a-half-minute video introducing herself,
HRC's new president did not once utter those words. She did
employ "queer."

Like nearly all words, "queer" has several meanings, and its
usage has evolved over time. Seventy years ago, some masculine
"straight-acting" gay men favored "queer" as a means of differ-
entiating themselves from their more effeminate brothers,
whom they derided as "fairies." (Gays are as capable as any
minority group of replicating among themselves the prejudice
that they endure in mainstream society, a lamentable form
of self-hatred that often stigmatizes the more flamboyant,

the more gender nonconforming, the "swish" who could not "pass" for straight if his life depended on it. As Kameny himself argued, homosexuals "are as honest and as dishonest, as reliable and as unreliable, as industrious and as lazy, as conscientious and as irresponsible, as liberal and as conservative, as religious and as irreligious, as much law-abiding and law-breaking as is the citizenry at large.") The most common usage of "queer," however, was as a derogatory epithet. It ranked with "faggot," and was often the last word a gay man heard before having his head bashed in.

Around the late 1980's, justifiably angered at the societal apathy towards the AIDS crisis, some left-wing gays and lesbians defiantly appropriated "queer" from the homophobes. The radical direct-action group Queer Nation outed closeted public figures and famously disrupted a taping of the "Arsenio Hall Show" to protest the appearance of the gay-bashing comedian Andrew Dice Clay. Today, in its most innocuous application, "queer" can serve as a concise label for the entire LGBTQ community — not all transgender people are homosexuals, and many lesbians feel left out by the term "gay." Popular television shows such as *Queer Eye for the Straight Guy* and *Queer as Folk* do not carry a political connotation so much as they do a playful one. To adopt a critical "queer" approach — to examine literature, film, art, historical episodes, or relationships for homosexual subtexts — can be a valid method of analysis. Adopting a slur used by one's enemies, according to this reasoning, robs the word of its ability to harm.

Some argue that the embrace of "queer" over "gay" represents a natural evolution in the use of language, no different from the way in which "gay" started to replace "homosexual" and "homophile" in the 1970's. But whether used pejoratively, proudly, or as a matter of mere linguistic

convenience, "queer" has always been a loaded word, encompassing meanings and implications that the more neutral "gay" lacks. Some of those who embrace "queer" liken themselves to African-Americans who have reclaimed "nigger." But the comparison doesn't wash. Where university course books abound in Queer Studies classes, there are no course offerings, mercifully, in N-word Studies. (See the difference? Having reluctantly used the word once I don't wish to use it again.) You will never hear Oprah Winfrey, Henry Louis Gates, Jr., or Hakeem Jeffries use this word to refer to themselves or another black person. The disgusting word has of course been given a new lease on life in popular African-American culture, particularly in hip-hop, where it is commonplace, the result of a complicated psychology and sociology; but there, too, all the entertainment pleasure notwithstanding, it grates.

The Oxford English Dictionary defines "queer" adjectivally as "strange, odd, peculiar, eccentric, in appearance or character." As a noun, "queer" denotes a "questionable character, suspicious, dubious." Many of those who embrace "queer" over "gay" do so precisely because it connotes marginalization. All minorities have found a certain dark glamor in deviance, a kind of reverse prestige in marginalization, even if none have ever wished to pay the price. Many gays — like many straights — reject the mainstream, which they find stifling and oppressive, and they wish to subvert it. "Queer," in this sense, implies less a sexual orientation than a socio-political one. Identifying herself as "queer past gay," the late radical feminist author bell hooks said that being queer is not "about who you're having sex with — that can be a dimension of it — but queer as being about the self that is at odds with everything around it and it has

41

to invent and create and find a place to speak and to thrive and to live." After years of rejection by society, acceptance can mean the end of dissidence, of coolness, of the romance of rebellion.

Such an expansive definition, however, means that anyone — including heterosexuals — can now identify as queer. Not long ago a male journalist "came out" as queer on Twitter while making sure to note that "I'm attracted to a wide range of women, but not men at all." In case this identity saga seemed illogical, he explained that "embracing being queer was as much an intellectual journey as it was other areas. Just the way I think of structural oppression comes from not feeling heteronormative in my thinking about things." What regular gay people strived long and hard to transform into one identity attribute among many, to make as relevant to a person's character as their eye color or shoe size, queers seek to italicize and imbue with transgression. "Queerness" is an attempt to revive homosexuality's lost radical splendor, which is the inevitable consequence of the attainment of rights and the spread of decency. "Queerness" is a means by which anyone — regardless of sexual orientation — can assume a posture of defiance against mainstream society and bourgeois values.

The first thing a gay person understands about their sexual orientation is that they harbor a dangerous secret, one requiring them to pretend that they are something that they are not. For gay people, the process of coming out is sacred, marking the point when they stop living a lie and begin living in truth. For this reason, a heterosexual who "comes out" as queer disrespects a long and harsh struggle and reeks of identity slumming, like the episode of "Seinfeld" in which Jerry's dentist converts to Judaism "just for the jokes." The pose is a moral travesty. The British lesbian writer Julie Bindel has observed

that "queer" has increasingly come to describe "anyone who decides that admitting to being heterosexual is boring."

The proliferation of functionally straight people declaring themselves queer has been a subject of bemused ridicule among actual gay people for some time. But the adoption of various queer identities is no longer an isolated trend. Over the past decade, the proportion of Generation Z (those born after 1997) which identifies as LGBT has tripled to twenty-one percent. (One poll puts the figure at forty percent). Among millennials (those born between 1980 and 1997), this figure doubled from slightly over five percent to ten and a half percent. The rapid rise in LGBT identification is a phenomenon exclusive to young people; the fraction of Generation X, Baby Boomers, and those born before 1946 who identify as LGBT has remained roughly stable (at 4.2 percent, 2.6 percent, and .8 percent, respectively).

Some might argue that this increase in LGBT identification among the young is the natural, and welcome, result of America becoming more tolerant of diverse sexual and gender identities; that, just as the number of left-handed people increased once we stopped forcing kids to write with their right hands, so has the number of people willing to acknowledge their LGBT identity similarly grown. But the increase in LGBT identity has not correlated with a rise in same-sex behavior. In 2008, five percent of Americans under thirty identified as LGBT, and a similar number reported engaging in same-sex relations. By 2021, while the proportion of this cohort identifying as LGBT more than tripled, only half of them reported same-sex sexual activity.

This incongruence is owed partly to the increase in the number of people, particularly young people, identifying as bisexual. More than half of LGBT Americans,

43

fifty-seven percent, define themselves this way. Yet among those married or cohabitating, they are overwhelmingly paired with a member of the opposite sex. This has led to the curious outcome whereby LGBT Americans — a group once known quaintly as "the gay community" — are now more likely to be married or living with someone of the opposite sex (twenty-two percent) than with someone of the same sex (sixteen percent). Queerness, then, is increasingly becoming just another trend that gay people innovate (like fashionable neighborhoods, music, clothing, and other forms of cultural expression) and straight people adopt.

The rise in LGBT identity is also a markedly political development. Across time, cultures, and geography, homosexuality has always been a naturally occurring and randomly distributed phenomenon, "numbering its adherents everywhere," as Proust wrote, "among the people, in the army, in the church, in the prison, on the throne." Gay people can be found among every race, class, nationality, and political camp; the only way in which they are uniform is in the nature of their same-sex attraction. And yet, from 2008 to 2021, LGBT identification tripled among self-identified "very liberal" college students while rising only three to nine percent among those who are slightly liberal, moderate, and conservative. Today, while five percent of "very conservative" college students identify as LGBT, a full half of "very liberal" students do. Even accounting for the entirely understandable fact that gay people tend to be more liberal than the rest of the general population (a trend that has been decreasing along with the political saliency of homosexuality), there is no explanation for this massive disparity other than that it is exogenously influenced.

Heavily influenced by social media and the broader political environment, the biological identity of gayness is

44

being superseded by the subjective identity of queerness. Whereas the former is innate and has no inherent political ramifications, the latter can be freely chosen and is politically radical. According to the Foundation for Individual Rights and Expression, a very liberal white female college student who supports shouting down a campus speaker has a seventy percent likelihood of identifying as LGBT. Unsurprisingly, there are psychological consequences for those who decide to put themselves "at odds with everything around" them. Despite the growing societal acceptance of homosexuality, the number of LGBT students reporting mental health issues has soared over the past decade. "It is possible that the groups which report worse mental health — such as young LGBT and very liberal people — have disproportionately shaped, and been shaped by, a new left-modernist culture," writes Eric Kaufmann of Birkbeck College, who has studied the rise in LGBT identity among youth. "This zeitgeist values transgressing social boundaries while valorizing vulnerability and victimhood."

A zeitgeist of transgression and victimhood is one that, by definition, will never be satisfied. It will forever be in opposition. "I feel an inexplicable amount of rage witnessing the Senate likely to overcome the filibuster to vote to codify marriage rights for same-sex couples." These words condemning last year's belated legislative codification of marriage equality came not from a fire-breathing evangelical preacher, but from the deputy director for Transgender Justice at the American Civil Liberties Union, a leading figure of the queer left named Chase Strangio.

A significant part of my career has (begrudgingly) been devoted to marriage-related litigation. I find it disap-

pointing how much time and resources went into fighting for inclusion in the deeply flawed and fundamentally violent institution of civil marriage. I believe in many ways, the mainstream LGBTQ legal movement caused significant harm in further entrenching the institution of marriage as an organizing structure of US civil society.

Even equality, for him, is not worth the renunciation of the glamour of outsiderhood.

This cleaving to marginality helps to explain the queer aversion to Pete Buttigieg, whose most vocal opponents were found not among the homophobic right but among the queer left, who saw in the former mayor of South Bend a paragon of "homonormativity." During the campaign of 2020, a group of activists calling themselves "Queers Against Pete" attempted to disrupt his events. In a screed for *The New Republic* that the magazine later retracted, the writer Dale Peck derided Buttigieg as "Mary Pete," the gay version of an Uncle Tom. That Buttigieg is not a "socialist" or a "revolutionary" offended Masha Gessen of *The New Yorker*, who bemoaned his appeal to "older, white, straight people," a quality that rendered him "a straight politician in a gay man's body." There is something repulsive about the policing of authenticity, and historically it has been one of the most destructive ways in which members of a minority turn on each other.

Reflecting upon a *TIME* magazine cover featuring Buttigieg and his husband standing outside their home, Greta LaFleur, a professor of American Studies at Yale, considered how "our first gay first family might actually be a straight one." For those confused as to how a same-sex couple could qualify as "straight," LaFleur explained: "If straight people can be queer — as so many of them seem so impatient to explain to

me — can't gay people also be straight?" The title of this ugly little diatribe? "Heterosexuality Without Women." LaFleur never delineated just what she meant by "heterosexuality," imputing it to the Buttigiegs based upon their appearance ("I wondered, for a second, if they were *actually* wearing the same pair of pants,") traditionalism (the image reeked of "Norman Rockwell,") and sexual modesty ("there's actually *no* sex at center stage").

It is important to say clearly, therefore, that aside from same-sex attraction, there is no "correct" way to be gay, just as there is no "correct" way to be left-handed, and to claim otherwise is not progressive but regressive, foisting upon gay people the same gendered expectations and roles from which they fought so long and hard to break free. These critics are like the progressive fools of the 1980s who said that Margaret Thatcher was not really a woman, and their doctrinaire definitions are pernicious. That Buttigieg has chosen a life of white picket fences, childrearing, and monogamy makes him no less of a gay man than one who opts for a life of childless hedonism in the gay ghetto. Of course Buttigieg is gay. What he isn't is queer.

With its insistence that gay people adhere to a very narrow set of political and identitarian commitments, to a particular definition that delegitimates everything outside of itself, political queerness is deeply illiberal. This is in stark opposition to the spirit of the mainstream gay rights movement, which was liberal in every sense — philosophically, temperamentally, and procedurally. It achieved its liberal aspirations (securing equality) by striving for liberal aims (access to marriage and the military) via liberal means (at the ballot box, through the courts, and in the public square). Appealing to liberal values, it accomplished an incredible revolution in

human consciousness, radically transforming how Americans viewed a once despised minority. And it did so animated by the liberal belief that inclusion does not require the erasure of one's own particular identity, or even the tempering of it. By design, the gay movement was capacious, and made room for queers in its vision of an America where sexual orientation was no longer a barrier to equal citizenship. Queerness, alas, has no room for gays.

The victory of the gay movement and its usurpation by the queer one represents an ominous succession. The gay movement sought to reform laws and attitudes so that they would align with America's founding liberal principles; the queer movement posits that such principles are intrinsically oppressive and therefore deserving of denigration. The gay movement was grounded in objective fact; the queer movement is rooted in Gnostic postmodernism. For the gay movement, homosexuality was something to be treated as any other benign human trait, whereas the queer movement imbues same-sex desire and gender nonconformity with a revolutionary socio-political valence. (Not for the first time, revolution is deemed more important than rights.) And whereas the gay movement strived for mainstream acceptance of gay people, the queer movement finds the very concept of a mainstream malevolent, a form of "structural violence." Illiberal in its tactics, antinomian in its ideology, scornful of ordinary people and how they choose to live, and glorifying marginalization, queerness is a betrayal of the gay movement, and of gay people themselves.

III

The foundations of queer politics lie in queer theory. Like the other tributaries of post-structuralist thought, queer theory

explains the entirety of human relations — indeed, of human existence itself — in terms of power. In his pioneering *History of Sexuality*, Michel Foucault posited that homosexuality is a socially constructed identity that was imposed upon a set of practices in the middle of the nineteenth century. "Homosexuality appeared as one of the forms of sexuality when it was transposed from the practice of sodomy onto a kind of superior androgyny, a hermaphroditism of the soul," he wrote. "The sodomite had been a temporary sinner; the homosexual was now a species." The homosexual did not exist until this point; he was created by "discourses" that privileged the "normal." The classification of homosexuality, and the subsequent "creation" of the homosexual, was another bourgeois capitalist tool of oppression.

Foucault was right to contend that the concept of sexual orientation, and the subsequent "invention" of the homosexual, were uniquely modern. Where he erred was in his claim that this new understanding was an oppressive deployment of discursive power. On the contrary, it was the single most liberating development in the history of homosexuality, in that it allowed society to understand gay people as a distinct minority group that could seek legal recognition and protection.

When you work your way through their ostentatiously abstruse vocabulary, the intent of the queer theorists becomes clear: revolution against the "normal," however it happens to be understood. "Queer is by definition whatever is at odds with the normal, the legitimate, the dominant," David Halperin, one of the leading academic queer theorists, explained in 1995 in *Saint Foucault: Towards a Gay Historiography*. In this analysis, expanding our conception of the normal — which the gay movement stupendously achieved — is worse than insufficient. It is a sordid collaboration with power. (This is how the

49

extension of hard-won marriage rights to gay people becomes the strengthening of a "fundamentally violent institution.") Standing among the vanguard that is striving to hasten our redemption, our glorious human future, is a never-ending obligation. "Normalizing the queer would be, after all, its sad finish," Judith Butler, one of the grand poobahs of queer theory, explains. Only liberation from the normal will do. Lacking a normative dimension to its analysis, queer theory is, at its essence, nihilistic. "There is nothing in particular to which [queer] necessarily refers," Halperin writes. "It is an identity without an essence." Which allows for an ideology without limits.

In 1984, in her influential article "Thinking Sex: Notes for a Radical Theory of the Politics of Sexuality," Gayle Rubin delineated the consequences of such an ideology. Widely considered to be one of the foundational texts of queer theory, Rubin's thesis is that "sex is always political." Hip to the fact that "sexuality is impervious to political analysis as long as it is primarily conceived as a biological phenomenon or an aspect of individual psychology," she must therefore negate biology, psychology, and the historical record. Rubin is a cultural anthropologist; like the other leading queer theorists, she has no formal training in the hard sciences or history. This absence of knowledge is of no hindrance to the queer theorists, of course. Biology, psychology, and even in history, after all, are mere "discourses" shaped by those holding "power," and all must bow before the tyranny of the emancipatory theory.

Heavily influenced by Marx, the queer theorists neatly apply his economic analysis to sexual relations. In place of his pyramidical class system with its oppressive capitalists on top and oppressed proletarians toiling down below, Rubin constructs a "sexual hierarchy" in the form of a "charmed circle"

reinforcing a system of laws that "operate to coerce everyone towards normality." In the middle of this circle sits the various forms of privileged sexuality: "heterosexual, marital, monogamous, reproductive, and non-commercial. It should be coupled, relational, within the same generation, and occur at home." Existing precariously on the circle's "outer limits" is "bad, abnormal, unnatural, damned sexuality," as well as sex that is "homosexual, unmarried, promiscuous, non-procreative, or commercial." Rubin's description of how this sexual system operates parodies the Marxist dialectic of class struggle:

> Differences in social value create friction among these groups, who engage in political contest to alter or maintain their place in the ranking. Contemporary sexual politics should be reconceptualized in terms of the emergence and on-going development of this system, its social relations, the ideologies which interpret it, and its characteristic modes of conflict.

The sexual hierarchy is of a piece with the other forms of oppression that exist within bourgeois societies. "All these hierarchies of sexual value — religious, psychiatric, and popular — function in much the same ways as do ideological systems of racism, ethnocentrism, and religious chauvinism," Rubin writes. "They rationalize the well-being of the sexually privileged and the adversity of the sexual rabble."

According to Rubin, Western societies vigilantly police their systems of sexual oppression lest the acceptance of any form of "abnormal" sexuality spark the "domino theory of sexual peril" whereby the entire structure would collapse. "If anything is permitted to cross this erotic DMZ, the barrier against scary sex will crumble and something unspeakable will

skitter across," she declares. The goal, then, should be not to expand the "charmed circle" so as to include homosexuality, but do away with it altogether. Foreshadowing the attacks on Pete Buttigieg and other "cisgender white gay men" that has become such a staple of queer discourse, Rubin observes that while "most homosexuality is still on the bad side of the line... if it is coupled and monogamous, the society is beginning to recognize that it includes the full range of human interaction." That, believe it or not, is a bad thing. By contrast, she complains that "promiscuous homosexuality, sadomasochism, fetishism, transsexuality, and cross-generational encounters are still viewed as unmodulated horrors incapable of affection, love, free choice, kindness, or transcendence."

Most gay people would be repelled at seeing their sexual orientation, a core aspect of their identity, conflated with pastimes such as "sadomasochism" and "fetishism." Elsewhere Rubin lists homosexuality alongside other "innocuous behaviors" such as "prostitution, obscenity, or recreational drug use." But if the biological phenomenon of sexual orientation is no more legitimate a basis for sexual identity than anything else, and all notions of boundaries and propriety are mere instruments of power dynamics, then there is no justification — moral, philosophical, or legal — for deeming a homosexual identity more valid than a sadomasochistic or fetishistic one. (The Reverend Jerry Falwell agreed.) The happiness of the many is to be held hostage to the cheap transgressiveness of the few. Devoid of any limiting principle, queer theory compels its adherents to wage perpetual war against the "normal" — often from the precious and protected ramparts of the faculty lounge.

This ethos of self-imposed marginalization is a recipe for permanent despair, but for its advocates it is thrilling all the

52

same, for one must forever be seeking novel ways to *épater la bourgeoisie*. "Sexualities keep marching out of the *Diagnostic and Statistical Manual* and on to the pages of social history," Rubin marvels. "At present, several other groups are trying to emulate the success of homosexuals. Bisexuals, sadomasochists, individuals who prefer cross-generational encounters, transsexuals, and transvestites are all in various states of community formation and identity acquisition." She has seen the future and it is queer.

In their contention that homosexuality is a series of freely chosen acts, a voluntary persona rather than an inborn identity (a claim directly at odds with the most fundamental premise of the gay rights movement), the queer theorists are in odd alignment with the reactionary forces which have everywhere sought to repress gay people. And this is not the only notion that the queer theorists share with their far-right antagonists; the two sides operate in a perverse symbiosis. Rubin seems keen on validating the portents of anti-gay bigots who argue that toleration of homosexuality will open the floodgates to other moral depredations. Her warning is like Scalia's. "Sodomy laws, adult incest laws…clearly interfere with consensual behavior and impose criminal penalties on it," she writes. "If it is difficult for gay people to find employment where they do not have to pretend, it is doubly and triply so for more exotically sexed individuals. Sadomasochists leave their fetish clothes at home, and know that they must be especially careful to conceal their real identities. An exposed pedophile would probably be stoned out of the office."

This lament for the plight of pedophiles — one of several groups whom Rubin sympathetically describes, alongside homosexuals, as "erotic dissidents" — is not an isolated one. Throughout her canonical essay Rubin decries the

treatment of those preferring "cross-generational encounters," a euphemism that she employs not in reference to the May-December romance. "Adults who deviate too much from conventional standards of sexual conduct are often denied contact with the young, even their own," she laments, along with the fact that "members of the teaching professions are closely monitored for signs of sexual misconduct." Rubin lauds the notorious North American Man Boy Love Association (NAMBLA) for its opposition to child pornography laws. "Although the Supreme Court has also ruled that it is a constitutional right to possess obscene material for private use, some child pornography laws prohibit even the private possession of any sexual material involving minors." The horror! America's treatment of pedophiles brings to her mind nothing so much as the twinned Red and Lavender Scares of the McCarthy era:

> Like communists and homosexuals in the 1950s, boylovers are so stigmatized that it is difficult to find defenders for their civil liberties, let alone for their erotic orientation. Consequently, the police have feasted on them. Local police, the FBI, and watchdog postal inspectors have joined to build a huge apparatus whose sole aim is to wipe out the community of men who love underaged youth. In twenty years or so, when some of the smoke has cleared, it will be much easier to show that these men have been the victims of a savage and undeserved witch hunt. A lot of people will be embarrassed by their collaboration with this persecution, but it will be too late to do much good for those men who have spent their lives in prison.

The defense of pedophilia is a running theme in the literature of queer theory. Describing the transformation of sexual acts into sexual orientation in his *History of Sexuality*, Foucault relates the story of a nineteenth-century French farmhand who "had obtained a few caresses from a little girl" and was subsequently reported to the authorities by her parents. "What is the significant thing about this story?" Foucault asks. "The pettiness of it all; the fact that this everyday occurrence in the life of village sexuality, these inconsequential bucolic pleasures, could become, from a certain time, the object not only of a collective intolerance but of a judicial action, a medical intervention, a careful clinical examination, and an entire theoretical elaboration." The possibility that the "bucolic pleasures" Foucault so elegiacally describes in this rhapsody to child molestation might not have been "inconsequential" for the "little girl" does not vex him. No, what concerns Foucault is that the behavior of the farmhand is seized upon by jurists, doctors, clinicians, magistrates, and all the other lickspittles of "power." Foucault is shaken by how "our society — and it was doubtless the first in history to take such measures — assembled around these timeless gestures, these barely furtive pleasures between simple-minded adults and alert children, a whole machinery for speechifying, analyzing, and investigating." In the late 1970s Foucault advocated for abolishing France's age of consent laws, and in 2021 he was accused posthumously of raping boys as young as eight while living in Tunisia in the late 1960s.

For the queer theorists, the taboo on "cross-generational" or "intergenerational" sex is just another deplorable boundary to "queerness." "Why is age — unlike, say, race or class — understood as a sexualized power-differential protected by law?" asks Annamarie Jagose in *Queer Theory: An Introduction*.

55

"Is it possible to eroticize children in an ethical way? These are the questions commonly raised — and by no means yet resolved — in the controversy over intergenerational sex." Judith Butler, an internationally renowned practitioner of the rhetorical question, smuggles pedophilia into a long list including a number of worthy concerns: "If marriage and the military are to remain contested zones, as they surely should, it will be crucial to maintain a political culture of contestation on these and other parallel issues, such as the legitimacy and legality of public zones of sexual exchange, intergenerational sex, adoption outside marriage, increased research and testing for AIDS, and transgender politics. All of these are debated issues, but where can the debate, the contest, take place?" Are pedophiles, then, merely queer?

Thankfully, Rubin's prescience is as deficient as her ethics, and her prediction that sometime in the not-too-distant future "it will be much easier to show" that "boylovers" were the "victims of a savage and undeserved witch hunt" in the way that gay men and lesbians were purged from the federal government has not come to pass. While its normalization of pedophilia — suddenly the dream of normality is valid! — remains on the margins, where decency and empathy decree it should be, queer theory has managed to infect our public life in other ways, mainly through its deconstruction of the sex binary and the supplanting of sex with gender.

The idea for which Butler is most famous — that gender is a social construct — is an important notion, even if thinkers from Plato to Wollstonecraft to Mill had recognized it long before she did. (To be sure, Butler's claim that gender is *entirely* a social construct is far more sweeping and radical than what any of these earlier philosophers proposed.) Socially imposed gender norms can be a prison for many people, especially

gay men and lesbians, who by their very nature as same-sex-attracted beings challenge the traditional notions of what it means to be a man or a woman. One of the great achievements of the gay movement was to rupture the conflation between biological sex and socially constructed gender; a man need not be stereotypically masculine in order to qualify as a man, nor need a woman be stereotypically feminine to count as a woman. Blurring the gender binary has helped all of us — gay, straight, bisexual — to live our lives free of gendered expectations and roles.

But there are limits to what social constructionism can explain. While gender may be, as Butler contends, in significant part "performative," biological sex is not. It is real, immutable, and, among humans, dimorphic. The sex binary is certainly essential to homosexuality; without it, gay men and women would have no ability to comprehend themselves or to explain their same-sex orientation. If "man" and "woman" are not stable categories, then neither are "gay" and "lesbian." These realities are at odds with the ascendant ideology of gender, which holds that the very existence of binaries and categories are mechanisms of oppression. By arguing that both biological sex and the sex binary are social constructions, gender ideology truncates gay identity by conceptualizing it as a halfway point to another sex. It also makes a mockery of transgender identity, which relies on the existence of the sex binary in an even more essential way. The renowned transgender economist Deirdre McCloskey entitled her memoir about her transition *Crossing*, evoking the process of traveling from one side of a boundary to another.

Until fairly recently, the term "transgender" referred to those with gender dysphoria, the psychological term, and the medical diagnosis, describing the severe sense of unease

that one feels at the discordance between their biological sex and their gender identity. This condition affects an extremely small number of people. Today, the meaning of "transgender" has been broadened to include anyone who does not conform to stereotypical gender roles, a process of etymological imperialism that threatens to delegitimate gay men and lesbians. The Human Rights Campaign, for instance, defines "transgender" as "an umbrella term for people whose gender identity and/or expression is different from cultural expectations based on the sex they were assigned at birth," a meaning so far-reaching as to comprise every gay person, who, by dint of their attraction to members of the same sex, expresses their gender in ways which are at odds with "cultural expectations." A slide presentation recently delivered at my old elementary school described a "transgender person" as "someone whose gender identity or gender expression does not correspond with their sex assigned at birth," which would make many effeminate men and masculine women transgender, and unwittingly invokes the nineteenth-century theory of "sexual inversion" that conceptualizes gay people as heterosexuals born in the wrong body.

It is ideas such as these which Republican politicians have cited as evidence for their claim that America's public schools have become hotbeds of radical queer and gender theory. At first blush, this fracas seems like a rehash of the perennial battle over school curricula. From the Scopes trial to the Reagan-era clash over abstinence education, these controversies are invariably framed as contests between enlightened modernizers and neanderthal reactionaries. While claims of a nationwide effort to "groom" prepubescent children show the signs of an all-American moral panic, it is unfortunately the case that some of the central tenets of queer theory have escaped the ivory tower and found their way into some public

schools. Materials published by the San Diego Unified School District, for instance, call for a "linguistic revolution to move beyond gender binaries," whereby men are to be called "people with a penis" and women "people with a vulva." A document promulgated by the Portland Public Schools maintains that the gender binary is a vestige of "white colonizers" and that terms such as "girls and boys," "ladies and gentleman," and "mom and dad" should be replaced with "people," "folx," and "guardians." An education guide for teachers in Grades 3-8 promulgated by the Human Rights Campaign advises replacing the term "Snowman" with "Snowperson" so that students be made to "understand the differences between gender identity, sexual orientation and sex assigned at birth."

In 2016, the Gay-Straight Alliance Network — an informal association of support groups for gay students with some four thousand chapters across the country — officially changed its name to the Genders & Sexualities Alliance Network, purportedly at the insistence of the "countless youth leaders who understand their genders and sexualities to be uniquely theirs and have moved beyond the labels of gay and straight, and the limits of a binary gender system." A nine point manifesto drafted by the organization, explicitly inspired by the Black Panther Party's Ten-Point Program, calls for "the abolition of the police, ICE, Borders and the Judicial System," "Decolonization and Reparations for all Indigenous and Black People," and "an End of the Cisgender Heterosexual Patriarchy."

59

The educators advancing this agenda surely think of themselves as well-intentioned, and the impulse to make schools — long sites of trauma for gay and transgender youth — more welcoming is salutary. But by inculcating young people in the tenets of radical gender ideology, these would-be revolutionaries are actually doing harm, proliferating sloppy

and dogmatic ideas about some of the most fundamental dimensions of human life, exploiting the good will that the gay movement finally accrued, and confusing and hurting the very students they purport to help.

IV

It was to be expected, as societal approval of homosexuality soared and legal equality for gay people was finally achieved, that the infrastructure of the gay rights movement would be deployed on behalf of transgender people. So long as the aims and the tactics of the movement remain the same — securing legal equality and social acceptance — this is a worthy endeavor. Beholden to the concepts of radical gender ideology, however, the movement has gone beyond seeking for trans people what it won for gays, evolving from being a force that changed reality by transforming public attitudes into something that opposes reality itself.

The examples of this illusory program lie all around us. The steady erasure of the word "woman" in favor of the dehumanizing "pregnant person," "menstruators," and "bodies with vaginas." The athletic triumphs of natal men competing in women's sports competitions. The placement of natal men in women's rape shelters and prisons. The ACLU's expurgation of the words "woman," "she," and "her" from a Ruth Bader Ginsburg quotation extolling the importance of abortion rights. Facebook offering its users the option of seventy-one genders. Recently trying to locate the men's room at a restaurant, I could only smile at the sign that sought to cause the least possible offense: "This is a bathroom with urinals and stalls."

It used to be conservatives who told gay people that their sexuality could be corrected, that gay men finding "the right girl" (or, in the case of lesbians, "the right guy") would

fix their condition. Now it is self-fashioned progressives who instruct gays that they must get over their archaic attraction to people of the same-sex. According to the BBC style guide, a "homosexual" is a person who is "attracted to people of their own *gender*," a linguistic legerdemain that, by virtue of the mantra that "trans women are women and trans men are men," has led to lesbians being called "vagina fetishists" for their refusal to date "people with a penis." In her lauded book *The Right to Sex*, the Oxford philosopher Amia Srinivasan asks us to "consider the gay men who express delighted disgust at vaginas ... Is this the expression of an innate, and thus permissible revulsion — or a learned and suspect misogyny?" It happens that one of my earliest memories of the terrifying recognition that I might be different from other boys transpired when one of my bunkmates at summer camp unveiled a nudie mag hidden beneath his bed. We all huddled around, and when he turned to the page on which the object of our desires spread her legs, I felt a pit in my stomach as my bunkmates erupted in cries of adolescent exaltation. I can assure Professor Srinivasan that the basis of my reaction to that photograph, which I understood immediately as something I needed to keep secret, and which became a source of shame for years, was the furthest thing from "learned."

The conflation of gender nonconformity with transgenderism has predictably resulted in an explosion in the number of young people identifying as transgender. Many if not most of these children are likely to be gay. In 2021 a study of boys with gender dysphoria found only a 12.2% persistence rate, and of the 87.8% who desisted, 63.6% grew up to be gay. Placing gender dysphoric children on puberty blockers, while perhaps necessary for an extremely small number undergoing severe distress, disrupts the stage of human development

when sexual orientation becomes recognizable. "Gender-affirming care" involves procedures that can lead to a lifetime of being unable to achieve orgasm, and in most cases results in sterilization. The not insignificant number of those who undergo transition only to regret it later, the growing constituency known as "detransitioners," commonly cite internalized homophobia as the impetus for believing they were trans — the false hope that, by changing their sex, they could rid themselves of their unwanted same-sex attraction. Staff at the United Kingdom's leading gender identity clinic for young people (recently forced to shut down following a government investigation which faulted it for rushing young people to transition) used to morbidly joke that, thanks to their work, "there would be no gay people left."

More recently than we would care to admit, gay people were institutionalized, lobotomized, and subjected to electroshock therapy, all in the attempt to "make" them straight. Today the inhuman practice of "conversion therapy" is outlawed in many states, and rightfully so. But a similar campaign is afoot to conflate this discredited practice with talk therapy for gender dysphoria, so that a child's assertion that they are transgender would be sufficient grounds to place them on the path to gender reassignment surgery. Under this dispensation, anything short of "affirming" a transgender child's identity would be considered a human rights violation. According to the Human Rights Campaign, "being transgender is not a phase, and trying to dismiss it as such can be harmful," a claim at odds with the available scientific research and the experiences of other advanced democracies such as Finland, Sweden, and the United Kingdom, which have all imposed stricter standards for the disbursement of puberty blockers to gender dysphoric children.

Gays have for decades been falsely accused of trying to "convert" children to their "lifestyle." Ironically, it is now gay children who, by having their gender nonconformity misdiagnosed as gender dysphoria, are most at risk of undergoing a new form of conversion therapy. For what else are we to call the phenomenon by which children who would otherwise grow up to be healthy gay adults are encouraged to undergo irreversible medical interventions? This is conversion therapy, progressive-style.

The long march of what Rubin calls "identity acquisition" has no end, and in their incessant quest for norms against which to rebel, the advocates of queerness invent ever more obscure identities to embrace. As being gay no longer carries the cachet that it once did in progressive spaces, and public figures such as Caitlyn Jenner demonstrate that even transgender people can be Republicans, the progressive avant-garde has had to create new categories on the outermost limits of the "charmed circle" through which to stake their claim on marginality, and thereby on virtue. Hence the emergence of the latest boutique identity to fasten itself onto the LGBT community: nonbinary.

Adopted by those who identify as existing outside the gender binary, the term "nonbinary" actually reifies the system that it is meant to deconstruct. By anointing themselves the possessors of a special and exclusive status — those who are neither male nor female — the members of this caste, this sexual-social avant-garde, relegate the rest of us to a sort of gender purgatory. "In reality, everybody is non-binary," explains the political philosopher Rebecca Reilly-Cooper. "We all actively participate in some gender norms, passively acquiesce with others, and positively rail against others still. So to call oneself non-binary is in fact to create a

63

new false binary. It also often seems to involve, at least implicitly, placing oneself on the more complex and interesting side of that binary, enabling the non-binary person to claim to be both misunderstood and politically oppressed by the binary cisgender people."

But apart from the infinitesimally small number of people born with both male and female sex characteristics (known as intersex), the concept of nonbinary is nonsensical. It is not an orientation (like homosexuality) or a medical condition (like gender dysphoria), but a political statement. Literally embodying the triumph of gender over sex, it is the queering of the self. The illogicality of the proposition, and the details of its real-life consequences, do not trouble those promoting it. "Clark prefers they/them/he pronouns and would like to be known as my kid/my son who is nonbinary," the mother of a nonbinary kindergartner announced in a social media post with the pride that one reserves for sharing the news of their child's acceptance into Harvard. "My son who is nonbinary" is as paradoxical as "nonbinary lesbian," considering that the definition of a lesbian is a *woman* attracted to other *women*.

Mimicking the work of gay historians who have endeavored to document the pervasiveness of homosexuality throughout the span of human existence, queer activists have ransacked the past for validation of their identities. The principal result of this revisionist project to "queer" history has been the erasure of gay people, and women. One can scarcely read about the Stonewall Uprising today without being informed that it was "trans women of color," not gay men and lesbians, who led the revolt; the elevation of two figures in particular, Marsha P. Johnson and Sylvia Rivera, can only be described as a form of secular apotheosis. The list of famous figures (almost all women) posthumously claimed

64

as having been transgender or nonbinary meanwhile grows at an impressive clip. Queen Hatshepsut, Joan of Arc, Vita Sackville-West, Radclyffe Hall, Louisa May Alcott, Marlene Dietrich — all have been classified as either transgender men or nonbinary, as anything other than what they were: women. Apparently, because these women refused to conform to stereotypical notions of femininity, excelled at traditionally male pursuits, and exhibited character traits commonly associated with men (strength, outspokenness, ambition), they were not actually women. Such interpretations are deeply regressive, and downplay the pervasive sexism that motivated some women to unshackle themselves from oppressive gender roles.

In 2020, "to ensure all members of the LGBTQ community feel welcome," the famed gay Chicago neighborhood of Boystown was renamed "Northalsted." Last year, in an article about the legacy of *West Side Story*, a contributor to the *New York Times* denigrated this classic and moving work of Americana as the creation of "four white men," their homosexuality (never mind their Jewishness) offering no exculpation for their part in the racist patriarchy. In progressive spaces today, there are few social offenses worse than "dead-naming" a transgender person — to identify them by their given name rather than their chosen one. We have yet to devise a neologism for the process by which women and gay people are being queered out of existence.

Walt Whitman rhapsodized about the "unifying force" of the "dear love of comrades," and gay writers across the generations have expounded upon the egalitarian promise of same-sex love. Transcending all lines of race, class, nationality, and social caste, the gay community is, by nature, representative of the whole of mankind. One of the most enriching aspects of being gay is the ability to venture anywhere in the

world — from the remotest hamlet to the most bustling city — and find one's brothers and sisters. But queerness, with its relentless creation of new sexual and gender identities, seeks to atomize us, and rather than toppling hierarchies it inverts them. "Trans people are sacred," declares Joan of Arc in a recent production at Shakespeare's Globe in London that envisioned the titular character as nonbinary. "We are the divine." Hypocritically for a movement purporting to be progressive, queerness is the ultimate status symbol of a new elite, signifying one's place above the "cishet" (cisgender heterosexual) masses. "Gay is good," Frank Kameny valiantly assured his fellow homosexuals. "Queer is better," our new leaders glibly declare.

V

To understand where queerness inevitably leads, consider the case of Sam Brinton.

Until late last year, Brinton was the deputy assistant secretary of spent fuel and waste disposition in the Office of Nuclear Energy at the Department of Energy in Washington, D.C. What distinguished Brinton from being just another Washington bureaucrat with a highfalutin' title was their (Brinton uses they/them/their pronouns) status as the "first openly genderfluid" employee of the federal government, "genderfluid" being a gender identity that changes over time. According to one website, the frequency of this variance "can be occasionally, every month, every week, every day, to even every few moments a day depending upon the person."

Aside from nuclear waste, Brinton's other passion is "pup play," a type of sexual fetish whose devotees adorn themselves in leather outfits and perform the rituals of a dog and its master. We know this because Brinton spoke frequently in

public venues about the most intimate details of his sex life, traveling the country to deliver seminars on subjects such as "Spanking: From Calculus To Chemistry." Visiting the campus of Rensselaer Polytechnic Institute for a lecture on kink in 2017, Brinton discussed "how he enjoys tying up his significant other like a table, and eating his dinner on him while he watches Star Trek." (The article in which this description appears was published before Brinton "came out" as gender-fluid, thus the use of the masculine pronoun). Brinton is also a member of the Sisters of Perpetual Indulgence, a group of drag queens who take on the personas of nuns, where he is known as "Sister Ray Dee O'Active." At a "Lavender Mass" in 2021, Brinton sang a song in tribute to "Daddy Fauci."

Prior to his appointment at the Department of Energy, Brinton had worked as a nuclear waste advisor in the Trump administration, and held a high-profile job with the Trevor Project, an LGBTQ suicide prevention hotline. Brinton's expertise in this latter effort was hard-earned: as a young boy he was sent by their parents to a conversion therapist whose ghastly course of treatment included "tiny needles being stuck into my fingers and then pictures of explicit acts between men would be shown and I'd be electrocuted." As they would later recount in the *New York Times*, "the therapist ordered me bound to a table to have ice, heat and electricity applied to my body." In 2014, Brinton testified about their ordeal before the United Nations Convention Against Torture, alongside the mother of Michael Brown and a former inmate at the U.S. military prison in Guantanamo Bay. Brinton's status as a conversion therapy victim made them a star on the LGBTQ activism circuit, earning them a place on the red carpet at the Academy Awards in 2018.

In their adoption of an eccentric gender identity, and the

67

flaunting of their sexual kinks, and their resistance against the normal, Brinton was the epitome of the "queer" public servant — the antithesis of "homonormative" Pete Buttigieg. On their first day of work, Brinton posted a photo of themselves on Instagram vamping for the camera resplendent in stiletto heels, bright red lipstick, and a crimson dress. We had come a long way from Frank Kameny telling his fellow Mattachine Society members marching outside the White House in 1965, "If you're asking for equal employment rights, look employable."

Yet just a few months into Brinton's tenure, the wisdom of Kameny's admonition was confirmed when Brinton was charged with felony theft for allegedly stealing a woman's suitcase worth $2,325 from a carousel at Minneapolis Airport. A few weeks later Brinton was again charged with theft for absconding with a woman's bag in Las Vegas. After the Department of Energy fired Brinton, their status as a "survivor" of conversion therapy was called into question. According to a leading anti-conversion therapy activist, Brinton had refused to tell him either the name of their therapist or the clinic where their supposed torture occurred, making them, in the words of the activist, "the *only* survivor of conversion therapy I've encountered since 1998" to withhold such information. In light of this record, many of the other claims Brinton had made during their time in the limelight — that they had advised Michelle Obama on her footwear, or that they had secured a clause in their government contract releasing them from having to be in the same room as Mike Pence — began to look, well, queer.

In struggling for the right to serve their country, all that gay people ever asked for was to be treated equally. They did not insist upon different codes of dress or standards of conduct, nor did they feel the exhibitionistic need to share

their sexual proclivities in public. (Indeed, it was the false perception of them as sex-obsessed that gay people had to overcome). The basis upon which gay people were discriminated — homosexuality — is an immutable trait, not a novel and freely chosen identity that changes by the hour. That Brinton was a suspect character ought to have been obvious long before they were promoted by the LGBTQ movement as a spokesperson, or hired by the federal government as a trailblazer for civil rights. But by 2022, no one in the LGBTQ movement, or in the leadership of a Democratic presidential administration, would state the obvious. And how could they? Queer had triumphed over gay. I gather that the reaction to the Brinton affair among the vast majority of gay people was similar to what every day Muslims feel following a terrorist attack. Where are the moderate gay leaders willing to come out and say that homosexuality is a religion of peace?

The words that oppressed groups choose to describe themselves are an indicator of their inner condition, of their self-respect or their lack of it. The words are synecdoches, informing us about how a group's members perceive themselves and what they aspire to be. "Gay" was proclaimed with pride, and with the aspiration that a group of marginalized people might be recognized as part of the human whole. "Queer" is shouted with rejection, and the resigned expectation — the hope, even — that its adherents will remain forever on the margins. Queer has no faith in tolerance; on the contrary, it despises the concept as synonymous with sufferance. In its refusal to take yes for an answer, an essential avowal for any member of a minority group who gains the right to live equally in a free and open society, queerness is undoing decades of incontrovertible progress. It is a refusal to accept acceptance.

From Queer to Gay to Queer

In America, being an individual and being a part of the mainstream are not antithetical propositions. For minority groups in Europe, the process of emancipation, the granting of recognition and rights, was conditional on the abandonment of difference. In America, no such grubby exchange is required. Here assimilation is not the same as homogenization. There is indeed a beautiful tradition of otherness in being gay, and one still comes across gay people who affectingly mourn what they feel has been lost with the triumph of gay equality and the mainstreaming of gay life. They resent the expectation that they should straighten up and get married and present themselves like Pete Buttigieg, and they speak with a sense of nostalgic sorrow about the rites and rituals of the old gay subculture. They endured discrimination, but they knew happiness. They miss the thrill of being a sexual outlaw, the feeling that they are getting away with something of which society disapproves. This sentiment is found almost exclusively among gay men of an older generation (lesbians being far too practical for such indulgences). But the important point is this: gay people can be gay in any way they wish to be gay. Otherness — or alterity, as the theorists like to say — does not need to be surrendered in exchange for acceptance.

Most gay people have no interest being conscripted into a furious ideological battering ram against bourgeois values, the sex binary, and the societal mainstream, and if the attempt to associate them with such a dead-end project succeeds, it will not be on their account. It will succeed because the forces of reaction, working in perverse synergy with the forces of queerness, make it so. At a time when reactionary homophobia is enjoying a resurgence, queerness plays directly into its hands. If the values represented by "LGBTQ" come to

be seen by a majority of the public as hostile to their own —
rather than as a confirmation of those values, which is what
the older generation of gay activists, the valiant heroes of our
cause, insisted — then gay people will suffer the consequences.
It is long past time to recognize queerness for what it has
become: a parasite on the gay rights movement, and on gay
identity itself. Successive generations of gay men and women
did not survive social ostracism, medicalized torture, govern-
mental oppression, and a deadly plague only for the beneficia-
ries of their sacrifice to go back to being queers.

MICHAEL WALZER

The Left and The Nation-State

For many years, professors of international politics have been telling us about the decline of the nation-state and the coming transcendence of the Westphalian system. But the political critique of the nation-state comes most often from men and women on the left, who condemn its parochialism, its tendency to produce nationalist fanaticism and xenophobia, its repression of minorities. Many of them yearn for a cosmopolitan alternative, a world without borders and border guards. And yet, at this moment, much of the world or, better, the Western part of it, including many Western leftists, is rallying in support of a beleaguered Ukraine, a classic nation-state

that has in the past been guilty of all the sins I just listed. The world and the West are right to rally. Why is that?

I live on the left and argue often with my fellow leftists about the value of the nation-state and of the international order, or disorder, of sovereign states. The arguments are sometimes concrete and practical, about immigration, say, or the treatment of minorities — good things to argue about (I will come to them). But the arguments are more often theoretical, since in practice the leftists who argue with me have been remarkably supportive of the creation of new states and, especially, nation-states. Their political choices over the last seventy-five years give little evidence of cosmopolitanism.

They celebrated the end of the European empires and the creation of independent, mostly multi-ethnic, states across Africa — and many of them then supported nationalist secessions in Biafra and South Sudan. Leftists who recognized the evil of Stalinism rejoiced when East European nation-states were liberated from Soviet domination — and watched without regret the breakup of the Soviet Union (a modern-style empire) that produced fifteen new nation-states: Lithuania; Latvia and Estonia in the north; Ukraine and Belarus in the center; Armenia and Georgia in the south; and the Muslim states of Central Asia. Some older leftists were disappointed by the collapse of Yugoslavia (remembering Tito's nationalist defiance of Stalin), but they mostly joined in supporting the liberation of Bosnia, Kosovo, and Montenegro from Serbian rule. Leftists around the world supported the creation of an Algerian nation-state and a united Vietnamese nation-state. Here in the United States, they have championed the independence and self-determination of all the states of Central and South America. And many of them today are eager to promote Palestinian, Kurdish, and Tibetan indepen-

dence, which would add three nation-states to the world —
each of them with borders and border police. In fact, opposi-
tion to colonialism and great power (and regional) hegemony
seems to lead, quite naturally, to repeated endorsements of the
nation-state.

There is, however, one exception, one refusal of endorse-
ment: the nation-state of Israel. Many leftists believe that it
should not exist. Anti-Zionism is the latest left pathology, not
so different (for those of us who have an ear for these things)
from the love affair with authoritarian regimes that stand
against "the West." Still, Israel is a strange exception, especially
right now, since it is a nation-state remarkably similar to
Ukraine. Both these countries are the creation of peoples
with strong national commitments; both Jews and Ukrainians
experienced murderous oppression in the recent past — the
Nazi Holocaust and the political famine organized by Stalin.
Both dreamed of self-determination and political indepen-
dence. And both have achieved sovereignty in territory that
includes a minority population of roughly twenty percent.

I speak only of "green-line" Israel here, not of the occupied
West Bank. It is possible, and I believe morally necessary, to
oppose the occupation *and* support the Jewish right to a state
— which is, indeed, no different from the Ukrainian right. The
new ultra-nationalist government in Israel doesn't understand
that this right, like every national right, has limits. It is limited
by the rights of the nation that comes next. But to make the
oppression of the Palestinians a reason for the elimination
and then the replacement of Israel is an example of ultra-na-
tionalism turned around — and no better for the turning. The
nation that comes first also has rights.

In any case, the Israeli exception proves the rule: in
practice, there are not many signs of leftist hostility to the

nation-state. Criticism, yes, but never (almost never) a critique that is also a call for elimination. My defense of the nation-state here is also an argument against eliminationism in the Israeli case — or, if it matters, anywhere else.

There is an easy explanation for the left's historical support of sovereignty and nation-statehood: classic anti-imperialism. Though more can be said for empires than leftists usually say — once established, they often make for tolerance and peace — their rule is necessarily authoritarian and often brutally authoritarian. Moreover, it is the rule of foreigners, soldiers, and bureaucrats sent from some distant center — or of local collaborators who are viewed with suspicion and hatred by the people they rule. Whenever popular politics is possible, it takes on, again and again, the same political form: a movement for independence, for national liberation. The movement isn't necessarily democratic. It often produces a new authoritarianism — but now the rulers are genuinely local; they don't serve foreign masters; they serve themselves. It is a hard truth that men and women prefer to be ruled, whatever the character of the rule, by rulers of their own "kind." I know some leftists who don't believe in "kinds"; but even they have supported (almost) all the national liberation struggles.

What justifies their support, whether they admit it or not, is this crucial idea: that there is in fact a local "kind," that the men and women who live *here* constitute a "people" and share a language, a culture, and a history (real and imagined). This is what makes the territory that they inhabit a political place. I mean by that a place where liberation and self-government are possible. Empires have never been political places, though the

75

imperial center usually was — the city of Rome, where plebes and patricians competed for power, or Little England, where Liberals and Labor challenged the Tories. The world is full of actual and potential political places.

The world itself, however, is not a political place, though there are some left militants (and liberal philosophers) who pretend that it is. Geographical enclosure and some version of peoplehood are the prerequisites of self-government (there has to be a collective "self"). The kingdoms of ancient Israel and the city-states of ancient Greece — these were among the earliest political places, where recognized if ill-defined borders made possible the creation of a common life. The modern nation-state is the standard political place in the world today. Leftists know it well, for it is pretty much the only place where the left, or at least the democratic left, has been politically successful. The sense of peoplehood, the solidarity of the citizens, was critical to the victories of social democracy after the Second World War — and to the establishment and maintenance of the welfare state.

When men and women come together to create institutions and practices that they recognize as their own, they will also, always, attribute value to their creation — and this is a value that the rest of us, whatever our political convictions, should acknowledge (even if we are critical of parts of the creation). If an invading army crosses the border and threatens their institutions and practices, these same people will fight to defend what they have created — and the rest of us, or most of us, will recognize the justice of their resistance. By contrast, if the common life has been usurped by an authoritarian gang, then it is likely that the invaders will not be resisted. Hence the difference between Iraq, where the American invasion was unopposed if not welcomed by most Iraqis (the occupa-

tion was a different story), and Ukraine, where the immediate resistance to the Russian invasion proved that the country was the political place of the Ukrainian people.

So the nation-state is a place of value. I acknowledge, however, that there is much to worry about, and not only in theory. The central problem, and the primary source of left hostility, has to do with the necessary enclosure, which leaves "others" within and without. There are better and worse ways of dealing with these "others," but the problem of their existence cannot be avoided. There is no way of drawing a line, establishing a border, without leaving some people on each side who would probably be better off on the other side. And there is no common life, no political place, without a border.

Consider first the "others" within. There are many ways to accommodate national, ethnic, and religious minorities — and one way not to do that: subordination, with its usual accompaniments of discrimination, inequality, and repression. I will consider three versions of accommodation, all of which are consistent, or can be consistent, with leftist commitments. First is the invitation to assimilate, to take on, at least in public, the language, culture, and even the history of the majority nation and become fully equal citizens — relegating old beliefs and practices to the familial sphere. This is the French model, and it has been remarkably successful, though it remains unclear whether it will work with a large population of Muslim immigrants. Success here would represent a triumph for the nation-state: one nation, one culture, with no remainders.

French-style civic nationalism is the preference of those left activists who acknowledge the possible value of the

nation-state. But it doesn't always work, as the Turkish case suggests. Turkey, like France, invites all its inhabitants to assimilate and take on a common Turkishness. But when the invitation is refused — when Kurds, for example, reject the name "Mountain Turks" and seek cultural and language rights — the invitation to assimilate becomes a demand, and the civic nation turns into a repressive state, hostile to its recalcitrant minorities. Then we have to look for other ways of dealing with those minorities.

The second version of accommodation is multiculturalism: the public recognition of different cultures alongside the majority culture and some form of public support for each of them — extending, perhaps, to a promise that minority men and women will be represented at every level of political and social life. Multiculturalism can take hard and soft forms; hardness, favored by many "woke" leftists, comes with a demand for rigid quotas, politically correct school textbooks that feature minority history and censure the majority's past and present sins, an official commitment never to offend minority sensibilities, and financial support for the reproduction of minority cultures and religions.

This sort of thing has provoked a backlash from defenders of the majority culture and the nation-state, who insist that majorities as well as minorities have rights. Which is true, of course: everyone has rights. It would be a strange position for leftists who believe in democracy to deny the right of cultural expression to a majority of the state's inhabitants. Multiculturalism works best when the majority culture is firmly established but very lightly enforced, when the majority, for example, fixes the public calendar and its holidays but allows room for minority groups to organize their own celebrations — or when national history is taught proudly but also

honestly in the public schools, with room for each new wave of revisionists. I can imagine a liberal nation-state where minority groups have no difficulty asserting themselves politically and expressing themselves culturally: this is not a utopian fantasy.

But it is also important to say that multiculturalism only works if everyone's citizenship is as valuable as everyone else's. Equal citizenship should produce a soft multi-culturalism, where all the minorities live comfortably, if sometimes competitively, with each other and with the majority nation. Given full equality, no one would actually need hardline guarantees of political representation, social ease, or cultural reproduction.

The third version of accommodation is designed for national minorities who are at the same time regional majorities and who ask for autonomy where they live. Autonomy can take different forms, but all of them fall short of secession, so they are compatible with a nation-state whose official culture, overall economy, and foreign policy are shaped by a nation-wide democratic majority. Refusals of autonomy are likely to produce movements for national liberation (as with the Kurds), but there are minority "peoples" whose history and culture permit them to live peacefully within what we might think of as a "near" nation-state, where differences are relatively small — one view, not everyone's, of the Quebecois in Canada. Autonomy for Crimea and Donbas, at least in matters of language, might have been the way to go in Ukraine after 2014, though the Russian puppeteers would never have agreed — and only the smartest Ukrainian nationalists would have gone along. But now the Russian invasion may well turn all Ukraine into a single civic nation, French-style.

There are probably other ways of accommodating minorities — and different versions of these three — but all of them are tested by the single standard of equality. Do minority men

and women function in politics, society, and economy on a par with the men and women of the majority? Are careers open to talents? Are civil servants equally civil to all the people they deal with? Do the police respect cultural differences? There are right answers to these questions, but they often don't come naturally to the national majority; they require political struggle. But this cannot be a reason to reject the nation-state, or any particular nation-state, so long as the rights of criticism and opposition are in place or can be fought for. Has there ever been a state of any sort in which political struggle wasn't necessary?

What is most important for my purposes here is that the right answers to the questions I posed above are politically possible in the nation-state generally and in each particular case. They had better be possible, since it appears that most people, and most "peoples," prefer this political formation.

What about the "others" without? One common leftist answer is simply to let them in: open the borders. Over time, this would probably mean the "transcendence" of the nation-state, or at least the end of those nation-states that are most attractive to migrants. We would have to expect, then, resistance from the majority nation, defending "their own" political place. Though borders are far from open, we see this already in rightwing arguments about "replacement." Do not expect good faith in arguments like this. A Polish politician from the nationalist right claimed some years ago that taking in five thousand Syrian refugees would endanger the Polish-ness of Poland. There are thirty-eight million Poles.

Actually, taking in a million Syrians, as the Germans did in 2015–2016, would not make Poland less Polish, though it

might make Polishness less provincial — probably a good thing for the Poles as it would be for any national majority. Leftists should defend a generous immigration policy on behalf of refugees and asylum seekers (more on this below), but I don't think that the call for open borders makes political sense; nor would it serve the goal of political victory. Activists on the left, if they hope to win, need to respect the particularity of each political place and the common life created within it. These are, after all, places that they hope to govern. When in power they will defend social and economic equality and work to create a strong welfare system — relying on the sense of mutuality and shared interests among the citizens. Mutuality and shared interests are produced, and can only be reproduced, in enclosed political places.

Is the European Union an exception to this rule? I don't think so, but it is an interesting attempt at revision. It is a "union" that does not abolish the nation-states that it incorporates, and so it raises two new questions: Is Europe itself a political place? And can there be a hierarchy of political places, such that Europe is the nation-state of the Europeans while Poland, France, and Germany remain the nation-states of their own peoples? A federal scheme of some sort, with defined jurisdictions and protection for all the "others" within. But there would still be, there still are, "others" without. If the European Union is a political place, it is a political place with borders.

I don't mean to suggest that solidarity is not possible across borders; American, NATO, and EU support for Ukraine is a moving example of international solidarity. The extent of the support is greater than most people expected, though possibly not yet sufficient. In the past, however, internationalism has been tenuous and difficult to sustain, as the history

of the left in World War One and in the run-up to World War Two demonstrates.

Immigration policy is a critical test of solidarity across borders. In all nation-states, the first expression of solidarity is the commitment to fellow nationals in trouble abroad. When the Soviet Union collapsed, for example, Finland provided a refuge for thousands of Russo-Finns who might have had a hard time in the new Russia — and put them all on a fast road to citizenship. This is a common practice: remember how Greece, in the years after the First World War, took in huge numbers of Greeks who had been living in Ottoman Turkey, or how the West Germans, after 1945, took in refugees from what had been East Prussia. The Israeli "Law of Return" is the only example of this commitment to nationals abroad that has come under criticism. Another exception that proves the rule.

Yet this first solidarity should not exclude a willingness to take in non-national refugees and asylum-seekers. The numbers will always be a subject for democratic debate, but we should look for strong support for the admission of refugees in these debates. No one is more at risk in our world than stateless men and women, driven from their homelands by persecution or civil war, with no place to go. They are the actual cosmopolitans. They might be citizens of the world if the world was a political place capable of granting citizenship — but it isn't, and so refugees are citizens nowhere, desperately in need of help.

We can get some sense of specific moral obligations to non-nationals abroad if we consider what immigration policy should be like here in the United States. I doubt that the United States is, strictly speaking, a nation-state, though we may be (however it looks right now) in the process of forming ourselves into a single American nation. At this moment,

we are a nation of nationalities, multi-cultural, multi-racial, multi-ethnic, and multi-religious. Recognizing our pluralism, we bar any cultural, racial, or religious establishments. But we do have a political establishment, a constitutional democracy, and some degree of shared commitment to it — which should shape our own debates about immigration.

Americans have clear obligations abroad. Democratic and freedom-loving dissidents fleeing oppressive regimes are among the immigrants we should always welcome: they are already political kinfolk. Refugees fleeing from oppressive regimes that the American government has promoted and supported are also people for whom we already have responsibility. And we are clearly obligated to the thousands of men and women who cooperated with us in one or another of our foreign adventures or who "came out" as democrats, trade unionists, or feminists under our cover — they too are, all of them, prospective Americans. American leftists should be proud of the cover we provided in places such as Afghanistan and Iraq, even if there was much else that they rightly criticized.

The number of immigrants that we ought to welcome may seem large, but it really doesn't threaten to "replace" the American majority (if anything like that exists). Indeed, these immigrants are likely to "Americanize" fairly quickly in one of the two versions that we offer: they will assimilate, learn English, admire George Washington, and venerate the Constitution, or they will form one of the resident cultures in our (soft) multiculturalism. Something of both is most likely, as it was among the earlier immigrants of the 1840s, the 1890s, and after — who became good citizens and sustained a (second) common life in ethnic or religious versions.

The Left and The Nation-State

So it is possible in our own state and in nation-states such as those I began with, whose creation leftists supported, to deal decently and justly with "others" inside and out. But nothing is easy, not in this political formation or in any other; no one can promise success. It will always be necessary to fight for decency and justice and to oppose ultra-nationalists and racist and religious bigots within the nation-state — just as leftists opposed arrogant imperialists in the past and as they (better, some of them) opposed totalitarian militants and apologists. Still, the nation-state is the political place where the left has had, from the beginning — say, France in 1789 — the best chance of achieving its goals. Transcending the nation-state is a project without any prospect of success, nor would left activists be likely to find allies among citizens of the world. Again, the world is not a political place.

Think about this: men and women on the left know how to organize political parties, labor unions, and social movements in the places where they currently live. They wouldn't know how to organize among the global multitudes — billions of people, speaking a thousand languages, with radically different religions and political cultures. Solidarity with humanity is no doubt a fine thing, and help for embattled peoples abroad is morally necessary, but leftists should realize that they need fellow citizens.

OLÚFẸ́MI TÁÍWÒ

The African Case for The Enlightenment

I

Can one think of a more inauspicious time than now to offer
a case for the continuing relevance, the necessity even, of the
Enlightenment project to the fortunes of contemporary
Africa? What follows is not a defense of the Enlightenment and
its ideals. Where that is concerned, the great enterprise does
not need my defense. By the same token, those who claim to
be defending it in the name of a racial identity or an even more
groundless civilizational supremacy originating in one corner
of the globe may be mortified by what I have to say. Once we
move away from smug affirmations of identities and from
the homogenization of diverse historicities, it will become

clear that just as sure as humans are *zoon dunamikon,* mobile animals, like the snail and its shell, their ideas are no less given to migrating. Even when their original discoverers are loathe to share them, it is well-nigh impossible for them to stop their fellow humans from copying, buying, or pilfering those ideas for whatever ends they wish to realize. In this marketplace of ideas only the foolhardy would permit themselves to think that anyone or any group can claim absolute ownership of any idea they have articulated in a form that is no longer opaque to their fellows.

It does not require courage to defend the Enlightenment project; all it requires is knowledge and an openness to considering other ways of organizing life and thought. As will become clear, much of the animus towards the Enlightenment project in the African context is traceable to an ignorance of Africa's relations with it over time, and to witting or unwitting misreadings of its core elements. When this is not the case, it is founded on a dubious identity politics the origins of which are exogenous to the African context and the embrace of which must, perforce, trash or, minimally, deny Africa's place in the global circuit of ideas and the meritorious contributions of African minds to that circuit through time.

There are many reasons for us, contemporary Africans, especially scholars and other intellectuals, to embrace the project. Regardless of how we account for the genealogy and the pedigree of the Enlightenment, I submit that, with all its limitations, a world in which its core elements are in place would be a superior world to the one that we inhabit, and not only in Africa. Does this mean that a world structured by Enlightenment ideals will be a perfect or near-perfect one — whatever that may mean? Absolutely not. Indeed, it is a failure to engage with the complexity of those ideals — and a

related eagerness to caricature them in the service of dubious identity-driven politics — that incline many to dismiss or to demonize them. I can only hope that what follows shows this complexity and, as a result, makes it less easy to abandon them.

What obstacles have stood, in our day, in the way of the embrace of these ideals? Those obstacles are of recent vintage; they have not always been there. Africa has not always been hostile to the Enlightenment project. Despite the widespread and justifiable indictment of it by antiracist scholars, especially in our day, a responsible perusal of the history of ideas reveals an important distinction between the racialization of the Enlightenment and its historicization. It may be true that the European Enlightenment was conducted by Europeans and principally in Europe, or in a world dominated and framed by Europe. Notwithstanding this acknowledgment, the question is whether the ideas that form the warp and woof of the Enlightenment are, simply for that reason, incorrigibly "European" ideas such that they become invalid for retrieval and adoption in non-European contexts and by non-European thinkers.

When scholars write as if ideas come in colors or are indissolubly linked to certain geographies, cultures, or epidermal inheritances one should be suspicious. Doubtless, ideas emerge in certain contexts, yet when all is said and done they really emerge in individual thinkers' minds, albeit in conversation with others. If this be granted, even if we say that the Enlightenment project and the ideals that it fostered were undiluted emanations from European minds, it is a giant step to saying that this alone suffices to make them unavailable for appropriation by non-Europeans. Similarly, it would be just as implausible to suggest that only under compulsion, enslavement, conquest, or other non-voluntary methods

could non-Europeans come to have ideas become a part of their world. And only if we dubiously assume a singular, almost hollow, conception of European identity, totally unaffected by history or with a history marked by absolute isolation, might we even permit ourselves to entertain the idea that the Enlightenment was a product of what Biodun Jeyifo, in a different context, has termed "absolute autochthony."

Only if we racialize it and color it "white," Caucasian, essentially European, not even Eurasian, only if we regard its provenance as the most important thing about it, can we call the Enlightenment project a strictly parochial inheritance that other racial groups must shun or, if they embrace it, find a way to justify such an orientation. The relevance of the distinction between "racializing" and "historicizing" is that the first term erects an almost unbridgeable gulf between the two sides, while the second looks upon the discourse as a consequence of historical contingencies, a move that allows members of both sides to narrow the gulf and lay claim to any part of each other's inheritance in the broad framework of a common humanity.

The Enlightenment, a certifiably European movement that was the intellectual charter for the epoch we now identify with modernity, must be historicized, not racialized. To historicize it means that we place it where it belongs: in the history of ideas in the evolution of the history of humans and their unceasing efforts to come to terms with their world and to conceptualize that world in the most expansive manner possible — to figure out why we are here, how we should live, who we are and what we owe one another, in the context framed by having language and reason and developing tapestries of existence that involve recognition and ostracism, cooperation and conflict, praise and shame, and so on. Since the tasks that I just adumbrated are not restricted to any human group, and since we know that

different groups have, over time, offered different models of being in and with the world, and since even among the same groups none can be said to have contained only one model that never changed through time, it is a plausible model of the history of ideas never to sever any new iteration from this general concern of our species.

The Enlightenment was not a bolt from the blue. Yes, it represented a severe rupture with previous models for the human tasks that I identified above, but in a very significant sense it was continuous with them. If the Greeks provided inspirations and interlocutors, then that inheritance involved Africa and Asia through Egypt, Christianity, and Islam. But of even greater significance is that, even when they are conceded as a strictly European phenomenon, the signal ideas of the Enlightenment — a philosophical anthropology that affirms that freedom and the possession of reason — are essential to *human* identity. The promotion of reason as the main or only arbiter of the great moral and social and political questions was the decisive break with what came before, and it held the key to mature subjectivity and self-ownership. The Enlightenment was a radical break with what had been the rule in much of Europe before it: the paramount role of revelation, tradition, and authority in the affairs of human beings and their being in the world.

89

The idea of free humans capable of deploying reason to enlarge and improve themselves became the template for a slew of new modes of organizing life and thought. In politics, divine ordainment became inferior to the rational enthronement of rulers whose claim to legitimacy rests on the consent of the governed. This was the answer to one of the central questions of political philosophy inaugurated by the Enlightenment: who ought to rule when not all can rule? If

divine ordainment no longer passed muster in the sphere of politics or social relations generally, neither did tradition and any authority founded solely upon it. On the issue of whether we know, how we know, and how we know that we know, Enlightenment thinkers assailed any knowledge claim that was not an instance of a demonstrable proof executed by reason or, as science rapidly developed, by the experimental method. If the evils that they inveighed against were universal—the institution of chieftaincy, for example, and rule based on status, and the continuing dominance of supernaturalism in our world — and not necessarily "white," "European," or "Caucasian," it would be a mistake to read their proposed solution as if they were indissolubly linked to the racial inheritance of its proponents. Nor should we assume that they had any proprietary ownership of those ideas or that they alone possessed the genius to generate those ideas. Once those ideas were formulated and shared with the world, anyone who was willing to expend the sweat equity to understand and appropriate them immediately became an interlocutor and a part-owner of the discourse. In *The Wretched of the Earth*, Frantz Fanon wrote that "all the elements for a solution to the major problems of humanity existed at one time or another in European thought."

I would not like to be misunderstood. No significant modern white European thinker, not Hume or Kant or Voltaire or Hegel or Marx, had anything good to say about African-descended people. That many of the Enlightenment thinkers were racists is not open to argument or contention. But here is the irony. When they exploded previous models of being human in the world, when they substituted "human" for particularistic and tribal descriptions and privileged the same human's capacity to know independently of revelation

or other occult powers, and adopted "self-governance" in place of other-dependent hierarchies — that is, when they claimed universality for what they had discovered — they simultaneously created a central contradiction that would forever upset any and all attempts by them or their followers to adjectivize the human and assign preselected inferior status to certain groups and people on account of ever contingent particularisms — race, creed, ethnicity, and the like. Those categories can hold only if they give up on the universal and accept that they have merely mistaken their provincialism for universalism.

Nothing in the Cartesian cogito limits it to Caucasian humans. It is either universal or it is meaningless. Even in the thralldom of chattel slavery, African humans never failed to claim their cogito inheritance even as they faced lethal consequences for their defiance. We have evidence that at no time did those who were enslaved stop proclaiming the same natural right to freedom that Locke, Hume, Rousseau, and Kant had championed as essential to and inviolate in the human individual. The inventors of these ideas, the liberal pioneers, lived acutely inconsistent lives, and had to contort themselves into all sorts of shapes and craft various calumniations in order to live with the contradiction between their thinking and their lives — most dramatically in the case of slave owners such as Jefferson. They were universalists who also proclaimed, like Kant, that some part of that universal — black people, in this case — is not really of it.

Beyond the logical contradiction, there was the inconvenient matter of history. Various Enlightenment thinkers, notably Rousseau, Diderot, Voltaire, Montesquieu, and Locke, enlisted in different ways the aid of non-Caucasians, from Tahiti to Haiti to the United States, for good or ill, in constructing their philosophies. The "wild Indian" was

91

Locke's metaphor for an unowned world waiting for labor to privatize it; travel writing offered Persians to Montesquieu and Tahitians to Diderot as foils for their critiques of the old ways in Europe. But they did not need native peoples as a foil for their constructions. They had with them fellow interlocutors, ex-enslaved persons, who themselves had become singers of freedom's song and, this is crucial, who never failed to point out, in real time no less, the contradiction that we only now are retrospectively pointing out. Ottobah Cugoano and Olaudah Equiano are two shining examples of this category of eighteenth-century Enlightenment thinkers who are routinely excluded from its annals. Both were enslaved persons who became free and serious thinkers as well as intellectual leaders of the anti-slavery movement while they lived in London. Cugoano was born in present-day Ghana and Equiano in present-day Nigeria. Equiano's book, *The Interesting Narrative of the Life of Olaudah Equiano,* which appeared in 1789 and played a role in the passage of the British Slave Trade Act 1807 that abolished the slave trade, was a bestseller in its day. They, too, provided the original case for the Enlightenment — but from their African-inflected standpoint. The path that they blazed as active participants in the movement would be trodden by other African thinkers in their opposition to colonialism and the racism that was used to justify it. However sensitive they are or claim to be to African agency, many Africanist scholars, be they African or non-African, seem to think that what Africans have to say regarding the intellectual legacy of their engagement with Euro-America is not worthy of serious engagement. They often leave the impression that the idea of freedom has not exercised African thinkers at a level of sophistication and rigor that would merit the attention of serious political scientists or philosophers.

II

The crucial question is, what do we do with the legacy of these thinkers and of their successors in the global African world who have embraced the Enlightenment and its ideals? Do we ignore, deny, or dismiss them as lackeys or, at best, mimics, as many do in our time? But then we doubly orphan them: they are deprived of recognition by their fellow residents of the Enlightenment universe and their successors, and we, their legatees in the global African world, pour scorn on their legacy, for dubious reasons that I will now address.

The principal way in which Enlightenment thinkers and their successors excluded African-descended thinkers' participation in and contributions to their shared discourse was by encasing their black interlocutors in the concrete of difference. This was the original source of what I call the metaphysics of difference, according to which the very being of African-descended peoples was defined by the attribute of their race, such that none of the ordinary affirmations applicable to every human group avail when it comes to African being. This was not merely a social distinction but an ontological one. They insisted either that Africans were not human or, if they were, that they were so far down the ladder of human attainments that they could be regarded as less-than-human who will need a long time to attain full human status. Just like that, Enlightenment humanism, the great invention that overthrew millennia of hierarchies framed by revelation, tradition, and authority, summarily banished Africans from its purview. The first casualty of this exclusion was the scrubbing from the annals of the global circuit of ideas the records of African achievements from remote antiquity through ancient times, from the medieval period to the eighteenth century. It eventually enabled Hegel's libel against

93

Africa in his *Philosophy of History* in the nineteenth century.

One does not have to subscribe to Afrocentrism or any other nationalist creed, one has only to be a good student of the history of ideas, to see through this charade. If, as we have observed, Africa had never been absent from the global circuit of ideas, the burden of proof is on those who decided to erase Africa from their account for the relationship between Egypt and Greece as parts of the Mediterranean continuum of commerce in goods, services, and ideas; and to omit Africa's role in the emergence of Christianity and its evolution through its many schisms and the resulting constitution of the Roman and Greek Eastern Orthodox denominations, respectively; and scant to Africa's part in the intercourse that persisted in Roman and Byzantine colonialisms in the continent's north, the Maghreb more specifically, and so on. When it comes to the modernity for which the Enlightenment provided the intellectual charter, Howard French has powerfully argued, in *Born in Blackness: Africa, Africans, and the Making of the Modern World, 1471 to the Second World War,* for the restoration of Africa to its place at the very origin of the epoch. We need to recognize the long historical period when nothing human was foreign to Africa and Africans were an integral part of the movement of ideas and people in the world. That world did not exclude the Enlightenment, even if its principal proponents sought to exclude the continent and its peoples. What they crafted would later become a ready tool for Africans — including for those who chose to inherit not the liberal doctrine of the Enlightenment but its metaphysics of difference, who decided that Africans are indeed essentially different.

Fast forward to the nineteenth century, in which the pivotal events took place that structured the alienation of

Africans from the Enlightenment based on the metaphysics of difference, and in which, simultaneously, other African embracers of Enlightenment freedom picked up from where those we have already encountered left off. Not even the long dark period of the trans-Atlantic slave trade witnessed any break in Africans' continuing engagement in the global circuit of ideas; and one of the lamentable elements of contemporary discourse is a disinterest in taking this dimension of Africa seriously. The nineteenth century, in its early decades, saw the abolition of the trans-Atlantic slave trade and the intensification, especially in West Africa, of Christian evangelization spearheaded by the Church Mission Society, the evangelizing arm of the Church of England, which would be the crucial link to the continuing relevance of the Enlightenment project even when it was couched in the language of Christianity and civilization.

Again, because too many scholars could not or would not wrap their heads around the agency of Africans — chiefs or plebeians, it does not much matter — African participation in the relevant discourses has been elided, denied, or denigrated. But — and this is key — when formal colonialism was imposed on the continent in the final two decades of the nineteenth century, the beginning of which was the Berlin West Africa Conference of 1884–1885, the colonizers had to contend with Africans who had not merely embraced the new ideals but were also already engaged in the task of attempting to transition their societies to modernity. The colonialism that dominated in Africa, whether settler, exploitation, or settler/exploitation colonialism, all shared a defining characteristic when it came to the view of the humanity of African: Africans were adjudged to be either not human or, if human, of the most inferior kind. The old metaphysics of difference of the

eighteenth century received a new charter in the nineteenth. And just as in the previous era there were Africans who challenged, precisely in the name of the ideals of the Enlightenment, the metaphysics of difference, in this later period there were also African apostles of modernity, as I will show. These included the converts that the Church Mission Society and other missionary groups had sought to train to put African agency back in control of African affairs and accelerate the progress of the continent towards securing the gains of modernity for their people.

These African modernizers made common cause with their fellow denizens of modernity's universe powered by the Enlightenment ideas that some of their forebears had helped to elucidate a hundred years earlier. Once colonialism prevailed, however, Africans ran into the buzzsaw of colonial racism and its ontological distinctions. Something terrible happened. Many African thinkers, though by no means all, resorted to what some have called a reactive nationalism characterized by, guess what, the metaphysics of difference. Notable examples would include Rev. Dr. Mojola Agbebi (previously called D.B. Vincent), William Essuman Gwira Sekyi a.k.a. Kobina Sekyi, Orishatuke Faduma a.k.a. W.J. Davies, and Edward Wilmot Blyden, all men of letters and public intellectuals. They gave up on the idea of modernity, which they began to impute to racism. The key ideas of the Enlightenment — universalism, humanism, the centrality of reason, the insistence that knowledge not be based on revelation, tradition or authority, governance by consent — began to be counterposed to a pristine African identity uncontaminated by alien ideologies and borrowings emanating from their colonial oppressors. They responded to racism with the same racialization of ideas that had led their colonial oppres-

96

sors astray to begin with. This was a tragic response, if psychologically understandable. Thus was inaugurated many of the ills that we are still struggling to remedy today, and for the remedying of which, I believe, the Enlightenment remains urgently relevant.

Those who are familiar with African history know that before the imposition of formal colonialism, the continent was a veritable workshop of political experiments ranging from the incorporation of various Islam-inspired theocracies to the dismantling and reconstitution of many old regimes, the agglomeration of different demographics to form new identities, and so on. At the intellectual level, in West Africa, the dominant discourses turned on what to do with Enlightenment-inspired ideas with Protestant Christianity as the vector, Islam as an intellectual tradition, and the competition between these two (and other indigenous intellectual traditions) as the context for any possible progress. In North Africa, Napoleon Bonaparte's failed colonial adventure had inaugurated for Egypt and the rest of the region a momentous debate, still continuing, about the relationship between Islam and modernity. Many arguments for liberal constitutionalism and social reform figured in this debate.

These contestations included different factions of various African elites, old and new. Some wanted to preserve their original modes of being human with minimal or no changes; others wanted to cast out the old *tout court* and substitute borrowings from either Islam- or Christianity-inflected modernity, and still others wanted a creative admixture of the old and the new. It is West Africa that interests us here. Similar situations obtained with different actors in North Africa and South Africa, but it was in West Africa that there was a critical mass of intellectuals of varying sorts and all in

conversation with Enlightenment ideals and the modernity that they undergirded. They set in motion a transition to modernity directed by native agency. The Fanti nation in what became Ghana, for example, formed a confederacy for which they authored and formally adopted a broadly liberal constitution in 1871, one of the earliest efforts at liberal constitution-making outside the European heartland. About the same time, a new form of constitution-making under modern inspiration was undertaken by the Egba in Abeokuta, Nigeria, called the Egba United Board of Management, around 1868.

For these graduates of the missionary school of modernity, the metaphysics of difference had no resonance, because the Enlightenment and modernity were an epoch in human history that was to be judged by how well or ill it enhanced being human, and because they had decided that their societies were backward not on account of any genetic defects in their race but as a contingent fact of history, a good part of which was traceable to the inhumane and unChristian trans-Atlantic slave trade. Here the example of James Africanus Beale Horton (1835–1883) is particularly instructive. In his *West African Countries and Peoples*, he countered from a place of superior knowledge the scientific racism that was being peddled and he showed that science did not support the attributions that were being made to African-descended peoples by racists. These modernizers also believed that Africans and their societies would do well to shun exactly all that the Enlightenment was meant to overthrow — revelation, tradition, and authority — even as they were Christians like their Euro-American co-speakers of the Enlightenment vocabulary. In sum, they set out to reorganize their societies on the basis of those principles. Like their African predecessors, they had historicized, not racialized, the Enlightenment.

The record is indisputable. The example of Joseph Ephraim Casely Hayford of Ghana, teacher, journalist, lawyer, a pioneer leader of the anticolonial movement in West Africa, is instructive. While Horton, and Samuel Ajayi Crowther, from Nigeria, the first black to be consecrated Bishop in the Church of England and a genuine polymath, and Edward Wilmot Blyden, a polyglot philosopher and diplomat, originally from the West Indies, and Alexander Crummell, pastor and theologian and an African American, were all firmly of the nineteenth century, Hayford was writing at the turn of the twentieth century, signaling a remarkable continuity in thought that deserves serious attention from scholars, and not only African ones. He adduced all the elements of the Enlightenment that we have been talking about. I will cite him here directly, so that those who wish to make it seem as if there was a break in African intellectual history when the Enlightenment lost its relevance will hear the voice of a thinker and political leader who was heir to its intellectual strivings.

We are living in a new age and a new order of which we who participate in them, are hardly aware. One important element of this new order is the growing consciousness of our race the world over, of which practical statesmanship must take cognizance. Among world problems today is the appeal which goes from the heart of the African to be accorded certain rights which are common to humanity... We claim that we have the right to our opinion and to the expression of it. We say that we have passed the childhood stage, and that, much as we appreciate the concern of our guardians, the time has come for us to take an intelligent, active part in the guiding of our own national destiny; and that is the primary fact that

The African Case for The Enlightenment

has called into being the National Congress of British West Africa.

Elsewhere, he declared:

> We claim, in common with the rest of mankind, that taxation without representation is a bad thing, and we are pledged, as all free peoples have had to do, that in our several communities the African shall have that common weapon for the protection and safeguarding of his rights and interests, namely, the franchise. It is desirable, we hold, that by our vote we shall determine by what laws we shall be governed and how the revenues which we help to put together shall be utilized. Equally do we hold with others that there should be free scope for the members of the community, irrespective of creed or colour, to hold any office under the crown or flag to which a person's merits entitle him or her.

And, finally, we have the following:

> We shall have to examine the constitutions of British West Africa and discover how far they make for national progress, and, where they fail, it will be our duty to say so explicitly and without reserve. If we find that the instrument which we have forged in defense of our national rights, our national integrity, is not sufficiently effective, we shall have to devise means to strengthen it. What is obsolete must be scrapped, and unwieldy agencies and obstacles in our path must be weeded out. Personalities must not stand in the way of principles, and the national soul must be more important to us than the strappings

of mere conventionality to the end that we, Africans, who have borne the heat and burden of the day in the world's work and in the world's progress, may benefit fully by the resultant harvest.

Hayford was channeling the "Western" ideals that we are considering here.

If Africans are not essentially different, it stands to reason that their histories and those of their ideations, institutions, and practices, too, would have undergone the same buffetings through time that is the inescapable fate of humans and their lifeworlds anywhere in the world. To the extent that the ills that Enlightenment ideals were designed to heal are replicated anywhere in the world, at any given time, why would we forbid those confronting and suffering from similar woes from laying hold of what their fellow humans elsewhere have offered as remedies in their own locations? After all, humans have always borrowed and "appropriated" from each other, and an unreasoning insistence on purity is the path to extinction for civilizations. Why do we make it seem that to acknowledge a lack in ourselves is to concede the point that our racist detractors appear to be making when it comes to Africa's place in the world of ideas: that Africa has always been an absence?

Meanwhile, as we remarked above, these modern prophets, beginning in the third quarter of the nineteenth century and accelerating in the decades after 1885, had to contend with the administrators that ran colonialism and a new cohort of white missionaries who jointly installed a regime built wholly on the metaphysics of difference. This preference was embodied in the primary denial of the humanity of Africans, and they did everything and I mean

everything, to undo the achievements that Africans had garnered for themselves before colonial dominance. Over time, two things happened. First, there persisted among our "excluded moderns" a group that remained steadfast in their commitment to changing their communities along modern lines — but they started working mostly in civil society, many choosing to become professionals who did not have to depend on civil service appointments that required them, no matter their skills and credentials, to serve under otherwise inferior white superintendents. And second, there emerged in their ranks a group that turned its back on the modern idea, embraced the metaphysics of difference and sought to preserve, proudly, as a matter of identity and authenticity, the arrested image that the racist colonial establishment foisted on them. They began embracing ideas consistent with the conservatism that was holding the continent back and was exemplified most tragically in the colonial regime's preservation and enhancement of chieftaincy. For the colonial rulers, the lineaments of the Enlightenment project were not for Africans, who, they insisted, would need centuries to qualify for its ideals.

In what was at best a reactive nationalism, this portion of the African elite began embracing cultural practices many of which they had neither studied nor even understood, and began to make common cause with the same rulers that they had earlier shunned for being complicit in the slave trade and the rapine that was its calling card. The most heartbreaking consequence was that they, too, began to racialize the Enlightenment and modernity, and to promote African institutions and ideas as the counter to European hegemony. Difference became the defining mode of being African, and borrowing from Europe was a sign that the racists were right: Africa had

never contributed anything to the march of human progress. Mercifully, however, the likes of Hayford, a leading light of the anticolonial struggle in West Africa, were not buying it.

III

Here, then, is the crucible in which was forged the inertia that all of us must push against who wish to have our contemporary African societies and their peoples become beneficiaries of the best that the Enlightenment ideals have to offer. Other than the Native Americans, no people have borne more of the burdens of modernity without ever having enjoyed any of its tremendous benefits than Africans. Or again, as Hayford put it: "we, Africans, who have borne the heat and burden of the day in the world's work and in the world's progress, may benefit fully by the resultant harvest." That harvest continues to elude ordinary Africans.

A few other consequences follow from the sad convergence of racist colonialists defining the very being of Africans in the terms of an absolute difference and a group of African intellectuals who were either ignorant of their own complicated intellectual heritage, or saw a quick and easy path to recognition, or were just weary of being told they that were worth nothing, and, as a result, were content to define themselves and their heritages by the same absolute difference. If, indeed, Africans are unlike common humanity, it is but a short distance to embracing Africa as it is, and to concluding that its institutions and practices must change little, if at all. Concurrently, preserving this inherited situation and essentialist identity becomes an all-consuming concern, and this, again, produced the convergence that enabled colonial authorities — French, British, Portuguese, German — to arrest the progress of African societies on the path of change

103

to better futures. Instead, as the colonial authorities insisted on petrifying African institutions even while distorting them in the name of "respecting" the integrity of African usages, these native aficionados of difference became mortally afraid of altering their actual inheritances, because to seek inspiration in foreign Enlightenment ideals would be tantamount to borrowing from the colonialists and their band of racists, or an index of one's inauthenticity as an African. I cannot think of a better route to the fossilization of our best inheritance and its ultimate extinction.

But even this cult of authenticity does not mean that the colonialists are out of your hair. One unfortunate, if unintended, consequence of embracing the metaphysics of difference is the emergence and dominance of what I have called "occident anxiety" in the African mindscape. Your frozen reality induces anxiety because you are continually agitated by how well it stands up to what the West claims about itself and about you. An idealized past is always more satisfying, more fortifying, than a racist present. And since you have not really embraced your inheritance critically, critical evaluations by your fellows or, worse, by outsiders will always sound to you like declarations of hostility. The so-called West that you are separating yourself from hovers over you like a ghost, and your almost every move is circumscribed by it. Though you proclaim your autonomy, you have thickened your servitude.

The preceding has made it necessary to remind ourselves, and especially our younger scholars, that things have not always been this way. We now know from the historical evidence that the career of the Enlightenment in Africa has not always been defined by hostility. Nor has its path been singular: Africans contributed to its constitution, have embraced,

shunned, criticized, and helped to shape its course globally. This is partly why colonialism had a hard time of it in West Africa, where African intellectuals called out its hypocrisy and fought it on the same principles that it pretended to share with them. It is imperative to insist, contrary to conventional wisdom and a lot of the scholarship dominated by "decolonizing" and related discourses, that there never was a time when African thinkers were absent from the global discourse on the Enlightenment. What I have offered here is only one version of an old truth about African intellectual history. The tragedy of contemporary scholarship about Africa is its willful neglect of the prior embrace of the Enlightenment project by African thinkers.

How might life be different were we deliberately to embrace the Enlightenment ideals and incorporate them into life as we lead it at the present time across the continent? Recall that our forebears embraced this philosophy because they were convinced that it was the path to a better world than the alternatives available to them in their own time. Yet my defense of African Enlightenment is not the same as claiming that, on balance, this is the best possible life for humans. Even if we could incorporate the best society that Enlightenment-based modernity can deliver, it would still fall short of "the good society." Moreover, there may be some admirable local models of society in some of our African civilizations. No thanks to my limited knowledge, I cannot claim to know if this is so, and if others do, I hope they educate the rest of us. (The "authentic" models that are often on offer generally build on the idea of communalism or communitarianism, which do not hold much appeal for me.) Nor is there any suggestion in my argument that the kind of borrowing I am recommending is tantamount to a conces-

sion that some racial group is superior to another. To the extent that even the European Enlightenment was European only in respect of its geographical location, but was not authored only by Caucasians (it even included non-Caucasian Europeans), it cannot be a stretch or a betrayal for Africans to embrace it. And for those who continue to racialize the Enlightenment and liberal modernity, they would do well to note that even in countries such as the United States, which many people too glibly regard as a paragon of both, and in the "post-liberal" countries of Europe, the principles of the Enlightenment are imperiled. White people, too, need to learn, or re-learn, them.

I will give two concrete examples, one African, one American. In 1997, at the Pan-African Historical Festival in Cape Coast, Ghana, I gave a lecture in which I laid out what the doctrine of the presumption of innocence until proven guilty really involves, and why it is one of the cornerstones of the modern legal system that is dominant in Africa today, and what it means for the idea of human dignity and the freedom that is its principal means of expression. A presenter on one of the radio stations in the country insisted that I come on his very popular radio show to explain to his listeners exactly what had struck him at my session, which he had attended merely to report the event for his station. Something inside him had kindled. Dissolve now to the classes that I teach in philosophy in the United States. I often ask my American students if a police officer can, at a traffic stop, routinely search their cars. Of course they say no. Then I ask them to explain why not. Often enough, they have no idea; they just think it's wrong. And this gives me an opportunity to make them aware of how much of what they take for granted is dependent upon a discipline that they hardly ever think about and which they

are convinced is totally irrelevant to their daily lives: philosophy.

What is the connection between the doctrine of the presumption of innocence and the prohibition of routine searches of people's property? A fundamental tenet of the Enlightenment is the idea that, despite certain Biblical accounts of human origins, the abjection that attached to human nature, which doomed the species to the rule of revelation, tradition, and authority, is not an essential element of our being. On the contrary, we are equipped with reason that gives us a path to true and useful knowledge that is not beholden to the three sources just mentioned. One sure consequence of this endowment is that we must be free to deploy this attribute, and whoever is counted in this species must not be hampered in their development and deployment of this capability. That is, freedom is an essential element of what it is to be human, and curbs on this freedom must necessarily be adjudged a diminution of the dignity and respect that attach to every human individual. Additionally, this liberty to know and to think must be unfettered, and anything that interferes with these paradigmatically human powers must be condemned.

Over time, this philosophical model yielded practices, institutions, and processes that made the protection of individuals against unwarranted interventions by the state and their fellows and their dignity inviolate. But it is not just the body of the individual that is implicated in this demand for respect, it is also everything else that can be construed as pertaining to the idea of the individual. To the extent that your property is regarded as an extension of your body or as the right reward of its labor, it is peremptorily exempt from unwarranted interference from outside. The officer searching your glove compartment without

your permission, absent evidence of a crime, is violating all these rational principles.

The concern for the individual is the template from which is fashioned that central object of solicitousness in the legal system: the legal subject. In any situation of legal wrongdoing, how you process the subject, when you are an agent of the state, matters to whether you are going to have a successful prosecution of the case. This is where the doctrine of the presumption of innocence converges with this prohibition of what is called illegal search and seizure — hence the requirement that, in order to interfere with an individual's person or her possessions, you must show that there is a good reason for such an interference. The doctrine of the presumption of innocence draws in its wake also another core principle of the modern legal system, that is, the insistence that the onus of proving the guilt of an accused person lies on the state and not on the individual to prove his or her innocence, and this disables the state and its agents from taking liberties with the individual that may violate her dignity and her rights. More generally, the Enlightenment injunction about the preservation of human dignity issues in the fundamental recognition that it is the individual that needs to be protected from the power of the state, not the state that needs protection from the individual.

This recognition, or the lack of it, is important for a proper understanding of contemporary Africa and its ills. Many of those who led the first struggle for freedom, the struggle for independence, in Africa were committed to ensuring that these prohibitions would be institutionalized in the post-independence order that they created. In the colonial era, they had been honored only in the breach, and routinely so, even though the colonizers proclaimed that a part of their mission in Africa was to bring the continent to modernity. (They lied.)

Unfortunately, two things impeded progress on this path. First, given that colonialism was not exactly a finishing school for liberal democrats or civil servants or other state agents equipped with the Enlightenment temperament, it is no surprise that many African states succumbed to the inadequacies that resulted, and to the political disasters that were facilitated also by other elements, such as wayward personalities and external interventions. This brought the second thing that ruined the successor regimes of the colonial state: military coups, which proceeded to make an already illiberal culture worse. And this provoked what I call the second struggle for freedom across the continent, which is still unfolding, This second struggle includes the end of various military regimes and other authoritarian and totalitarian regimes, or one-party states, under the pressure of ordinary Africans who still cling to the goals of the first struggle for independence — the freedom to be the authors of the own lives, to have states that they charter and governments that are responsible and responsive to them, and to enjoy the inviolate dignity that attaches to their persons by right. The second struggle has made an embrace of Enlightenment ideals, and the establishment of states that are more than superficially modern, even more urgent.

Across the African continent the dominant judicatures are based on these ideals, but they are unfortunately thwarted by the pressures of the identity-driven opposition to modernity and its Enlightenment principles. The education, especially in philosophy and jurisprudence, that is needed for the system to work as it does in the places from which we have borrowed them is sorely lacking. As I write, the continent is awash in NGOs, governmental agencies, and numerous movements canvassing everything from child rights to civil

rights to women's rights, workers' rights, the rights of the disabled, the rule of law, freedom of expression; the list is long. I am convinced, alas, that these reformist efforts still lack a basis in our culture. This surfeit of movements and organizations is not matched by an equally intense participation in the philosophical discourse that undergirds these practical engagements, or in the widespread dissemination, especially through institutions, of the relevant education.

Ironically, all this is happening at the same time as scholarship in the continent is dominated by an anti-Western spirit that determinedly, and wrongheadedly, strives to delegitimize these philosophical ideals as indelibly tarnished by colonialism and racism. We end up in a situation in which judges think more like civil servants than impartial arbiters empowered to protect the puny individual from the overweening powers of the modern state. We have law professors and political philosophers who start out always with the idea of freedom being limited rather than what it really is: absolute, unless its exercise clashes with its equal exercise by others. We have constitutions that boast the most ponderous Bills of Rights but are chock full of "clawback clauses" that take away with the left hand what they give with the right. We have young women proclaiming their rights of ownership of their bodies who at the same time know nothing about the philosophical foundations of that idea, its recent intellectual history and its universal reach. Some African societies have recently recognized or decriminalized homosexuality even as many African scholars denounce such moves as alien to their "African cultures," which are founded, they are quite sure, on the creation story of the Christian Bible.

What I am arguing is that all the institutions that dominate our social and political landscape across the continent at the

present time, however well or not they are working they are working, and irrespective of the civilizational diversities to be found therein, are traceable to Enlightenment-inspired modern origins. This does not mean that our diverse indigenous civilizations are no good, or that our embrace of foreign models is proof of our backwardness or of having contributed nothing to humanity's progress through time. We are merely evincing the human imperative to cross borders without qualms and beg, borrow, or steal whatever in our neighbors' lifeworlds would make a better one for us.

Here is a final illustration of this imperative at the present time. When judges are empaneled as impartial arbiters, we are fully cognizant of the fact that, like other human beings, they have personal preferences, and in many situations may have been card-carrying partisans of various factions in their respective societies. What is required of judges — and of jurors — is that they be willing and able to put aside their preferences and judge the case at hand purely on the basis of the merits. When this standard is met, we celebrate the jurors and the judges for approaching the almost superhuman capacity for impartiality. They do not develop this ability overnight. Jurors and judges have had lifetimes to develop the appropriate temperament through education, socialization into public life, a commitment to this practice as essential to what they regard as a just and admirable society. But this kind of existential training does not occur in many African jurisdictions. A judge who approaches the person in the dock suspiciously — if you didn't do something, why were you picked up by the officers from among your fellows and brought before me? — is already on his way, without any political push, toward a miscarriage of justice. The standard is even more difficult for ordinary jurors who have never had to think about what impartiality entails

when it comes to judging cases, especially when those cases involve sending someone to jail for long terms. And the fact that we do not have jury systems in much of the continent means that we are even more at the mercy of individual judges who, increasingly, may not be seriously educated in or engaged with the rigorous demands of their institution beyond their "technical" understanding of the rules. Our purview must be extended, then, beyond technical training in law to deeper engagements with philosophy, sociology, political theory, and so on. The reason is very simple. The philosophical anthropology that undergirds the institutions spawned by the Enlightenment, even when it dumped revelation as a source of knowledge, held on to the idea of the radical insufficiency of human nature. This ineradicable proclivity to error, this essential fallibility, is what reason is partly required to remedy.

As in law, so in science. Since the Enlightenment, and the scientific revolution that it accelerated, our relationship to the world has no longer been dominated by an attitude of submission to and worship of nature. Instead we decode more and more of the underlying operative principles of nature. As we tame its previously unpredictable ferocity, we now make nature work for us, for the most part. The experimental method, certified by corroboration, replicability, and predictability, has shrunk the number of people in many societies who are still dominated by mythological and religious paradigms; such "explanations" are regarded as quaint, funny, maybe crazy. It used to be that our explanatory framework for phenomena which we could not otherwise wrap our heads around featured stories about gods, goddesses, and similar creatures — and this was not the exclusive preserve of any people. The scientific revolution changed all that. And one does not have to be subjugated to Western hegemony, however

that is construed, to be a partisan of the scientific revolution. As we say in Yoruba, the sky is big enough for all birds to fly without touching wings.

And yet we, across the African continent, have never embraced the scientific method, even though many of our ancient civilizations handed down to us evidence of their commitment to evidence-based processes of engaging the world even as they identified with religious myth, Egypt being the most important example. We persist in embracing, deploying, and celebrating magical attitudes. I daresay that ours is the only continent that continues to thrash around in this morass. Certainly, other societies in our world have their share of such explanatory fantasies. India is full of gurus who are ready to convey the gullible and the confused to nirvana (if they pay up). In the United States there is no shortage of mad pastors who teach that hurricanes are our recompense for homosexuality and legislators who insist that Jews have special access to celestial laser weapons. But in those places few pay such occultists any heed, and their media and intellectuals refuse to be complicit in the swindle, in the peddling of ignorance. I wish I could say the same about Africa, where we need science so desperately.

It is past time to heed the admonition of one of the most modern African thinkers of the twentieth century. Amilcar Cabral, the writer and anti-colonial revolutionary from Guinea-Bissau, was a legatee of the Enlightenment. He worked with peasants for the most part, but was never reticent when it came to educating Africans about the limits of mythical and religious thinking and its irrelevance in our present world. "Our culture should be developed on the basis of science," he wrote in *Resistance and Decolonization*, "it should be scientific— which is to say, not involve believing in imaginary things.

The African Case for The Enlightenment

Tomorrow our culture should avoid instances where any one of us thinks that lightning is a sign that God has become enraged or that a thunderstorm is the sky's voice when a furious 'spirit' speaks. In our culture tomorrow, everyone should know that, while we dance when there are thunderstorms, a thunderstorm occurs when two clouds clash, one with a positive electrical charge and another with a negative electrical charge; and when they clash they cause a flash, which is lightning, and a noise, which is the thunder." What Cabral called our tomorrow ought to have been our yesterday. The scandal is that it is not even our today.

The Enlightenment was crafted to end our uncritical dependence upon revelation, tradition, and authority. These defects continue to afflict African life and thought in our time. Does availing ourselves of modern tools make us into permanent subalterns, or an inferior race, or people who have never contributed to the world's progress? There is no basis for such a conclusion. If we are set on securing for Africans a better life than we have right now, can we afford to ignore these tools? Of course not.

114

DECLAN RYAN

Halcyon Days

There's only one time when you were perfect for loving in life,
and if you miss that time, if you ignore it or pass it by, you've
really missed something.

<div align="right">JAMES SALTER</div>

I

Autumn wind, the leaves a golden mash
at our feet in the kind, quiet blaze
of the streetlight; I am taking your arm
under the umbrella, leaning into you,
waiting, imagining sweet violences.
My tongue is stoppered; its unfamiliar
ecstasies. I cannot say any of this
here, in ordinary streets, in the woods
around home, walking into the warmth
and taking off my woolen hat,
putting on records.
I can only take off one glove and press
my palm to your cheek, for a moment,
a sort of sigh, the whole world made
of lavender and foxglove, of those dreams
we have but don't discuss, of bedsheets
and mornings, our circling talk.
I call you old Zeus, your big, noble head,
your serious heart I haven't yet dived

through, even after everything;
Primrose Hill, that dream of fireworks and port
and staying
on the train. I want to hear you say it,
that we're the children of a king
and we've nowhere to go but a cottage built
on other peoples' sorrow.

II

And now you're leaving me to find out
what's in store? You talk of fate, of oracles:
this is the future, here. You have no need
of seers. What was that, on the Heath,
your last birthday, a willow tree for heaven,
our legs entwined, the cricket songs of June — you
smelled of soap and suncream and we were still
nervous of each other. You think there's another
path? If you have to find it out
I'll come with you. You think I fear the sea,
that wrecking clown. I'd sooner face
the fiercest waves than see you off, handkerchief
in hand. If what waits is death, let's both
meet it: being here alone is worse than that,
the sudden silence, not knowing if you'll come.

III

I've come to know the morning, first light
in the window, fussing around, making endless

tea. You not here is impossible; I want to send
a note, a ghost message, I can't bear not speaking,
not knowing how to reach you. It's Friday
morning and it's snowing and I've just walked
through the white woods to the station
and I wish you were coming round this afternoon
to talk about the snow, and have toast,
and sit with me with the fire on, and tell me
about your worries because I do quite miss you.

IV

I've been preparing to have you back, trying on dresses,
darning the old reliables, the gloves you left; I'm fixing
up the drawers, all busy work. These past nights I haven't
seen you, and it's made me feel afraid,
but now you've come to me again.
There's something unfamiliar in your face,
this isn't how you move, as if a stranger
was impersonating, uncannily — but still, I'd know
you anywhere. Why are you so pale, dear heart,
what is it that you want to say? What's this
dullness in your eye, this slow and faltering speech?

V

So this is what we're left, these seven days a year,
the wind died down around us, enough to
live on, just about. Lighter, no less in love,
glutted on the memory of being young,

our onetime flesh. You made a promise early on,
to pretend I wasn't all your daylight,
that the world's voice was no louder than the peace
we'd briefly found, that you didn't know I'd walk out
on it all, and wanted to. That I chose you.

VI

I've come down to the shore,
the pebbled place I saw you last, the last spot
where you held me; it was here, I think,
these very stones, your shadow fell across that final
time, where mine now falls, alone, stretching
its arms towards you, further than I can.
How can you be gone when I still love you?
When I can call out to you in whichever tense
I choose. Come home.

VII

Though it's so far off I know it's you,
that you've returned. Before I pause to think
I'm wading out, the sea is ice,
I'm packed for the grave
as yesterday's catch. Kingfisher,
heart's bird, I dive into your death
like catching headfirst fish. I swallow
all your scales and feel alive.

TAMAR JACOBY

The Battle
of Irpin

On the day the Russians invaded Ukraine, Patol Moshevitz,
a landscape architect and painter, woke early and looked out
the window of his apartment on the fourteenth floor of one
of the newest, most desirable buildings in the city of Irpin. He
could see for miles in almost every direction: Kyiv, Bucha, most
of Irpin, and the Hostomel airfield just across the marsh to the
north. A big bear of a man with a shaved head, he saw a swarm
of Russian helicopters descending on the airport. The noise
was deafening even where he was, and a dark plume of smoke
rose on the horizon.

Moshevitz dressed hurriedly and went into town, hoping

to sign up with a Territorial Defense unit and fight alongside the regular army. But the recruitment center was swamped with volunteers, and there were no guns, so he went back to his apartment. "I decided to help in my own way," he told me later. He spent the next nine days in his crow's-nest flat observing the region with binoculars and providing detailed reports on enemy positions — approaching tanks, gun placements, checkpoints, and other vital information — to the fighters defending Irpin.

I met Moshevitz in early June, eight weeks after the battle of Irpin. We sat in his apartment, subsequently shelled and now partially restored, as he narrated the month-long fight, using a spoon to point out strategic locations on a map I pulled up on my iPad. If he had been found and caught, he understood by then, he would almost surely have been tortured and shot. At the time, he didn't stop to think. "I was caught up in the moment," he said. "It seemed like a game — the little tanks and armored vehicles seemed so far away. I can't call myself brave. I just found a place for myself — a way to be useful."

Before the Russian invasion, Irpin was a charming commuter town — a mix of old Soviet-style dachas and new high rises ringed by forests and scenic marshland. Many poems have been written about the beauty of its surroundings. By the time the Russians left in March, Irpin was a patchwork of charred ruins. Almost all of the city's hundred thousand residents had evacuated in the weeks after the invasion, leaving Russian and Ukrainian troops to battle for a month at close range. Seventy percent of the buildings were severely damaged or destroyed. Hundreds of civilians were killed. But ultimately the defenders prevailed. Strategically located between Bucha and Kyiv, less than five miles from the outskirts of the capital, Irpin was one of a handful of places that prevented the Russian

army from reaching Kyiv. The savage battle of Irpin was a pivotal battle of the war.

I spent a month in Irpin after the battle, talking to people about it and listening to their stories. Ukrainian acquaintances introduced me to friends, who introduced me to other friends — doctors, nurses, priests, small business owners, city officials, soldiers and volunteers like Moshevitz. People were eager to talk. The conversations lasted two, three, four hours — and even when the talk ran out, some people wanted to meet again the next day. Several fighters walked or drove me around town, pointing out where they had fought or where a friend had died.

I asked everyone the same questions. Why did you do what you did? What were you fighting for? What is the war about for you — and what do you hope will come of it if Ukraine wins? Many people, like Moshevitz, started with a simple answer. "It was my duty." Or, "It seemed obvious — I couldn't imagine doing otherwise." As Orwell wrote about going to fight in Catalonia, "at that time and in that atmosphere it seemed the only conceivable thing to do." But almost everyone I spoke with in Irpin, from the deputy mayor to the cook at the university, also had a more complicated answer — something to do with freedom and democracy and their vision of what those grand ideas could mean for Ukraine.

By the time I arrived in Irpin, the city was starting to rebuild. Some thirty to forty percent of the residents had returned. Shops were open; there was traffic in the streets. Lilacs were blooming and children were playing in the parks — so it wasn't always easy to imagine the fighting that had taken place in the

same streets just weeks before. Yet even in the spring sunshine, it was hard to not to fixate on the mutilated buildings. Some had been burned to the ground. Many others were missing their top stories. Very few had all their windows — much of the city's glass had been shattered by shock waves. At first, the destruction seemed inconceivable, then infuriating — how can you train human beings to be this brutal, especially at close range?

I often spent evenings in my rented flat watching news videos of the fighting, and after a while I felt I was living in parallel universes: one green and recovering, the other cold and gray — desolate streets, fires raging on the horizon, rubble strewn chaotically everywhere you looked, a tank waiting around every corner. One soldier with whom I walked the city was suffering from the same kind of double vision. "It used to be all black and white," he said. "Now, it's in color. I can't get used to it." Then he reminded me that war was still raging in eastern Ukraine: just four hundred miles away, many cities still looked like the Irpin of late February.

This was not the first battle of Irpin — far from it; and almost everyone I met mentioned history, either of the city or of Ukraine. Unlike in most other places where people look back on the birth and blossoming of a nation, for Ukrainians history means an old longing for a nation-state that rarely existed until the Soviet Union collapsed in 1991. What people remember is a story about an old feudal monarchy, the Kievan Rus', and a long string of wars — a centuries-long fight for independence. In medieval times, before all of Europe had settled into nation-states, the enemies were Lithuanians invading from Europe and Mongols pushing west from Asia. For much of the eighteenth century, the Irpin River served as the border between Poland and Russia, two hostile powers bent on suppressing Ukrainian identity. In World War I, the

Ukrainian people were again caught between two rival empires — this time Austria-Hungary and Russia. In World War II, it was the Nazis and the Red Army. And even in peacetime, the territory now claimed by Ukraine was usually controlled by some larger power: Russia, Poland, Austria-Hungary, or the Soviet Union. Like other Ukrainians, the city of Irpin often had to take sides, stalling the Wehrmacht, for example, on its way to Kyiv in 1941, just as it stopped the Russians in 2022. But these were usually alliances of convenience — siding with the lesser of two evils.

I stumbled one morning on the town's history museum, a nondescript storefront in a shopping complex just coming back to life after the battle. Its old-fashioned glass cases featured relics from many previous fights: shells from both world wars, dog-eared images of soldiers and partisans, a fraying document attesting to Irpin's death toll in the Holodomor, a montage on the mid-twentieth-century Soviet writers' colony that gave the town its dachas and its reputation for dissidence, plus a final glass vitrine of fading color photos — soldiers from Irpin who died fighting the Russians in eastern Ukraine in 2014. "This war is just another cycle in an old history," one military man told me a few days later, sitting out in the sunshine by a concrete bunker built for World War II and now in use again as a shelter. "We've been fighting the Russians for centuries. The difference this time is that we might be strong enough to win."

It was the dozen or so fighters I spoke with who did most to help me understand the recent battle. Within a day or two of the attack on Hostomel, Russian troops had occupied Bucha. The first Russian soldiers were seen in Irpin on February 26, and the first battle occurred the next day at a small shopping center called Giraffe on the road between Bucha and Irpin. Several dozen Ukrainian fighters,

mostly inexperienced Territorial Defense volunteers, held off a large column of Russian tanks that was then destroyed by Ukrainian artillery. On March 4, Russian tanks broke through on the western edge of the city, not far from Moshevitz's apartment in the high-rise development known as Synergy. By March 6, the invaders were in control of the whole west side of town, setting the stage for what one fighter called a "dynamic stalemate" — a chillingly antiseptic term for the vicious three-week struggle that followed. Tanks roamed the deserted streets. There was constant shelling from every direction — thousands of artillery and mortar shells — punctuated by occasional aerial bombardment and close-range firefights at three strategic locations.

The battle at Giraffe continued on and off throughout the month. Some of the most intense shelling occurred at the Romanivka Bridge on the southern tip of the city. Known to many Westerners from news photographs, the bridge was destroyed by Ukrainian forces to prevent the Russians from entering Kyiv, requiring tens of thousands of evacuees to ford the river on foot. The third hot spot, scene of a decisive battle at the end of March, was in the northeast corner of town near the Ukrainian military hospital and another new high-rise development called Lipky. According to city officials, some three hundred civilians were killed over five weeks. Many of the people I spoke with thought that the toll was much higher, maybe as many as fifteen hundred.

The first weeks of the battle were a time of hard decisions for just about everyone in Irpin — whether to stay or leave the city, whether or not to sign up to fight. Viktoria Mogolyvets and her family left the first day. A thirty-six-year-old speech therapist with three small children and a premium apartment in the Synergy complex, she got into her car at 7 a.m. and drove

124

out of town — one of the last cars to cross the Romanivka Bridge before it was destroyed. It took her three days to reach the Polish border, normally an eight-hour drive, and another several weeks to get to Germany. But looking back, it was an all but miraculous escape compared to what would come later for many others.

Viktoria Ismestyeva, 43, a cook at the city's Fiscal University, made the opposite decision. She didn't know anyone outside Irpin — had no friends or relatives elsewhere in Ukraine, much less abroad. For her, it seemed safer to stay at home than to "head out into nowhere, like a ship lost at sea." As the fighting intensified, she and her fourteen-year-old daughter took shelter in the basement of the university, and she soon found herself cooking for several hundred people hiding there. Looking back, she can't imagine doing anything else. The people in the basement needed her, she told me, and she was glad to do what she could to help.

Many of the city's fighting-age men made the same kind of calculation. Roman Shklyar is a former security guard with friends in progressive political circles. In the wake of a recent accident that left a piece of shrapnel in his skull, he has been prone to epileptic fits and is not supposed to drive or expose himself to loud noises. Yet he joined the Territorial Defense on the first day of the war and saw action all around Irpin as a paramedic assistant. Stefan Protenyak is a professional skier who was supposed to be on a plane to Switzerland on the day the war started. Vlad Ruma was out of town on a business trip, and when he found out that the trains had stopped running he hitchhiked his way back into war-torn Irpin. The fireman Vitalii Kravchenko is fifty-seven — no one expected him to sign up to fight. Vitalii Petriv, nineteen, is a student at the national university's elite international relations school,

where most of his peers expect deferments or privileged spots as officers.

It wasn't easy to get a place in the Territorial Defense in the first days after the invasion. In Irpin, the line of aspiring recruits waited for hours in a park in the freezing cold. When they got to the front of the line, there were no guns, no helmets, no bulletproof vests. A few older men with military experience stepped up as commanders and set up a first checkpoint on the road to the Hostomel airfield. But even there, on the first day, the only weapons were shovels. The next day, five guns arrived for a ragtag unit of twenty men. Yet none of this deterred the fighters I spoke with, many of whom had to try several times before being admitted to a volunteer unit. Kravchenko the fireman made do for several days with his hunter's shotgun. Ruma fought for two weeks with no weapon at all; his unit had nothing but a bucket of grenades. Why did they fight? Shklyar spoke for many when he told me he couldn't imagine doing otherwise. "How can you run away and leave your home behind — or your family or your homeland? Of course, we had to protect what's ours — our nation and our right to choose our own way, free of foreign domination."

Other people in Irpin had more questions than answers in the first days of the invasion. Did the Russians mean business — or was the goal just to scare the city? Would most residents stay or go? What would they do in case of a siege — where would they get food and other supplies? Many people packed an emergency bag and slept in their clothes. But by the third or fourth day the grim true picture was coming into focus, and large numbers of residents started making their way out of the city. On February 24, about a hundred people showed up to sleep in the basement of the Baptist church, the largest

in Irpin, which took charge of the effort to evacuate civilians. A few nights later there were four hundred and fifty people, and requests for help getting out to safety snowballed as the fighting intensified. In the first week of the war, the Baptists estimate, they evacuated four thousand people. The biggest push was on March 5 and 6, when the crowds crossing the river on foot under the Romanivka Bridge caught the attention of the international media, and four civilians, including a volunteer from the Baptist church, were killed by a Russian shell on the Kyiv side of the span.

The overwhelming majority of Irpin's residents left town in those first two weeks. But evacuations continued through the month, even after the Russians retreated, when authorities estimated there were no more than five thousand civilians left in the city. More than ninety thousand people had managed to escape.

The hardest part was getting people to the bridge. It is only five miles from one side of town to the other, but the constant shelling made it impossible to walk even a block or two. So the Baptists and other volunteers stepped in with a slightly safer alternative: a civilian car or van would pick people up at their homes and bring them to the bridge. Territorial Defense fighters and regular soldiers helped with the next leg of the relay, supporting evacuees as they descended through the ruins of the old span and balanced on a walkway over the rushing water — at first just two pipes, later a shaky plank. Then a different fleet of vans and buses organized by humanitarian aid groups picked people up on the other side of the river and drove them into Kyiv. The largest challenge came when the Kyiv TV tower was shelled on March 1 and most phones went out; suddenly there was no way of knowing where people were hiding around town — in which basement,

in what part of the city — or where to pick them up to ferry them to the bridge.

I sat with a Baptist volunteer named Andrii Rizhov on a sun-dappled bench on the church's wooded campus and marveled as he spoke in a quiet matter-of-fact way about driving directly into the shelling to find evacuees. Rizhov called his forays "raids," and another volunteer, a toughened fighter, underscored the point. "Evacuations or fighting," Artur Arestenko explained, "they're not that different. You're driving into artillery and mortar fire. You have no idea what to expect. There could be a tank waiting — there's danger around every corner." Rizhov told me that he often felt close to death but never questioned the task he had taken on. "Morally, I had no other option. Of course I cared about my own life, but there was something bigger at stake. Putin's goal is to destroy us — our nation and our identity. This has to be stopped — stopped here and now. And I did what I could to be part of it."

On one of my last days in the city, a Territorial Defense fighter walked me across Romanivka Bridge. The span was still impassible, and we had to trace the same path as the evacuees, balancing on a rough plank to get across the river. But what struck me most — what I hadn't understood from countless photographs — was how exposed the route was, an easy target in a vast expanse of open marsh, within reach not just of distant artillery but also of snipers in the high-rise buildings on the horizon. Standing there, out in the open and completely vulnerable, I realized that the Russians shelling of the bridge could have no intention other than to kill civilians. There were no other targets anywhere nearby.

The Baptist senior pastor Mykola Romanyuk illustrated the danger in a different way — with his phone. Many of the people I met in Irpin used their phones to tell me their story: a

128

parade of grisly photographs and harrowing videos. For many, this visual chronicle was a way of making sense of what they had just experienced. "Here's me facing a tank," one paramedic said as he scrolled through his photos. "Here's me with an enemy corpse. Here's a dogfight I filmed out my window." Then, after a moment of silence: "Sometimes it's hard to watch — and hard to believe it really happened to me." Pastor Mykola's video was grey and grainy. Even on his tinny phone, the rat-a-tat of the shelling was almost unbearable. The road to the bridge was littered with debris, and there was smoke at several points on the horizon. A battered van emerged. Four men jumped out and scrambled to extract an old man on a stretcher. You could assess the danger from the speed of their movements: even a few seconds in the open could be lethal. But they trotted the stretcher past a line of body bags and set it down under the bridge. Then the video loop began again.

The lack of weapons and training took its toll on the west side of the city in the first week of March. A small band of Ukrainian fighters with a few weapons had managed to hold off a large force at Giraffe in late February with little except daring and ingenuity. A couple of men with a shoulder-fired rocket launcher hid by the side of the road from Bucha to Irpin and struck the lead vehicle in an armored column from the side, immobilizing it and all the tanks behind it. On the west side of town, the Russians attacked across a wider front with a large convoy of tanks and well-equipped elite fighters. As at Giraffe, the Ukrainians had no regular troops, just inexperienced volunteers. "We had one tank and one armored personnel carrier," Kravchenko the fireman recalled. "They had dozens." "We had no one to send in," a top commander admitted ruefully, "so we used drones to break up the enemy column. But the tanks and APCs scattered in the city,

dispersing in civilian neighborhoods where they knew we'd hesitate to fight." Moshevitz saw the vehicles entering the Synergy complex and watched as they found places to hide between the buildings.

Andrii Kolesnyk knew something was wrong when he heard automatic rifle fire just a block or two away from his Scandinavian-style boutique hotel. Later that day, he saw an armored personnel carrier in the woods outside the building. He wasn't sure if it was Russian or Ukrainian, and he was afraid to go to the window to check. Then the shell hit, tearing a hole through the third and fourth floors of the stylish guesthouse. At seven the next morning, there were tanks in the yard and men shouting in Russian as they smashed their way through the cars in the parking lot. Kolesnyk's wife and their guests had left a few days earlier, leaving him and another man whom he called by his first name, Pavel, to protect the business. The Russians who broke down the door searched them both and then searched the building. They didn't like what they found: Kolesnyk's hunting rifle, his passport, and about $11,000 in reserve cash. "The commander had never seen Euros before, and he found them suspicious," Kolesnyk remembered, with laughter. Many people I met in Irpin laughed at what seemed like anything but a funny story. Even more suspect were the visas in Kolesnyk's passport — German, French, English, American — and the photos of a Russian helicopter in Pavel's phone.

Even so, Kolesnyk thought the intruders were joking when the commander told a young recruit that he could "decide," and the deadpan soldier answered that he would execute Kolesnyk and let Pavel go. The fighter took both men into the kitchen and told them where to sit, then left the room and closed the door. Within seconds there were shots and bullets tearing through the kitchen. Kolesnyk was wounded just below the

knee, and the leg of the stool he was sitting on was cut clear in half. But thanks to the thick wooden door, he was still alive. The ordeal played out for another few hours almost as senselessly as it had begun. The shooter shrugged when he found Kolesnyk alive, and his comrades laughed. Later the Russians ordered Pavel to run to a nearby shop for cigarettes and warned that if he wasn't back in twenty minutes they would shoot Kolesnyk again, and this time they wouldn't miss.

What ultimately saved him, Kolesnyk believes, was that the invaders were afraid he would find some way to signal their location to a Ukrainian artillery unit, and so he and Pavel were allowed to leave the house and spend the night in a nearby basement. Then, the next day, the Russian unit moved on. After four more days of nearly constant shelling, Kolesnyk decided to leave Irpin, walking under heavy fire to the Romanivka Bridge. In the three miles between his house and the river, he counted eight corpses.

For most of the residents of Irpin who remained in the city throughout the battle, life revolved around a basement, where they huddled with others from their apartment block or neighborhood or church. The word that came up again and again when they talked about their experience was "community." Some basements were dank and dingy, others comfortable and well-equipped. Some communities held together with prayer; others had little parties now and then, "toasting the heroes in the armed forces," as one resident put it. Some groups dispersed after a few days as people fled the city. Others endured through the five-week siege and even beyond in buildings where the apartments were no longer habitable.

Olha Malach's eighty-family apartment building is located between Synergy and Kolesnyk's guesthouse, in the heart of the neighborhood that was eventually occupied by Russian forces. Malach and her husband run a small construction business. But as important to her as her day job, she is the elected head of the building's tenant council, known in Ukrainian by the acronym OSBB. OSBBs are the grassroots cogs of Ukraine's fledgling democracy. In Soviet times, most apartment blocks were managed by hired watchdogs who reported to the secret police on suspicious behavior — who seemed to have extra money, who went in and out at odd hours or had unusual visitors. In the years since independence, the new Ukrainian state has worked to devolve power from the national government to the local level, granting taxing authority to mayors and creating OSBBs with elected leaders. In the battle of Irpin, many of these managers played an essential role organizing life in the basements where people hid through the occupation.

Like other OSBB heads across the city, Malach had no instructions to speak of and no playbook. "Everyone pitched in," she recalled. "Each person found their way to be helpful." The first task was equipping the basement: filling sandbags, finding bedding, organizing communal chores. Men were assigned to patrol duty and fetching water from a nearby well; women took charge of the cooking. In Malach's building as in others, many tenants who fled the city gave their keys to those who remained and told them to take what they needed from the freezer — so the building soon had a surfeit of food that had to be preserved before it went bad. This got harder on March 5, when the invaders cut the electric line providing power to the city. But Malach and the other women organized an outdoor grill, and they soon had enough canned meat for several months.

On the first night it was ready, Malach's basement housed three hundred people — her tenants and several dozen from the nearby Synergy complex. In the days that followed, she urged people to leave the city, working with other OSBB heads to organize evacuations, and over time the headcount dwindled, down to forty-three after two weeks and just fifteen by the end of the month. The residents knew because they kept careful track, gathering most mornings in the courtyard and counting heads — just to make sure that everyone was still alive.

In the first weeks, the basement group had relatively little contact with the Russian troops marauding through the neighborhood. Malach saw an armored column roll by on March 5. Residents heard heavy shelling in the streets, along with gunfire and grenades. But most of the tenants rarely left the courtyard except to go to the well, and they could only guess what was playing out in the neighborhood. One thing was different in the occupied part of the city: unlike other basements, where Territorial Defense fighters and volunteers stopped by on a regular basis, Malach's building had no visitors. "We had no humanitarian aid, no news, no information, no power to charge our phones, almost no cell connection," Malach said. "It was as if we were alone on an island — and most people had no way of telling their loved ones they were still alive."

Then things took a turn for the worse. The shelling in the streets intensified; there was a noisy firefight a few blocks away. Virtually everyone was in the basement on the morning of March 23, when a missile sheared the roof and most of the top floor off the five-story building. The shock wave knocked Malach to the ground, and she remembers "the walls trembling." Then a tank appeared in the courtyard. Like

many people in Irpin, Malach calls the invaders Orcs — a name borrowed from Tolkien, who coined it to describe a race of brutal and malevolent monsters — and true to form, the Orcs who entered her courtyard did their best to terrorize her and her tenants. They collected phones and smashed them. They issued meaningless make-work orders to move from one part of the basement to another, and anyone who left the shelter to cook or to retrieve water was followed at gunpoint by a Russian soldier. Then the looting began — everything that could be removed from an apartment, from warm clothes and bedding to kitchen appliances.

Yet Malach was not intimidated, and her phone still worked. She had rarely turned it on since the invasion, so it still had a charge, and she could still get a connection in one corner of the courtyard. In the days before the tank entered the building, she had worked out a simple code with her daughter in Kyiv and used it to relay Russian positions that the daughter passed on to the armed forces. That was even more dangerous now with Russians in the courtyard, but it was also much more useful, and Malach didn't hesitate to collect intelligence on the occupiers, radioing three times in the three following days.

The one thing she couldn't stop was the murder of the building's abject shut-in, a man known as Genya. Malach described him as a sullen drunk. Few people in the complex knew or liked him, and he had taken no part in basement life, preferring to drink alone in his apartment, which Malach said reeked of alcohol. When the Russians searched the building, they found him and fastened on some paperwork that they picked up in his apartment. Malach says it was poker bets that the invaders mistook for a sketch of Russian positions. Malach and some other tenants watched as two soldiers marched the

frightened man out of the courtyard, and a few minutes later they heard the shot. After the Russians left the neighborhood, some tenants found the body and buried it, under heavy shelling, in a nearby park.

When I asked Malach why she did what she did, she brushed off the question. "I'm not a hero," she insisted, "I did nothing special." I pushed back a little: very few people I know would have taken the risk she took, relaying information about the invaders even as they held her and her tenants at gunpoint. "Someone had to do it," she answered, shrugging. "My neighbors fought on the front lines. Others risked their lives to deliver food and medicine to basements like ours. Someone had to help here, coordinating and organizing. I did what I could. But everyone who stayed was a hero. Everyone found a way to play a part."

By the time I arrived in Irpin, most elite fighters — armed forces regulars, special forces, and volunteer international brigades — had moved on, following the war as it shifted eastward. But the city was still full of soldiers. You saw uniforms in the streets and in every shop as well as at the checkpoints, several of which were still controlling who went in and out of town. Most of these men were Territorial Defense volunteers, and everyone I met was eager to talk — eager to tell me what they did and why they did it.Vlad Ruma is a thirty-one-year-old marketing manager with two young children who was still serving full time in the Territorial Defense when I met him. After our first conversation, he asked to meet again and then again, a third time, and on the third day we spent several hours walking around Irpin — visiting the places where he had fought and his

comrades had fallen. He said it was duty that drove him to do what he did during the battle, and he brought the same earnest good will to our conversations — he was determined that I get the full story and understand everything. He wore fatigues on the hot day we walked the town and carried a heavy Kalashnikov slung over his shoulder. We started at the old Soviet House of Writers — it served as Territorial Defense headquarters in the first days of the battle — then walked north through what had been no-man's-land between invading Russians and defending Ukrainians. The next stop was the Giraffe shopping center, then the Romanivka Bridge. The only spot we missed was the west side of town, where Ruma's unit had fought for several days not far from Kolesnyk's guesthouse.

It took me a while to understand exactly what part Ruma had played in those engagements. Some Territorial Defense units serve largely in auxiliary positions, enforcing curfew or monitoring security on public transportation. Others fight in blended units alongside the regular armed forces. Still others see combat in a support role, serving just behind a front line manned by elite forces. Ruma was one of several volunteers I met who told me that he was dissatisfied with the first unit he served in and asked to be moved to more active duty. "I didn't sign up to guard a café in Kyiv or police dog walkers breaking curfew," he said. "I wanted to fight — and eventually I was transferred to a fighting unit." But like others in the Territorial Defense, he also drew a bright line between himself and the elite troops he fought alongside. "Our orders were to hold the line," he explained. "We built defensive positions — checkpoints, trenches, gun placements — and we manned them. We used our guns when the enemy approached. But our task was to hold the invaders, not to advance. That's a job for people with military training and experience."

Still, Ruma had a lot to teach me as we traversed the town. He demonstrated how to cross an intersection in an occupied zone, crouching low with your gun at the ready. He explained the difference between a reconnaissance skirmish and a full-scale engagement. At one point I gave him my notebook and he filled a page with drawings — the different parabolas traced through the sky by artillery, mortar, and tank-fired missiles. He also helped me to understand exactly what had happened at Romanivka and Synergy. The most sobering lesson was at Giraffe, where we turned off the road to Bucha — the artery that Russian troops had hoped to use to enter Irpin — into a big open area where defending forces had stood waiting to ambush the invading column. The lines of sight were different now, obscured by summer foliage. But otherwise it didn't look as if much had changed since the February battle that stopped the Russian advance.

You could see the positions where Ukrainian gunners had stood, the surrounding ground littered with cigarette packages. There was debris everywhere and occasional pieces of discarded gear. At one point Ruma crouched to the ground to pick up a handful of rusting bullets. And it was then that it hit me, naïve as I was and eager to romanticize the fight for freedom: even defensive forces must be ready to kill — not just to sacrifice their own lives but also take the lives of others.

I returned to Giraffe a few days later. A forensic team was scheduled to visit and exhume three Russian corpses thought to be buried under the rubble of the destroyed mall. Two of the three had been killed in the first moments of the firefight. The third was wounded, then waited cunningly until Ukrainian fighters approached to blow himself up with a grenade. By the time the shell fire that consumed the building burned out, more than twenty-four hours later, all three bodies were

buried under several tons of charred metal and loose brick. I and the owner of the mall waited a few hours for the forensic team. It didn't show until the next day, so I didn't witness the disinterment. Later that night, when I saw the photos of the gruesome corpses, I was glad that I missed it.

The day I walked the city with Vitalii Petriv had a happier ending. A fresh-faced university student with no military training or experience, Petriv signed up for the Territorial Defense in Kyiv in the first days of the war. He spent a couple of weeks on guard duty before being transferred to what he was told would be combat in an undisclosed location. When he arrived and got his bearings, he learned that Irpin was then ground zero. He was defending the east side of the city against Russians attacking from the north.

He and the rest of his five-man unit — all inexperienced, with just a few days of training — asked to be sent as far forward as possible, and they were told to dig a position on a residential street just three blocks south of Russian forces trying to break through near the military hospital. "We were eager to do something important," Petriv recalled when we met the first time in a busy café in downtown Kyiv. "We had no idea what we were getting into." Petriv grew up a lot in the next ten days. It was bitter cold in the streets of Irpin. There was no one — no other soldiers — between him and the enemy. The shelling was constant. At night the sky was as light as day. He and his comrades rotated two hours on, two hours off — but as he remembers it, he hardly slept, powered mostly by adrenalin. A few days after he arrived, the pontoon bridge that his unit had used to cross the Irpin River was dismantled, so there were no further supplies. This left him and other units to live off the all-but-abandoned neighborhoods where they were stationed — to find someone local who they felt they

138

could trust to provide food and water and an occasional hour inside by a stove.

Everyone in Petriv's unit eventually made it out alive. But when I first met him, he was worried sick about the two civilian families they had found to help them — a construction worker and his wife with ties to the Baptist church and the owners of a neighborhood veterinary clinic. Like Moshevitz and Malach and anyone else in Irpin who helped the Ukrainian forces, both families were risking death if the Russians overran their neighborhood. And the last time Petriv had seen the construction worker, his house, where Petriv had slept, was engulfed in flames, with enemy troops approaching.

I suggested that Petriv come back to Irpin with me to look for these families, and frightened as he was about what he might find, he eventually agreed. We walked through the neighborhood on a perfect summer's day, and the young man marveled — could these really be the hard-fought blocks he thought he knew so well? We expected to have to search for Ivan, the construction worker; Petriv was convinced that his house had been demolished by a Russian missile. But when we arrived at what we thought would be a burnt-out shell and knocked on the fence, Ivan came to the gate. Half the house was a rubble-filled ruin, but the other half was still standing, and Ivan and his wife had stopped by to pick up a few things. Petriv gasped when Ivan appeared — a man he believed dead, in part because of him, was standing before him in the sunshine.

Later that afternoon we followed Petriv's retreat from his unit's initial placement in front of Ivan's house to a second position, just two hundred yards to the rear, where he and his comrades had spent the next week. He showed me what was left of their trench and the rude graffiti they left on the wall to greet any Russians who got that far south. Petriv was starting

to feel better and hoping for the best when we knocked at the clinic. The woman who answered stared at the young man for a few seconds and then let out a cry of joy, hugging him and peering at him again and hugging him some more. In this case, it turned out, it was the civilians, Nataliya and her husband Vitalii, who had been most anxious in the months since the fighting ended, convinced that Petriv and his comrades had saved their lives but worried that they were dead. We sat at the family's kitchen table in the fading afternoon light, drinking tea and eating chocolates: Nataliya ransacked her cupboards for the most festive thing she could serve us. When her husband arrived, he broke into quiet tears as we chatted casually about nothing in particular.

What struck me most as I listened to them catch up was that they, too, seemed to be living in parallel universes — constantly reliving the battle even as they tried to put it behind them. Nataliya and Vitalii told us about one recent evening when they found themselves eating in the dark, trying to conserve electricity as they had when their only power was a generator. Someone else said it was so quiet now — no mortar fire, no artillery — that they couldn't sleep. "Yes," someone else said, as if marveling at a dream, "it's hard to believe we lived through it." And yet, for most of the people around the table, the trauma of the siege seemed almost more real than the present.

Why did the Russians retreat at the end of a month from Irpin? What turned the tide of the battle? Everyone I met during my visit had their own theory. What I realized as I made my way around town was that each individual had fought their own

140

war, in their own small corner of the city. People such as Malach and Petriv knew only the block they lived or fought on, and even others such as Rizhov and Moshevitz, who had seen more of the battle, knew only their own experiences.

But by the time I visited, two months after the fighting stopped, many people were piecing the story together, and they sometimes argued among themselves about what kept the Russians out of Kyiv. A few things seemed obvious. The terrain posed a huge advantage for the defenders. Tanks and armored personnel carriers cannot cross a marsh except on a road, and the Ukrainians were able to control most of the roads and bridges in and out of Irpin. It didn't hurt that the city had grown exponentially since Ukraine was part of the Soviet Union — so Russian maps showed forest and swamp where there were now high-rise apartment buildings. A handful of military men helped me to understand the context — how Irpin fit into the larger battle of Kyiv. Still true to Stalin, who called artillery "the god of war," the troops advancing on Kyiv were counting on artillery — if only they could position their guns within fifteen miles of the capital. They got close in Irpin, almost within range, but never close enough. Then, in late March, a Ukrainian counteroffensive north and east of the commuter town threatened to encircle the invaders, and they withdrew abruptly — shelling Irpin with everything they had left as they pulled back from the city.

Another critical factor was local intelligence — what one commander called "our eyes and ears on the ground." The armed forces drew on information from scores of informants such as Malach and Moshevitz, some civilian, others military. Some spotters texted friends or relatives in the armed forces. Others used a government app, Yevorog, to report anonymously on enemy positions. And even with sophis-

ticated technology, the Russians seemed unable to match Ukrainian intelligence. On the contrary, many Ukrainians told me, the invaders sorely misjudged what they were up against in Irpin. "The Russians often thought there were more of us than there were," Territorial Defense coordinator Aleksandr Shemetun explained. "If they had only known we were so few," Ruma echoed, "with almost no anti-tank guns, they would have overrun us easily. Instead, again and again, they retreated."

Other survivors of the battle stressed the "unity" that they had witnessed in Irpin — a shared determination to do whatever it took to win. "Look at Ukrainian history," one seasoned fighter told me. "We don't have much experience governing, but we know how to defend ourselves. We've been a battlefield for centuries, and we have always survived." In the streets, in the basements, under the bridge, among the legions of humanitarian aid volunteers who showed up to help, driving food and medicine into the city and ferrying evacuees out: here was civil society at its best, rallying under threat. From the volunteer fighters to the evacuees who left their apartment keys, everyone did what they could and pitched in with whatever they had. "I didn't expect it," recalled Olha Vereha, an OSBB head from the northern part of town. "People are people, and let's just say — they don't always cooperate. But everyone found their place. Everyone did what they needed to do, and somehow, together, we prevailed."

I wasn't always sure how to ask the bigger questions that brought me to Irpin: why people chose to fight and what they were fighting for — what they thought was at stake in the war with Russia. Some of the people I met thought this was too obvious to need explaining. Others shrugged it off as irrelevant. "I'm not a philosopher," one soldier told me. "I did what I did — that's what matters." But in this case too, after a while,

there emerged a handful of shared answers. I came to think of it as a kind of hierarchy of needs.

"The fundamental instinct is simple," Aleksandr Yurchenko, a member of the Ukrainian parliament, or Rada, explained to me. "To resist aggression from outside — someone who comes to your house and tries to take it." "It's not highbrow," a young instructor at the Fiscal University said. "It's in the details. My home, my gym, my cat, my friends and family, the land where my ancestors are buried — I needed to stay and protect them." A second common answer was the appeal to duty. Doctors talked about duty to their patients, priests about their congregations, soldiers about their comrades in arms, OSBB heads about their tenants — and many about their families or some sense of a larger common good. Firdosi Kitankyshyiev was the security guard at Giraffe, at his post on the morning of February 27, and he helped dispatch the first Russian fighters who arrived in Irpin. "It was simple math," he recalled, "the life of one man or the fate of Kyiv. That's why the military exists — for soldiers to die so that others may live." And a third answer, offered in their own way by almost everyone, was the desire for an independent Ukraine. Anatoliy Zborovsky, a graying, mustachioed man who has been running the town's history museum for thirty-five years, declared that "You don't have to be a historian. All Ukrainians understand — this is a war for independence and sovereignty."

Many of the people I met in Irpin, educated and less educated, see the present through the lens of the past — most often, the hated Soviet years or the Cossack era. Nomadic seventeenth-century fighters who practiced a kind of rough democracy in the frontier forts where they withstood waves of Russian, Polish, and Turkish invaders, the Cossacks are widely viewed as the standard-bearers of Ukrainian independence.

143

Some neighboring peoples at the time and since, especially the Jews, have seen the Cossacks as murderous outlaws. But most of the Ukrainians I spoke with looked back on the Cossack era with a deep reverence. Two of the Ukrainian military's most elite units — the Azov battalion and the Carpathian Sich — are named for Cossack forts, and people idealize both the bravery of the pre-modern fighters and the soldierly egalitarianism that prevailed in their frontier settlements. "The Cossacks had a written constitution," one militiaman reminded me. "They were electing leaders when most Europeans were still bowing down to monarchs."

The unity of purpose was extraordinary. "Ukrainians have never been enslaved and never will be," proclaimed the military chaplain Father Vitalii Voyetza, evoking the spirit of the Cossacks. "We've never fallen on our knees before a foreign ruler. No tsar or dictator has been able to impose their way of life." And of course Vladimir Putin fits this mold exactly — the overpowering foreign potentate who must be rebuffed. "Russians don't see Ukraine as a sovereign state. They see it as their land," explained Nastya Melnychenko, a former student activist and a writer with a home in Irpin, now living as a refugee in England. "The terrors, the purges, the Holodomor were all about breaking our collective will. Russia wants to erase our sovereignty and identity. We have no choice but to resist — and continue resisting."

It is a simple, powerful answer, and for many of the people I spoke with it was enough: Ukraine is fighting for its independence. But what would independence look like? An independent state is not necessarily a free and democratic state — just look at Russia. How do Ukrainians want to live once they are free? What will they do with their independence? For many, the answer is defined negatively. Putin claims that "Russians

144

and Ukrainians are one people — a single whole." Just about everyone I met in Irpin begged to differ, often fiercely. "We are not Russia," Kolesnyk told me emphatically, sitting in the yard outside his ruined guesthouse. "Over nearly a thousand years, we developed differently from Russia. We live completely differently. We have a radically different worldview. Russia is a KGB state — no freedom, no opposition, dissenters go to prison. We're a freedom-loving people — we always have been. I can go to the Maidan and shout, 'Zelensky is an idiot!'" I heard the same point made in a different way. "You can't have a good life under the Russians," the fireman and Territorial Defense fighter Kravchenko told me. "You can't aim for anything or earn anything or achieve anything. That's not what we want in Ukraine. It's not what I want for my children." Many if not most people in Irpin seemed to have visited Europe. They went as students or as tourists, as migrant farmworkers or on business trips — and many volunteered European life as a way of life to strive for. "We're tired of being a battleground," one Territorial Defense fighter told me. "We want to join Europe."

In Irpin, as everywhere, it often seemed easier to declare in favor of freedom than to define exactly what it means or should look like in practice. Many people reeled off a list: freedom to think what you want and say what you think, to pray in your own way and speak any language you wish to speak — Russian or Ukrainian. Others spoke about freedom to travel and to spend and to invest. Near the top of the list for many was the right to protest. "We have a long history of protest," one Territorial Defense fighter told me. "The Maidan revolutions of the last two decades are just the most recent." But others recognized that it can be easier to protest than to govern. "We were disappointed by our early presidents," Andrii Lubenko, the owner of Giraffe, told me. "They betrayed

145

our hopes with their corruption. They ignored our yearning for independence. But we're still fighting for those hopes — and for our right to choose our own leaders. We may not always make the best choices, but we want to choose our own way." So, too, with joining Europe: many seemed to understand that it might not be easy. "It is a clash of civilizations," the Greek Catholic priest Andrii Nahirniak, director of services at Caritas Ukraine, maintained. "The East stands for darkness and tyranny. Europe is about freedom and free expression, science, justice, property and the rule of law. We've been trying to make the choice for centuries, and we've failed over and over. We still don't know if it will work this time. But winning the war is an essential first step."

What he didn't say, but what he could have said, is that the war has made the choice much more appealing. Judging by what I saw in the rubble of Irpin, the West has never looked more attractive to most Ukrainians.

I thought I must have the wrong address for Luda Rudenko. I had walked by the ruins of her café before — a huge pile of charred metal in front of a burnt-out building in the northeast corner of town where the fighting had been most intense. I checked the address and made my way in, and the first room looked as I expected: torched beyond recognition and piled high with rubble. But it led to an open terrace, freshly plastered and painted, overlooking a dock and an idyllic sunlit lake. Then Rudenko came bustling in, a fountain of energy and hopeful good cheer. What did I want to see first, she asked — the old, destroyed part of the building or the new, bigger café rising out of the ashes?

A handful of photographs pinned to the wall told me her story. Here was Rudenko in late February, unloading a crate of food and medical supplies for the fighters on the town's first checkpoint. In the next picture, a long line of freezing-looking neighbors snaked into the café, by then one of the few places where they could find food or water. The next photo was the luxury high-rise complex known as Lipky, just a few blocks up the street. Every window was shattered, and many apartments had no exterior walls — some of the worst destruction sustained in the battle. And the last image looked like a jack-o-lantern: it was the café on fire. The shell hit on March 23, just days before the Russians retreated, and Rudenko still had it, and kept it on display in the kitchen. Now, like everything else she was restoring, it was as clean as new — a cluster bomb about a foot taller than she was.

We started on a tour of the restaurant, walking through the debris to the restored terrace, where Rudenko was sanding chairs and nursing a pallet of plants back to life. An old woman from the neighborhood wandered in and interrupted us, her voice full of emotion. I needed to understand, she insisted, how many elderly people such as herself Rudenko had saved, feeding and housing them until the end, then helping them escape the city. But gradually it dawned on me that, as courageous as Rudenko had been in battle, her most heroic act was to restore the café. "It's just bricks. We'll rebuild," she remarked. "It's not a big price to pay to defeat the Russians." She had left Irpin on the day the café was destroyed, stepping over a corpse and running through the blackened streets, one of the last people still alive in the gutted city. But after about two weeks she came back to town and began by cleaning up the rubble and broken glass at her house a few blocks away. That took nearly a month. Then she moved on to the café.

"Yes," she said, looking around a little wistfully, "two stories of the building have been destroyed. But we'll build back three stories — it will be even better than it was before."

Not everyone in town was so hopeful. One fighter whose home had been destroyed railed angrily at the municipal authorities. "They used me when they needed me," he sputtered, "and now they're throwing me away like trash." Others worried about corruption — that funding allocated for reconstruction would be siphoned off before it reached them, leaving them with fifty cents on the dollar for the value of their property. Baptist Pastor Mykola's biggest fear was that the town's collective trauma could take years to heal — and like many, he wondered how many residents would return to Irpin. When we met, in June, about forty percent of his congregation had come back. He expected another twenty to thirty percent to return in the next month or two. But he wasn't sure about the rest; he thought the town might shrink by a full third.

Rudenko, however, was having none of it. "None of us have had any help yet," she said. "But you have to find a way to start — we need to rebuild." We sat for a couple of hours on her terrace and at one point she reached for her phone — she wanted to read me a poem. "I'm a people who has never been conquered," she recited in a stirring voice. "I'm a people whose strength is truth." She paused for a moment and then added: "We have been fighting the Russians for centuries. They advance, we resist. Maybe this time the cycle will be broken, and Ukraine will take its place — its rightful place — as a beacon of the Western values that we are fighting for."

ALFRED BRENDEL

Goethe and Beethoven

Thinking about extraordinary figures such as Goethe and Beethoven, one gets the feeling of observing in the distance two inconceivably tall towers. Their height seems impossible to calculate. What do they have in common? Where do they differ from each other? How harmonious is their architecture? Are there areas of dilapidation? Getting nearer, you can count the number of stories and windows, but the highest features are hidden in the clouds.

Let me start by establishing what Goethe and Beethoven are not. Beethoven's music is not, as the legend has it, harsh and heroic, in the sense that this would indicate the core of

his personality. To be sure, he composed grand works such as the Eroica Symphony and the Fifth Symphony, and he had to endure the latter part of his life heroically with his hearing gravely diminished. But where does the harsh-and-heroic picture leave the profundity of his incomparable slow movements, his *dolce* and his *pianissimo*, his personal variety of grace, the dancing character of some of his finales, the humor that is discernible up to his final works? Without recognizing the full range of his expressivity and his innovative urge, we would fail to do justice to Beethoven's greatness. Goethe, similarly, is not captured by his legend. He was not just the Olympian spirit or the privy councillor, the stormy poet or the distanced classicist of *Iphigenia*; he was all these things at once and so much more. The singularity of both are steeped in their personal diversity.

Both lived in a period of upheaval. Goethe as well as Beethoven, who was a generation younger, admired Napoleon, and Goethe, in awe, considered him demonic. Napoleon told Goethe that he had read *The Sorrows of Young Werther* for the seventh time. Beethoven tore up his dedication to Napoleon of the Eroica Symphony after he had proclaimed himself the French Emperor, but Goethe's admiration did not cease. He continued to wear the cross of the *Légion d'honneur* that was presented to him by Napoleon, and he kept a portrait relief of the French emperor next to his desk. Goethe's art collection included no less than fifty Napoleon medals. He never shared the patriotic frenzy that Napoleon provoked in German circles.

An aesthetic upheaval around 1800 was the transition to Romanticism. Goethe's late pronouncement that "the Classical is healthy, the Romantic sick" should not lead us astray. He himself had taken part in the formation of Romantic poets

and philosophers at the University of Jena, an institution that he had masterminded. Some of these writers were Goethe's personal friends, and his *Wilhelm Meister's Apprenticeship* was profusely praised by Friedrich Schlegel. In the second part of *Faust* and in some of his papers on the natural sciences, Goethe's writing came close to the romantic idea of *Universalpoesie*, of poetry merging with science. Late in his life, he declared that "it is high time that the passionate discord between Classics and Romantics will finally be reconciled."

Beethoven seems to us to belong safely to the classical side: even in the experimental works of his late style, he presents us with something autonomous and self-contained. And yet the contemporary German writer and composer E.T.A. Hoffmann, in his celebrated essay on the Fifth Symphony, called Beethoven a Romantic, while for the French he has always been *romantique*. Thus we find contradictions not only in their personalities but also in the way they were perceived, and in the manner in which they remain meaningful to us. Neither of them quite add up.

Beethoven and Goethe shared huge renown already in their lifetime. Beethoven's coffin was followed in the streets of Vienna by many thousands of mourners, while Goethe in his later Weimar years received the homage of countless visitors whom he generously entertained. His *Werther* brought him early fame. Later his posterity seemed to owe more to his *Faust*, the impact of which in books, plays, opera, and film continue into our time. His posthumous fame grew to make him the most widely appreciated of all composers. His Ninth Symphony has become the universal anthem of progress; it is presented to the public throughout the world on any occasion that points towards peace, freedom, and fraternity, if possible with a cast of thousands. Napoleon aimed to conquer the

world, but it was Beethoven, it would seem, who succeeded in doing so, and permanently.

Beethoven and Goethe also share a similar range of expression. Beethoven's musical compass reaches from the lyrical to the heroic, from simplicity to complexity, from humor to tragedy, from every mode of motion including dance to the utmost calm, from extraversion to contemplation, from triumph to desolation, from turbulence to composure, from string quartets, sonatas, and symphonies to bagatelles, from the lofty universal to the patriotic aberration.

Goethe's abundance, while no less impressive, was supplemented by the enormous range of his interests. Let me start with the literatures. Goethe had an impressive command of languages, read Greek and Latin in the original, wrote poems in English and French as a teenager, loved Persian poetry, and translated from the French, English, and Italian. He read Kant, and, to him even more important, Spinoza. He collected folk songs at Herder's suggestion, and warmly welcomed Arnim's and Brentano's compilation of German folk poetry *Des Knaben Wunderhorn*, which appeared in 1805–1808. In his writings he treated history and politics, and also public affairs, economics, and mining. He immersed himself passionately in the arts and contemplated for a while whether to become a painter. Inspired by Winckelmann, he enthused about the art of antiquity, while Palladio became his architectural guiding light. His musical needs ought by no means to be forgotten — they were particularly geared towards singing. For comic opera and *opera buffa*, he even wrote a number of libretti that were composed and performed. In Weimar, where he kept all of Mozart's later operas in the repertory, he remained in charge of theatre and opera for many years, frequently stage-directing the performances himself. Yet what fascinated

152

Goethe more than anything during his late years were the natural sciences. His *Theory of Colors*, written in opposition to Newton's, was particularly close to his heart. His phenomenological approach has recently found a number of advocates; it stands opposed to the empirical world of Galileo or Newton. If there was a blind spot in Goethe's quest for knowledge, it was mathematics.

And what Goethe and Beethoven further shared, if only for a while, were the persistent advances of Bettina von Arnim, an attractive young woman of considerable eloquence, a kind of female Cherubino, who pursued them both relentlessly. The ardor with which she tried to persuade Goethe of Beethoven's greatness obviously did not fall on receptive ears.

Beethoven remained a staunch admirer of Goethe throughout his life — without, however, earning any acknowledgement for his settings of several of Goethe's poems. The only one of Beethoven's works that Goethe appreciated was his incidental music for Goethe's play *Egmont*, a stirring plea for freedom that was performed at the Weimar court. But not overly much: it appears that Goethe, who was hardly a born revolutionary, perceived Beethoven's music as excessively violent. Goethe admired Mozart above all; he staged *Don Giovanni* at his theatre with particular care. Like his political ideas, Goethe's musical views were strongly defined but hardly progressive. For this reason, the magnificence of Schubert's *lieder* eluded him as well. Where Goethe's ears continued to serve him to perfection was in the perception of the sound of his own poetic language.

When Beethoven and Goethe met in Teplitz in 1812 and spent time together, Goethe sent a note to Christiane Vulpius:

153

"Never have I encountered an artist more concentrated, more energetic, or more cordial." It is remarkable that, for once, this lucid characterization of the person may also be applied to Beethoven's music: to its concentration, its propelling impulse, its warmth. Soon, however, some differences became apparent — for example, Goethe's effortless socializing with dukes, queens, and ladies-in-waiting versus Beethoven's grim unconventionality and social sullenness, his way of sometimes brusquely dealing with friends and antagonizing even male benefactors — Lobkowitz, Kinsky, Lichnowsky, Razumovsky — who nevertheless generously continued to finance his life in Vienna, keeping the Schuppanzigh Quartet at his disposal, and organising extensive rehearsals for the Eroica Symphony in various of Lobkowitz' castles ahead of its first performance in Vienna. A glance at their handwriting serves to make their social difference apparent. Goethe writes in a thoroughly controlled manner, the lines strictly horizontal, the letters strongly slanted to the right. Beethoven's letters, notes, and music manuscripts, by contrast, frequently push at the borders of the legible in their chaotic disorder.

While Beethoven's hearing problems progressively excluded him from social contact, Goethe retained his reputation as a superb conversationalist and reciter over many years. Within a remarkable circle of poets, writers, and intellectuals living in Weimar or teaching in Jena, Goethe always stood out. So how did he look? For his time he was tall. Tending towards corpulence, he had stunning dark brown eyes, a sonorous bass voice, yellow and somewhat crooked teeth, and an impressively sizeable nose. All the same, he was considered good-looking, and not just by women. Count Wolf Baudissin — who, jointly with August Wilhelm Schlegel, Dorothea Schlegel and Ludwig Tieck, produced the great

German-language version of Shakespeare — pronounced that he never saw a more beautiful man of sixty. Goethe's eloquence was legendary. He spoke softly and in a very measured way, it was said, but with an incredible assurance and adroitness of expression, with vivid mimicry and expressive gestures in an uninterrupted flow.

Yet Goethe also loved to contradict, which brings me to a principal feature of his personality. His inner constitution consisted of contradictions, a fact of which he was well aware. He called himself "a person whose nature constantly throws him from one extreme to the other." Like his Faust, he himself is "a man with his contradictions." Contradictions embraced the whole of his life. Goethe didn't think highly of opinions and contradicted them with pleasure. "Each uttered word stimulates its contrary sense." Kanzler von Müller, one of his most intelligent conversation partners, speaks of his ability "to transform himself into all shapes, to play with everything, to absorb the most diverse of opinions and let them pass."

On the one side, Goethe declared: "For poems conjured out of nothing I have no use." On the other: "All my poems are occasional." (*Alle meine Gedichte sind Gelegenheitsgedichte.*) For Goethe, "the obstinacy of the moment" embodied the natural and the norm. He demanded spontaneity, though he reported to Frau von Stein about his work on Wilhelm Meister's Theatrical Mission "that he was infusing artificiality into his style, in order to make it appear more natural." "The conscience of the poet is a precious thing, yet the true power of production always rests, in the end, in the unconscious." Goethe mistrusted the Socratic "know thyself," but he also wrote a memoir called *Dichtung und Wahrheit*, or *Poetry and Truth*. He is light and dark, a man of alternations, open both to reason and the irrational. He criticizes sentimentalism

155

while simultaneously penning his own productions in the sentimental manner, not to forget his satire called "The Triumph of Sentimentality." He avoided funerals but he clandestinely kept Schiller's skull at his house for decades. He protested that "there is nothing more painful to me than writing letters," but he produced, by the estimate of Albrecht Schöne, more than twenty thousand of them. Against an all-devouring empiricism he counterposed his own dogmatic worldview.

He even contradicts his own contradiction. Surprisingly enough, there is one constant in Goethe's life: the unassailability of nature. "In a conversation with another human being I am never quite sure who of us is right, but in conflict with nature I can tell from the start that she is right." "The consistency of nature consoles us beautifully about the inconsistency of men." "In whatever fashion, life is good." Goethe accepts nature in all its beauty and terror. Nature is unfeeling, illuminating the good and the bad in equal measure. The disastrous earthquake of Lisbon in 1755 did not unsettle him as it did Voltaire. Goethe, who mistrusted all rules and dogmas, surrendered to natural law, to the consistency of nature. He called nature an organ played by our Lord, with the devil operating the bellows.

Similarly, the artist in Goethe's view proceeds not as an imitator but as an innovator and a creator. Here he agrees with Kant, of whom he said in old age: "His immeasurable merit on behalf of the world and, I may say, on my own behalf, is that in his *Critique of Judgement* art and nature are positioned next to one another and both are entitled to act aimlessly from grand principles." Madame de Staël, one of the most perceptive women of her time, who greatly contributed to Goethe's fame, once remarked that Goethe "feels powerful enough to bring, like nature, destruction into his own work."

156

In literature, Goethe saw Shakespeare's creations as nature's embodiment. His plays, as Goethe says, all rotate around that secret point, the one that no philosopher has yet been able to determine, the point where the peculiarity of our self, the pretended freedom of our will, collides with the necessary motion of the whole. To describe freedom of will as pretended and questionable strikes the present reader as strangely modern.

Beethoven, too, was close to nature, but hardly in the same fundamental sense. In his roamings through the countryside, you would hardly imagine him philosophizing or cataloguing the plants rather than pursuing his musical ideas. To be sure, a work such as the Pastoral Symphony gives evidence for Beethoven's warm rural sympathy and affection. Yet I see liberty, not nature, as his principal concern, while Goethe, as he himself says, in a conflict between *Natur- und Freiheitsmännern*, between the adherents of nature and the adherents of liberty, would choose the naturalist. What concerns Goethe is inner freedom, the freedom of the single individual and not, as in Beethoven's case, that of a future, utopian mankind. In his *Mephisto* he declares that he wouldn't mind raising a glass in honor of liberty "if only the quality of your wines were slightly better."

Already in Bonn, Beethoven encountered the writings of Kant and Schiller. In Kant he would have found this: "The beautiful things indicate that human beings fit into the world" — an essential sentence. (Nietzsche made it even more poignant when he later said that "the only justification of the world and of humankind is aesthetic.") Of Goethe's poems,

Beethoven's set twenty to music, although *lied* composition was not his foremost interest. As we know, Beethoven had decided already in Bonn to compose Schiller's "Ode to Joy." When he finally did so in Vienna, he shortened the poem and left out those stanzas which celebrate nature.

How did Beethoven look? Again, like Goethe, he was equipped with a sonorous bass voice. For the rest, his appearance was markedly different — stocky, pockmarked, with curly hair, untidy in his numerous Viennese quarters, negligent also in his attire. This unruliness stands in utter contrast to the rigorous control of his compositions. Yet Beethoven famously improvised on the piano. Goethe as well must have been an outstanding improviser — of poems, of course — as was Marianne von Willemer, for a while his poetic companion, who contributed a few of the finest pieces to his *West-Eastern Divan*. Already in Goethe's early poems of this "Storm and Stress" period, we encounter a directness and a spontaneity not seen before.

Opinions about Goethe's and Beethoven's posthumous impact have differed. Both Heine and Nietzsche, two vociferous if not uncritical admirers, thought Goethe to have been an event within the German language that remained without consequence. On the other hand, there does not seem to be any doubt about his impact on various other disciplines. Beethoven's later music remained an enigma even to some of his friends. It was admiringly absorbed by Berlioz, Mendelssohn, Liszt, and Wagner, yet its audacity found its true continuation only in the twentieth century. Schumann, Mendelssohn, and Brahms responded to the challenge of the late quartets by domesticating them, smoothing them out.

The ambition to write and to think about the meaning of music has persisted for centuries. One of Beethoven's leading commentators calls him an ideological composer. Others have different and equally simplifying views. The urge to derive from his works a formal analysis or to impose on it poetic, philosophical, religious, or even political ideas makes us easily forget that music has above all to be performed, turned into sound. (I am speaking here both as a performer and a listener.) The notion that the personal life of an artist will inform us about the reason for a work or furnish us with the explanatory background of a piece is widespread. But art and artist are not an equation — rarely does one mirror the other. What the composer creates may even be the opposite of his personality. We are talking about two incommensurable spheres — the common human one necessarily limited, the one within a great artist almost unlimited.

The first piece that Mozart seems to have composed after the death of his father was "A Musical Joke." Beethoven's Fifth Piano Concerto, a work so obviously given to the positive, was composed during Napoleon's siege of Vienna 1809, which the composer described: "What a destructive and desolate life around me. Nothing but drums, cannons, human misery of all kinds." By no means does Beethoven's sympathy for Napoleon explain the musical greatness of his Third Symphony, nor does his longing for liberty and brotherhood explain the stature of his Ninth Symphony. (Program music after Beethoven, which is inspired by personalities from imagination and myth such as Faust, Don Quixote, Zarathustra, Taras Bulba or Scheherazade, or by artists and ideas, only rarely aims at self-disclosure.) Goethe understood this irreducibility: in his view music possesses a demonic dimension — rising from cryptic depths, chaos turns into order.

159

Can music tell a story? There are instances where one could believe it. Here is an example. In Beethoven's two-movement Sonata Op. 54, the title *La Belle et la Bête* that was bestowed on it by Richard Rosenberg seems apt, because it also hints at the formal process. A gracefully feminine theme and a fiercely stomping masculine theme are juxtaposed. In the course of the movement, *la belle* gradually gets the upper hand: the space that is granted to the beast is curtailed at each recurrence. When in the coda a new lyrical theme appears, *la bête* is reduced to soft triplets in the bass. After an ultimate short outburst of the beast in *fortissimo*, the concluding bars belong to *la belle* alone.

There is something like a psychology of music that follows the trail of its frame of mind, its characters, its tensions and resolutions. To be able to hear it is a special talent. Beethoven seems to have toyed with the idea of providing his works with poetic titles, but he refrained from it in the end. And yet his skill at characterization has never been surpassed. He had honed it in several smaller variation works before, while in his three most important sets of theme and variations he extended and diversified the variation form to an unprecedented degree. Whoever plays all his sonatas will constantly be reminded of the fact that Beethoven does not repeat himself. Obviously, his memory for what he had already composed was as powerful as his urge for innovation. Was there any other composer who covered a comparable distance from his beginnings to the string quartet Op. 135?

In humor, Beethoven has a marked advantage. Goethe, it is said, possessed a brilliant skill in reciting comic texts, but he was not a humorist and he did not want to be one. Can you imagine Goethe laughing? When he called a writer a humorist, he was excluding him from the possibility of greatness. The

exception was Laurence Sterne, the author of *Tristram Shandy*, who delighted him to no end. Goethe distinguished between "good" humor and "evil" humor, but he only appreciated the good kind because it requires "equanimity and strength of character," whereas the evil kind includes misanthropy and contempt of the world. When humor becomes grotesque, Goethe feels threatened. He talks of his own "timidity in the face of the absurd," which can be overcome only by good humor and irony. He was familiar with Schlegel's statement that naivety and irony are the hallmarks of genius. Schiller counted Goethe among the naifs, and Goethe did not object.

In Goethe's main poetic artery, blood from the heart continued pulsing until the end. His encounters with Ulrike von Levetzow and the Polish pianist Maria Szymanowska generated glorious poems. Up to his last days, however, we also come across those states of mind of which Goethe says: "I find myself in a veritable poetic mood in which I don't know what I want or what I ought to do." He counts his *Wilhelm Meister* among the most incalculable productions "to which I myself do not own the key." Madame de Staël mentions, not without justification, his deep-seated immorality covered by a veil of mysticism.

But finally the veil obscures both of them. Whatever one can say about Beethoven and Goethe remains incomplete, an inadmissible simplification. The highest stories of the towers remain invisible.

161

Goethe and Beethoven

MELVYN P. LEFFLER

Iraq After Twenty Years

At this time two decades ago, President George W. Bush resolved
to invade Iraq and topple its brutal dictator Saddam Hussein.
His decision was the most consequential American foreign
policy decision since the end of the Cold War, and arguably the
most significant foreign policy action of the United States in
the twenty-first century. As the invasion turned into a bloody
occupation and triggered civil strife and insurrection, more
than two hundred thousand Iraqis perished and almost nine
million were displaced or fled abroad — about one-third of
Iraq's prewar population. Two decades later, a small contingent
of American troops remain in the country helping to provide

security for a struggling young democracy, whose constitution, elections, parties, and political institutions, at least in part, still bear the imprint of the American occupation policies.

For the United States, the invasion was a turning point. When it invaded Iraq, it was at the height of its hegemonic post-World War II power. But the war and insurrection exacted a human, financial, economic, and psychological toll on the United States that few had foreseen. According to Brown University's Costs of War Project, almost nine thousand American soldiers and contractors died in Iraq and over thirty thousand Americans were wounded in action. Several hundred thousand veterans suffered brain injuries or experienced post-traumatic stress. The invasion, the war, and the occupation will have cost American taxpayers more than two trillion dollars. The conflict distracted policymakers' attention from the mounting chicanery on Wall Street that precipitated the worst economic contraction since the Great Depression. The war accentuated partisan rifts and sundered trust in government. Believing that President Bush and his advisers had lied about their motives and then acted incompetently, Americans grew more disillusioned with their leaders and institutions. Its consequences have ramified throughout American politics to this day. Faith in the American way of life slipped.

Geopolitically, the war enhanced Iranian power in the Persian Gulf, diverted resources and attention from the ongoing struggle inside Afghanistan, divided our European allies, and provided additional opportunity for China's rise and Russia's revanchism. Globally, it fueled the sense of grievance among Muslims, accentuated perceptions of American arrogance, complicated the struggle against terrorism, and dampened hopes for democracy and peace among Arabs and Jews in the Middle East. Rather than enhancing the spread

163

of liberty, as the president hoped it would, the invasion and occupation of Iraq contributed to the worldwide recession of freedom, a development chronicled in 2007 and 2008 annual in the Freedom House studies of the state of democracy around the globe.

Why did this happen? Why did the United States invade Iraq and why did the decisions turn out so badly? As an historian of American foreign relations, I have been intrigued with these questions ever since I witnessed these developments as a visiting professor at Oxford University in 2002–2003. I was there to lecture about a book I was then writing about the origins and evolution of the Cold War. But Oxford students and professors pummeled me with questions about why my country was acting as it was. Why was it hyping the perception of threat and exaggerating the dangers of terrorism? Why was it so blind to the complicated socio-economic conditions inside Iraq and the religious rifts that an invasion was likely to accentuate? Why was it oblivious to the hatred that its own policies had spawned? So intense were the queries, so passionate the opposition to the trajectory of America's policies, that I found myself almost daily trying to explain, if not to justify, the Bush administration's behavior — my country's behavior. Eventually, I decided to push aside the idea of speaking about the peaceful end to the Cold War and to focus on the frenzied aftermath of the attacks on the World Trade Center in New York City and the Pentagon in Washington, D.C. on September 11, 2001. I called my Harmsworth lecture, "9/11 and American Foreign Policy."

After I returned to the University of Virginia I finished my book on the Cold War, but I could not put out of my mind the ongoing traumatic developments in Iraq. Journalists began turning out impressive accounts of the Bush administration's

policies. Most were critical, stressing the malevolent influence of conservative nationalists such as Vice President Dick Cheney and Secretary of Defense Donald Rumsfeld; others focused on the naiveté and ideological zealotry of neo-conservatives such as Paul Wolfowitz and Douglas Feith, respectively the Deputy Secretary and Under Secretary of Defense. The president himself often seemed like a minor actor easily manipulated by experienced, sophisticated, and devious advisers who distorted intelligence information and exaggerated threats in pursuit of American hegemony, or the region's oil, or the interests of its ally Israel. The dysfunction portrayed inside the administration was not simply disturbing; it was ominous. Bush himself often was portrayed as a dumb zealot on a crusade to spread American ideals and God-given freedoms around the globe.

I found many of the accounts by journalists such as Bob Woodward, George Packer, Ron Suskind, and James Fallows to be informative, but not altogether convincing or explanatory. As a student of American foreign relations, I could not imagine the American president to be a minor actor. Nor had my previous assessments of U.S. foreign policy after World War I and World War II led me to believe that American policymakers were naïve idealists seeking mainly to spread American values or capitalist predators yearning to control the resources of the Global South, as many left-wing commentators claimed. Values and interests, I believed, sometimes clashed, but often intersected and reinforced one another. American foreign policy always was the result of a complicated mix of factors, heightened at times by perceptions of threat, and shaped by the contestation of many well-organized interest groups in a pluralist society. I did not think that the accounts I was reading captured the complex realities of decision-making in

165

a presidential administration; I believed they were inspired by an understandable revulsion to the consequences of the Bush administration's actions rather than a careful analysis of its motivations. Anyone observing developments in Iraq between 2003 and 2008 could not help but be distressed by the strife and destruction the American invasion had catalyzed.

I decided to explore the possibility of writing an analysis of the administration's decision-making. I knew it would be difficult and would take time. In contrast to my studies of previous administrations' policies, I realized there would be a dearth of archival materials. Most U.S. national security records remain classified for twenty-five or more years. Some researchers, journalists, and organizations, such as the National Security Archive, struggle to get specific documents declassified through Freedom of Information or Mandatory Declassification requests, and these appear on their own websites or those of agencies such as the CIA, the Department of State, and the Office of the Secretary of Defense. But the processes are laborious and time-consuming. As of today, the vast trove of documents related to Bush administration foreign policies remain classified, despite occasional efforts by retired officials to get some documents released in conjunction with the publication of their memoirs, as did Rumsfeld, Feith, and William Burns, the assistant secretary of state for Near Eastern Affairs during the first administration of George W. Bush. Most of my own requests for documents have not been acted upon or have come back with huge redactions or outright rejections.

Fortunately, revealing documents can and did come from sources other than U.S. archival records. The British parliament conducted a comprehensive review — the Chilcot Inquiry — of the decision of the government of Tony Blair to

166

go to war alongside the United States. Aside from interviewing extensively every leading member of Blair's government, including more than a thousand pages with the prime minister himself and with Jack Straw, his foreign minister, the investigative committee, including renowned historians such as Martin Gilbert and Lawrence Freedman, subpoenaed documents, memoranda, and intelligence estimates and put them on a website open to all researchers. Meanwhile, the U.S. government, albeit reluctant to declassify its own records, did open up captured Iraqi records and had some of them translated. The Iraqi documents that outline Hussein's dealings with terrorist organizations and suicide bombings are especially illuminating. A volume of Saddam Hussein's own tape recordings of key meetings also has been published by Cambridge University Press.

But what makes an assessment of Bush's decisions to invade, liberate, and occupy Iraq so much more feasible today than a decade ago are the interviews with leading members of his administration. The Miller Center at the University of Virginia conducted an oral history of the Bush administration, and about two years ago released many (not all) of the interviews. One can now garner the impressions of top decision-makers such as Secretary of State Colin Powell and Deputy Secretary of State Richard Armitage, military leaders such as Generals Tommy Franks, George Casey, and Peter Pace, key diplomats such as Ryan Crocker, political advisers such as Karl Rove, and occupation officials such as Paul Bremer, the head of the Coalition Provisional Authority in postwar Iraq. In addition, I conducted my own set of interviews with top policymakers across the government, including Vice President Cheney and key assistants on his staff, such as I. Lewis (Scooter) Libby, as well as with the president's national security adviser,

Condoleezza Rice, and her deputy, Stephen Hadley. Unfortunately, President Bush himself refused requests for interviews. Yet his own attitudes and thinking can be gleaned from his speeches, press briefings, and conversations with his advisers and foreign leaders.

After years of interviews and research, I have concluded that much of what we think we know about the invasion of Iraq is misleading or exaggerated. Most emphatically, the United States did not go to war because an inattentive president was bent on war or was easily manipulated by his vice president or secretary of defense or by a conspiratorial group of neocon advisers. His decision was highly contingent; it was not preconceived or predetermined by the so-called Vulcans, the group of advisers who joined Rice to tutor the president about foreign policy before he was elected. Many of these advisers, such as Dov Zakheim, have written that Iraq was not even a key topic of their deliberations. When British officials such as Tony Blair or Christopher Meyer, the British ambassador, met with Bush prior to or after his election, they noted that Iraq seemed like a "grumbling appendix." Moreover, I have concluded that Bush's motivation was not an attempt to redress the failure of his father to overthrow Hussein after the first Persian Gulf War in 1991; nor was he preoccupied with retaliating over the Iraqi dictator's attempt to kill his father during a trip to Kuwait in 1993 after he left office. Aides such as Michael Morell, who was the president's daily CIA briefer during his first year in office, and the late Michael Gerson, his most important speechwriter, explicitly and persuasively rejected such allegations.

What emerges clearly from interviews with the president's

168

top advisers and from the memoirs of the most important officials in his administration is a portrait of a president vastly different than the one that has lodged itself in our collective memory. Elliott Abrams, a former assistant secretary of state in the Reagan administration, wrote in his memoir that when he joined Rice's NSC staff in the summer of 2001, "It took me just a few minutes . . . to see who was in charge. . . The caricature of [Bush] as lacking in intelligence was itself a joke." Like so many of the advisers who came to work for the president and who had not really known him previously, Abrams was impressed with Bush's energy, discipline, intelligence, self-confidence, and good humor. The president was straightforward, unpretentious, level-headed, honest, and easy to work with. He was a good listener, interactive in small groups, and incisive — if not always curious about the complex background of developments. His spiritual sensibilities and locker-room banter, however incongruous, garnered praise. Most of the people who came to work for Bush liked their president — and, more importantly, they deferred to him. Scooter Libby, for example, stressed to me that one of the biggest myths about the administration was that Vice President Cheney ran things. Richard Clarke, the president's first counter-terrorist expert who became a fierce critic, agreed. It is just an "urban legend," he wrote in his memoir, that Bush was the pawn of the vice president.

Bush was the key decision-maker inside the administration — not Cheney, not Rumsfeld, and not the neocons. He decided in early 2003 to invade Iraq. But he was not motivated by the fantasy of a democratic Iraq, or by hopes of nurturing a democratic peace. Nor were his advisers. Bush wanted a freer, more democratic Iraq to emerge if he deployed force and toppled Saddam, but that is *not* what motivated his decision to

invade Iraq. In fact, when Rice circulated a memorandum in August 2002 saying that the aim of the administration was to create a democratic and unified Iraq, Rumsfeld bristled. And so did his neo-conservative advisers. "We should be clear," Feith argued, "we are not starting a war to spread democracy... Would anybody be thinking about using military power in Iraq in order to do a political experiment in Iraq in the hope that it would have positive political spillover effects throughout the region? The answer is no."

Bush and his advisers went to war to overcome their fear of another attack on Americans and to preserve American primacy. The attack on 9/11 killed more than three thousand Americans and ravaged the symbols of American power and capitalism — the Pentagon and the World Trade Center. Policymakers were shocked, embarrassed, and infuriated. Accompanying the president on Air Force One as he flew back to Washington later that day, Morell, his CIA briefer, recounted his impressions: "I saw him transform from a president who really didn't have a strong agenda, didn't really have a clear path that he was on, that quite frankly was struggling. . . . I saw him transform from that to commander-in-chief and to somebody who almost instantaneously [knew he had a mission] to protect the country from this happening again; I saw that right in front of me." Another attack was expected imminently. Bush told his advisers that they must not allow it to happen.

And then, just weeks after the attack on 9/11, anthrax spores began circulating in American mail. A reporter in Florida died after inhaling anthrax. More letters, laced with anthrax, were found. One of the letters read, "You cannot stop us. We have this anthrax. You die now. Are you afraid? Death to America. Death to Israel. Allah is great." The anthrax scare

raised the specter of catastrophic terrorism with weapons of mass destruction. Intelligence analysts and policymakers riveted their attention on the prospect of an attack with biological and chemical weapons. "The threat reporting about additional attacks on the homeland was off the charts," Morell emphasized in his interview with me. "Al Qaeda's interest in anthrax was real." Seth Carus, one of three bioterrorist experts on Cheney's staff, labored with colleagues to determine whether the spores were of domestic or of foreign origin. The uncertainty compounded the anxiety. "It confirmed everybody's view that there were going to be these follow-on attacks," said Carus. "We were concerned," recalled General George Casey, the director of Strategic Plans and Policy on the Joint Staff in the Pentagon, "about some type of chemical weapon deployed, either in a US city, or brought in, in a container, on a boat. I just remember we were wargaming and scaring ourselves to death about how ill-prepared we were to do it."

In this atmosphere Bush's attention gravitated to Iraq. The president wanted to thwart an opportunistic, ruthless dictator who previously had developed, possessed, and employed chemical and biological weapons, who repeatedly threatened their further use, who glorified suicide bombers, and who had extensive ties with terrorist groups, if not al Qaeda or its leader Osama bin Laden. But assessing what was happening in Iraq was tough and confusing. If you "put all the stuff on the table," even now, said Morell, "you would come to the conclusion that he had a chemical weapons capability, that he had chemical weapons stockpiled, and that he had a biological weapons capability and he was restarting a nuclear program. Today you would come to that judgment based on what was on the table." But what was on the table was circumstantial and flimsy, much

171

of it coming from Iraqi Kurdish foes of the regime. We should have said, acknowledged Morell "that we had low confidence in that judgment and here is why." But instead Morell told the president, "Hussein had a chemical weapons program. He's got a biological weapons production capability."

The evidence now suggests that Bush operated out of a real sense of fear, out of a sense of responsibility that his overriding task as president was to prevent another attack. He had a duty to protect the American people. He recognized that should he fail to do so, he would be held responsible. Bush and Cheney knew that they had minimized or shirked warnings of an attack the previous summer; they knew that there was embarrassing evidence that they had not done everything that might have been done to prevent 9/11. They "missed it," Cheney crisply told me. They might be forgiven once, but not again. People would want to know, Rice acknowledged in her memoir, "why did you not do everything in your power to keep it from happening again."

The record shows that policymakers were more concerned about preserving freedom at home than spreading it abroad. Bush framed the struggle as a civilizational battle over a way of life. Like many of his advisers, he felt keenly that "our way of life" really was at stake. "We must rid our world of terrorists so our children and grandchildren can grow up in freedom," Bush declared. "By sowing fear," Rumsfeld wrote, "terrorists seek to change our behavior and alter our values. Through their attacks they trigger defensive reactions that could cause us to make our society less open, our civil liberties less expansive, and our official practices less democratic — effectively to nudge us closer to the totalitarianism they favor." This was an updated iteration of the fear of the garrison state, a concern that had inspired the struggles against Nazism and

172

Communism. The proponents of the global war on terror felt this keenly; instinctively, they fell back on rhetorical tropes that resonated deeply in the American psyche. "If we don't want our way of life to be fundamentally altered," Wolfowitz explained in an interview on September 13, 2001, "we have got to go after the terrorists and get rid of them. That is why the stakes are so high."

The evidence that we now have demonstrates that Bush and his top advisers were well aware that the intelligence the United States possessed about Iraq was highly ambiguous. Rumsfeld, for example, asked his general in charge of intelligence in October 2002 to assess the credibility of the evidence that they possessed. General Glen Shafer told him, "Our assessments rely heavily on analytic assumptions and judgment rather than hard evidence." He added that "we are struggling to estimate the unknowns." And in conclusion, he reported that "we don't know with any precision how much we don't know."

But what Bush did know was that Saddam once had possessed weapons of mass destruction, that he had used them, and that he had lied about them. What he knew was that in 1991 Saddam was much closer to developing a nuclear capability than analysts had deemed likely. Iraq's capabilities certainly had diminished since that time as a result of inspections and sanctions; but in 2001 the inspectors were gone and the sanctions were eroding. And nobody was telling Bush that Iraq did not possess weapons of mass destruction. Interviews and documents demonstrate that all Bush's advisers sincerely believed that Hussein had WMD. Not only Cheney, Rumsfeld, and Wolfowitz, but also Powell, Armitage, Rice and Hadley.

173

Their respective analysts did argue about the purposes of aluminum tubes that Hussein possessed and about the uranium yellowcake that he allegedly imported, but they did not argue about the fundamental issue: they all agreed that Hussein had WMD. "Not once in all my years in government," acknowledged Richard Haass, at the time the head of policy planning inside the State Department, "did an intelligence analyst or anyone else for that matter argue openly or take me aside and say privately that Iraq possessed nothing in the way of weapons of mass destruction. If the emperor had no clothes, no one thought so or was prepared to say so." Discussing his own beliefs, General Franks reflected that when he deployed troops to Iraq in 2003 "there was not a doubt in my mind [that Iraq had weapons of mass destruction]. Because of my talking to Bush," he continued, "I can guarantee you that there was not a doubt in his mind."

Yet there were doubts, many doubts, about Iraq's links to al Qaeda. That relationship, according to the intelligence community, was "murky" — but not so the relationship between Hussein and terror. In daily briefings, Morell told the president that "there was no Iraq involvement in 9/11 . . . zero; zippo; nothing." Still, he also told Bush that Iraq was a terrorist state. "They conduct their own terrorism. Their intelligence service conducts terrorism [in] places around the world and they . . . give money, training, to a bunch of Palestinian groups. So, they were to some extent in bed with terrorism, not al Qaeda, but with their own terrorism and support of terrorism." In Morell's view, the president turned his attention to Iraq because he was ruminating, "what if this guy [uses] this stuff . . . against us or what if he were to give this stuff to one of these groups that he supports and they were to use it against us? I would have failed in my final responsibility."

174

Morell had no doubt "that those links to terrorism . . . shaped the president's thinking." And it shaped the thinking of some of his top military chiefs: "Any power that could provide al Qaeda with nerve agents or anthrax was a major strategic concern," commented General Franks. Peter Pace, the vice chair of the Joint Chiefs of Staff, mused:

> What else don't we know? We didn't see 9/11 coming. . . What might hurt really, really badly? Then you start thinking about Saddam Hussein, and you say, Ok, he's got chemical weapons. We know that because he has used them on his own people, he has used them on his neighbors, so he's got that for sure. He has a nuclear program that the Israelis blew apart, but we know about the part that they blew apart above the ground; we don't know if he's got anything underground. If chemical weapons were to get in the hands of the terrorists, which is possible, what might that lead to? So, . . . I'm thinking to myself, Hmm, OK, this is certainly a place from which the next attack could emanate. This guy is obviously a bad guy.

Bush thought so. He detested Saddam Hussein. He knew about the Iraqi dictator's brutality. He learned that Hussein's newspapers and propaganda organs boasted about 9/11. Bush wanted to make sure that the Iraqi dictator would not hand off his chemical or biological weapons to terrorists, any terrorists, that might seek to inflict harm on Americans. His advisers, notably Rumsfeld and Wolfowitz, also wanted to make sure that Hussein's WMDs would not deter American officials from exercising American power in the region on behalf of its interests and its allies. Hussein must not be allowed to

"blackmail" the United States in the future, must not have the means to force Washington to self-deter. To gain reassurance, Bush and his advisers wanted Hussein to readmit inspectors and relinquish or destroy the very lethal weapons that they felt certain he still possessed. The only way to deal with Hussein, they resolved, was to intimidate him, to threaten him with the use of force. He must realize that his regime would be imperiled if he did not comply with the UN resolutions to allow inspections and relinquish and destroy his weapons of mass destruction.

Condoleezza Rice explained to the president that this strategy was called "coercive diplomacy" in academic circles (from which she came). Bush loved the concept. He believed it would force Saddam Hussein to comply with his promises or face extinction. Even leaders who did not want the United States to use force, such as France's Jacques Chirac and Russia's Vladimir Putin, nonetheless agreed that only the threat of force would persuade Hussein to end his defiance of UN resolutions. Most importantly, Hans Blix, the head of the UN monitoring team, concurred.

British documents now make clear that Bush took the diplomatic part of coercive diplomacy seriously. Even as he authorized the deployment of forces to the Persian Gulf in August 2002, he resolved to go to the United Nations and secure a new resolution demanding that Hussein allow the international inspectors back into Iraq, reveal all past efforts to conceal his weapons of mass destruction, and relinquish and destroy what he still possessed. Failure to comply, in Bush's view, would justify an invasion and the removal of the dictator. Bush assigned the diplomatic tasks to Secretary of State Powell and to John Negroponte, the American ambassador to the United Nations. They operated under the careful eye of the president's national

176

security adviser, Condoleezza Rice. The hawks in the administration opposed this effort: they worried that Hussein would prevaricate and procrastinate, sow divisions among members of the Security Council, and make it more difficult to employ force should the president decide to do so. Bush rejected their advice, compromising time and again to get a unanimous resolution out of the Security Council. "We were giving Saddam one final chance," the British prime minister subsequently explained: if the Iraqi dictator had complied, the invasion "would have been avoided. I made this clear to President Bush and he agreed." The Americans, declared David Manning, Blair's national security adviser, knew perfectly well "that we had given Saddam a get out of jail card if he chose to use it."

Bush, however, grasped that he was vesting his credibility — America's credibility — in the policy of coercive diplomacy. "Either he [Hussein] will come clean about his weapons or there will be war," Rice bluntly stated. But Bush genuinely did want the diplomacy to work. After meeting with the president in September, Blix thought the United States "was sincerely trying to advance in step with the UN. It was affirmation that, despite all the negative things that Mr. Cheney and others had said about the UN and about inspection, the US was with us for now." Yet Bush's patience was not unlimited. He felt that Hussein was toying with him. He would not allow it to go on indefinitely. "If we were to tell Saddam he had another chance — after declaring this was his last chance — we would shatter our credibility and embolden him."

The outcome of "coercive diplomacy" depended on what Saddam Hussein would do, and his actions in the fall and winter of 2002–2003 did not inspire confidence. Grudgingly, he allowed inspectors back into Iraq. But Blix did not think that the Iraqi ruler had made a "strategic" decision to cooperate

with the UN inspectors. He wrote in his memoir that his "gut" told him that Hussein "still engaged in prohibited activities" and that more military pressure might induce him to be more forthcoming. Like the Americans and the British, Blix thought that the Iraqi "declaration" of past efforts to deal with its WMD was totally inadequate. And when he and Mohamed El Baradei, the head of the International Atomic Energy Agency, visited Baghdad, Hussein would not meet with them. Although UN documents reveal that the inspectors did gain more and more latitude inside Iraq and found hardly any incriminating evidence during January, February, and early March 2003, Blix continued to think that Hussein was cheating and deceiving even as he also became increasingly embittered by American impatience.

The president felt that he had displayed inordinate patience, and that further delays would erode America's credibility among its allies in the region and demonstrate weakness once again to its adversaries, be they terrorists like bin Laden or rogue regimes like Hussein's. America would seem like the paper tiger that it was alleged to be. When Saddam Hussein's defiance seemed to challenge his resolve, Bush came to believe that he had no choice but to go to war.

Bush did not doubt that American power would prevail. Even before 9/11 he had committed his administration to enhancing American military might and to exploiting new technologies, notwithstanding the reality that the country's capabilities already far surpassed any potential rival and its defense expenditures exceeded almost all of them combined. Moreover, the president and his advisers were buoyed by the success that they thought they had achieved in Afghanistan when they toppled the Taliban government in November and December 2001 and then successfully helped to install

a new government in Kabul under Hamid Karzai. General Richard Myers, chairman of the JCS, waxed euphoric: "We had developed a new way to fight wars . . . [and] we had dared to use it." The Americans, recalled David Manning, Blair's national security adviser, "were fueled by the belief they had done something very important in Afghanistan." Bush thought so, too. "I was feeling more comfortable as commander-in-chief," he wrote in his memoir.

He was also confident that the outcome of an invasion, should he authorize it, would be benign — that the Iraqi people would embrace Americans as liberators. He liked to say that "out of the evil done to America" good would emerge. Iraqi dissidents assured him that American forces would be met "with flowers and sweets." He sincerely thought that this was true. He recalled the images of Berliners joyfully knocking down a wall and East Europeans overthrowing communist tyrants and celebrating America for championing the cause of freedom throughout the Cold War. If he went to war to protect Americans and enhance American security, Bush expected that a liberated Iraq "would show the power of freedom." "We're working to make sure America is more secure," the president declared, "but we're also making sure that the Iraqi people can be free." Freedom was America's founding principle, its fundamental canon. "We believe that freedom is a gift from the Almighty God for every person." Bush was unable to grasp the misgivings of Iraqi Kurds who distrusted the Americans for having abandoned them time and again in order to make deals with the regimes in Tehran or Baghdad, and he could not understand the skepticism of the Iraqi Shi'a who felt that his father had encouraged them to rise up after the Persian Gulf war in 1991 and then did little to stop Saddam Hussein from massacring them.

179

Motivated by fear for American security, buoyed by American military power, and confident that Iraqis would embrace the opportunity to be rid of a brutal tyrant, Bush ordered American troops to invade Iraq on March 20, 2003. But he failed to plan adequately for the postwar situation. He had thought rather little about what it would take to establish democratic institutions, build civil society, and nurture freedom — all of them Herculean objectives. In this respect, the early accounts by critical journalists were entirely on the mark. Bush spent many hours on many occasions discussing the war plans with Rumsfeld, General Franks, and other members of his national security team and the military establishment, but he gave scant attention to what would happen after Iraqi forces capitulated and the tyrant was toppled or killed.

Rice occasionally tried to get Bush to focus on the security dimension of the postwar situation, and considerable planning did go on inside the many different branches of the American government. Still, key decisions about the nature of postwar governance were deferred until the last moment, and insufficient troops were deployed and trained for preserving stability and undertaking reconstruction after the initial fighting ended. This was not accidental. Secretary of Defense Rumsfeld had little interest in postwar Iraq, and General Franks felt his mission was accomplished once Iraqi forces capitulated and the regime collapsed. Everyone knew, said General Casey, that "Secretary Rumsfeld did not want to be involved in the postwar reconstruction of Iraq. He wanted to be out of there as fast as he could." Even the official history of the U.S. Army in Iraq concludes that Phase IV of the war, the postwar stabilization phase, "was insufficiently detailed and largely uncoordinated."

President Bush must bear ultimate responsibility for the postwar fiasco. He knew that his top Cabinet officials were feuding over the mechanisms for the postwar liberation and occupation, but for the most part he did not interfere. He knew that the challenges in Iraq were arduous, and his answer was to devolve responsibility to the newly appointed head of the Coalition Provisional Authority, Paul Bremer. When weapons of mass destruction were not found, the president shifted his focus from security to democracy-promotion and nation-building. But he had not undertaken or demanded the requisite planning; nor had he allocated the appropriate resources. He never resolved the differences between Rumsfeld, who wanted to leave Iraq as quickly as possible, and Bremer, who wanted to take time to build the "shock absorbers" of a civil society and who yearned for more troops to deal with the horrendous chaos that he immediately encountered.

Despite Bush's many leadership qualities and the respect he garnered from his subordinates, the interviews, memoirs, and documents highlight his flaws as well as his strengths. He disliked heated arguments, and therefore he did not invite systematic scrutiny of the policies that he was inclined to pursue. He never directly asked his top advisers to examine and to debate whether invading Iraq was a good idea. He delegated too much authority and did not monitor implementation of the policies that he authorized. He did not order people to do things or criticize them for their failures. He allowed issues to linger in bureaucratic wonderlands, where their real-life outcomes had huge ramifications.

Fear, power, and hubris inspired Bush's invasion of Iraq and, along with administrative dysfunction, contributed to the failure of the American occupation. Like most Americans,

Bush and his advisers allowed their fears of another attack to overcome their more prudent inclinations; and their awe of American power to trump their judgment about the risks of employing it; and their pride in American values to dwarf their understanding of the people they were allegedly seeking to help. Like many Americans, Bush and his advisers conflated the evil that Saddam Hussein personified with a magnitude of threat that he did not embody.

While these failures are easy to chronicle, the new evidence allows us to better understand the fear, indeed the terror, that experienced policymakers felt after 9/11. Their worries mounted in the midst of the anthrax scare in the United States and persisted as a result of the ongoing terrorism and suicide bombings around the globe. Critics often forget how ominous the al Qaeda threat seemed and how vicious and manipulative Saddam Hussein really was. They overlook how imprecise the intelligence was, and the difficulties of gathering it. They ignore Hussein's links to terrorists and the ongoing havoc caused by acts of suicidal terror. They trivialize how difficult it was to measure the threat that the Iraqi strongman constituted, how easy it was to magnify the danger that he posed, how tempting it was to employ American power (after the seeming success in Afghanistan), and how consequential it would be if America were attacked again.

The tragedy in Iraq occurred not because leaders were ill-intentioned, stupid, naïve, and corrupt. The tragedy occurred because earnest officials sought to protect the American people and homeland without fully assessing the costs and the consequences of war. We delude ourselves to think that disastrous decisions can be avoided in the future if we simply have more honest officials or stronger leaders, or if we eschew the use of force altogether.

History suggests more complex and challenging lessons. On the one hand, we should not conclude that the projection of American power is always wrong or bound to fail. We must realize that the international arena remains populated by rivals and enemies, by malicious dictators and repressive regimes; we still live in a world where aggression occurs, as in Ukraine today, and where atrocious acts of ethnic, religious, and racial repression remain commonplace. In such a world, American power must play an important role. At the same time, however, on the twentieth anniversary of the invasion of Iraq, its tragic aftermath should force us to think more deliberately about when, where, and how American power may be used responsibly, effectively, and justly beyond U.S. borders.

Officials must learn to reassess entrenched beliefs and assumptions, like the ones that posited Saddam Hussein's continued possession of weapons of mass destruction. Early on, officials must rigorously assess the prospective costs of threatening the use of or employing American military power, an exercise that top policymakers mostly avoided and that their subordinates did poorly, belatedly, tentatively. Officials must recognize that threats entangle their credibility in certain outcomes, and credibility often obligates action that otherwise might be reconsidered, as might have been the case when the UN inspectors could not find Iraq's weapons of mass destruction during the winter of 2003. Priorities must be defined, something Bush was slow to do as he grappled with the overlapping yet sometimes competing goals of toppling Saddam Hussein or wresting control of his alleged weapons of mass destruction. "Coercive diplomacy" can become a viable strategy if diplomatic incentives — such as promising the end of sanctions — are designed to complement the means of coercion, an omission that diminished the possibilities that

183

Saddam Hussein would see any reason to engage in a process of confidence-building. And if a strategy of "coercive diplomacy" seems desirable, skeptics and critics must have the opportunity to present their doubts. Acrimonious debates before an attentive president might well have been less harmful than the dysfunction aroused, as it was, by bureaucratic rivals operating tenaciously, and sometimes furtively, to achieve clashing goals.

Good intentions, we can conclude, will not compensate for administrative dysfunction and insufficient prudence, for a dearth of thought and a failure of competence. Self-confidence must be chastened by self-doubt. Too much fear, too much arrogance, and too much faith in the use of military force produced tragedy. They will do so again, if we do not study the past honestly and apolitically, and wrestle with extrapolating difficult, tough-minded, and ideologically unsatisfying conclusions.

184

ALASTAIR MACAULAY

The History Man

I

An old theory has it that the most important architects of classical ballet have all been émigrés. In the late Renaissance and early Baroque eras, when ballet became primarily an art of the French courts and acquired some of its enduring characteristics, it was shaped by dancing-masters and composers from Italy. The most influential choreographer and theorist of the second half of the mid-eighteenth century, Jean-Georges Noverre, the foremost proponent of ballet as an art of dramatic expression, was French but had his greatest successes in Stuttgart and London. In Russia, in the late nineteenth century, Marius Petipa, whose choreography did much to bring ballet

to a new peak, came from France. Much of the most vital work in twentieth-century ballet was achieved by Russians who came along in Petipa's wake — Mikhail Fokine, Vaslav Nijinsky, Leonide Massine, Bronislava Nijinska, George Balanchine — and came West with the art that they had learned in the fatherland. London's Royal Ballet, which became the most internationally acclaimed of Western companies for decades after the Second World War, was the creation of Ninette de Valois and Frederick Ashton: de Valois was an Irishwoman who adopted a French name but always spoke of "the English style," Ashton an Englishman who had been born in South America (where he first saw ballet and became a convert) and told generations of dancers, "Stop being so stiff and English."

Let's not turn this migration theory into a formula, though. Several great choreographers have stayed in the land of their birth; many bad ones have swapped countries. Yet today Alexei Ratmansky — a choreographer who has held Ukrainian, Russian, and American passports — is a case study for any theory about classicism and migration. His life and career have been startlingly interlocked with major chapters of modern history. I mean history of several kinds: international politics, cultural revisionism, scholarly research, imaginative reconstruction, as well as the evolution of ballet itself. As the world has changed, so have his life, his choreography, his research into the past. As the history of dance has changed, so he has shown himself keen to add to it — opening new directions but also rediscovering or restoring what is in danger of being lost.

Ratmansky's name began to register on such dance cities as New York and London in 2005 and 2006, when he was artistic director of the Bolshoi Ballet. It was widely assumed then that he was Russian, but no. Born in 1968 in St Petersburg in the

era of the Soviet Union, he is largely of Ukrainian family, with a Ukrainian passport; his parents and other relatives are in Ukraine now. His father is Jewish. (Dance-history nerds will enjoy being reminded that the first known dancing master of the Italian Renaissance was Jewish, Guglielmo Ebreo.) He, Ratmansky, trained in Moscow at the Bolshoi Ballet School; he began his professional career as a dancer with the Ukrainian National Ballet. In the era of glasnost and perestroika, he began to dance in both the Soviet Union and the West. As a professional dancer, he reached principal level with the Ukrainian National Ballet, with the Royal Winnipeg Ballet, and with the Royal Ballet of Denmark. He danced lead roles in the nineteenth-century classics (not last Albrecht, the conflicted hero of *Giselle*), and Nijinsky's *L'Après-midi d'un faune*, and a wide selection of Balanchine ballets.

His earliest creations as a choreographer, in the late 1990s, were for companies spaced between Moscow and Winnipeg. Soon he won commissions from Russia's two most prestigious companies, the Kirov (or Mariinsky Ballet) of St Petersburg and the Bolshoi of Moscow. In 2003, when he made the two-act Shostakovich comedy *The Bright* Stream for the Bolshoi, it both helped to restore Shostakovich's reputation as a ballet composer (displeasing Stalin and his lackeys, though already under repair in Russia in the 1980s) and catapulted Ratmansky to the forefront of the world's ballet choreographers. More than that, *The Bright Stream* immediately made Ratmansky appear the most gifted Russian choreographer to have emerged since Balanchine (who left Russia in 1924). It helped to win him the artistic directorate of the Bolshoi Ballet; he was in his mid-thirties. It wasn't without controversy: Shostakovich's ballet depicted fun and games on a Soviet collective farm, and some New York observers voiced

concern that Ratmansky was ignoring the awful realities of those Soviet rural institutions. Ratmansky is not one to make any verbal reply to his critics, but he probably knew more of the Soviet realities than his American detractors; their strictures may have prompted the darker edges shown by his subsequent Shostakovich creations.

For many ballet people, no more prestigious job can be imagined than to run the Bolshoi. Ratmansky ran the old company as if opening windows everywhere, releasing energies, reviving various threads of Russian ballet tradition, introducing Western ballets by Balanchine, Twyla Tharp, and Christopher Wheeldon. The Bolshoi had been better known for making transcendent vitality from such choreographically thin warhorses and harmless trash as *Don Quixote* and *Spartacus* rather than as a home of important creativity — but, thanks to his energy and openness, it took its place at last on the map of the world's major choreographic capitals. He himself also made time to choreograph a new ballet for New York City Ballet, *Russian Seasons*, in 2006, to new music by the Russian composer Leonid Desyatnikov: this was immediately greeted as another sign of the Ratmansky gift for important dance poetry.

Yet in 2008, before his fortieth birthday, Ratmansky chose not to renew his contract with the Bolshoi. He did so without scandal. He, his wife Tatiana (also a former dancer and a close colleague to him in many of his productions), and their son moved to New York, but he maintained good relations with both the Maryinsky and Bolshoi companies, often returning to Russia to create new work and stage old ballets. Only gradually did it emerge that Ratmansky and his wife Tatiana had grown seriously critical of Putin's Russia. In a public interview at the New York Public Library in 2014, he spoke of

how the three of them wanted to build "a little Russia of our own" in the West.

He become a citizen of the United States in time to vote in the American presidential election in 2012. Between 2009 and 2023, he was artist in residence at American Ballet Theatre, staging a rich series of works old and new for that company that have changed not just its history but many aspects of ballet history. Under the new artistic directorate of Susan Jaffe, however, Ballet Theatre has now let him slip through its fingers. Instead, it was announced in January, that, as from August, Ratmansky is to become artist in residence to New York City Ballet, the company with the world's strongest reputation for connecting classical tradition to artistic innovation. He is both prolific and peripatetic — a citizen of the West who has now created new ballets for the top companies of Berlin, Copenhagen, London, Melbourne, Miami, Milan, Moscow, New York, Paris, St Petersburg, Toronto, Zürich. In 2013, I attended two consecutive Ratmansky world premieres one week apart, in London (February 22) and in San Francisco (March 1). Sure, most of their choreography had been prepared earlier, but they were also just the first two of the seven world premieres he clocked up that year: the others were in New York (three), Melbourne (a three-act *Cinderella*, his second treatment of the Prokofiev ballet), and Milan.

Consider how many different kinds of engagement with history we find when we rattle through the events of Ratmansky's career between autumn 2019 and spring 2023. On November 18, 2019, the Bolshoi Ballet gave, in Moscow, the world premiere of his new, historically informed, and intensely researched production of the Romantic ballet classic *Giselle*. He not only removed many of that famous ballet's twentieth-century accretions (some of which have

become widely cherished), he even pared away some of its nineteenth-century Russian accretions too; he restored some of the different drama and choreography that it had had when it premiered in 1841 and retained France in the 1840s and 1850s. Although the Bolshoi, a vast company with substantial touring divisions, had recently been fielding two other productions of *Giselle*, word soon got around that Ratmansky's was considered so satisfying that one of the others would now be retired. (One performance was streamed internationally. Extensive footage of two casts can now be seen on YouTube.)

On December 4 that year, in New York's Metropolitan Museum, Ballet Theatre presented an evening in which he and museum curators showed how his next ballet, the two-act *Of Love and Rage*, would be steeped in his study of the ancient world. Though the word "classical" is routinely used of ballet choreographers, few of them undertake research into the Graeco-Roman visual art and architecture that are one of the main sources of that classicism; and Ratmansky was showing that he was now among those few. *Of Love and Rage* is an adaptation of Chariton's *Callirhoë*, one of the five ancient Greek novels known today. (It may be the oldest, dating from the first century CE.) In a deliberate mismatch, Ratmansky tailored that source to intoxicating music from the Armenian-Russian composer Aram Khachaturian's *Gayaneh* (1939). On January 30, 2020, New York City Ballet gave the world premiere of Ratmansky's *Voices*, set to excerpts from an unusual new score by Peter Ablinger for piano and recorded voices, in which five ballerinas dance to the voices of five women artists. On March 5, 2020, Ballet Theatre gave the world premiere of *Of Love and Rage* in Costa Mesa, California.

Before that production could be seen in New York, however, two factors drastically changed world history:

the coronavirus and the Russian invasion of Ukraine. One of Ratmansky's responses to the lockdown was wonderful: in November 2020, he started a new series on Instagram, called Grecoromansky, in which he has now posted over five hundred photographs — all taken by himself — from his visits to the Greek and Roman rooms of museums from Copenhagen to Eleusis, from Istanbul to Los Angeles. His view of the Graeco-Roman world is generous and eclectic: it includes statues of hermaphrodites, sex, satyrs, and Cycladic art as well as ones of athletes, gods, heroes, and horses.

As ballet came back into action, he choreographed online, but also resumed his travels. March 2021 took him to St Petersburg to begin work on staging *The Pharaoh's Daughter*. This work, when it was originally made there in 1862, had been Petipa's first grand-scale success; it then remained in repertory for over four decades. Ratmansky's main source was the notation of a revival in 1898. (The French choreographer Pierre Lacotte staged an unreliably sourced version for the Bolshoi in 2000 that has remained in modern repertory; Ratmansky's version was expected to be far closer to Petipa's plan.) This production's premiere was planned to take place in May 2022. Other travels in late 2021 and early 2022, staging new productions of works he had already produced elsewhere, took Ratmansky to Melbourne, Vienna, Miami.

In late February 2022, he was back in Moscow, making a new creation to Bach's *The Art of the Fugue*, when news reached him of the invasion of Ukraine. Hitherto only quietly critical of Putin, he now became intensely political. He drummed up support for Ukraine all around the ballet world. He engaged in debate, not least on social media, about where politics and art should or should not intersect; he even took issue with Mikhail Baryshnikov, a colleague whom otherwise he holds in

the highest regard and for whom he had once choreographed a solo. (The bone of contention between them was whether Russian artists and athletes should be banned from performing in the West.) In all this, he demonstrated a passionate — and compassionate — anger never previously associated with him. No other choreographer uses social media so remarkably: on Facebook, he now began honoring the history of Ukrainian ballet and music, sharing videos and photographs of important Russian performers and composers, while also paying tribute to individual Ukrainian friends of his who have lost their lives in the invasion.

He remained in transit. He spent much of the spring of 2022 supervising new stagings of some of his older works in Munich, Melbourne, Madrid. June 2022 brought, at last, the New York premiere of *Of Love and Rage*, two years later than originally planned. It was praised for many reasons, while complaints were raised about its over-complex and excessively patriarchal scenario, bordering, for some, on misogyny. July took him to The Netherlands, working with the United Ukrainian Ballet to stage a "new interpretation" of *Giselle*, which had its premiere in August, was seen in London in September, and last February came to the Kennedy Center in Washington D.C. Though with less than ideal borrowed scenery and costumes, it went further than his Bolshoi staging in drawing from research into *Giselle's* nineteenth-century performance record. After the London engagement, Ratmansky flew to Seattle to complete his most politically topical ballet to date, *Wartime Elegy*, using music and visual ideas by Ukrainian artists, which reached the stage to acclaim in September 2022.

So there are many ways in which Ratmansky is a history man. He also takes us back to the primary meaning of

"history," that is, story. Probably more than any choreographer today, he is, at his best, a marvelous storyteller, not least in ballets that seem to have no narrative.

II

Ratmansky, famously soft-spoken, is not just in high demand from the top ballet companies, he is also held in high regard by individual dancers from Melbourne to Miami. "It's his silences that you make you work hardest," the American dancer David Hallberg, now artistic director of Australian Ballet, observed in 2010. The New York City Ballet principal Sara Mearns, who has worked with many of today's foremost choreographers, seems to reserve the word "genius" for him alone among the living.

Yet Ratmansky has been the focus of a series of controversies, especially in New York. His presentation of race troubled some people in the happy ending of his *Firebird* (American Ballet Theatre, 2012): when its twelve mythical princesses, freed from sorcery, regain their original forms, they are revealed to be uniformly Aryan blondes. Race, however, has not been a source of recurrent offense in his work. When he gave the role of the Firebird to Misty Copeland, it became a breakthrough role for her as she became the world's foremost African American dancer. The African American dancer Calvin Royal III is now a principal at Ballet Theatre; his first important lead role, nine years ago, came in the second cast of Ratmansky's *Shostakovich Trilogy*.

Ratmansky's treatment of gender, sexuality, and sexual relations has caused extensive arguments — but in this art form, argument on those fronts is actually healthy. Ballet has long been a sexist art, in which it is usually impossible to depict equality in the workplace. Its men are seldom allowed the privilege of going on point except in eccentric situations;

193

its women are seldom permitted to partner their menfolk. Ratmansky caused a firestorm on Facebook in 2017 when he observed that "There is no such thing as equality in ballet: women dance on point, men lift and support women. Women receive flowers, men escort women offstage, not the other way around (I know there are a couple of exceptions), and I'm very comfortable with that." In truth, this should have been an unremarkable statement. (I have been referring to ballet as a sexist art since the 1980s.) Still, in this woke era, Ratmansky's phrases "no equality" and "very comfortable" caused more trouble than they were worth. When pressed further by Gia Kourlas in the *New York Times*, he explained that "there are gender roles in traditional ballet. In other words, men and women are of equal value but have different tasks.... I agree that the rules are there to be broken, that's how art evolves. And I myself have enjoyed playing with those conventions. But I personally choose to work within a tradition because I find it too beautiful and historically important to be lost."

He had indeed already played with those conventions, and he has gone on doing so. One of the five equal couples in his *Dumbarton* (2011) is same-sex, scarcely differentiated from the other couples. The sorcerer in his *Firebird* keeps the princesses in thrall with some kind of psychosexual abuse whose nature is unspecific, but which raises the stakes for the hero, Ivan, as he struggles to bring freedom to this dark realm. Though few have discussed this, *Piano Concerto #1* (2013) takes its leading quartet of virtuoso dancers — two women, two men — through a dramatic range of quickly changing situations in which those two men are ultimately supported by their ballerinas. In this unanticipated reversal of customary ballet chivalry, those two heroes take rapid pirouettes ending in backbends that are held in place by those two heroines.

194

Curtain. Most of *Serenade after Plato's Symposium* (2016) belongs only to seven men, who are marvelously differentiated, and all intelligent — but when a single woman appears, she exudes authority, beauty, and wisdom in ways that command the respect of the foremost man. (If you know Plato's *Symposium*, you may infer that she and he are Diotima and Socrates.) The three leading women of his *Odessa* (2017) are all in heterosexual relationships where love is by no means enough. About this work, one critic complained "No More Gang Rape" on Instagram. You can imagine the ensuing brouhaha: it reached the pages of the *New York Times*. *Odessa's* dancers, some more outraged than others, all made it clear that, in their view, no gang rape had occurred. Certainly *Odessa* addresses the interaction between its women's social lives and their inner lives. It includes both moments of violence and glimpses of women's souls.

Ratmansky's *Voices* (2020) is set to a twenty-first century score featuring recordings of women artists speaking of themselves and their work. Its finale — in which women partner men and other women, while men support other men as well as women — is its finest section. Otherwise *Voices*, though highly praised in several quarters, is largely an intelligent but overly schematic essay in feminism. I admire it on many levels, but I don't believe in it. This is not to say that Ratmansky is insincere about feminism; but it is hard to believe that he, so often drawn to music of melody and harmony, believes in this score by Peter Ablinger — some of those speaking voices are very far from euphonious. It is striking that Ratmansky's next premiere, one month later, was *Of Love and Rage*, which (set in the world of the Hellenistic era and using a Soviet-era score) was also concerned with relations between the sexes. The central figure of its story is its heroine

Callirhoë, the world's most beautiful woman, but its action, moving from one ancient patriarchy to another, is controlled by the men who fall in love with her. When it reached New York in June 2022, at precisely the time that *Roe v. Wade* had been overturned, it did not prove a cheering ballet for American liberals to watch.

Ballet has always been prime terrain for talk of "the male gaze." Since at least the Romantic ballets of the 1830s, the subject of innumerable ballets has been the exceptional women who have been the visions, sirens, ideals, victims, of the (often poetic) heroes. Part of George Balanchine's legend is his remark that "ballet is woman" — to which, in our century, the choreographer Pam Tanowitz replied that "ballet is a man's idea of woman." Tanowitz is certainly right, but she was not denouncing many of the ideas men have had of women. In a number of Ratmansky ballets — *Namouna, a Grand Divertissement* (2010), *The Firebird* (2010), *Chamber Symphony* (2013) — the male protagonist is plainly the voyeur and the leading women are part of his vision, but he evidently cannot always control or even understand those women.

The solo that he made for Sara Mearns in *Namouna* has become celebrated as a *ne plus ultra* statement of full-throttle female power: it is so long and arduous that four Miami City Ballet dancers (male and female), in admiration as well as in fun, made a film collage in which each of them danced a different quarter of it. She kicks a leg powerfully outward, only then to sweep it backward like a searchlight. She courses forward through the air before her body arches powerfully back the other way. She turns on point, goes on turning, and then explodes in rapid jumps. She cavorts, she hurtles, she rotates. And in the rare moments that she stops, it's just to strike a heroic pose, and only for a second at a time. Does anyone

196

believe that subtitle *A Grand Divertissement*? *Namouna* seems to tell a story as big and changeful as an odyssey, with three fantastic heroines, a team of sisters each of whom gradually opens up a different plane of existence. Mearns is its Circe.

Chamber Symphony is the central work of *The Shostakovich Trilogy*, the ballet in which we come nearest to Shostakovich the artist. But its male protagonist, when we first see him, seems traumatized. Each of his unhappy relationships with three successive women (another female triad) is interrupted tragically. He is haunted — and from this condition he draws inspiration. It's not the stimulus of love but the loss of love that ignites his creativity. As the ballet ends, other dancers become a complex tableau, center-stage. He walks around it, as if asking "Did I build this sculpture?" as the curtain falls. The feeling is very far from artistic triumph.

But in the trilogy's opening and closing works, *Symphony #9* and *Piano Concerto #1*, the foremost women do much to share and convey the social climate of fear that pervades these works. In *Symphony # 9,* when one man and woman are dancing together, it's the woman whose eyes gleam large with awareness that they may be seen or heard by others; and she places a hand over his mouth, advising silence. In *Piano Concerto #2*, one woman shelters another, like her younger sister, while both of them look outward in alarm. We don't see what's scaring them, but we sense that it is Big Brother, that this is a world under constant surveillance.

III

In an essay on Ratmansky in *The Oxford Handbook of Contemporary Ballet*, the American scholar Anne Searcy claims that he is a breakthrough choreographer by way of dissolving some perceived dichotomy between narrative ballet and abstract

ballet. This, however, is a nonsense distinction. Sure, the twentieth century introduced a rich genre of plotless ballet that began at precisely the same time, in the years before the First World War, as easel painters took painting into abstraction. Sure, both plotless ballets and abstract painting were perceived by Soviet viewers as being part of Western formalism, and by Western observers as part of the new terrain of Western art. Sure, several Western observers have spoken, erroneously, of abstraction when discussing choreography that has gone further into seeming plotlessness. But the leading Western exponents of plotlessness in dance — George Balanchine, Merce Cunningham, Mark Morris — have all stressed that there can be no abstraction where there are human beings. Where you have a man and a woman together onstage, Balanchine observed, you already have a story. When watching dance, one important task is to see the stories that apparently plotless ballets actually contain. Human behavior says what it says. Choreographers who pretend otherwise are irresponsible.

Where Ratmansky has been unusual has been in successfully employing acting methods in ballet companies not generally known for acting. Watching any of the six ballets he has made for New York City Ballet, for example, you see few narrative incidents and motivations even where they aren't really explained. In April 2016, the dancer Adrian Danchig-Waring posted on Instagram a photograph of himself and his fellow dancer Gretchen Smith in Ratmansky's then most recent work for the company, *Pictures at an Exhibition* (2014), with the caption "Two old Jews (searching for lost glasses, memories)." What? On the face of it, this caption made no sense. As staged by Ratmansky, *Pictures* shows a series of stage incidents taking place in front of projections of different

198

sections of Kandinsky's painting *Color Study Squares with Concentric Circles* (yes, abstract). Smith and Danchig-Waring certainly were neither dressed to look old nor given any Jewish look. Thanks to Danchig-Waring, however, it then emerged that Ratmansky, without telling the audience, had given his dancers the ideas of each of the paintings by Viktor Hartmann that originally prompted Mussorgsky in his classic piano composition in 1874. Smith and Danchig-Waring were playing Samuel Goldenberg and Schmuÿle, Jewish men in two paintings actually owned by Mussorgsky. So the Ratmansky *Pictures* took place on two levels of existence: as a response to the Hartmann paintings that inspired the superb Mussorgsky score — and to the Kandinsky. (Ratmansky has said that he stared at a poster of this painting while his wife was in labor with their son.)

On the face of it, Ratmansky's "two old Jews" method is the opposite of how Balanchine and many other choreographers proceeded. To his biographer Bernard Taper, Balanchine identified an image of fate at the start of the final Elegy movement of *Serenade*: "Each man goes through the world with his destiny on his back. He sees a woman — he cares for her — but his destiny has other plans." Taper replied, "That's fascinating. Did you tell any of that to your dancers when you were choreographing the ballet?" Balanchine drew back in horror: "God forbid!" When Merce Cunningham performed his own choreography, his former dancer Douglas Dunn observed that "Merce always knew the story"; but it was a story that he almost never shared with anyone, and never with his dancers. Cunningham's notes for individual choreographic creations reveal multiple poetic ideas: he kept those to himself, however, always allowing for the finished work to express things beyond any intentions he may have had.

The History Man

Ratmansky gives dramatic motives to his dancers — watching them, you often think that they know the story — without telling those motives to his audience. In *Serenade After Plato's Symposium* (2016), Ratmansky's seven men and one woman know plenty about this symposium; the viewers do not. (Curiously, Balanchine used this method when coaching the title role of his *Apollo*, from 1928, speaking of character, imagery, and narrative threads as in no other ballet.) Eventually, as with Balanchine and Cunningham, the overall expression and interpretation of Ratmansky's choreography are left open to the audience. Nobody is spoon-feeding us with meanings. And if we choose to see the dance as sheer dance, that's more than fine. In most of his ballets, there is more than enough to watch.

I cannot explain the sources of many of the incidents in *The Shostakovich Trilogy* (2012–2013), but I recognize that each of its three ballets has its own vivid inner life, with enthralling details that add up powerfully. The stories that we are not being told are not our business. For us, what matters are the feelings that we can't help having while we watch. More than with any other Ratmansky choreography, the movement keeps showing elements of strain and tension. Dancers sometimes move from one position to the next as if the air is heavier than water. Or they hold onto one another as if the rest of existence is pulling them apart. Each of the three ballets has ensembles of asymmetrical multiplicity that suggest the randomness of the society onstage. Solos, duets, larger groups come and go with no larger pattern or structure. Individual dancers often stand on flat feet like ordinary folk, using informal body language or gestures.

Ratmansky is not in most senses radical, yet he has continually expanded ballet's expressive range. *The Shostakovich*

Trilogy belongs to a small group of ballets (Frederick Ashton's *Enigma Variations*, Balanchine's *Robert Schumann's "Davidsbündlertänze"*) that are about their composer's worlds, about the personal circumstances that impelled them to write that score. His trilogy is a highly imaginative instance of the genre, with meanings tightly bound up in the movement. One of the leading men of *Symphony #9*, the opening work, begins by waving into the sky, almost as if writing on it. His rapture and brilliance seems to inspire others. But he sometimes — not least at the end — crumbles, as if everything has been too much. The whole trilogy has always called to mind the famous quatrain at the end of Anna Akhmatova's poem *Voronezh* (and cut from Soviet editions of the poem), lines held by Nadezhda Mandelstam and others to describe the condition of the creative artist in Stalin's Russia:

> But Fear and the Muse take turns to guard
> the room where the exiled poet is banished,
> and the night, marching at full pace,
> of the coming dawn has no knowledge.

IV

Surely the trickiest controversy about Ratmansky is simply this: is he, so learned in the ways of classicism, actually a classical choreographer? New York has been the temple of Balanchine for decades. Ratmansky has been widely greeted as if he is the best ballet choreographer since Balanchine. But is he worthy of the Balanchine temple? I'm reminded of a classics don of the last century, the Plato specialist Walter Hamilton. When he heard a young woman exclaim, about a handsome man, "He's like a Greek god!," Hamilton gently inquired, "Which Greek god did you have in mind?"

The History Man

There has never been just one classicism. Or, as Diaghilev observed in 1928, "classicism evolves." No twenty-first-century choreographer, for example, can reasonably employ the drastic differentiation of masculine and female principles that characterizes much of Balanchine. What is remarkable about Ratmansky is that, unlike most other eminent choreographers today, he seems exceptionally free of Balanchine's influence. We know that he reveres Balanchine. As a dancer, he performed a range of Balanchine lead roles, from the exuberant duet *Tarantella* to the contemplative Sarabande in *Square Dance*. As a choreographer, however, he is cut from different cloth.

Balanchine saw himself as the heir of Petipa. Yet, except when working in the Petipa idiom of such ballets as *The Nutcracker,* he eliminated a great deal of the texture of Petipa's ballets: the processions, the non-dancing acting characters, the folk, national, and character dances, the gestural sign language, and more. When the great suites of pure-ballet dancing arrive in a Petipa ballet, their effect is that of Platonic ideals: they reveal heightened planes of existence amid all the surrounding earthly panoply. With Balanchine, however, most or all of each ballet is up on the Platonic peak.

With Ratmansky, the proportions are changed. His classicism is not often that of Apollo and Diana. Yet it is certainly classicism, a wonderfully varied classicism that includes Socrates, Alcibiades, and Aristophanes (all characters in his *Serenade on Plato's Symposium*); and the moods of his other ballets — often witty, human, skeptical — are comparable to those we encounter in Euripides, Aristophanes, and Plato. Although some of the composers he uses are the same Russians as Balanchine used (Tchaikovsky, Glazunov, Stravinsky), he also often turns to the composers

whom Balanchine usually avoided (Scarlatti, Rachmaninov, Prokofiev, Shostakovich).

There have been times when Ratmansky has seemed primarily what ballet folk call demi-character (*demi-caractère*): someone who uses a wide range of the ballet vocabulary without commanding the grandest, noblest aspects by which classicism has often been recognized. The kind of motivated ebullience that he gives to dancers has reminded a number of older observers of the performance style associated with the story ballets of a largely forgotten choreographer, Leonide Massine (1895–1979). In the 1920s and 1930s, Massine was widely thought to be the world's greatest ballet choreographer, but very few of his most important ballets have been danced in the last forty years. At first, the affinity between Ratmansky and Massine seemed uncanny. Ratmansky, born in 1968, grew up in the Soviet Union, where Massine's ballets were unknown. Any such resemblance must be fortuitous, it seemed. Yet not so: Ratmansky really is a history buff, who, especially on coming West, researched many lost ballets in films and photographs. And in 2005, he actually presented a triple bill of Massine ballets at the Bolshoi: a perfect gesture, since Massine was himself a Muscovite, now being seen at last in Moscow twenty-six years after his death.

I now suspect that Ratmansky had already recognized several kinds of affinity between Massine and himself. (Massine had even choreographed a Shostakovich symphony in 1939.) In his ballet *Les Présages*, in 1933, Massine had made an effect with a then unusual, heroic, overhead lift (the man holds the woman above his head with his hands on her thigh and waist so that she faces ahead). It became known as a *Présages* lift, and later, when dancers no longer knew *Présages*, as a "press lift." When Ratmansky employed one, center stage, in his *Concerto*

DSCH at the New York City Ballet in 2008, which is to Shosta-kovich's second piano concerto, he was surely saying, "Were it not for Massine, I wouldn't be tackling this music." When he was preparing his *Shostakovich Trilogy* in 2012, the critic Brian Seibert asked him if he had choreographers who were compositional models for choreographing symphonies. The first name in Ratmansky's reply was Massine.

Since 2015, however, Ratmansky has been restudying Petipa's. He and his wife spent much of 2014 studying Stepanov notation, the system devised in Russia in the late nineteenth century to record the ballets then in repertory there; but they also researched Petipa performance style. His 2015 production of Petipa's *The Sleeping Beauty* for American Ballet Theatre is this century's must-see account of that classic. It's faster, more multi-directional, with many changes of text and texture. Legs don't sweep so high, footwork is lower but faster. The fairy-tale characters who come to Princess Aurora's wedding really do re-tell their fairy tales. I don't mean to over-praise it. Its two greatest faults are that it works so hard to restore Petipa that it cuts at least one of Tchaikovsky's supremely poetic passages, the Arrival at the Palace (when the only thing happening onstage should be music), and it down-scales the most Apollonian passages of Petipa's glorious adagios. Yet it abounds in other revelations: it keeps meeting Tchaikovsky's score in fresh detail.

Ratmansky has gone on to stage a whole series of other ballets by Petipa and his colleague Lev Ivanov: *Swan Lake* in 2016, *Harlequinade* and *La Bayadère* in 2018. And with his account of *Giselle* in 2019, his historical research took him into pre-Petipa choreography from the Romantic era. His research is sensitive, intelligent, dramatic, but sometimes misapplied: the central idea of *La Bayadere* is unalterably racist (an Indian

204

temple dancer dies and goes to white ballet heaven), and too much of its music is tinkly-tumty-tinkly-tum third-rate.

He is by no means alone in these reconstructions. Since the 1980s, there has been an important wave of historically informed new productions of old ballets. But Ratmansky is the first choreographer of note to enter the field. There are blank passages in the notation where the stager must use creative imagination. He is also the most radical in asserting his view of nineteenth-century ballet style. The results are comparable to the major conductors who have transformed our idea of Bach, Handel, Haydn, Mozart, and Beethoven. And the results are already seen around the world. In his restless globetrotter way, Ratmansky has been mounting these productions of the nineteenth-century classics in New York, Zürich, Munich, and Moscow, then re-staging them in Milan, Miami, and The Hague. In most of these places, there has been some resistance, which is to be expected, just as it arises around new conceptions of Mozart and Beethoven. But Ratmansky is the main reason why ballet history in the twenty-first century feels like a living process rather than an area for archivists and antiquarians. That alone is a galvanizing gift to the art.

It seems clear that, more than any other choreographer in ballet today, Ratmansky is a poet: a dramatic poet working in many different forms. He is not, however, a ballet master in the traditional sense — a choreographer who shapes his dancers in their daily class. Balanchine, like such nineteenth-century masters as August Bournonville and Marius Petipa, created style in the classroom while preparing choreography as vehicles for style. Ratmansky is one of the many modern choreographers who does not teach (though he certainly has the wherewithal to do so). It is hard to discern where such non-teaching creators will take the art.

205

His era at American Ballet Theatre was the longest and most fertile regime of any single choreographer with that often feckless troupe. His departure may well now make Ballet Theatre of truly secondary importance to ballet history. But what will his move to the New York City Ballet bring? Might City Ballet's dancers unconsciously start to dance the masterpieces of the dead Balanchine with the actorly inflections of the living Ratmansky, and might their physicality also change in other ways? The Ratmansky story has been evolving unpredictably all century. His career has been changed by the history of our time; and he has done much to transform the history of ballet, both with his new creations and his new stagings of the classics. No other living choreographer better exemplifies that old theory: classicism migrates — and, in so doing, mutates.

ISHION HUTCHINSON

The Anabasis of Godspeed

1

Above deck, ice-scarred, off to Albion.

———

Let it be named so, for the dynastic
furies combed into heads, pressed into lines
of boys shouting 'here, sir,' and 'not here, sir'
at devotion or on the parade ground,
leaping over shadows as the sea broke
with their names interred in the same roster,
fidgeting with oceanic sorrow.

Happy Grove. They climbed the sea-charged cannons.
They looked up the school's purple and gray walls.
They chattered like parakeets in the breeze.

Then their scurrilous voices crossed strict waves,
bound by an ardor to move while standing
hidden in the open, an infantry
stalled in the holy metal of the sun.

Flecked dust and heat. Melting vellum. Lament.

———

A boy struggled with the flag, crack-lashing
from his hands like a fer-de-lance. Scorched, turned
and watched

 charcoal burners; shipwrights; tailors; clerks; fishermen;
motor engineers; blacksmiths; cooks; mechanics

as it whisked away in the grass.
Laughter broke across ranks. The chased earned him
his name: Godspeed. Godspeed! A khaki blitz
chorused their mute, fettered pain, the future's
fata morgana raging

sargasso eyes bulge as if a mirror lapses
time: Jesus of Lübeck? Braunfisch? No: iron twins
Karlsruhe and Dresden, incandescent drift amid
reefs at sunset rumoured to be wedding-torches

208

to puncture
these poppies blackened with the unknown names
stung to their chests each morning like courtiers
of empire, primed to rake the play field
small wars erupted noon: "A Ras! a Ras!"
aimed at the Zion-haired boy, who mirrored
the sound, that broken water place gurgled
from poppies: the dread Arras.

Through bells
he heard this, mouths gashed with ringing, fell in
ordered rows, tilted like ships in the glare.

So many,

sugar; rum; cocoa; coffee; rice; logwood; bauxite;
oranges, lime juice (for prevention of scurvy);
mahogany propellers and 9 aeroplanes;
 11 ambulances; cotton (for balloons)

 15,600
drawn into the affray cousins make,
mortared to haul martyrs from mud trenches,
then the sand trenches, where the anonymous
sprung up a permanent humility.

Recover,
ice-scarred, above deck,
back to Old Britain.

No. 46 Sgt. A.V. Chan "A" boy killed in action on the
ROMAN ROAD between GRANT RIDGE and
BAGHALLAT. He was buried at the foot of MUSSELABEH.
Veni redemptory gentium sang the celestial voice men of
SAINT VINCENT. Yes come gently. Gently like the small
rain of rosewater murmuring from a black hand.

It was around this time the principal cutoff Godspeed's
dreadlocks. His mother slapped the daylights out of
the principal and was thrown into the jail at GOLDEN
GROVE. Godspeed wept in his khaki as by GAZA when
Samson felt the pillars breathed in his palms.

He lit tails of foxes mongooses cats snakes and cousins with
lightnings. He poured rubbing alcohol in his jam jar of
fireflies and set it ablaze. He was knife scissors razors with
a sharp ringing in his ears and bald head and he hid in the
bosom of stars bald and chalked a circle of misery bald to
place every principal in and then buried the sheaves of his
head bald and with a jackass jawbone he stormed the jail
and fed his mother roasted corn thundering "It is easy
to remember and hard to forget I Bop I own the trumpet
I am the Gorgon."

210

To fierce Kumina drumming and rum at midnight No.46 Sgt.
A.V. Chan soul flew to MIDIAN accordingly.

After Godspeed lost the precept of his head he lost his mind
and found it in the larvae of bees outside EIN GEDI
where he exalted himself like a young palm tree.

The following other ranks boarded at "M" Special Hospital at
ABBASSIA awaiting passage to the WEST INDIES. Dark
matters in the sun they resembled prehistoric hills of
charcoal soaked by rain mouthing bits of the *Sixth Book of
Maccabees*. In KANTARA one handed his lice eaten mantle
to the other and neither saw death nor his island home
again then proceeded by barge to TARANTO.

JENNIE LIGHTWEIS-GOFF

Vulnerability in America

Six months ago, my yoga teacher decapitated his girlfriend. The police found her torso in the refrigerator of the RV he drove from New Orleans to Black Rock Desert every September for Burning Man. In this mid-size, decidedly regional Southern city — a site of national myth if not national importance — wars take place on Instagram rather than Twitter. There, the usual parties joked that "he tried Burning Man before Freezing Woman." Injunctions not to read the comments are made for crimes like this, because they are where temptation lives. (I followed temptation.) Progressive commentators found it appalling that the murderer parked his crime scene in a

gentrifying neighborhood, with no care for the residents' fight against displacement. Rightists publicly brayed that he ought to be raped and murdered in prison. Novices on gender violence wondered aloud if they should have known — read the signs, assumed that belligerence was escalating towards murder. Self-appointed experts assured them that they should have. Somewhere in between, we agonized about whether to say they/them or he/his for an accused murderer whose pronouns shifted more than once in the previous year. I confess I chose "his" in the first sentence because once you heard about a dead woman you began looking, like any assiduous detective, for a man with blood on his hands.

Both parties, I should note, are white. Despite the details — neck tattoos, semi-naked festivals, meth addiction, and fibrillating pronouns, all placed in a haunted gothic city — the story never attracted national attention. One might count as an exception Reddit, where Burners questioned one another about who had partied with the victim, the murderer, or both on the Festival's Playa. It is hard to predict what crimes become "red balls": police slang for cases with sufficient attention and resources to warrant closure, cameras, podcasts, new surveillance architecture, and think pieces. Certainly violence must surprise in order to terrify, but New Orleans is a high-crime city where tourists are warned to stay on the beaten path and to keep their wallets close. Crimes against visitors get more attention. Photogenic victims attract consistent coverage. Years into methamphetamine addiction, few people look good enough for the cable news B-reel. But how do we do the work of parsing reasons that are, by nature, multiple, in a political climate that encourages unitary, withering diagnostic certainty?

I bear witness to violence. During the high crime 1980s, my parents moved their four children from New York to Appala-

213

chia in hopes of keeping us alive. The shift brought violence closer. Our neighbor in South Carolina murdered his uncle in retaliation for childhood abuse. At a laundromat near Clemson University — the nearest cultural institution — an international graduate student was kidnapped the year of our arrival. The only sign of foul play was a pool of blood on the concrete floor where she kneeled to switch her laundry from washer to dryer. Her skeletal remains were found a few months later on the grounds of the county's nuclear power plant; the crime remains unsolved. A woman I grew up with was "murdered on the interstate," as in Neko Case's best murder ballad; my brother's dear friend died in a drive-by shooting.

By the time I returned to New York — upstate this time — for graduate school, a certain amount of violence felt quotidian. An FBI investigation exposed a child pornography ring on my campus. Cue the newspaper euphemisms: we can't tell you what we saw on those hard drives, but it's your worst nightmare. It interrupted my slow slog toward the dissertation, though this was hardly the most tragic outcome. Local news cameras appeared on campus. Amateur actors in search of accolades found the microphones into which they intoned that they felt so unsafe, though it was children — by definition, almost none of us — who had been harmed.

"We" are in danger whether from strange men or familiar ones, whose bullying in the workplace or at home indexes far more pathological sexual impulses that we cannot see. The behavior is always "escalating"; the mundane manipulative boyfriend bears the seed of Ted Bundy's evil. Victimhood does not hold as much capital as bullets dodged or predators outwitted. *Potential* victimhood — always waiting, kept at bay by our own will and ability to translate quotidian behaviors into "red flags" — pays emotional dividends. It is a boundless

214

energetic well. Walking among us are people who have never been hurt; they are confident that they remain unhurt because they have taken care. ("Be careful!" they say, when we leave their company.) Meanwhile, many of us live hurt, live unprepared for future hurt. I am confident that I am living because no one wants me dead. And I call this optimism.

In *Conflict Is Not Abuse*, her study of the damaging consequences of overstated harm, Sarah Schulman notes that the "fear of potential threat is not always based in actual experience.... It can also be a political construction, one that is fabricated and then advertised through popular culture, or enforced through systems of power." Sometimes, we phantasmatically build those systems, imposing them on our own experiences and fleeting encounters. Consider the poem "On the Subway" by Sharon Olds, in which she imagines a young black man measuring the bodily signs of a white woman's wealth.

> I look at his raw face,
> he looks at my fur coat, and I don't
> know if I am in his power —
> he could take my coat so easily, my
> briefcase, my life —
> or if he is in my power, the way I am
> living off his life, eating the steak
> he does not eat, as if I am taking
> the food from his mouth. And he is black
> and I am white, and without meaning or
> trying to I must profit from his darkness,
> the way he absorbs the murderous beams of the

215

nation's head, as black cotton
absorbs the heat of the sun and holds it.

The charge in the ocular cable between the benches lies not in the wealthy, fur-clad woman's observation of the potential mugger, but in his glance back at her. She imagines their lives as a zero-sum struggle and takes the "casual cold look of a mugger" on her possessions as a sign that he, too, weighs his costs against her benefits in a racist society. No words pass between them; we know that the man appraises the speaker only because she says so. City life is organized around someone else's glance at the wall; we flatter ourselves and think that they land on us. Race charges the danger of the stranger's gaze, though in truth we have likely already invited our killer to sit beside us.

Olds' poem was published in *The Gold Cell* in 1987. That is, it appeared in an era bookended by Bernard Goetz and the Central Park Five; call it the Paranoid Epoch of New York Public Life. Even a serial killer will pass, over the course of the day, several hundred or thousand people to whom he intends no harm, but there is no pleasure for Olds' speaker in imagining that the man she indicts as a mugger does not notice her. This delusion that we are recognized by the perpetrator is the animating idea of so much of the genre known as true crime. Now that our midcentury marquee serial killers are dead or imprisoned, the genre has gorged itself down to the crumbs. *My Favorite Murder*, a two-woman podcast that sometimes markets itself as a primer on how not to be killed, features a Monday "mini-sode" in which callers send in overwrought letters about fleeting encounters with serial killers. Six degrees of John Wayne Gacy; I was Jeffrey Dahmer's greengrocer; et cetera. If you doubt me, I'll be specific: Episode 145 features

the thrilling tale of an encounter with the murderous partners Gerald and Charlene Gallego by the former valet who sometimes *parked their car* at a Sacramento restaurant.

The postmodern genre of true crime — as feminist parable, as self-help — begins with an account of referred fear. Ann Rule worked at a crisis hotline in Seattle with Ted Bundy; she thought of him as brilliant and charismatic, though he possessed neither resource in sufficient quantity to secure an acquittal when he acted as his own counsel in his capital murder trial. In *The Stranger Beside Me*, Rule built the colloquial profile of the psychopath, not in proximity to his violence but to his seeming normalcy. True crime consumers learned that the normalcy was a mask for the violence, that cause-and-effect could not be reversed. That the killer's virtues were his greatest vices. It seems obviously true that Bundy never injured Rule because he never intended to do so, that dangerous men are not equally dangerous to each person they meet. They might even love their friends, and provide admirable service at the crisis hotline. But this is an unsatisfying conclusion for true crime, where an *absence* of suffering makes you the greater victim. In it, you are betrayed by the sociopath's superpower: his stealth. Rule rejected, as she later told *The Guardian*, stories of killers who were "ugly, mean, or had no charm. We're not interested in the kind of man who looks like he could commit a murder." Who *looks* like that? Upon his capture in 1978, Bundy purportedly pleaded with the Florida highway patrolman David Lee to kill him; one wonders what he looked like then. There is a comfort in imagining him smirking in the back of the police car — it validates his state-sanctioned death — but I wager that violent men feel little pleasure in feeding compulsions.

Years ago I fell in fascination — not love — with a man who, I belatedly discovered, had a distressing history of

violence. Taking beatings from his fellow men and giving them to women, as is often the case. An hour late for a date, he inadvertently offered me a few minutes of fiddling with my phone on the sidewalk outside the locked New Orleans restaurant where we sometimes met for shots of Death's Door gin and sex in the afternoon. (Literature wasn't his métier, but the shape of these afternoons taught him to love Cavafy.) From a single, fatal Google Search, I learned all the varieties of charge intensifiers that police append to the phrase "domestic violence." I neither confirmed preexisting suspicions nor explained quotidian bad behavior as a symptom of psychopathy. Those are the tent poles of true crime's deep fiction. Weeks after my discovery, in a frenzy of grief and lust, I thought about the crumbling plaster in that attic room above the bar where he reeled at the force of my appetite. If you'd given me a line-up of men — this lover, the lover that preceded him, and Ted Bundy — and asked me to rank the dangers they might do to *me* in that room, I would have placed this man last, Bundy in the middle, and the previous lover, an otherwise mild-mannered scholar with an electric temper, first. Nothing we did together provoked fear, only sorrow in its departure. I served time in hell later, when his estranged wife picked up his phone and learned my name. A vain and fearful woman, she professed to be broken not by beatings but by cheating. These days, I keep a velvet drawstring bag of jewelry broken between the sidewalk and the attic room. When I pull the strings it is with gratitude that he never had the occasion to love me, such as love feels for him. And for her.

Empathy is not finite, but it is a resource that we apportion selectively, based on our own need. I won't condescend and tell you that I have abundant empathy for the wife of my former lover; it is an obvious lie. She enforced compulsory

ghosting, as though the balance of her marriage could be restored in inverse proportion to the cruelty with which her husband treated his mistress. That is, she punished the distant perpetrator to protect her bond with the proximate one: an inversion of accountability. She followed me into a public restroom to pelt me with crumpled-up damp paper towels, an offense with far less pain than she received from him. But for a year or more I was certain a greater revenge was coming. I believed I deserved it. On our first date, this man reached to touch my hair, only to have my earring shatter under his hands. In some other universe, I am writing a letter to *My Favorite Murder* using this broken earring as an apotropaic mark against the violence he would have done to me. In that universe, I leave out a tender detail: that he saved the broken half for months during which he thought we were through. I can omit and disclose details to conjure up the Devil, but the end-product looks as lifelike as a hand-tinted photograph. I live in a universe of muddier hues.

Sometimes I joke that I am the only feminist in America to listen to Beyoncé's *Lemonade* and identify with the adulterous Jay-Z. The exposure. The humiliation. Skinlessness is the stuff of my nightmares; surely my rival's nightmares vary. The distance between us is not that she has experienced violence and I have not. From slaps and shoves to terrifying lapses in consent with another ex to a sucker punch from a beloved relative, my body has been a target. If you tell me I lack empathy for "abuse survivors" as a category, you are telling me that the rough men in my life didn't hit me hard enough for correction. (I assure you that there was pain to spare). My failing is not that I lack empathy for the wife — we are all dangerous to someone, lacking feeling for someone else — but that I possess empathy for her husband. His entry into a

room makes me recoil with identification. I see in his posture precisely which of his twenty-four ribs pains him after a long workday. In the frame of his hands, I see the fractions of his body that he would like to conceal. I hear the struggle for control in his incongruously soft voice. And I see in him what philosophers call moral luck. Like you, I am selfish, wicked, and vain, but the actuation of my vices stops short of assault. What we call morality is often good fortune, an arrogant survey of all the noxious compulsions we lack. When I gave up booze in 2019, I left behind the urge for self-annihilation, but I have never been able to shake empathy for my former lover. If we met again on some distant sidewalk, we could skip the shots of gin; I'd sate the greater thirst.

Gabby Petito died with her fiance's hands around her throat, but it is her disappearance, not her death, that rivets and remakes the landscape of true crime. Late in August 2021, Petito — a would-be Instagram influencer and #VanLife acolyte — went missing in the High Plains: symmetry between a photogenic subject and setting. That same week, a Jane Doe found forty years ago in the mythic landscape of the Mississippi Delta was confirmed to be a victim of the late Samuel Little, the South's most prolific serial killer. Petito's case, trending on Twitter and burned on twenty-four-hour cable news chyrons, stokes the appetites of a media underbelly: the obsessive true crime fans hungry to watch a murder investigation in "real time" and the detritus of the mainstream media, whose chyron coverage of photogenic missing persons cases borders on the lustful. The long-dead, newly identified Clara Birdlong appeared on less-traveled media pathways with a computer-generated

portrait, rather than the minute-by-minute Instagram diary of Petito's doomed road trip with Brian Laundrie, her lover and killer.

No photographs exist of Birdlong, whose body was found where the Yazoo and Sunflower Rivers run. Many of Little's ninety-three victims are identifiable only by the prison portraits he made of them on yellow legal pads. He was twice acquitted of murder, and once served a paltry three-year sentence for two attempted murders in one evening. After his release, he accumulated a massive body count. He died in California State Prison in Los Angeles in 2020. Both Birdlong and Little, I should note, are black. Despite the details — prison art, multi-state killing sprees, close calls, and stunning escapes — Little never held national attention like Bundy or Henry Lee Lucas. There are few pictures of the victims; images of the killer appear in decades-high stacks of mug shots, evidence of a criminal record that was never taken seriously. Birdlong had gold-capped teeth, walked with a limp after botched surgeries on her ankle, and worked at Ingalls Shipyard in Pascagoula, Mississippi; that biography is mostly written on her body, not in her own words. Change a few factors and the relative interest in her case and Petito's might change. If her killer had more often killed across racial lines, like Jeffrey Dahmer, perhaps his nearly triple-digit body count would attract more attention. Who can say? Again, how do we do the work of parsing reasons that are multiple, in a political climate that encourages unitary, withering diagnostic certainty?

Under other circumstances, interest in Gabby Petito's case would wane and crest with legal developments, arrests, trials, and sentencing. But after the so-called racial reckoning on crime, race, and punishment in 2020, headlines were instead sustained by "Missing White Girl Syndrome." Coined by

the journalist Gwen Ifill, the phrase indexes white women's outsized placed in crime coverage. They lead, even before the public is sure that they bleed. On September 19, 2021, Gabby Petito's remains were found in Teton County, Wyoming. It was punctuation to weeks of video forensics on body camera footage showing her and Laundrie questioned by Utah state troopers who answered a domestic distress call from passersby on the road. They are separated, but the acted-on may contact their aggressor. Punishment is required but haphazardly apportioned. Witnesses had only seen Petito hit Laundrie, so she was punished for grazing the man who would eventually kill her. Laundrie negotiates for Petito's release with the Moab Police Department.

Police Officer: "You do have injury....She was the primary aggressor, and she was striking you and you received injuries.... At this point you're the victim of domestic assault....Now I don't want to take this small — what is she — ?"

Laundrie [laughing]: "Twenty-two year old blonde haired blue eyed girl..."

Police Officer: "....that you could definitely defend yourself against — to jail."

A month later, Laundrie committed suicide in the Florida swamps; his notebook contained a provisional confession. He claims to have killed Petito because she wanted to die. But it was the murderer's other descriptions — the laughing dismissal of her as merely a young, small blue-eyed blonde — that neatly rhymed with the mainstream coverage. The night Petito's body was found, MSNBC's Joy Ann Reid hosted a panel of advocates for missing women of color to discuss the disproportionate interest in Petito's case. The same week, news anchor Frank Somerville was suspended by San Francisco's KTVU for appending a note about Missing White Girl

Syndrome to coverage of Petito. Take these rejections of a Jon Benet-like ubiquity as an affirmative sign if you are inclined to think that Petitto's family is better off grieving without cameras at their door. But the debate pretends to critique Petito's ubiquity while using it as a journalistic peg, thereby extending rather than dismantling her hyper-visibility. Framed as awareness campaigns, diagnoses of Missing White Girl Syndrome operate with the usual short-lived, burn-out heat of social media outrage. Absent policy arguments, fueled only by awareness, this rhetoric feeds the punishment bureaucracy and, before that, the social justice tendency to make white women the center of the universe even as it purports to tumble their pedestals. White women's privilege. White women's tears — which, Robyn D'Angelo confidently asserts, simultaneously remind every black person of Emmett Till's accuser Carolyn Bryant. Missing white women. Karens. Surely photographing these sobbing, raging, phone- and leash-wielding women in shaky, saturated iPhone footage will redistribute our attention by riveting it to the same target.

The threat inflation described by Sarah Schulman rests parallel on a scale with the threat-negation of contemporary confessions of social privilege. Think of all the loud declamations by white people that they will never be shot by a cop because of their race, even though they live in the country that leads the world in police-involved shootings, that they will never be shot at prayer, though they were in Sutherland Springs and Squirrel Hill. They are invulnerable under regimes of power as currently constituted, or so they think. Their certainty offers a tremendous psychological benefit to those regimes. One

thinks of Twitter's cancellation of Justine Sacco, a PR director with less than two hundred followers, in 2013. "Going to Africa. Hope I don't get AIDS. Just kidding. I'm white!" she tweeted. Change the tone a fraction and place Sacco in the middle of a learning circle. Place the items from the list (whiteness, able-bodiedness, Americanness) in a privilege walk or a story circle, and the utterance becomes an act of anti-racist allyship — that is, an assertion of one's immunity to the suffering they work to ameliorate.

This is an inversion of fifty years of storytelling about white women's peculiar risks. Stories of decapitation and strangulation, of drifter-killers and wife-beaters, function as allegories. True crime critic-practitioners Rachel Monroe and Sarah Marshall have both described the genre as operating on a kind of fairytale logic. It offers a prescriptive utterance, a warning against walking alone or going home with a stranger that simultaneously blames the victim and assures the audience that violation was inevitable. The monsters are impervious to intervention save the ones that come *after* the crime: long criminal sentences and lethal injection. I fantasize about a return of Netflix's *Mindhunter* — a scripted series about the team of profilers who invented the "serial killer" through jailhouse interviews — that features a key scene in which a killer speculates on why he had to murder many times to earn the attention of social workers and psychiatrists. Our imaginary serial killers instead fold into the real ones, promising that the work of mass incarceration exists only to contain sourceless, boundless evil. "Nothing happened to me, Agent Starling," says hyper-real serial killer simulacra Hannibal Lecter in *The Silence of the Lambs.* "I happened."

Dehumanizing the killer dehumanizes the victim, turning them into a mute repository of the spectator's collective need.

224

Poor Petito, described by the commentariat and her murderer alike as *just* a "blonde-haired blue-eyed" white girl, arrived too late to the genre of true crime, when her identity was crafted as an obstruction to the justice that is supposed to await the reader at the end of the story. Decades ago, advocates intent on bringing greater attention to murdered and missing women imagined themselves as ventriloquists for the mute, carrying a maximally punitive message from a sunlit afterlife. High-profile crimes like those committed by Ed Kemper and the Manson Family proffered privileged women as peculiarly vulnerable. Targeted mass incarceration and concentrated crime meant that the end of furloughs and widespread parole would affect more quotidian offenders. The Victim's Rights Movement of the 1970s aimed at Cielo Drive but landed in far poorer neighborhoods. Soon, long sentences would bring new residents to places like Chowchilla and St Francisville and Tutwiler and Norfolk and Moundsville: the capitals of mass incarceration in the nation's poorest provinces.

The historian Jill Lepore describes the Victim's Rights Movement as a compromise between feminism and the law-and-order New Right of the 1970s. Perhaps it is a depressing realization, that some of feminism's greatest gains have come through compromises with its traditional enemies. With the punishment bureaucracy, it produced a culture of protectionism that relies on violence against women and children for moral force even though both victims and perpetrators of violent crime tend to be *poor men*. For the purpose of forming a realistic sense of threat in our society, that is not an insignificant fact. In the 1970s, the National Organization of Women's demand for Social Security wages for carework fell by the wayside in pursuit of more women executives among mainstream feminists, thereby endorsing

225

the end of the family wage and the further immiseration of the working class. The movement to prevent sexual violence produced an alliance with prosecutors leading witch hunts against "Satanist" childcare providers accused of ritual abuse. (#MeToo also produced its own share of inquisitorial excess.) No less an institution than *Ms.* magazine participated in the frenzy, with a series of headlines: "Surviving the Unbelievable: A First-Person Account of Cult Ritual Abuse" and "Believe it! Cult Ritual Abuse Exists!" Over the next twenty years, massive rape rings were exposed within the hierarchies of the Catholic Church and USA Gymnastics, but the intimacy of authority created the conditions of abuse and their concealment. Stranger danger moral panics did not redress sexual violence; they only delayed redress.

The cable news ubiquity of missing white girls is not evidence of privilege, though they might possess that in abundance. Rather, the interminable coverage makes their bodies consumable, appealing, saleable, violable. Endless replay of these cases produces undue vigilance among white women that harms young men of color, as in Sharon Olds' "On the Subway." Parasocial relationships spring from these cases, and with them false confessions from fame-seekers, "recovered" memories from the deeply unwell, and internet sleuthing. Older crimes increasingly get this treatment, too. No fewer than three books and documentaries have credibly claimed that the author's *father* was the as-yet unidentified Zodiac Killer. Consider this curious desire to be close to a killer, to be in mediated danger, to explain one's suffering as evil rather than dysfunction; in it, one can observe the tragedy of how America serves and consumes its spectacles of violence. For some the sign of danger is a broken earring; for some it is a distant father.

226

Indignant evocations of the Missing White Girl Syndrome seek to widen the offerings of victims on the table, to expand — rather than right-size — the collective sense of danger. Both the Missing and Murdered Indigenous Women (MMIW) and Black and Missing Foundations admirably call attention to the disproportionate rates of violence for people of color, but it is unclear what they intend to do with this raised "awareness," always an erratic instrument. In fact there is near-parity in missing rates among black men and women, but the Black and Missing Foundation tends to push women to the front in their awareness campaigns, raising sinister specters of pimps and human traffickers to fuel a sense of imminent sexualized emergency: the kind that has aroused the culture for centuries. The foundation's four-part documentary series on HBO begins with a recitation of sex crimes, then shifts to a missing poster of Brittany Michelle Davis and an interview with the family of Keeshae Jacobs. No men in sight. Founded by Natalie and Derrica Wilson — sisters-in-law who worked in law enforcement and public relations, respectively — the organization raises the profile of missing people, showing how one might productively use social media as a tool to bypass legal negligence toward missing persons of color. Yet the fields in which its founders were embedded structures much of the rhetoric and the reception, cultivating a fear of profound evil lurking at the gates: an enemy-image that, in this instance ironically, has always harmed people on the margins. One pernicious instrument of racism is indifference. The opposite of indifference is infamously difficult to define, but in the realm of criminal justice, it is concrete enough to build more prisons.

What would it look like to right-size risk, especially after a recent spike in crime that followed exponentially larger

decreases of the previous three decades? Our safety and collective self-conception depend on getting the magnitude of our vulnerability right. Mastering fear is hard enough without demagoguery or panic. I have no definitive answer, though as a child of the 1980s I am quite certain that awareness of high-profile crimes offered little protection to their vulnerable targets. Etan Patz disappeared when my mother carried me in her body; Adam Walsh disappeared on my second birthday. The whiplash that followed those crimes made my childhood more terrifying, but I doubt that it made it significantly safer. These days, I banish my fear by taking risks that I survive (thus far).

Expanding awareness may, in the end, produce unintended consequences from the punishment bureaucracy. In the realm of high-profile police-involved shootings, awareness enshrines a vision of peculiar evil — the iconic image of a police officer coolly kneeling on the neck of an unarmed man — a theological notion that is the enemy of the "structural." To call violence structural is to say, simply, that for the most powerful precincts of our society the "crimes" are legal. I am not the first critic to note that the endless coverage of sexualized sprees and serial murderers in the '70s and '80s corresponded to a backlash against women's rights. Our presence in public space became vexed. Don't walk alone, don't forget your rape whistle, don't wear a scarf that a man could seize from behind. This folk wisdom trickled down to me, who came of age rather late to spend freshman year dodging "co-ed killers." A certain amount of caution protects, but a surfeit of it hobbles. Whether I am teaching in prison or cycling at night in my neighborhood in a city with an intractable murder rate, I take the pleasure I can in this life. (I mutter words of protection for *you.*) Two mantras guide me. One I lifted from a different yoga

teacher, who translated the Buddha into colloquial English: the bullet that kills me has already been fired. Another is the advice of an old neighbor from pre-Katrina New Orleans: bullets do not have names.

MARK LILLA

The Once and the Now

You will never be again
What you never were before.

THEODOR STORM

Every morning Odysseus sits on the beach and casts his eyes across the sun-freckled water. The breeze is fresh and the waves rumble gently as they break. He is crying. For seven years he has been a prisoner in paradise, the unwilling consort of the beautiful nymph Calypso, who loves and fawns on him. Odysseus can't bear it. Since leaving Troy victorious, he has wandered the seas, hounded by the god Poseidon, who would prevent him from finding his way home to Ithaca. Eventually Zeus is driven to pity and orders Calypso to release him. "Where shall a man find sweetness to surpass his own home and his parents? In far lands he shall not, though he find a house of gold." Odysseus

builds himself a raft, and after one last night of lovemaking and weeping he sails off alone.

The home we return to is never the home we left. When Odysseus lands on Ithaca, he learns that his estate has been occupied by suitors vying for the hand of his wife Penelope, and dissipating his fortune while they wait. Odysseus comes to her, disguised as a beggar, and kills the suitors. After he proves to her who he is, the couple goes to their bed, which Odysseus had made with his own hands, using a tree planted in the ground as one of the bedposts. They make love and fall asleep. There is no space between the two of them, between the couple and Odysseus's handiwork, between the bed and the tree, between the tree and the earth. It as if they all sprang fully formed from the soil of Ithaca. Oneness has been restored. At least for now.

The fate of Aeneas was to be different. Troy was no more, vanquished by the craven guile of the Greeks. As they poured from the belly of the wooden horse to destroy the city, Aeneas reached for his sword to resist. But Venus in a vision urged him to flee with others. A priest grabbed the fetish statues, their defeated gods, and headed for the ships, while Aeneas lifted his father onto his back and followed. In the confusion he became separated from his wife, and would never see her again. As the ship made for open seas, he watched the flames consume everything he had ever known, then turned his back on Troy forever. Odysseus would face many more dangers and suffer worse deprivations than Aeneas would on his journeys, but the Greek knew that Ithaca still existed in time and space, that hope for return was not vain. This balm is denied Aeneas. Only ashes litter the site of ancient Troy, and no Penelope awaits him.

The *Aeneid* is not about loss, though. It is a phoenix story of rebirth, about a city rising, quite literally, out of the flames.

The Once and the Now

While on his journey Aeneas makes a stop at Delos to consult the oracle about his fate, and he receives an enigmatic reply. *The land of your ancestors will welcome you again, return to her generous breast. Seek out your ancient mother.* He is baffled. But soon he has a dream in which his fetishes confirm the prophecy: *your home is elsewhere.*

That elsewhere would turn out to be Rome. The fetishes convince Aeneas that his ancestors were originally from the Italian peninsula, and not from Anatolia. By migrating to Italy, Aeneas will only be recovering what was rightfully his, just as Odysseus did when he returned to Ithaca. By building a new city inspired by Troy, and by making it more magnificent than the one he came from, invincible and prepared to conquer the world, Aeneas will in a sense be moving backward and forward in time simultaneously. Throughout his journey the gods confirm that this is his destiny. He is made to visit Hades and finds it crowded with Roman heroes of the future, who all look up to him as to a father. He is called to be the redeemer of history, the link between past and future. He accepts, and the poem then recounts in bloody detail how he conquered the native tribes and, in the book's last lines, brutally killed a rebel leader who had come to surrender. Yes, he thinks, laying down his sword in extreme fatigue, I have had my vision.

Nostalgia is a mood that mixes pleasure and pain in equal measure. Consider photographs. Why do we take them? Ask parents this question and they are likely to say that they want to preserve the memory of their children at every stage of development, so that one day they can look back and measure the time traversed. Photography is an exercise in anticipatory

232

nostalgia. We foresee that come a certain age we will want to experience an odd pleasure that comes from reflecting on what has been lost.

Yet how to describe the flood of feelings set off by seeing all those pictures? There are the simple pleasures of self-recognition, of recalling happiness and pride, of seeing life as a continuum, of reliving the journey. There is also bitter with the sweet. Baby pictures bring out longing for a time when the child was an innocent wonder, and regret over not having appreciated how fleeting it would be. It is a pain that the arrival of grandchildren only partially relieves. Vacation pictures remind us, or delude us into thinking, that family relations were once simpler and happier than they are now. We see ourselves, thinner and with more hair, looking carefree as we cradle the nursing baby or put our arms around wet, shivering, reluctant teenagers on a beach. This brings pain, then pleasure in the pain. There is something mildly masochistic about the family album.

Do we really want to return to the past conjured up by the images? In the end, no. Whenever we have tried to relive moments from the past, we have almost always experienced disappointment. The old neighborhood we visit looks shabby and dull. The ex-lover we invite for a drink does, too. Psychologists suggest that the suffering nostalgic does not really want to possess the lost object, he only wants to preserve the bittersweet desire for it. Actually retrieving it or accepting its loss would rob him of a feeling he has structured his life around. He is stuck, unable to let the past go. And his resistance to getting unstuck is tenacious, since it would force him to acknowledge the open horizon before him. Freud developed psychotherapies to free people of that fear. No such therapy has yet been found for nostalgic societies.

233

The Once and the Now

Nations and peoples fall into nostalgic moods just as individuals do. It is hard to think of societies that don't romanticize their origins. The myths they conjure up combine innocence and grandeur in varying proportions. *Once we were simple and pure! Once we were strong!* Or, most powerfully of all, *Once we were strong because we were simple and pure!* The parallel between individual and collective nostalgia only takes us so far, though. No matter how much I embellish my memories and force them into neat narratives to make sense of myself, the experiences I remember are my own, not someone else's. The first-hand memory of nations does not extend further back than a single human lifespan, less than a century. Every literate society's image of its past is necessarily mediated by embellished accounts handed down over the years, even millennia, and modified at each step. Or by retrospective attempts to reconstruct events and past psychological experience from shards that we in the present deem to be relevant. All history is pastiche. In pre-literate societies, collective memories from the distant past are imbedded in rituals; they are remembered by being reenacted, not heard or read. Literate societies remember through articulate myths and narratives whose second-hand, constructed nature has to be veiled if the stories are to hold their power.

It is always surprising to learn that an ancient tradition is not so ancient after all. Two amusing examples happen to concern the Scots. In the mid-eighteenth century, a poet of some talent named James MacPherson published what he claimed to be the English translation of fragments of an ancient Gaelic epic. It had been composed, he asserted, by a mysterious blind bard of the third century C.E. named Ossian — the Homer of the Scottish Highlands, a lie that appealed to the proto-Romantic mood of European letters at the time.

The poems — which MacPherson seems to have written by drawing from Irish poem cycles — were welcomed not only by his fellow nationalists but also by some of the greatest thinkers and poets of the age, including Goethe, who placed translated fragments of Ossian in one of his works. Dutch and German artists painted scenes found in the tales, Napoleon read and admired them, and a French opera based on them was a smash hit during his reign. From the start doubts were raised about the epic's authenticity by, among others, Samuel Johnson, who when asked whether he thought any man from the present age could have written it, replied, *Yes, sir, many men, many women, and many children.* MacPherson never produced the Gaelic manuscripts that he claimed to have translated. Still, the poem continued to be read and translated throughout the nineteenth century and fed nostalgia across Europe for a pre-imperial, pre-industrial age.

Another symbol of Scotland's heroic age, the clan kilt, has little more foundation in history than do the Ossian poems. There is no evidence of distinctive Highland dress before the sixteenth century, when Scots typically wore a long shirt covered by a belted cloak, sometimes made of murky tartan. The skirt we now call the kilt was in fact invented in the eighteenth century by an English Quaker manufacturer who wished his scantily clad Scottish factory workers to be properly dressed. Once kilts caught on, regional stylistic variations developed, but there were no distinctive clan tartans. The skirt experienced some popularity among workers, until it was banned by the British after the rebellion of 1745. Not until the English ban was lifted in 1782 did the kilt become a nationalist badge of honor, worn mainly by gentry wishing to play up their real or imagined highland roots. After the Napoleonic wars, during which the Scottish

kilt was observed by armies across Europe, it was extolled by Romantics fascinated with noble primitives, which is what they considered the Highlanders to be. Only thereafter did distinctive plaids become associated with clans, thanks to the marketing genius of a clothing manufacturer who developed his own fanciful pattern book, arbitrarily assigning this or that tartan to particular clans.

The practice continues to this day. In 2016, a Scottish rabbi registered a "kosher Jewish tartan" with the official Register of Tartans, which itself had only been established in 2008. The garment has gold to represent the Ark of the Covenant, silver to represent the Torah, and blue and white to represent the Israeli flag. It now festoons kilts, neckties, and yarmulkes. Golf balls with the tartan pattern are also available for purchase.

Nostalgia can be fun. Anyone with a good internet connection can now research his lineage himself or with the help of very profitable businesses that promise an ancestry worth celebrating. But when an entire nation or people or faith begins searching for lost time, darker emotions and fantasies emerge. Political nostalgia transforms a feeling that things are not as they should be into the conviction that things are not what they once were. Everything hangs on that *once*. Once we were innocent and pure, now we are not. Once we were kings, now we are slaves. Once we lived in Eden, now we live in Los Angeles or Cairo or Dubai. Once we were nigh unto gods, now we are all too human.

The impulse to see the human condition as the result of a temporal fall from perfection is widespread in human culture, and there are numerous versions of the myth of the Golden

Age. The one told by the ancient Greek poet Hesiod is the most familiar to us. Frustrated by his lazy, shiftless brother Perses, Hesiod wrote a poem to explain to him why human beings had to work. He described a divinely created golden race that once lived off of the fruit of the earth without toil. But when this race disappeared, each subsequent one was fatally flawed and now we must live in the age of iron. For us, life is toil and suffering, and so it will remain until our destruction. That end is inevitable, but it can be postponed if we are decent, law-abiding, and respect the gods. Hesiod does not dangle before his brother any hope of returning to the Golden Age or of entering a new one. His message is: back to the plow.

The modern historical imagination is not terribly drawn to moral parables like this one, but it is still subject to the entwined emotions of hope in the future and nostalgia for the past. No sooner had poets and thinkers in the Renaissance announced the rebirth of ancient learning than their adversaries began romanticizing the older darkness. It is remarkable how quickly nostalgia for the Middle Ages grew up in Europe after they ended. Already in the seventeenth century there was a vast literature, mocked by Cervantes in *Don Quixote*, that extolled the medieval chivalric virtues of simplicity and valor, which stood in contrast to the new bourgeois spirit of gain and the terrifying impersonal mechanization of warfare. By the nineteenth century, Romantics such as John Ruskin were stoking a passion for Gothic architecture and the ruins of Catholic Europe, and encouraging architects to return to the old forms. The more advanced the nineteenth century became in science, industry, and even politics, the more nostalgic it became in spirit. Such are the hydraulics of historical consciousness.

237

The modern literature of nostalgia is enormous. Rare, though, are writers who explore the psychology of this longing without succumbing to it themselves. The Sicilian writer Giuseppe Tomasi di Lampedusa was an exception. His only novel, *The Leopard,* published posthumously in 1958, is the most poignant portrait we have of nostalgic melancholy — and its futility. It concerns a fictitious Count of Salinas, the last of a line of Sicilian aristocrats, who can only be a spectator as the world familiar to him evaporates before his eyes in the late nineteenth century. Trains replace carriages, revolutionaries demand a democratic state, and a new class of greedy, untrustworthy arrivistes take advantage of distracted nobles who care more about observing the gentleman's code than turning a profit.

Lampedusa, himself the last prince of his line in Italy, is subtle. The aristocracy that he portrays is no longer glorious; it is lethargic, anemic. It is dying of wounds self-inflicted over centuries and prefers ruminating on the past to seizing the present. When the Prince's forward-looking nephew tells him, famously, that *if we want things to stay as they are, things will have to change,* he sees the point. But he and his class are incapable of acting on it. *They are coming to teach us good manners. But they won't succeed, because we think we are gods...We were the Leopards, the Lions; those who will take our place will be little jackals, hyenas.* There is no anger in his voice. He knows himself and his class, and he has reconciled himself to its fate. *The Leopard* is an elegy, not a tragedy. The sun has set. It takes a great soul to recognize this without betraying memories of the past or succumbing to hatred of the present. The prince gives all honor due to the lost world, but he is immune to fantasies of recovering it.

Feeling inferior is no easier for nations and cultures than it is for individuals. Powerful empires can also live with chips on their shoulders — even the greatest of all, Rome. It grew from a small city into an extensive empire within a cultural arena dominated by the Greeks. The religion, the art, the architecture, the literature, the philosophy, the sciences — to none of these could the Romans lay exclusive claim. Their cultural dependence made Roman elites double-minded. On the one hand, they had Greek masters educate their children, knowing that their cultural status in society would depend partly on how well they spoke the language and mastered the literature. Their palaces were full of copies of Greek sculptures. On the other, the Romans felt shame at their own belatedness and their dependence on the achievements of another people. Imitators can never fully respect themselves. And so, at different points in their history, even after Rome had entirely subjugated Greece militarily, they rebelled against Greek high ideals and asserted pride in things that distinguished themselves from their rivals. Romans, they told themselves, are simple and direct, not slippery and refined like the Hellenes. They are doers, not talkers, honest, not treacherous, courageous, not cowardly, tanned and strong, not pale and weak. Romanness (*Romanitas*) was the pinnacle of virtue and everything that came from the Greeks carried a disease (*morbus graecus*).

The Romans were always haunted by the specter of decline, always worrying that their vital essence was being sapped or had already disappeared. Fixing the moment when Roman decadence began was a parlor game that educated Romans loved to play. Already in the late republican period, when Roman power was rapidly expanding, nostalgic patricians such as Cato the Elder were railing against the effects of luxury, declaring that Rome was losing its rustic virility and

The Once and the Now

becoming effeminate. He was especially obsessed with Greek philosophers. When a group of them visited Rome he made speeches against them, declaring in the Senate, as if he were a prophet or a seer, that Rome would lose its empire if its youth listened to them. He then managed to get them banned from the city and transported back to Greece.

Rome's experience with Greece has become a global psychological experience. Beginning in the eighteenth century, due to trade and then to colonialism, and today with travel and the internet, non-Western countries and cultures have had no choice but to confront the modern West as idea and reality. And simultaneously to confront themselves. For all their interest today in cultural encounter, contemporary historians generally lack the psychological acuity that ancient historians once brought to the study of relations among peoples. Herodotus would not have been surprised to learn how significantly the dynamics of cultural pride and shame have shaped global history in the modern era, since they did so in the ancient world as well.

Nineteenth-century Russia was an extraordinary theater for this kind of drama. Long before Napoleon tempted the fates by marching on Moscow, Russia felt itself invaded by the West. Ideas associated with the Enlightenment were first introduced by Peter the Great at the beginning of the eighteenth century and inspired his radical, and much resented, reforms. Catherine the Great, who cultivated personal relations with the French *philosophes*, pushed those reforms further. More important, the French-speaking elite also embraced these ideas and began educating their children along modern European lines, much as the Romans used to send theirs to Greek tutors. And as in Rome, a powerful intellectual and political reaction to these changes then set in.

In the great novels of Turgenev and Dostoevsky, we are witness to clashes between modernizers and anti-modernizers, Westernizers and chauvinists, atheists and neo-orthodox Slavophiles, fathers and sons. The Russians were perhaps the first to go through a political-intellectual cycle that has become familiar elsewhere in the world: a nation or culture encounters the modern West and, at first, feels backward and humiliated, and so begins to slavishly imitate its ways. When the expected benefits of modernization do not materialize — or when they do, but with unexpected consequences — a reaction sets in. At that moment there arises from the depths of the nostalgic imagination the idea of returning to an idealized past. Then ideological movements spring up promising to do just that, to lead the way out of Egypt and back to the Promised Land.

The Slavophiles were one such movement, or family of movements. The questions that they asked were not foolish ones. What will happen to religious faith if we modernize? How can traditional authority be maintained? Will common decency and fellow feeling die out? And art as well? As Dostoevsky once put it, will a pair of boots or a barrel of oil become more valuable than Shakespeare or Raphael? For the Slavophiles, modernization meant the destruction of all that was virtuous and noble in the traditional Russian way of life. But like so many nostalgic political activists, they had trouble distinguishing the modern innovations themselves from the Western countries that had brought them to Russia. They were incapable of seeing modernization as a general historical process that only happened to begin in the West, and was originally directed against traditional life there as well. Instead the Slavophiles convinced themselves that modernization was the fullest realization of a distinctive Western culture, and all that was wrong with it. The struggle that they saw

was not between pre-modern and modern life everywhere, it was between the West and the rest. Their writings endlessly repeat the same refrain: the Western *mind* is rigid, abstract, rationalistic, and so fixated on the future that it destroys life in the present, while the Russian *soul* and *heart* are authentic, charitable, devout, and bring everything into harmony. The same tropes litter the literature of political Islamism, which purports to explain *the obvious incongruity between the Once and the Now*, as one revered thinker put it.

When Augustus declared himself emperor in 27 BCE, nostalgia became official state policy. After the Civil Wars, with their intrigues and senseless slaughter, at a time when the *urbs romana* was already sinking into the decadence that Tacitus and Suetonius would later chronicle, Augustus made an effort to re-instill civic virtue by giving patronage to artists and writers who were to celebrate ancient *Romanitas*. Bucolic poetry — a Greek invention, as it happens — became the rage and invoked a mythical past when Latin shepherds led simple lives tending to their sheep, playing the flute, and singing of love to blushing maidens. Other works, such as the *Aeneid*, gave Rome a noble mythical history independent of the Greeks, something crucial for self-respect. Its great innovation, though, was to redirect nostalgia for the past toward the future and raise the prospect of leapfrogging over the present to arrive at a utopian world to come. All the energy that old republicans such as Cato once wasted trying to call Romans back to a lost Golden Age was now freed up to inaugurate a new one.

The ideologies of modern fascism are all heirs to the *Aeneid*. Nazism, though, was also inspired by an obscure

work of Tacitus's called *On Germany*. It was an odd choice of subject for the ancient historian, since it seems that he never once set foot in Germany. His account, drawn from various sources including Caesar's memoirs, appear to have been written largely for contemporary polemical purposes. Tacitus deplored the decadence of the empire, which he later evoked so vividly in his *Annals* and *Histories*, and *On Germany* appears to be an early, veiled attempt to criticize it. The book describes a strong rustic people resembling the ancient Latin tribes: rude, truthful, loyal, united, proud, belligerent. They knew neither luxury nor adultery. Encouraged by women baring their breasts, men marched off singing into battle, indifferent to cold and hunger. And any man who had not killed an enemy had to go unshaven and wear a ring in his nose, as signs of his shame. The contrast between these Teutons and the imperial Romans could not be greater, which was Tacitus' point. Over the centuries *On Germany* became a reference for writers in many countries who condemned the decadence of their time, and it contains many of the commonplaces about noble savages that one finds throughout European literature. The book became particularly popular in German lands after Luther translated it, no doubt to contrast the corruptions of papal Rome with the virtuousness of his own flock.

243

Luther's translation also became a key source for *völkisch* thinkers of the nineteenth century who wanted to distinguish the earthy culture of rural Germany from the salon culture being imported from effeminate France. They quoted approvingly Tacitus' report that the Teutons practiced a brutal justice, killing slaves if they seriously disobeyed, drowning traitors and deserters in the swamps, and in some cases practicing human sacrifice. But one sentence in particularly drew their attention. It is where Tacitus says, in passing, that *I accept the*

view of those who think that the peoples of Germania have never been tainted by intermarriage with other nations, and stand out as a race distinctive, pure and unique of its kind. He goes on to describe them as blue-eyed and ruddy-haired, with immensely strong bodies that could bear severe cold and hunger. In these passages the modern racial "theorists" found their ur-text. Just as Rome was supposedly weakened and collapsed due to racial mixing with the peoples it conquered, so Germany was threatened by mixing with alien races and cultures, particularly the Jews. This is how *On Germany* became, in the words of one Nazi propagandist, *a bible that every thinking German should possess, as this booklet by the Roman patriot fills us with pride in our forefathers' superior character.*

For a nostalgic like Heinrich Himmler, Tacitus's portrayal of racially pure and belligerent Teutons in their dark forests provided sufficient mythological inspiration for the Nazi policy of racial extermination. For Hitler, it did not. While he recognized the usefulness of *völkisch* propaganda, he also understood that idealizing such an undeveloped culture would keep Germans' attention focused on the impossible task of restoring the past, rather than on the future they were capable of building. As he already complained in *Mein Kampf* in the 1920s, the imagination of many of his dreamy early followers, meeting in the back rooms of seedy taverns, clad in lederhosen, did not extend beyond the romance of conservative villages nestled in Bavarian valleys. Hitler wanted to create an empire that would be mentioned by posterity in the same breath as those of classical antiquity, and be remembered equally for its military conquests and its cultural achievements.

Associating the Germans with ancient high culture has always been a fraught and dubious enterprise, given that Germany was well outside the orbit of classical culture in

antiquity, and slow to participate in its revival in the Renaissance. Mussolini, by contrast, had only to give a speech in front of the Colosseum to drive the connection home. In one such speech he declared, "the Rome that we contemplate with pleasure and are preparing is a different one. It's not about the stones of the past, but a difficult preparation for the future. Rome is our point of departure and point of reference. It is our symbol. Or, if you like, our myth...*Civis romanus sum.*" The Nazis had to find some other way to connect Walhalla with the agora, the fur-clad Germans with the toga-clad Greeks.

They eventually did so in the racial theory of the Aryan people. The term "Aryan" was first adopted by Western linguists in the late eighteenth century to describe a family of Indo-European languages, not a race or a people. But in the nineteenth century, when romantic nationalism was at its peak, European scholars began to speculate about the existence of an Aryan ur-race. And as the century progressed, that speculation became for many a scientific certainty, which was used across Europe and the Americas to justify slavery, colonialism, anti-Semitism, and much else.

In its original form, Aryan race theory suggested that all the European peoples — French, German, English, Spanish, Italian — had a common ancestry, and so in racial terms were fundamentally equal. Nazi race theorists came up with a brilliant, and in the end lethal, variation of this idea. They argued, on the basis of no evidence whatsoever, that the original Aryans had not spread out from the Indus Valley into Europe. Rather, just as Aeneas had discovered that the Trojans were originally from Italy, so these "scientists" discovered that the Aryans' original home was actually in the German forests (and probably, as one straight-faced Nazi scholar suggested, near the port city of Lübeck). The Aryans subsequently

spread out from Germany into the rest of Europe and thence into India — and not the other way around. The Nazi regime invested enormous energy into propagating this myth, and through its own Department of Classical Antiquity — yes, you read that right — supported pseudo-academic research in history and anthropology to demonstrate its truth.

Once this Aryan racial link was made, the full range of symbols from the ancient world lay at the service of Nazi propaganda officials. All the cultural achievements of ancient Greece could now be claimed as German. And all the military achievements of Rome as well. Pericles was blue-eyed, Augustus was blond. And the Spartans offered the model for a new system of education giving precedence to physical prowess and toughness over intellectual inquiry. Hitler declared Sparta to have been the first racist state, and sycophantic Nazi scholars called them the Prussians of antiquity. In 1933, the race-obsessed German philosopher Alfred Baümler gave a lecture in Berlin titled "Against the Un-German Spirit," in which he contrasted the manly political education of the Spartans, who aimed to form citizen-soldiers, with the effeminate, Jew-infected democratic education of the Weimar Republic. He then called out to his student audience, many in SS uniforms, to take the first step toward restoring the Spartan spirit by burning all books poisoning the German soul. That night they did just that, heaping twenty thousand volumes from the University of Berlin library into a pile and setting it alight.

Hitler was also fond of drawing a parallel between the Spartan practice of abandoning handicapped children in the wild to the Nazi's industrialized-scale eugenic cleansing. The difference was that the Spartans were amateurs who acted out of instinct. Modern racial science had discovered that the only way for a people to be genuinely reborn is through self-conscious

selection. The future was to be won by the first modern people that returned to this ancient practice, but carried it out with the most advanced scientific and technological means available.

Political nostalgia has lost none of its allure or destructive potential. And since the end of what now must be called the First Cold War, it is filling the vacuum left by the abandonment of progressive ideologies like socialism and democratic liberalism. Even Aryan race theory has been revived, in the Hindutva movement that inspires the core of Narenda Modi's Bharatiya Janata Party which dreams of driving Muslims out of the country.

In China and Russia the nostalgia is more complicated, since they live with double historical legacies: that of modern revolutions inspired by universalistic political ideals, and that of the traditional societies which those revolutions destroyed. Call it the Two Edens Problem. The link between them that Xi Jinping and Vladimir Putin seem to be trying to articulate is a new ideology of *longue-durée* imperialism that is supposedly the deepest expression of the national essence. Whatever the differences between Puyi and Mao, or Alexander II and Lenin, they were all leaders of great empires, and it is these empires that must be restored or expanded. The Soviet one was abandoned with hardly a shot being fired; the Chinese one still lacks Taiwan, and Xinjiang Province refuses to bend its knee. Now we have a goal, now we have a historical destiny: to restore our lost wholeness. The Uyghurs and the Ukrainians are only the latest victims to be sacrificed on the altar of this fantasy. There will be others.

247

MITCHELL ABIDOR

The Abjection of Albert Cohen

Albert Cohen died in 1981, hailed in France as one of the greatest writers of the twentieth century. His passing barely registered in the English-speaking world; not even the *New York Times* ran an obituary, and it is unlikely to correct this particular mistake in its "Overlooked" feature. Cohen was the author of a fictional tetralogy that included a masterpiece called *Belle du Seigneur*, as well as three volumes of memoirs, but at the time of his death he had not been translated into English since 1933. In that year his first novel, *Solal*, published in 1930 in France, appeared in English to dithyrambic reviews. The vagaries of the translation market deprived us of translations of *Belle du*

Seigneur until 1995 and of *The Book of My Mother* until 2012. The rest of Cohen's work remains untranslated.

Lost to Anglophone readers is a body of work of real genius, books that are humorous, romantic, tragic, sensuous, challenging, enthralling, and occasionally exasperating and even repugnant. They are books that are overflowing with love, thought, and ambiguity; that are extremely Jewish and extremely French, and explore the ties and the disjunctions between those two adjectives of belonging. There is much in them to admire and even to adore, and much that will enrage. Cohen really does contain multitudes, a writer roaming in style and form — there is humor, there is Biblical narrative, there is stream-of-consciousness realism, there is exalted lyricism, there is even the language of swashbuckling tales and serial novels à la Eugène Sue. His language flows drunkenly and freely yet also precisely, with a seeming infinity of verbal resources, able to change tone on a dime. The result is a body of work that is utterly unique. It is also, in both its fictional and autobiographical forms, an oeuvre that contains a philosophy of love, mortality, and Jewishness that is complex and sometimes shocking.

Cohen was born in Corfu on August 16, 1895 to a Jewish family involved in the soap trade. The Jewish settlement on Corfu dates back at least to the High Middle Ages, and in the early modern period the community — which developed customs and liturgies uniquely its own — suffered many anti-Semitic adversities, and so into the modern centuries, until in 1891 a blood libel forced many Jews to flee the island. In 1944 almost two thousand Jews were deported to Auschwitz. As for Cohen's family, business difficulties led them to move to Marseille in 1900. He attended school there and began a lifelong friendship with Marcel Pagnol, the novelist and

filmmaker, the bard of Marseille and the Midi. Cohen adapted well to the Midi — but on the day of his tenth birthday he experienced the central event of his life, the formative event that "drove [him] from humankind."

On August 16 at 3:05 in the afternoon, as he was leaving summer school, Albert saw a street vendor selling stain remover. He listened with delight to the seller's pitch and held out the coins to him. As he later recalled, the vendor addressed him directly:

> "You, you're a kike, right?" said the blond street
> merchant with his thin mustache whom I'd gone to
> listen to with faith and tenderness on the way from
> school. 'You're a filthy kike, right? I can see it in your
> mug. You don't eat pig, right? Given that pigs don't
> eat each other you're a miser, right? I can see it in your
> mug, you eat gold coins, right? You like them more than
> you do candy, right? You're a fake Frenchman, right?
> I can see that in your mug, you're a filthy Jew, right? A
> filthy Jew, right? Your father is in international finance,
> right? You've come here to eat the bread of the French,
> right? Ladies and gentlemen, I present to you a buddy of
> Dreyfus, a little purebred yid, guaranteed member of the
> brotherhood of the snipped, shortened where he should
> be. I recognize them on sight: me, I can't be fooled. Well,
> we don't like Jews around here, it's a filthy race, they're
> all spies in the pay of Germany, look at Dreyfus, they're
> all traitors, they're all bastards, they're as awful as the
> mange, bloodsuckers of the poor world, they roll on
> gold and smoke big fat cigars while we have to tighten
> our belts: am I right or am I right, ladies and gentlemen.
> Get lost, we've seen enough of you, you're not at home

here, this isn't your country, you have no place here in our home, c'mon, get lost, take a hike, get going, go see if I'm in Jerusalem."

Cohen never recovered from this tirade, though he later declared that his love of the country that had "rejected" him did not waver, finding its focus instead in literature. Cohen's suspicion of all claims about universal brotherhood grew from this early confrontation with the actual, smiling face of hatred.

Cohen attended law school in Geneva from 1914 and took Swiss citizenship in 1919, the same year in which he married his first wife, Elisabeth Brocher, a Protestant pastor's daughter. He published his first book, a volume of poetry called *Paroles juives*, in 1921, a volume that he refused to republish during his lifetime though it was eventually included in the Pléiade collection of his work. The poetry of the young Cohen bears within it the same pride about Jews and Jewishness, later diversified by ambiguity, that will persist throughout his writing life. In the first lines of the collection Cohen writes:

Listen
My People.
My people
I looked upon you.
You taught me.

As he admits, "my words are crude." These poems are exhortations to his people, which sometimes involve criticism of them.

I know only how to shout
I know only how to shout.
I come to you

My people lacking in courage.
Ah, how my words burn you
Ah, rise and go forth.
Ah, puff up your mane and growl
Indolent lion
Lion that awakens the flame of the south.

The young Cohen was a muscular and unapologetic poet of
Jewishness, and of Zionism:

You drink the wine of joy.
And you cry out
This year we sing in a foreign land
And next year it is certain
A free people in Jerusalem.
And you do not smile at each year that passes
Stubborn people
Strong people.

And his national pride extended also to metaphysical
matters. *Paroles juives* contains Cohen's love of a god in whom
he is unable to believe:

I lost my God
I no longer know my God
But I know that my God is stronger than your gods.

That last line is childish and coarse, but Cohen was writing
when Jews were increasingly in jeopardy, and like some
other Jewish intellectuals of his time he chose to respond to
the threats with defiance and Jewish self-assertion. *Paroles
juives*, a slight volume, is nevertheless a key to much of

Cohen's thought, to his feelings about the Jewish people, his "brother slaves."

Cohen's wife died in 1924, leaving him a daughter, Myriam, born in 1921. The following year he became editor of a new Zionist publication, *La Revue juive*. It published work by Einstein, Freud, Buber, Max Jacob, Elie Faure, Max Brod, and Louis Massignon — and, most notably, Proust, with a previously unpublished chapter of *À la recherche du temps perdu*. But its life was short; it lasted six issues.

Cohen lived parallel lives in literature and world affairs, publishing in 1930 his first novel, *Solal*, as well as his sole theatrical piece, *Ezéchiel*. During this period he was employed at the Geneva-based International Labor Organization, and served also as the Zionist Organization's representative to the League of Nations. In 1931 Cohen married his second wife, Marianne Goss. His involvement in these two spheres continued into the late 1930s: in 1938 he published *Mangeclous*, the second novel of what would be his tetralogy, while continuing his Zionist labors, serving as Chaim Weizmann's personal representative in Paris in 1939. He fled France for London in June 1940, where he served as the Jewish Agency's special representative to the Allied governments in exile, and worked with De Gaulle's Free French, publishing regularly in their journal, *La France libre*. At war's end he worked as assistant director of the International Refugee Organization, retiring in 1951 and dedicating the rest of his life to his writing. Cohen wed Bella Bercovich in 1955, the only Jewish woman among his spouses.

Cohen's first autobiographical book, *Le Livre de ma mère (The Book of My Mother)*, appeared in 1954, and the two final novels of his tetralogy, *Belle du Seigneur*, his masterpiece, in 1968 and *Les Valeureux (The Valorous)* in 1969. He published

two further autobiographical volumes after that novel, *O vous, frères humains* (*O You, Brother Humans*) in 1972, and his final book, *Carnets 1978* (*Notebooks 1978*), in 1979. Abraham Albert Cohen died in Geneva on October 17, 1981, and was buried two days later in the city's Jewish cemetery.

Solal, Cohen's first novel, was published to great acclaim in France in 1930. The critic for *Comoedia*, for example, concluded that it "marked perhaps the rebirth of the novel of imagination in our literature," continuing that it is "certainly the masterpiece" of Jewish literature. (The latter remark is certainly excessive.) Its translation into English in 1933 was also highly praised. Its overwhelmingly Jewish otherness was stressed by the critics. *The New York Times'* reviewer wrote of the exoticism of the author and his cultural distance from "us": "There is a subtle Oriental hormone in M. Cohen's blood which separates him from us by leagues and centuries. It will be difficult for the Western mind, which is still subconsciously dominated by inherited Greek notions of form and unity, to comprehend this strange, Byzantine composite, this magnificent, disordered work." (A backhanded compliment if ever there was one.) *Time* magazine said of the book that "though Jewry has given the world many a magnum opus, including Christendom's best-known book, few true-blue Jewish novels aim at or succeed in putting Christian readers in a state of grace. *Solal* does just that; it is a wild, melodramatic romance, stuffed with grotesque comedy, Old Testament lamentations, sensual psalms, shrewd cynicism and shrewder kindliness, ending finally in pure parable."

An uncommon book, obviously. *Solal* is the story of Solal

des Solal, a dashing young Greek Jew born on the island of Cephalonia, for whom the tiny world of a Greek island and its even tinier Jewish ghetto are not big enough to satisfy his hungers and ambitions. Bursting with confidence, Solal des Solal — the firstborn son of the head of the Solal family in every generation bears this doubled name — is the apple of his family's eye. He is above all a boy who never allows anyone or anything to get in his way, capable even of knocking his tutor unconscious in order to steal the latter's invitation to a party hosted by the woman he loves. All that Solal will later show himself to be — impetuous, foolhardy, selfish, romantic, dominating, and cruel; Jewish and anti-Semitic — can be found in Cohen's first novel. It is not without reason that Cohen's great admirer Bernard-Henri Lévy described this novel as a "draft" of his great work of almost forty years later, *Belle du Seigneur*.

Solal recounts the title character's youth and early manhood, whose life is ruled by his ambition, his love of women, and his tormented Jewishness. When it opens the day before his bar mitzvah, Solal is in love with Adrienne de Valdonne, the wife of the French consul, ten years his senior, a woman he has adored "since he saw her at the distribution of prizes at the French high school." After three years of pursuit, the now sixteen-year-old Solal succeeds in winning and abducting Mme. de Valdonne, with whom he runs off to Italy, an event taken from Cohen's life and his abduction at sixteen of an opera singer in Marseille. In the first instance of what will become Solal's normal course in love, he quickly begins to tire of his lover. He meets Aude de Maussane, whom he will court and, as if a character in a Dumas or Sabatini novel, pursue on horseback and capture on the day of her planned marriage to another man.

The Abjection of Albert Cohen

Solal is irresistible to women, described in the act of love as a "god" and "master," with women his "slaves." Solal and Aude wed, and Solal, this Greek Jew, skillfully exploiting his new relations — Aude's father is highly placed in the French government — and his almost magical charm, is named to a post in the ministry of foreign affairs. He is dauntless and will not be denied: when he loses that position, he recovers quickly to become the editor of a socialist newspaper and a power in the French Chamber of Deputies.

His personality and his actions throughout the tetralogy induce an almost unbearable tension in the reader. Cohen seems to acknowledge that his protagonist is somewhat hard to take, and he offers relief with scenes of a group of Cephalonian Jews, known as the Valorous of France — five relatives of Solal who, by a twist of Jewish fate, are citizens of France thanks to their descent from a line of the Solal family that traces its roots to that country. Like Solal, they will be recurring characters in Cohen's novels and the central figures in two of them. They serve as comic relief, but more than that, they represent Solal's roots, which he has chosen to deny in order to reach the heights that he attains.

In *Solal*, the hero's attraction/repulsion for his roots will ultimately be his undoing, costing him his career, his wife, his son, and (temporarily!) his life. As the novel ends, Solal's acceptance of his Jewishness, of his filiation with the "grotesque" Jews of his native isle as represented by the Valorous, have led to his descent into abject poverty. His wife leaves for parts unknown with their son, their love twisted and killed by her rejection of his background and his refusal to wash his hands of it. He succeeds in tracking down his estranged spouse and their child and, with a medieval dagger, holding his baby in his arms, he stabs himself and dies. But

death is unable to hold Solal and he revives. His impervious-ness to death is expressed in the final words of the novel: "The sun illuminated the tears of the bloody lord with his rebellious smile, mad with love for the earth and crowned with beauty, headed to tomorrow and his marvelous defeat. In the sky a royal bird spread its wings. Solal rode off on his horse and looked the sun in the face." There are moments in Cohen's flamboyant novels when he seems to have hit upon magical realism.

In all Cohen's novels, Solal des Solal's great loves are gentile women, as were two of the author's three wives. In Cohen's appearance on the French literary talk show *Apostrophes* in 1977, he accepted the host's observation that this was a fruit of the desire for "integration" into the larger society. Solal is motivated by love, desire, and ambition: his ambition to possess any woman he is drawn to, but also the ambition to get ahead, which requires leaving Cephalonia and his religion behind. His inability to shed his Jewish self and to avoid the label "Jew" attached to him by the non-Jewish world will be his downfall. Solal learns that in his world success is possible for a Jew, but only at the cost of denying his Jewishness. The modern Jewish drama of assimilation and allegiance is played at a very high pitch.

If Solal's Jewishness is replete with contradictions, the Valorous of France, his comically "grotesque" Greek family, live their Jewishness to the hilt. Cohen, the proudly Zionist editor of *La Revue juive,* has them emigrate to Palestine. There they join with a group of Polish Jews, a Jewry unknown to these simple Sephardim, in the shared objective of making the land flourish in the face of Arab opposition. The Valorous give their hearts to the Zionist task, though they are more than somewhat lacking in the skills needed to make the land fertile.

Uncle Saltiel and Salomon joins the workers in the fields, with less than sterling results. These pioneers from a Greek island struggle mightily. Salomon almost cuts off his own foot with his scythe, and he is foiled in his effort to "decipher the Zionist anthem that he had had sent from Jerusalem... He quickly grew tired of it, realizing that he understood nothing of these five lines and the accursed little circles, sometimes round, sometimes black, sometimes white. He scratched himself and sought other amusement." Though their undertaking ends in disaster, Cohen finds them admirable: "All these former nomads knew they were clumsy. But what did it matter? They were working in the sun and their children would find fertile fields. Sweating and peaceful, they carried on. Honor to the new children of Zion." They are attacked by Arabs, and the saintly Valorous Salomon and Uncle Saltiel are killed. The survivors decide to quit Palestine. Mangeclous, a schemer of the first order interested primarily in his own well-being, explains that "I've had enough. To tell you the truth, there are too many Arabs around here and it's not hygienic for my health." We last see them setting out for Greece and safety.

"Israel," in Solal's eyes, "was a poor nightingale, an old, plucked bird that sang in the night of centuries while young nations constructed their empires." The contradictions of Solal's Jewishness are strikingly drawn. Solal is capable of tossing a *tallis* out the window, but also of destroying his future by making sure that his wife sees him praying in the traditional way, rocking back and forth. She is horrified by the spectacle, and his carefully constructed French life collapses. This wavering in his attitude towards his religion plants the seed of his destruction: as his father-in-law and boss tells him, "No ambiguity. French. Solely French and all that that means." Try as he might, Solal can never totally adopt this attitude. As

a Jew he refuses to vanish. His is the tragedy of the figure who lives on the seam and straddles it, for whom the only life he can live with integrity is a dual life.

Cohen gives Solal's Jewishness a moving spatial and symbolic representation. Using Aude's money, Solal purchases a chateau in France, solidifying his French bona fides: the foreign Jew is now the lord of a manor in the countryside. But one night Solal slips out of the marital bed, and Aude sets out to find him. She discovers that a wooden chest has a false bottom that opens onto a staircase. "She walked down fifty steps, followed a dark corridor at the end of which a lit candle cast shifting shadows. She cracked open a studded door and glimpsed a hall with a vault sprinkled with stars, supported by great pillars. At the back, the seven branches of a candelabra shone before a velvet curtain embroidered with square and triangular letters." Unbeknownst to his wife, Solal, this modern marrano, had constructed his own synagogue beneath their ostensibly Christian home. Ultimately she makes for Solal the choice that he cannot make, the choice between being Jewish and being French, and abandons her husband to his Jewish fate.

259

In 1938, Cohen followed *Solal* with *Mangeclous*, its plot dedicated primarily to the Valorous, and in particular to its title character, Pinhas Solal: Mangeclous. Mangeclous means Naileater. The Rabelaisian tone of the book begins on the title page, where we are told that its hero is also called "Long Teeth and Satan's Eye and Lord High Life and Sultan of Coughers, and Saddle Skull and Black Feet and Top Hat and Bey of Liars and Word of Honor and Almost lawyer..." and so on and

delightfully on. *Mangeclous* is for most of its length a radical departure from *Solal*. In his first novel the Valorous were injected into the story as comic relief, and as exemplars, in burlesque form, of an authentic Jewishness, one lived with no ambiguity, far from that of the tortured Solal. But *Mangeclous* is in its entirety a comic novel. With its improbably eccentric characters and its almost steadfast refusal to advance in a straight line, it feels very much like a French *Tristram Shandy*, though in *Mangeclous* every character is Uncle Toby.

When we had last seen the Valorous, they were leaving Palestine after a disastrous attempt at settlement, leaving two of their number dead. Now both of the formerly deceased, Salomon and Saltiel, have returned from the dead. Verisimilitude takes second (or third or fourth) place to the writer's love for his characters. Cohen is a gifted fabulist. The novel's extravagant plot is set in motion by a mysterious letter telling Salomon and Saltiel that they are the recipient of a munificent sum of money. They are instructed to travel to Geneva. From that point nothing goes simply, as the correct distribution of the funds becomes a matter of debate, this debate giving rise to the group's self-induced notion that there is actually more money involved than the mysterious letter claims. A secret code is then assumed to exist that will lead to more money still. Finally all this is settled, and they depart for Geneva and a meeting with an unknown individual who will turn out to be Solal.

In Geneva, the Valorous, misled by a telegram that they think authentic, constitute themselves as a Zionist government and attempt to extract a promise of land in Palestine from the League of Nations. During Solal's brief appearances in *Mangeclous* we learn he has climbed back up to the heights and is now under-secretary general of the League of Nations. (Again, the strange mixture of high politics and

florid narrative, of history and fantasy, that is characteristic of Cohen.) And Solal is again madly in love with a gentile woman who is as beautiful as he is handsome. Though he has brought his eccentric relatives to Geneva and is ostentatiously generous with them, he remains deeply ashamed of the Jew in them that he sees reflected in himself. "Enough, enough of this Jewish leprosy."

His own Jewishness is not all that Solal finds repulsive. The League of Nations, which at the time of the novel's appearance had not yet definitively proved its uselessness, is shown to be a den of laziness, sycophancy, and social climbing. The goal of those employed there (I use "employed" because no one actually works there) is to do as little as possible, and we are treated to the workday of one of them, a certain Adrien Deume — the husband of the woman Solal is in love with as the book ends — as he spends an entire day avoiding writing a letter on his boss' behalf. "The ideal of Adrien Deume was to live in proximity to his superiors and to raise thanks to them in order to know superiors. In short, he aspired to forever live as an inferior."

In true Solalian fashion, in this wild tetralogy of identity, when he finally meets his Greek relatives at the fanciest hotel in Geneva, the cost for which he is covering, he is disguised and his face covered in bandages. He loves the Valorous, but in a way that only Solal can love a Jew: "Yes, he was the only one to respect these Jewish grotesques, these ill-bred Jews with their noses, and their humpbacks and fearful gazes." That one sentence can serve as a summary of the psychological complexity of Solal's attitude to Jews, Jewishness, and that part of himself that is attached to his origins. It is difficult to imagine feeling "respect" for "grotesques" who are described in the tropes of anti-Semitism. The oscillation in Solal's feelings

The Abjection of Albert Cohen

is a constant in Cohen's tetralogy. But just as clearly as it demonstrates a certain hatred, it demonstrates an unquestionably love. Yes, they are "grotesque" in the eyes of the striver Solal, forever in conflict with the Jew Solal — but what better way to stick a thumb in the eye of the non-Jewish world than to respect, and even love, these Jews in their grotesqueness?

As the book draws to a close, we are introduced to the Deume family in their Geneva home, where Solal has spent the night hidden naked in the bedroom of Ariane Deume, the beauty whom he now loves. He finally covers his nudity not with the clothing of the diplomat that he is, but with the ragged clothing that he had purchased from a poor Jew who had been traveling with the Valorous. Along with his ragged attire, Solal applies makeup that reduces him to the appearance of a toothless vagabond. Once again, it seems, Solal, having achieved all a young man could desire, rejects it in the most blatant way, assuming as a disguise the image of what he actually is: a Jew. The emblem is wrenching. But there is more to it than this, as we will learn in *Belle du Seigneur.* Cohen's readers would have to wait thirty years, until 1968, to learn of the events of that night and its consequences.

Translated into English (after an unconscionably long time and under a strange title) as *Her Lover*, Cohen's massive novel was hailed as a classic upon its publication. Bernard-Henri Lévy, who has written eloquently and perceptively of the novel over the years, described it as "the most sublime love novel of the twentieth century," a characterization that, as we will see, is difficult to support. It is a novel of extremes; of love and hatred, of tenderness and cruelty. It is a profoundly Jewish novel that

at once exalts and expresses the misery of the Jewish condition. It is a pure distillation of the Cohenian worldview: his recognition of the impossibility of love and the impossibility of living happily as a Jew. (Zionism was created in part as a solution to Jewish unhappiness, and there is a deep connection between Cohen's Zionism and his explorations of eroticism.) It is a book that contains passages that reach the romantic heights, and others that describe a cruelty that many will find unbearable, even unreadable.

Belle du Seigneur picks up almost exactly where *Mangeclous* left off, making this a single continuous tale. Solal is hiding in his disguise of a hideous Jew in the bedroom of Ariane Deume. For the novel's length, its plot is actually a simple one: Adrien Deume's ambition to become a highly placed functionary of the League of Nations is fulfilled, but he owes his rise to Solal who, in love with Deume's wife, has Adrien sent away on a lengthy diplomatic mission. In his absence, Solal and Ariane embark on the love affair that will fill the second half of the book. Solal loses his French citizenship (an anonymous letter sent to the French government informs them that Solal is not yet entitled to citizenship, a letter that he himself had sent) as well as his post at the League of Nations. The two lovers live in isolation, loving and tormenting each other, Solal doing almost all of the tormenting, Ariane almost all of the loving.

His rage is increased by the thought that she had a lover prior to him. No baseness is beyond him. He asks Ariane, "'Tell me darling, have you had other men?' 'My God, who do you take me for?' 'For a whore,' he said melodiously. 'For a tricky little whore.'" Physical violence and abuse are not beyond Solal, but he multiplies its horror by adding emotional cruelty to it: "Holding her by her hair he struck her beautiful face. 'I forbid you,' she said in her magnificent child-like voice. 'I forbid you!

Don't hit me again. For you, for our love, don't hit me again.'
To cover his shame with an even stronger shame, he struck
her again." At another moment, as Solal's cruelty grows ever
more extreme, the volatile nature of his moods horrifically
clear, he throws a cup of hot chocolate in Ariane's face, though
he had tried to miss her. Struck momentarily with guilt, "he
rushed into the bathroom, came back with a towel and rubbed
the damp corner on the dishonored face. On his knees, he
kissed the hem of her dress, kissed her naked feet, raised his
eyes to her..." Ariane, as always, forgives him, telling Solal: "Go
to bed, I'll cuddle next to you, I'll caress your hair and you'll
fall asleep." He proposes to cut up his own face to make up
for his misdeed, but he quickly changes his mind. "Archangel
of rage, he moved closer to the bed and, handling the belt of
his dressing gown as if it were a whip, threatened her with it."
Their paradisiacal life eventually becomes infernal, and Cohen
offers them only one way out, the most darkly romantic one
of all: a double suicide.

In the decades between *Mangeclous* and *Belle du Seigneur*,
much had occurred on the world stage upon which Cohen's
novels moved, and Cohen's biting satire of the functioning
of the League of Nations, which formally expired in 1946
but was effectively dead in 1939, takes on a different edge,
a harsher valence, in *Belle du Seigneur*. Cohen is a brilliant
and coruscating satirist of bureaucracy, its vanity and its
impotence against the larger forces of history. He gives
abundant evidence of his comic genius in the first half of
Belle du Seigneur, expanding mercilessly on the description in
Mangeclous of the daily life at the League of Nations of Adrien
Deume, the soon-to-be-cuckolded husband of Ariane. Later in
the novel, Cohen drops a hint about the model for his satire
of the League of Nations, when Solal picks up at a *bouquiniste's*

stall a copy of Saint-Simon's great memoir of the court of Louis XIV. Very little needs to be changed for that portrait of life at the court of the Sun King to fit the doings at the Palais des Nations in Geneva. Reading in his stolen copy of the book — in Solal's view, a Jew has no need to obey the law in a land where "Death to the Jews" is written on the walls — he is struck by a passage in which the author is "complimented by the entire court, for His Majesty honored him with a phrase." As at Deume's office, the goal is "to learn who is in favor and who in disgrace in order to be looked on kindly by the former and to avoid the latter." The magnificent pages in *Belle du Seigneur* on the social and professional climbing of the staff at the League of Nations, on their craven careerism and their hunger to rise by being looked upon kindly by those above them, are all drawn from the marvelously absurd life described by Saint-Simon.

Time is itself a character in *Belle du Seigneur*, counted in minutes, hours, and years. Adrien's entire work life is based on killing as much of it as possible, in doing as little as he can in the time he spends at work. Perhaps the funniest pages in the novel are those in which Adrien demonstrates to his wife, with great pride, that thanks to vacation time, weekends, and professional breaks, he works less than half the days of the year. But the most weighty and weighted count of time is the mortal distance that follows the first moments of the love of Solal and Ariane. Time is, for Solal, a murder weapon: every minute that takes Ariane and Solal further away from the birth of their romance is a step closer to its — and their — death. Love, and the fact that its death is present in its birth, and the way physical death haunts everything in life, are the central themes of *Belle du Seigneur*. It is an epic repudiation of the certainty in the *Song of Songs* that "love is as strong as death."

265

The Abjection of Albert Cohen

Solal repeats constantly in the novels, as does Cohen in all his works, that those walking the earth are nothing but "future corpses." *That* is Cohen's view of the world: bitter, morbid, disillusioned, hurt.

The love affair between Solal and Ariane will fail, like all of Solal's previous ones, and fail dismally. Solal always falls madly and unlimitedly in love, from the wife of the French consul in *Solal* to Ariane, in the *belle du seigneur*, her lord's beloved. But Solal almost immediately grows tired of women once conquest (and that is the only word that fits) has been accomplished. Love not only does not last; it cannot last. Solal knows that his loves are doomed, because he dooms them. Love *must* fail, for him, given the very nature of attraction, which for Solal is always based on falsehood. The hideous disguises that he assumes, starting with the night of his initial attempt at the seduction of Ariane, the ragged clothes, the tape over his teeth to make it appear that he is a pathetic husk of a man — all this was a test. He obsesses over the three grams that a tooth weighs and how love, in all its falsity, depends on those few grams. For Solal, would any woman love him or any other man, if, when he opened his mouth, the spectacle was ugly? Solal's answer is no. That being the case, what is there to love and attraction artifice, deceit, falsehood? He is as a lover what he is as a Jew — a pessimist.

Late in the novel, he challenges Ariane, who loves him beyond all measure, to agree that she would have loved him if he had no arms or legs, "Me, a little nauseating trunk... without arms, without legs, without thighs, but still, unfortunately and disgustingly for you, possessing the principle of virility." He goes even further: "My God, there's no need to even slice me up; a few missing teeth would be enough for your soul to no longer find any pleasure in mine." He is certain that

she would not, which is further proof that love is a lie. As he "rubs his hands together" at the joyful idea of rendering himself hideous, Ariane, faithful to her love for him, cries out: "Beloved! Enough of this. Why do you want to destroy everything?" This last is the question that can be applied to almost all of Solal's actions.

Love, all this implies, can only be love if it exists outside the body and the appearance of its beloved. "Baboonery" is the cruel and angry word that Cohen employs to signify the love that women feel; it is animalistic, enamored of violence. And the body, whose pleasures Solal has pursued his entire life, is also the enemy of enduring love. Not just its inevitable degradation over time: no, any deviation from perfection in daily life, however natural, is fatal to love. With their love still fresh and new, Ariane and Solal struggle to hide anything pertaining to the body that mars the image of perfection that they consider essential to protracting the purity of its beginnings. Rings under the eyes, the rumblings of the stomach, all these concessions to the slow ravages of the clock and the calendar, must be hidden at all costs, because they can damage or even destroy desire. Even contact with others is forbidden, since it might soil the lover or the beloved. Running off with Ariane has cost Solal his prestigious post, and they live in isolation in a hotel; and this isolation, too, is not a means of exalting their love, but also a magnifier of all their perceived or invented flaws. Both lovers share these unreasonable expectations, Ariane in her innocence, Solal in his brutal cynicism. For Cohen, the heights are the only place where love should reside, and where it can flourish. When it doesn't, when it can't, it dies, as it should. His pessimism was the outlook of a disappointed purist.

Solal is a deeply unattractive figure. He is not just an extraordinarily complex personality, but also an unpleasant

one. His overwhelming selfishness, his insistence upon extremes, has led to the suicide of several of his lovers, starting with his first love, Adrienne de Valdonne. His discarded lovers sacrificed everything for him, but none of their sacrifices seem to have had any impact on him. He is often, especially in *Belle du Seigneur*, quite reprehensible. How else describe a man who slaps Ariane, the woman he claims to love, who pulls her hair, who calls her a "whore," who tortures and torments her mentally concerning an affair that occurred before she met him?

Bella Cohen, the writer's third wife, defended her husband against the charge of misogyny in her *Autour d'Albert Cohen*. Her defense of her husband is, to put it mildly, weak. "How can one be a ladies' man yet hate and scorn women?" That there is no contradiction between the two is too obvious to require refutation. She also wonders how he could have been a misogynist when "so many female readers wrote to tell him of their happiness at having read him or, for some, at having met him." (Her final proof of Cohen's lack of misogyny is that Simone de Beauvoir "that pioneer of feminism, wanted to meet him.") She also draws Cohen's defense against this charge from the pages of *Belle du Seigneur*. Solal wonders, for example: "How is it possible that these women, so sweet and tender, these women, my ideal and my religion, how is it that these women love gorillas and their gorillaness?" From statements such as these Cohen's widow concludes that far from "attacking women... Albert Cohen essentially says that women are superior to men. He attacks only those women who betray themselves by accepting being treated not like women, but as *femelles*."

If Bella Cohen is right, then *Belle du Seigneur* and the rest of Cohen's fictional work is the vision of a man who knows what is best for women far better than they do themselves.

But is that not one of the characteristics of the misogynist? His is a world in which every woman whom he encounters, for the mere fact of loving him, and for other reasons as well, fails to be a woman and lives as a mere animal. This would be painful enough if it were a passing event, but it is his very nature as an amorist. Lengthy chapters are dedicated to Solal's degrading and insulting of Ariane, and they are hard to read without disgust; and even when she occasionally rebels, even if only for a moment, the dynamics of scorn and "lordship" remain the same. The love of Solal and Ariane is not remotely one of the "great romances." The lovers live cut off from the world, shunned by all who knew them, in a world of hotel rooms, where they disappoint and torment each other. In this way *Belle du Seigneur* is an heir to the punishing novels of the Marquis de Sade, which take place in locales cut off from the surrounding world. Sadean physical torture is replaced here with mental torture, but it is torture all the same.

Jewishness forever hovers over the novel, appearing in a strange chapter in Germany where Solal is held underground by a group of Jews in Berlin hiding from the Nazis. The theme explodes late in the book in a long and almost biblical section in which Cohen sings the praises of Jews and Judaism, of the Eternal in whom he does not believe. He writes lyrically of Jews' fidelity to their faith despite centuries of massacre. And he has a theory about the special destiny of the Jews, one that he repeats in his volumes of memoirs: that Judaism stands for "anti-nature," in contradistinction to the Nazis, but not only to them, who valorize nature, which unleashes the beast in humans. Judaism is great, and Jews are hated, because their religion is not a part of nature and rises above all that surrounds them. The laws and the prohibitions of the religion, which extract the Jews from the immanent terrestrial world,

The Abjection of Albert Cohen

are Judaism's grandeur. (Cohen did not practice them himself.)

"One beautiful day that was the glory of the universe," he writes rhapsodically, "one of my ancestors, a being who was part of nature and member of the animal species, madly decided on the schism, ridiculously decided on his two hairy and still deformed legs, that he no longer wanted to be part of nature and obey its laws. He decided that he would obey the new Commandments that he invented in the name of God, whom he also invented." When the anti-Semites "massacre and torture my Jews," it is because they "know or sensed that they were the people of nature and that Israel was the people of anti-nature, bearers of a mad determination that nature abhors. They are instinctively the people on the other side, who made God its chosen one and who, on Mount Sinai, declared war on nature and all that was animal in man." The notion that Judaism has an anti-naturalistic bias is not Cohen's invention, of course; to some extent it characterizes all the monotheisms, in which the Creator, and not the creation, is to be worshipped. For Cohen, this notion of the Jewish secession from nature was important in explaining his own abjection as a Jew and a lover. How can a libertine be opposed to nature?

Yet Cohen's quasi-philosophical paean to Judaism did not clinch the matter for him. Solal, remember, is dramatically torn between accepting his Jewishness and rejecting it. Solal only loves non-Jewish women, and the passages in which Jewish wives are proposed to him by the Valorous are treated as comic; he is attracted to beautiful non-Jewish women, some of whom are not uninfected with anti-Semitism — in the same way that his creator, the Zionist editor and activist, married two non-Jews before finally marrying a Jewish woman. Lévy gets to the heart of this: "One could — one can still — read this book as an allegory of Jewishness in the West and a wager on

the inevitable tragedy that results from it… One could read it as a novel that spoke of the temptation to deny oneself, the temptation, as Solal says at one point, to "play the monkey" with Christians and to be more Christian than the Christians… One can read this novel — and it's how I would reread it today — as the great novel of contemporary neo-Marranism, the great novel that expresses the internal torment of neo-Marranism: a goy outside, a Jew inside, living during the day in the world and returning at night to one's internal ghetto."

Lévy ultimately rejects such a reading in favor of viewing Solal as the *"Juif heureux,"* the happy Jew, a "Nietzschean" character, a "neo-pagan" reveling in the body. For Lévy, the voluptuary Solal is a response to the image of the Jew as a "being of reason"; Solal is defiantly, Jewishly, a "being of flesh." I am not so sure. For a start, such a view of the Jewish difference is an unwitting confirmation of the ancient Christian charge that Judaism is essentially, and nothing more than, carnal. And contra Lévy, it is precisely the contradiction between reason and flesh, the presence of both modes of being, and Solal's imposition of a twisted reason on the pleasures of the flesh, that makes the latter so fleeting. It is Solal's reason that leads to his death, to the suicide pact that ends the novel. A being of flesh, a "happy Jew," would accept the joys of this moment, and then of the next; but Solal is reason exacerbated — a fevered reason, if that is possible; reason finally heeded.

Cohen wrote one more novel after *Belle du Seigneur, Les Valeureux*, which appeared in 1969. Like *Mangeclous* after *Solal*, a comic novel following one drenched in Solal's rage at himself and his world. *Les Valeureux* is pure comedy; or almost so.

271

Cohen retreats here to the island of Cephalonia and the five oddballs who make up the group of Jews who have dubbed themselves *les valeureux de France*. The claustrophobia and the refusal of happiness of *Belle du Seigneur* is replaced here by a *rocambolesque* tale of five poor but joyous Jews making their difficult way in life. As in all their other appearances in Cohen's writing, no scheme is too wild for them in order to get by. Pinhas Solal, alias Mangeclous, is again at the heart of the story. Once again, no idea is too absurd to be entertained in his ceaseless search for wealth and prestige. For him, the only obstacle to publishing a newspaper in almond paste printed on chocolate is that the materials are too expensive. Here Cervantes meets Sholem Aleichem, sort of.

Mangeclous hits on the idea of establishing a university of which he will be the rector, the *Université Supérieure et Philosophique*, its classes held in the kitchen cellar of his home. To save money, no chairs are provided and students are charged for courses in subjects such as "amorous seduction in the Europes" at a rate of one drachma per hour, though food is accepted in its stead. "The intellectual elite of the ruelle D'Or," the main street of the Jewish quarter, attends its opening lecture, with fifty-nine eyes trained on Mangeclous, since one of the thirty students had only one eye. Students were taught that Vronsky was a close friend of the Tsar and made him laugh by tickling his feet. Between classes Mangeclous, not wanting to waste an opportunity to turn a profit, makes himself available to trim corns.

Solal figures nowhere in the book, whose events take place before those in *Belle du Seigneur*. Disturbingly and unexpectedly, however, his spirit suddenly seizes control of the novel, taking over the comic, egotistic character of Mangeclous. Professor and Rector Pinhas Solal, dressed

clownishly in a robe decorated with fabric cut from his skinny daughters' Sabbath dresses, in the middle of his analysis of *Anna Karenina*, suddenly begins espousing the theories of Solal. "European ladies are mad about the soul and what they call invisible realities, but they demand that the canines be visible," Mangeclous lectures his students. Women demand a full mouth of teeth, or love cannot arise; their potential lovers must be just the right height, just the right weight. Karenina, he says, is disgusted with her husband because of his trips to the bathroom, an act of daily life that Ariane and Solal held in contempt as well. What is "important for [women]...is the gorilla who delivers blows while looking like a man." "In short," Mangeclous tells his assembled pupils, "in order to feel true love they need a gorilla."

These grotesque passages mar a book that is a minor masterpiece of comic literature, but this seeming retreat from its bitter predecessor has a purpose. *Les Valeureux* is a valedictory work, returning Cohen to his native land for a final farewell. When we think of the vanished Jewish world, we most often think of the destruction of Eastern European Jewry in World War II, but this book is a reminder of another loss: the destruction of Greek Jewry, one of the grandest Jewries of all. The Jews of Cohen's Cephalonia are no more, nor is their ghetto. *Les Valeureux* is not just a depiction of five eccentrics. It is a memorial to a whole world. Cohen makes this movingly clear: "Praise and glory to you, brothers in Israel, you, adult and dignified, serious and sparing of speech, courageous fighters, builders of the fatherland and justice, Israeli Israel, my love and my pride. But what can I do if I also love my Valorous, who are neither adult nor dignified nor serious nor sparing in speech? I will thus write about them again, and this book will be my farewell to a dying species

about which I wanted to leave a trace behind me, my farewell to the ghetto where I was born, the charming ghetto of my mother, a homage to my dead mother."

The dead mother haunts and dominates Cohen's three volumes of memoirs. He wrote three autobiographical books, *Le Livre de ma mère* (published in 1954 and translated into English as *The Book of My Mother*), *O Vous, frères humains* (O You, My Human Brothers) published in 1972), and *Carnets 1978* (*Notebooks 1978*), published in 1979. In a very real sense they are one book, for the central concern of all of them is Cohen's undying love for his mother. All of them are what Cohen calls in *Le Livre de ma mère*, "a song of death," the title he gave an article on his mother's death in Occupied France in 1943 (during the war but not as a direct result of the Holocaust) that he published that same year in *La France libre*. He is tortured by the thought of her buried in her coffin, the earth weighing her down, hiding her forever. In *Le Livre de ma mère*, Cohen describes her lovingly preparing the Sabbath meal. Even the act of making meatballs is invoked movingly: "From time to time she went to the kitchen to make, with her tiny hands on which shone an august wedding ring, useless and graceful artistic tapping sounds with the wooden spoon on the meatballs simmering in the dark red coulis of the tomatoes. Her tiny hands, pudgy with delicate skin, for which I complimented her with a bit of hypocrisy and much love, for her naïve happiness delighted me." He expressed his filial devotion most fully in his final book: "In my old age I turn again to you, my dead Maman, and it is my pathetic joy to again bring you back to life a bit, holy sentinel and guardian of your son. To bring you to life again just a little bit before soon joining you, this is my pitiful magic and my poor trick in order not to have entirely lost you, Maman to whom I absurdly love to talk, dead

274

Maman to whom, stupidly smiling, I want to recount the days of my childhood." Cohen presents his mother as a saint, as his "beloved." She is the exception to his fatalism about love: "my mother's love, unlike any other."

His love for his mother excluded his father, who barely figures in his memoirs, and is all but cast out of the author's life in his final book. "As I child," he says "I told myself that my father had nothing to do with my birth, that I was born magically, that a prince arranged my birth through powerful words, that he is my true father, a magnificent prince and father." By the end of his life Cohen all but stripped his father of that title, calling him his "mother's husband." His hatred for his father is as unbounded as his love for his mother. His father is a monster: one "horrible day when, having found that the moussaka was not in conformity with that cooked by a famous great-aunt Rebecca, the persnickety *gastronome* had, with indignation, pulled to him with one tug the entire tablecloth as a fine for imperfect moussaka."

Cohen claims to have hated his father above all for his treatment of his beloved mother, whom he calls "the slave of her husband." "She worked, worked, the slave queen without music without literature and without thoroughbred horses, worked, worked, then came upstairs to take care of me, then went back downstairs, then came back upstairs, for years and years." But he was himself also a little culpable for her anxieties. She suffered, he says, from an "inferiority complex" towards the cultivated people that her son frequented: he once left her sitting in a park for five hours while he was with a woman, and he never introduced her to people in the social world in which he moved. Decades later he was consumed with guilt for all this, and tried to make amends for it with his pen. And at the end: "My beloved, I introduce you to them all now, proud of

you, proud of your Oriental accent, proud of your mistakes in French, insanely proud of your ignorance of high-class usages. A little late, this pride."

Though he preached the failure of love, Cohen was an ardent creature of loves. His books are full of them: of women, of his mother, of Pagnol, of literature, of the Jews and Judaism, of France, of God. (If one can hate a God in whose existence one does not believe, as many atheists have done, perhaps it is possible also to love a God in whose existence one does not believe.) Even as a Swiss citizen, Cohen faithfully loved France all his life, defending its honor as a participant in the Free French movement during the war. As a child he constructed an altar to his adoptive homeland. Along with a torn flag "to make it more glorious," a small cannon, and a picture of the president of the Republic, his "reliquary" to the glory of his adopted nation included "portraits of Racine, of La Fontaine, of Corneille, of Joan of Arc, of du Guesclin, of Napoleon, of Pasteur, of Jules Verne of course, and even of a certain Louis Boussenard." (Boussenard was a late nineteenth-century writer of exotic adventure novels.)

Cohen remained proud of the monumental philosophical revolution that his people had enacted in their rejection of the natural. There are many dazzling pages about this in *Belle du Seigneur*, and some of them belong with the epiphanic beauties of Joyce. But his pride in being a Jew remained tainted by the hideous event of his tenth birthday. In the final pages of his final book, he could only say that "that day when I turned ten was a day of new birth in which I lost all faith, the day of a new gaze, a Jewish gaze that came to me forever." Given how disabused and disappointed Cohen was, how damaged he was by the effects of reality on his ideal, his achievement as a writer of both comedy and rhapsody is sort of miraculous. Yet his

harshest truth, one that fills his autobiographical volumes, is this: that the love of one's neighbor is nothing but "futility and a gust of wind." "How," Albert Cohen asked, "can you sincerely love strangers? How can you love them in their thousands or millions, how can you love them with a real love?" Who, really, has an answer to his lonely question?

JOHN PSAROPOULOS

How Dictators Use Refugees

2014

On September 4, 2014, the top brass of the Hellenic Coast Guard held a rare press conference at their Piraeus headquarters. Commodore Yiannis Karageorgopoulos presented a series of slides showing the Aegean and Ionian seas, plus a portion of the east Mediterranean south of Crete, which comprise the Coast Guard's vast jurisdiction. Against this he flashed the number of intercepted entries of migrants seeking refugee status — 1,627 in 2012, followed by 12,156 the following year. Arrivals in 2014 suggested that Greece was on track for 31,000 arrivals. This was an underestimation. The annual total that year would almost quadruple, to 43,938.

The Coast Guard's concerns were very clear. Half of all the arrivals were Syrians. A third were Afghans. The Arab Spring that had resulted in regime change in Tunisia and Egypt and plunged Syria into catastrophe three years earlier was compounding the effects of America's regime change efforts in Iraq and Afghanistan, which created lengthy insurgencies, to produce unprecedented waves of refugees, and these crises were growing worse. The Islamic State of Iraq and the Levant, which emerged in Iraq's insurgency, had that summer taken control of Mosul, was slaughtering Yazidi in northern Iraq, and was marching across Syria. NATO's destruction of Muammar Gaddafi's regime in Libya had led to civil war there, further inflaming regional instability.

The Greek authorities knew that this spontaneous population of asylum-seekers had created a human trafficking industry in Turkey, just a few miles from Greece's easternmost Aegean islands. The vast majority of Coast Guard interceptions had taken place in the narrow straits between the Anatolian mainland and the Greek islands of Lesvos, Chios, Samos, Kos, and Leros. The smugglers were astute. They had launched refugees on inflatable dinghies with the following instructions: "When a Greek patrol boat appears, let them approach and THEN make a hole in one of the air tubes with the knife... Don't be afraid. Greeks will rescue you. They cannot repatriate you back to the Turkish mainland." (This note was found by the Coast Guard in the possession of asylum-seekers, and it is corroborated by my own interviews with refugees.) This was true. International maritime law obliges any sailor to rescue anyone who is shipwrecked, and the 1951 Geneva Convention on the Status of Refugees prevents national authorities from repatriating asylum-seekers to areas where they may be in danger — a hazard accurately known as refoulment.

How Dictators Use Refugees

The fact that Turkish smugglers were taking commercial advantage of humanitarian law struck the Greeks as cynical, but what alarmed them were changes in trafficking methods. "Because of the geographical configuration of the east Aegean islands and their proximity to Turkish coastlines," Karageorgopoulos said, "facilitators may no longer be needed and it is the migrants themselves who navigate the small boats." Earlier that year I had travelled to Kos to report on this shift in tactics. Two boatyards were full of court-confiscated speedboats that had come from Turkey, filled with refugees. Some of their outboard engines had bullet holes — even those whose owners had fitted them with additional fiberglass casings. "Last year we were facing a kind of invasion of very fast boats with a smuggler on board, and we needed to deploy our patrol boats to tackle this situation, and make some hot pursuits as well," the harbor master Ioannis Mispinas explained to me.

The loss of these vessels had raised smugglers' costs and led to lengthy imprisonments of up to twenty-five years. 2014 was the year in which smugglers realized that they could reduce their legal risk and costs by setting up production warehouses of two-tube rubber dinghies with plywood floors and small outboard engines assembled in Turkey. This worked. The proportion of arrested facilitators to refugees went down over two years, from 1.2% to 0.8%. More importantly, it meant an inexhaustible supply of boats and an explosion of turnover, and it was beginning to overwhelm the Greeks.

The authorities were looking at the numbers and had become genuinely concerned about their ability to police their borders. But asylum law is concerned with individuals, not masses, and balancing national security with humanitarian values was now a challenge. I remember meeting a Syrian man as he huddled with his children on the harbor wharf on

280

Kos, having just been picked up by the Coast Guard. "I want safety," Hany Asef told me. "I am coming from death — I am and my family — coming from death. I want any safety." Asef's children had seen Aleppo reduced to rubble. More than once, their parents said, men's throats had been cut before their eyes. The Asefs were not rich. Hany worked in the water utility. His wife, Bara'a, was a teacher. They had spent all their savings — $3,500 dollars — on this crossing. It is precisely for people like them that the Geneva Convention was drafted.

How was Greece to reconcile its obligations towards individuals under the Geneva Convention with its obligation to safeguard its borders, which are also the European Union's external borders?

2015

If 2014 had troubled the Greeks, 2015 was apocalyptic. The September 2014 press conference had been held out of alarm at more than 17,000 refugee arrivals so far that year. At another press conference in September 2015, it was revealed that January-to-August arrivals numbered over 230,000.

Showing aerial photographs of dinghies setting out from Turkey, Deputy Merchant Marine Minister Christos Zois told journalists, "Here you see a dozen craft setting sail within thirty or sixty minutes of each other — in other words, almost simultaneously. I'm not allowed to use the phrase 'sea landing,' because it's not one in the strict sense. But these pictures show that we are talking about an organized industry that takes advantage of human pain and human need. And it's up to the Hellenic Coast Guard to respond in real time."

The Hellenic Coast Guard wasn't by then responding in

real time. Only fifty thousand asylum-seekers had punctured their boats to be plucked from the sea. Many had beached their dinghies on Greek islands without ever encountering the Coast Guard. It was simply overwhelmed. What Zois didn't show was photographs later made public by the Coast Guard showing Turkish gendarmes helping direct asylum-seekers onto boats. The collusion of the authorities was known at the time, but the Greeks were trying not to antagonize the Turkish government.

Shortly afterward I found myself on Lesvos' north shore. Dinghies loaded with upwards of fifty people were coming in every few minutes. Even though they didn't need to wreck themselves to be rescued, they ceremoniously punctured their boats as if to say there was no going back, so that each arrival was marked with an explosion of air. They splashed into the shallows with cries of *Allahu Akbar!* and indiscriminate cries from the elderly Afghans, who never having been suspended over a body of depthless water now gave vent to their accumulated terror. Some kneeled and prayed gratefully. The beach was littered with deflated vinyl, plywood, and 25hp engines. Scavengers picked up the engines and the plywood. Authorities trucked the vinyl and lifejackets to a nearby landfill, where black and orange mountains accrued. Just behind the beach, volunteers had set up makeshift shelters where they provided gold foil capes, dry clothes, Nutella sandwiches, and juice. The island's taxi drivers had abandoned their Greek clients and lined up to ferry refugees to the reception center for fifty euros from dawn till dusk. All had been years behind on their social security payments, the mayor later told me, and all had now caught up.

The phenomenon caused alarm in Europe as well. The islands of Lesvos, Chios, Samos, Leros, and Kos, which had

Reception and Identification Centers, were not sufficiently staffed or equipped to cope with these numbers. It was difficult to fingerprint and register everyone on arrival. Nor was there room enough for new arrivals to stay. The government chartered ferries to take people to the mainland, where they pursued their journeys inland. There was concern that Islamic terrorists could infiltrate, as indeed they did. On November 13, 2015, three simultaneous suicide attacks in the northern Paris suburbs killed one hundred and thirty people, ninety of them at the Bataclan theater: at least two of the attackers had arrived on Lesvos a month earlier, where they had been registered as asylum-seekers. Two villains out of many thousands may seem a mercifully small proportion, but at the time it unnerved northern Europe, where the 9/11 attackers had been recruited.

"2015 was for Europe what the Twin Towers was for the US," says a retired senior police officer who was responsible for refugee affairs. "After Bataclan, France insisted that the European Commission pull out of its drawers whatever proposal existed regarding security on the migration issue. In 2016 Greece signed an agreement for Europol guest officers to conduct secondary security checks on asylum-seekers. Europol signed a memorandum with Frontex [the European border and Coast Guard, which interviewed refugees] to further analyze information from asylum-seekers' debriefings, when they explained what route they took and what smugglers they used. At the same time, Europol demanded the data from suspects' cell phones."

If Europe was worried about terrorists, Greece was worried about a Turkish provocation. In March 2015, Andreas Iliopoulos was Deputy Chief of the Army and oversaw the Supreme Military Command for the Interior and Islands (ASDEN), which is in charge of the National Guard in

the Aegean. "I became extremely worried, because it was impossible to fend off a potential malicious act by Turkey under the guise of the refugee crisis," he told me. "It's very easy for commandos to infiltrate that crowd and stage a surprise."

The risk of infiltration by Turkish commandos was real to the Greeks. In 1996, Turkey had landed commandos on the islets of Imia, between Kalymnos and the Turkish coast. Greek sovereignty over Imia had never been questioned before. Greece responded with a naval deployment. President Clinton told both NATO allies to pull back, and put the islets out of bounds to both. What had been Greek territory was now a grey zone. Since that incident, Turkish nationalist think-tanks circulated a list of one hundred and fifty two Greek islets and islands whose sovereignty should be similarly disputed. (That has now percolated into official policy in virtually every Turkish party.) By 2015, many Greek officials were concerned that Turkey might land refugees instead of commandos on islets that it wished to claim, and then ostentatiously rescue them to demonstrate Turkish search-and-rescue jurisdiction in those areas. This soft form of sovereignty could gradually harden through a subsequent threat of confrontation.

284

Not all Greek political parties saw refugees as a potential cloak to a security threat. The conservative New Democracy party had in January 2015 lost power to the Coalition of the Radical Left, or Syriza — the result of a deconstruction of Greece's bipartisan political system wrought by five years of austerity policies, which flung voters to extremes like a centrifuge. The Conservative Prime Minister Antonis Samaras had come to power in 2012 referring to irregular migration as "an unarmed invasion." New Democracy had prided itself on cleaning the streets of unregistered migrants and putting them into camps: the first time this had happened in Greece.

The government had been accused of pushbacks — turning people around at the border without the chance to apply for asylum.

But the tenor under Syriza was very different. "It was the first time we heard a cabinet minister say the word 'refugees.' Until then we heard 'migrants' or worse — illegal migrants, and so on," said a retired senior Coast Guard officer. "We heard the prime minister [Alexis Tsipras] wondering aloud whether there is such a thing as a border at sea. This suggested a different school of thought, one that was very friendly to the entry of these many thousands of people by land or sea." Government statements reflected this. In September 2015, the Migration Minister Yiannis Mouzalas told journalists that "the problem is a refugee problem, not a migration problem. Eighty percent of these people are refugees." This assumption in turn suggested that Turkey was not the problem. "Turks say they do not actively promote these people to our shores. If they say so, I do not wish to doubt it," Antonis Makrydimi-tris, the Deputy Minister of Public Order, said at the same press conference. With respect to pushbacks, the Deputy Minister of the Merchant Marine Christos Zois now said, "To ask us to send them back is irresponsible. This cannot form a strategy or a tactic. Our country is a law-abiding member of the EU and international law is a code we must follow."

When this principled position was voiced by the leader of Europe's biggest economy, it became more consequential. "It is certainly correct, that whoever wants to come to us for economic reasons, must be told, 'you cannot stay long-term, we cannot manage that,'" Chancellor Angela Merkel told the Bundestag on September 4. "But who flees misery, war, political oppression, there we have the responsibility to help, based on the Geneva conventions for refugees, based on our asylum

285

policy and on article one of our constitutional law, whether we want to or not." Arrivals in Greece for August 2015 had been just under 108,000. In September, after Merkel's historic speech, they shot up to 147,000, and in October to nearly 212,000. They began to fall again in November and December as winter made crossings more difficult and dangerous. Germany had expected its open-door policy to bring eight hundred thousand asylum-seekers, and that number had been reached by the end of the year, as European border controls were suspended and asylum-seekers were allowed to walk through Greece, North Macedonia, Serbia, Croatia and Austria into Germany.

But Europe feared a repeat performance in the spring. In February 2016, Austria created a separate refugee monitoring system with the police chiefs of the former Yugoslavia, prevailing on North Macedonia to put up barbed wire along its border with Greece. This effectively closed the Balkan route, bottling up arrivals in Greece. On March 20, Merkel engineered the EU-Turkey agreement, calling on Turkey to "readmit, upon application by a Member State... all third-country nationals or stateless persons who do not, or who no longer, fulfill the conditions in force for entry to, presence in, or residence on, the territory of the requesting Member State."

Turkey now demonstrated its ability to hold back flows when it wanted to. Arrivals on the Greek islands dropped dramatically, from an average of 2,700 a day in early 2016 to 300 a day by the end of March, and double digits shortly after that. But Turkey never fully implemented readmission clauses, and in July 2019 it unilaterally suspended them, saying that from its point of view these had always been meant as *quid pro quo* for visa-free travel for Turkish nationals in the EU. This was Turkey's first open admission that it meant to instrumentalize the refugee issue to bargain with Europe.

Some officials believe that Merkel had struck a secret deal with Erdogan to allow eight hundred thousand refugees into Europe. Whether that is true or not, Merkel's official deal with Erdogan, known as the EU-Turkey Statement, handed him control of the sluice gate. He had uses for Europe's fear of immigrants. And impotently stuck between the North Macedonian barbed wire and the discretionary arrangements between Ankara and Berlin, Greece was manifestly unable to manage its maritime border.

Those Turkish uses for the crisis soon became clear. The spike in refugees in 2015 dovetailed with the launching of a new Turkish doctrine called *Mavi Vatan*, or Blue Homeland — an expansionist claim of sovereign rights to search for undersea oil and gas. Maps circulated by the Turkish admiralty cut the Aegean Sea in half, claiming as Turkish all sovereign rights east of the 25th parallel. This includes the islands of the east Aegean, where refugees alight.

Mavi Vatan was a direct reaction to two things. Under the United Nations Convention on the Law of the Sea (UNCLOS), the international standard law for maritime rights and borders, Greece's islands give it half a million square kilometers of Exclusive Economic Zone in the east Mediterranean — an area beyond territorial waters where sole sovereign rights to exploit undersea wealth apply. That is four times Greece's territorial expanse. A map of the EEZs of Greece and Cyprus under UNCLOS, published by two researchers at the University of Seville in 2004, shows a vast maritime area described by one expert as "a continuous Cypriot-Hellenic maritime area, encircling almost the entire Anatolian peninsula and enclosing Turkey in its land space." Turkey violently disagrees with UNCLOS and walked out of the negotiations that shaped it in the 1970s.

The second development to which *Mavi Vatan* was reacting was the discovery of undersea oil and gas by Israel in 1999, Cyprus in 2010, Greece in 2014, and Egypt in 2015. In 2014, seismic explorations across Greece's EEZ suggested that it may have natural gas reserves of 70-90 trillion cubic feet — almost as much as Israel, Egypt and Cyprus have discovered since the turn of the century combined, with a pre-Covid market value of about two hundred billion dollars. *Mavi Vatan* was a directly competitive claim for the sovereign rights of Greece and Cyprus, and it reinvigorated a Turkish policy to challenge all forms of Greek jurisdiction and sovereignty in the Aegean and east Mediterranean. This policy aims to press Greece into a discretionary political delimitation of maritime boundaries, rather than a legal one at the International Court of Justice at the Hague, as Greece has suggested.

Turkey has intensified every tactic short of war to realize this aim. Turkish violations of Greek territorial waters numbered in the dozens per year until 2009. Since 2017 they have been in the thousands. In 2014, the year Greece discovered natural gas in its Aegean, Ionian, and Mediterranean EEZ, violations quadrupled to over two thousand two hundred. After that, they rose to about four thousand annually, and included overflights of inhabited Greek islands. Last year they reached a new record of over ten thousand.

Search-and-rescue with respect to refugees and shipping has also been mobilized as part of this jurisdictional dispute. Ten years ago, the Turkish Coast Guard changed tactics. Instead of patrolling along the length of the coast of Asia Minor, it launched sorties towards the puddles of international waters that lie in the middle of the Aegean — areas that would become Greek if Greece were to exercise its right under UNCLOS to claim twelve nautical miles of territorial waters around its

288

islands — double what it claims today in the Aegean. Turkey has issued a threat of war if that happens. "These are the waters ships sail through when they clear the Dardanelles, so the first thing they see when they enter the Aegean is a Turkish boat," says the retired senior coastguard officer. "There the ships operate as hailing platforms, and they show the flag."

Hailing, like flag-showing, is a way of projecting power. "Let's say a merchant vessel is sailing off Sounion," says the officer, referring to the cape that lies just forty kilometers south of Athens. "Around 3 a.m. there is a lone officer at the helm, and he is hailed by the Turkish Coast Guard: 'What are you carrying? Where did you load? Where are you unloading? What is the nationality and number of your crew? And by the way, if you need anything, call us.' This happens hundreds of times a year," he says. "The tactic is to hail boats crossing through Greek territorial waters. Then shipowners from around the world are under the impression that the Aegean is under joint management with Turkey. Their feeling is that their ships are safe, and they thank Turkey for showing an interest. Anything to do with accidents, groundings, refugees, accidents and so on — Turkey turns it into a race with the Greek authorities. They force us to defend our turf daily." The Turkish regime saw the refugee influx not as a humanitarian crisis but as a strategic opportunity.

2020
On February 27, 2020, Turkey lost at least thirty-four military personnel to advancing Syrian forces in Idlib. The Turkish president Recep Tayyip Erdogan held an overnight national security meeting, after which he announced that Turkey

would open its borders to asylum-seekers crossing to Europe. Erdogan wanted to involve NATO in policing a thirty-kilometers-deep military zone that it had created on the Syrian side of the border, and he was leveraging the threat of a replay of the 2015 refugee crisis to put pressure on the EU, whose members make up most of NATO. "Europe cannot endure this, cannot handle this," Erdogan's Interior Minister, Suleyman Soylu, told CNN Turk. "The governments in Europe will change, their economies will deteriorate, their stock markets will collapse."

Erdogan had often used the threat of unleashing refugees on Europe before. Now it seemed that he would act on his threat. The news fell like a bombshell in Greece and Bulgaria, which braced themselves for the expected influx; but over the next two weeks only Greek borders would be assailed. To the Greeks it was apparent that Turkish pressure on NATO dovetailed with its *Mavi Vatan* territorial ambitions against them, because a demonstrable Turkish ability to render Greek borders ineffective would be a display of power to control those borders.

Erdogan advertised free bus rides for asylum-seekers from Istanbul to the Greek-Turkish land border. On Lesvos, I spoke with asylum-seekers who told me that they had been plucked out of church, or stopped on the beach, by smugglers who offered them free passage. Typical fare for the crossing a few days earlier was five hundred dollars. The smugglers did not say who was paying them to waive their fee now, but Greek suspicion fell on the Turkish government. Soon the suspicion was confirmed. The Hellenic Coast Guard released video of Turkish Coast Guard vessels escorting refugee boats to the edge of Turkish territorial waters and directing them to continue towards the Greek islands.

Turkey consciously manufactured this refugee crisis to

demonstrate that it was disputing maritime jurisdiction and had the Greeks on the run. It repeatedly released videos showing Turkish Coast Guard boats pursuing Hellenic Coast Guard boats to the point of nearly colliding with them, while the Greeks stayed on the defensive and conducted evasive maneuvers.

It was a different story on land. Only one hundred and sixty kilometers long, Greece's land border with Turkey follows the natural defenses of the Evros river and its marshy delta. Tens of thousands of Greece's best trained and equipped troops are stationed there. Greece built ten kilometers of double chain link fence along the most vulnerable stretch in 2012, and this helped it to repel asylum-seekers who had amassed on the Turkish side of the border. Europe came to its aid, politically and practically. First Austria and later other EU member states sent elite police units to help patrol the Greek side of the border. The EU pledged seven hundred million euros in emergency aid. Visiting the Evros on March 3, the European Commission president Ursula Von Der Leyen called Greece "our European shield." By March 9, Greece registered 2,164 successful crossings, of which 313 by land and 1,851 by sea. This was by no means the deluge that would bring down European governments.

"What Turkey tried to do in March 2020 was to have a mass intrusion of more than one hundred and fifty thousand people in the north within a few days," a Greek government official who was present at prime minister Kyriakos Mitsotakis' crisis meetings in 2020 told me earlier this year. The sudden influx of even one hundred and fifty thousand "would obviously be beyond any capacity to sleep, feed, protect this population," the official said on condition of anonymity. "And that would have led to a collapse of the country in the north. If we... were a failed state, unable to provide for anything, and there were

people breaking into houses to eat because there would be no food because there are no camps for one hundred and fifty thouand people... I don't know what would be the military implication if that happened."

The Greek government had decided that this was a state-backed mobilization requiring a security response unburdened by humanitarian concerns. Officially the HCG denied conducting pushbacks, but the Migration Minister Notis Mitarakis stated on March 1 that "the Hellenic Navy and Hellenic Coast Guard have prevented many, many cases of migrant entry by sea," effectively admitting to the policy. But the European Commission also reined Greece in from abandoning the Geneva Convention altogether. Greece initially denied new entrants the right to apply for asylum, saying they were acting as Turkish agents. Under pressure from Brussels, they reinstated the right in early April.

After the events of 2020, Greece replaced the Evros chain link fence with a four-meter-tall steel palisade capable of stopping armored vehicles, reinforced with extra patrols, thermal and visual cameras, ground sensors, drones, and other high-tech equipment linked to software designed to alert guards to suspicious activity. It extended this palisade to forty kilometers and in May 2022 said it will extend it to one hundred and twenty kilometers. It is arguably the European Union's most heavily fortified and monitored external border.

Turkey failed to blackmail the EU and NATO into backing its operation in Syria, and EU-Turkey relations have since darkened. Europe is amending the Schengen Code, which allows borderless travel within the European Union contingent on strong external borders, to reflect the events of 2020. "The instrumentalization [of refugees] was discussed, and this will be put into the Schengen code as a legal term," says

a Brussels diplomat involved in the discussion. "Everyone remembers the 2015–2016 experience, and the fact that 2020 was an attempt to recreate it. So Greece remains on the agenda. Everyone is very happy that Greece is guarding its border effectively," the diplomat told me.

This securitization of borders, apart from keeping freedom of movement within the EU intact, serves another purpose. "There is a discussion on the right to access to asylum," the diplomat said. "In this context, anyone needs to be able to enter European borders and then we will see what we will do with them. But to all intents and purposes that means we keep them, because statistically 85% of those who enter remain. It is extremely difficult to do deportations." Keeping people out therefore means fewer asylum acceptances and less politically toxic debate about how many non-European Muslims the EU can integrate.

2021

Shortly after an election in August 2020 returned Alexander Lukashenko to a sixth term as president of Belarus, riots erupted in the streets of Minsk. Lukashenko's margin of eighty percent of the popular vote was not credible to many who had voted for his opponent, the thirty-eight-year-old school teacher Sviatlana Tsikhanouskaya, who claimed that she had won sixty percent of the vote. (She was running in place of her husband, whom Lukashenko had jailed.)

Lukashenko's ensuing crackdown prompted EU travel bans and asset freezes on dozens of businesspeople and individuals in the state apparatus that was responsible for the repression, and eventually included banning Belarusian

293

carriers from EU airspace. On May 26 2021, Belarus' President Alexander Lukashenko retaliated, threatening to flood his neighbors with "refugees and drugs." Another dictator had found his own political use for refugees. Refugees crossing into Lithuania from Belarus, most of them Iraqis, were reported to number 4,100 by September, fifty-five times the previous year's flows.

In the autumn Lithuania began building a five-hundred-kilometer-long fence along its border with Belarus. By then refugees were walking over Belarus' borders with Latvia and Poland as well. The European Union condemned Lukashenko's policy as an attempt to destabilize its neighbors and press the bloc to lift sanctions. Belarus said sanctions were depriving it of the ability to control its borders. "The instrumentalization of migrants for political purposes by Belarus is unacceptable," Ursula von der Leyen said on November 8. "Instrumentalization" was a phrase first used in the context of Turkey's 2020 operation against Greece, and the reference was not coincidental. Unlike Turkey, Belarus does not border on refugee-producing states, but its state airline, Belavia, was offering visa-free travel to refugees from Istanbul, as were Turkish Airlines, and those flights were enabling it to stage a refugee crisis in Central Europe.

The EU slapped sanctions on Belavia in December. "Migrants wishing to cross the Union's external border have been flying to Minsk on board flights operated by Belavia from a number of Middle Eastern countries, in particular Lebanon, UAE and Turkey," said the European Commission. "In order to facilitate this, Belavia opened new air routes and expanded the number of flights on existing routes." Von Der Leyen told the European Parliament that traffickers were acting as "specialized travel agents offering all-inclusive

deals: visas, flights, hotels and, somewhat cynically, taxis and buses up to the border," which was independently verified by media reports.

The Commission began to methodically disarm Lukashenko. It gave Iraq three and a half million euros to repatriate its nationals, and threatened airlines carrying refugees to Belarus with deprivation of overflight and landing rights within the EU. Within days, several airlines had said they would only transport Belarusian nationals and those with residence rights. The Commission also funded border protection measures, as it had done on the Evros. It tripled border management funds to Latvia, Lithuania and Poland to two-hundred-million euros for 2021–2022. It put forward a set of temporary asylum procedures which allowed the three countries to apply "simplified and quicker national procedures" to deport those whose asylum applications are rejected. It was an attempt to hew to the Geneva Convention, but the three member states were reluctant to follow even accelerated procedures, preferring to eject asylum-seekers outright, as Greece had done.

"The feeling was that Europe is being attacked and needs to respond dynamically," said the Brussels diplomat. "There was a lot of tolerance for strict border control... The Commission believes its reaction [to Belarus] was a success," he said, but cautioned that legislative efforts to achieve greater solidarity and burden-sharing of asylum processing within the EU will fall by the wayside as a result. "I think the tendency will be to leave legislation untouched and to tighten procedures — exchanges of information, databases, etc. You have better border protection, the EU spending money on surveillance."

Vladimir Putin is the latest elected dictator to utilize refugees as an instrument against Europe. Russia has already achieved a refugee crisis on the continent. The United Nations says that fourteen million Ukrainians, about a third of the population, are displaced as a result of the war, six and a half million inside Ukraine and almost eight million in Europe. Moreover, European leaders believe that in blockading the export of Ukrainian wheat through the Black Sea, Russia is consciously trying to create a famine in Africa, leading to a new refugee wave. Europe's High Representative put it this way to *Journal du Dimanche*: "Russia is using the grain blockade as a weapon of war, everyone should be aware of that. And if the two great sources of grains and oilseeds cannot leave Ukrainian ports, yes, there will be famines in the world."

In 2021, Ukraine produced almost forty percent of the world's sunflower seed oil, fifteen percent of its barley, and ten percent of its wheat and maize. Wheat prices jumped from about $800 a bushel to around $1,100 after the war in Ukraine began. The EU estimated that twenty million tons of grain remained in storage in Ukraine last summer, and ships were needed to move them. "Whole trains and river barges in the thousands will not be enough," said the European Council President Charles Michel. And Russian commentators confirmed the tactic. The Kremlin propagandist and editorial director of *Russia Today* Margarita Simonyan told the St. Petersburg Economic Forum in June that Muscovites were joking that "the famine is our only hope." She explained that this was a reference to Russia's blockade. "The famine will start now, and [the West] will lift the sanctions and be friends with us, because they will realize that it is necessary."

The head of Ukraine's presidential office, Andriy Yermak,

said that Ukraine had evidence that Russia, apart from shipping thousands of tons of captured grain to Crimea, was attempting to destroy unharvested fields with incendiary bombs. North African countries have already felt the pinch, and those that have the money, like Egypt, have negotiated block purchase agreements. But what such a food crisis will do in war-torn Libya and the unstable countries of the Sahel is anyone's guess.

Imperiling food security so as to create conditions that will produce a strategically useful eruption of refugees: this seems to be Russia's plan. And Turkey's ambivalent stance towards Russia raises questions about possible collusion. In contrast to other NATO members, who are donating weapons to Ukraine, Turkey is selling it hundreds of TB2 drones at five million dollars a piece. (It has also donated four.) Turkey is the only NATO member not to impose sanctions on Russia, and encouraged Russian oligarchs to view it as a safe haven. Interviewed by CNBC at the Doha Forum in Qatar, the Turkish Foreign Minister Mevlut Čavusoglu said in March last year that "if you mean that these oligarchs can do any business in Turkey, then of course if it is legal, and it is not against any international law, then I will consider."

Cavusoglu's comments came twenty-four hours after Turkey's president Erdogan appeared to invite Russian oligarchs to relocate their assets in Turkey. Erdogan told journalists accompanying him home from the NATO summit on March 25 that he welcomed international companies departing Russia to establish operations in Turkey instead. He then added, "Apart from that, if there are certain capital groups that want to come to our country and 'park' their facilities with us, of course, we won't keep our doors closed to them. Our door is open to them as well." Satellite images show that

Russian oligarchs have indeed been sending their yachts and private jets to Turkey. Data from last May show that Turkey is the top destination for Russian overseas home buyers and passport applicants. At best, this equidistance between Russia and NATO implies opportunism, since Turkey is in dire need of foreign currency reserves to bolster its sliding lira, and at worst an arrangement with Putin.

In Greece, meanwhile, refugee policy again hardened when New Democracy was returned to power in 2019. A new immigration law made appealing first-time asylum denials impossible without a lawyer. Applications began to be fast-tracked to match the speed of arrivals. "The rules have changed," the Migration Minister Notis Mitarakis said in January, 2020. "We are not open to people without a refugee profile" — a phrase that remains undefined but is generally taken to mean nationalities not ravaged by war. A new generation of closable camps on the islands has expanded capacity from six thousand to twenty thousand.

Treating potential asylum-seekers as a security risk and even a military threat has a huge cost to those who are neither. Most of the Syrians, Iraqis, and Afghans who crossed into Europe are middle-class professionals or, in some cases, productive farmers. They seek secular rule-of-law countries where they would be safe from arbitrary fiat and violence. They desire open societies where their children could be educated and free from discrimination. They are not in Europe to threaten its liberal order but to affirm it. I have come across this again and again.

Some examples: Annas Khalifa, a Syrian man from Aleppo in his early twenties, just wanted to finish his electronics degree when he fled the draft. I interviewed him on a ferry gangway in the Greek port of Igoumenitsa, moments after he was arrested trying to escape to Italy in 2014. "You will

choose to fight with Assad or against Assad," he told me. "My mission is to invent stuff because I love electronics... I don't need to fight anybody. I just need to study." Fatima Ahmadi, who was sixteen, and Zahra Teimouri, who was fifteen, when I interviewed them in 2016, left Afghanistan because the Taliban persecutes their Hazara sect of Islam. I spoke to them at the Melissa Network in Athens, which organizes language and skills classes for women. Zahra told me that she had seen fighting and explosions in her town since she was ten. "It was so bad, I cannot explain," she said. She wanted to become a civil engineer or a chemist. Fatima wanted to be a doctor. Didn't their parents expect them to get married at their age? "My parents said first study, and second get married," Fatima said. Zahra had received the same advice. And in May 2015, I met Hashim, a Yemeni businessman, on the Greek border with North Macedonia. In the dead of night, he was trying to spirit himself and his two teenaged sons north. "I decided to leave Yemen so that I will never see my children fight for Al Qaeda or any other side. Sooner or later, one militia or another will approach them," he told me. He had left his wife and four youngest children behind to face the perils of malnutrition, sickness, and war.

The values and the priorities expressed by these and other asylum-seekers essentially make them Europeans. They aspire to the same things as middle-class Westerners. They know that their own societies have failed, often catastrophically, and that their adult generations are lost. Many want to return and rebuild their homelands with the skills that they learned in the West when it is safe to do so. The idea of asylum was precisely this — to shelter and nurture until the storm has passed. It is difficult. People ripped out of their social context cannot be productive. They need investment and support. Often they are

forced lower in the social order, but they are more than willing to undertake these sacrifices to save their families and improve their children's lot.

Increasingly, though, asylum is being ignored — an inevitable consequence of preventing irregular entry at the border. What was meant to be an award on the merits of individuals is increasingly nudged in the direction of a summary judgment based on national profiling. Numbers are partly responsible for this, but so is instrumentalization. "The refugee crisis is a humanitarian crisis, and that's how we should face it, but it is also used as an aggressive act — I'd say a form of hybrid war," Iliopoulos told me. "The result is that the refugee issue has been transformed from a humanitarian issue into a form of attack." The cynicism of this is breathtaking.

On March 2 last year, the Turkish government released video of the Hellenic Coast Guard attempting to push back refugee-filled rubber dinghies with long poles, maneuvering in front of them threateningly, and even firing into the water. Part of Turkey's hybrid warfare was to trap Greece in a moral dilemma; Greece could either display the power to prevent irregular entry or the humanity to accept them in the spirit of the Geneva Convention, but not both. All of Europe is now caught in this moral dilemma, as dictators (and the would-be dictators of the new European right, who demagogically and proto-fascistically exploit the presence of refugees in their countries to frighten voters into supporting them at the ballot box) make it a priority to spin a narrative about the moral superiority of an imperiled West.

Legal aid NGOs in Greece, Germany, and France have begun to document evidence of summary expulsions without due process, especially at the Evros. They filed thirty-two lawsuits at the European Court of Justice last year alone.

300

At least one case has been filed with the UN Human Rights Committee. The reason that these cases do not go to Greek prosecutors is that they are not prosecuted. The Greek Helsinki Monitor, a human rights watchdog, told me that over the past three years it has sent more than two hundred cases of summary expulsion — including torture, rape, and robbery — to twenty Greek prosecutors, to the National Agency for Transparency, and to the Greek Ombudsman. *None* has resulted in prosecutions.

This lack of accountability at home and mounting cases in international courts are a reputational risk for Greece. "Everyone can make the connection," remarked Pavlos Eleftheriadis, professor of public law at the University of Oxford. "If you don't respect the rule of law in one area, especially an area where you might get political benefit, you might not respect the law somewhere else, too... In terms of creating a hospitable environment for foreign direct investment, I'm sure it's going to reflect very badly on the standing of Greece." And not only Greece. The cases are also a reputational risk for Europe. More than once the European Commission has called on Greece to refrain from pushbacks, but more likely than not these remonstrations are phony, just high-level virtue-signaling. Spain has conducted high-profile pushbacks at its territories in Morocco; Lithuania and Poland refused entry to thousands in 2021; and Italy has paid and equipped the Libyan coastguard to retain asylum-seekers under inhumane conditions in North Africa.

All of these exclusionary practices were suspended during the Ukraine war, when the refugees were white, Christian, and European. Within days of the war starting, Europe activated Temporary Protection status for Ukrainians, an extraordinary measure first designed for Yugoslav refugees in the 1990s but

never used. It meant that Ukrainians did not need to apply for asylum for a year, extendable to three years. They were considered *de facto* refugees. It was the right thing to do given that there was a war on European soil, but it underlined the discretionary way in which Europe is prepared to apply asylum law, and it had consequences. The civilizational triage was painful to behold. Germany evicted Afghan refugees from their temporary homes to make space for Ukrainians.

Many officials believe that after the Ukraine war is over, and with or without Putin's famine, refugee flows to Europe will again increase due to wars, failed states, and a failing global environment. The question for Europe is whether it will continue to put itself in Turkey's Machiavellian hands or develop a deeper and genuinely humane strategy. This could entail incentives to invest North Africa and the Middle East. Creating jobs and strengthening the middle class there would contribute immensely to Europe's security. Europe could also circumvent human traffickers by allowing direct resettlement of asylum-seekers. Such a policy implies a solidarity mechanism within the European Union that would allow countries to share asylum recipients according to the size of their population and economy. It also implies solidarity between the United States and Europe to create a global movement for asylum, much as was done for Afghans fleeing the fall of Kabul in 2021.

Yet both Europe and America fear that a stable, principled, common asylum policy will act as an attraction for economic migrants and encourage dictators to take advantage of the instabilities. Nor is there support for an open-hearted policy among electorates, a reflection of the economic insecurity of our increasingly Darwinian societies in an age when the promise of capitalism to lift all boats has faded. And both in

Europe and North America, it is clear that the Geneva Conventions are thought to apply primarily to the white Christians whose plight in World War Two inspired them, but not to different people from less economically developed societies. Human rights are not truly felt to be universal, but seem to be reserved for the societies that thought of them.

The lesson of 2014–2022, however, is clear. It is that inhumanity gives dictators easier ways to shape narratives against us and politically to divide us. The West can decide to address economic inequality, organize society around centrist and humane policies, and adopt a common stance towards asylum-seekers, or it can continue to provide despots with ways to blackmail it and malign its otherwise glorious commitment to the Enlightenment and the individual rights that it inspired.

CELESTE MARCUS

Good Painting

304 The temple is a latch on the skull where four bones fuse: the frontal, parietal, temporal, and sphenoid. In anatomy courses at art academies students study the latch and its quadruple planes with the help of diagrams and gypsum reproductions. Students draw and redraw these models, accustoming themselves to the relations of the shapes which make up the skull and the rest of the skeleton until at last they can consistently, almost perfunctorily, sketch the outline of a human form with precision. The pencil line will conjure the sweep of the collarbone into the shoulder blade, the spine's curve, and the haunches above the hips as if the whole figure were fully

formed in the artist's mind and the hand holding the pencil was itself manipulated by the figure in the artist's imagination — as if the pencil was automatically, without thought, acting on a directive issued by the artist's subconscious. This automaticity is the point, the essence of the draftsman's skill. Like a dancer whose knowledge of the choreography is not reflective but muscular, the artist will know the human body so well that even a sketch — say, a hastily rendered likeness copied surreptitiously into a Moleskine on a subway car before the unwitting model, a fellow passenger, has a chance to shift her weight, or to catch the snoop in action — will evince this understanding. The sketch is not just of a face, it is of a face which sheathes a skull, connected to a spinal cord and a ribcage, and even if the artist has not drawn these things she knows that they are all of a piece, smoothly fitted into one another, and the marks in the Moleskine are informed by this prior understanding.

If the flesh of a model is pulled tightly over the skull, then the planes which converge at the temple ought to be rendered by the painter in different hues, because the light will reflect off of these planes with stark contrast. This offers an opportunity for the artist to communicate, with a subtle shift in tone, that she has noticed and appreciated the peculiarity of each plane, and how the gradations of color and light border one another. If a model is made to sit for long hours while the painter toils, the light will shift, and then fade, as the day darkens, and the flesh will subtly change color. Fittingly, the word "temple" comes from the Latin *tempus*, or "time," because the hair on the temporal bone is often the first hair to turn gray and recede, so temporal means both "pertaining to time" and "pertaining to the anatomical temple." Take your forefinger and stroke the small field on the side of your head behind your eyes, between your forehead and ear. It curves gently down

where the skull-sphere bends inwards at the earlobe and then up and out around the eye socket's rim.

In Vuillard's *Self Portrait, Aged 21*, painted in 1889, the viewer can see precisely where the artist's skull curves. That plane on the portrait — it looks like a slim, obtuse triangle — is yellow ochre, whereas the patch of skin below it which stretches out towards Vuillard's high cheekbone is a fleshy pink. The temple's highest point, the point at which the light source would have hit the plane directly, contains the most white. In this painting, the lightest stretch is the curve which lines the upper, outer edge of the eyebrow. The photo of *Self Portrait, Aged 21* on the National Gallery in Washington, D.C. website is appallingly lit. One must visit the canvas in the Small French Paintings Gallery to relish the exquisite delicacy with which the painter established this passage. Generally, the temple offers a remarkably satisfying opportunity for portraitists because it is a point of complicated geometry (the four planes converging) and it is encased in the flesh which rests above the eye, so it is delicate. The severity of the edges and the softness of the flesh juxtapose deliciously. When exquisitely rendered, I find it more consistently delightful than almost any other passage of painted flesh.

The severity of an edge in a painting, I mean the place at which a plane ends, can be immensely pleasing. From ordinary experience, from the edges that we see every day in buildings, bookcases, furniture, and so on, we are accustomed to an orderliness and a lucidity — not a perfect lucidity, which ordinary perception may not provide, but a clarity sufficient to establish the scene — which painters must render expertly in order to make the universe on the canvas convincing. The lines must be firm even when they are gentle. Geometries, even twisted or interpreted geometries, ground paintings;

they are the scaffolding which the eye leans upon for elementary comprehension.

Cezanne was a master of geometries. Look closely at the walls of Cezanne's buildings: the contours of every wall and roof and object are established not just by lines (there rarely is a single line) but by the shape or stroke directly behind the object and the gradations of color within it and against it. A shadow behind the house establishes the end of the building as clearly as the edge of the wall itself. And the same is true of the apples in his bowls of fruit. Shapes and their limits are what interested him. There is a mathematical field called topology, a branch of geometry, that studies the properties of shapes that stay constant when they are stretched or twisted: Cezanne was a topologist. In a letter to Emile Bernard, he remarked that "you must see in nature the cylinder, the sphere, the cone." The formal integrity of the object, which preceded the perception of it, had to survive the artist's interpretation of it.

The composition, or the relationships of the shapes within a painting, does not have to be complex in order for the painting to be accomplished, but it must be clean, coherent, and legible, and it must be as internally consistent, and with a structural logic, as the shapes which make up a skull. There must be a balance of its elements, an accounting of their internal relations. The painting must not look lopsided or unfinished (which is an internal measure and not an aspiration to "perfect finish," as Cezanne's unfinished paintings, with their stretches of bare canvas, demonstrate); the objects within it must appear as if they belong alongside one another, as if they are members of the same universe. They must be proportional, even if they are not governed by realistic proportions; the hues must vary complementarily so that it is clear they are lit by the same sources. Portraits are in some sense simple

because the composition is given to the artist: the proportions are perfect because a face is already proportional, and when a face is distorted by the painter's interpretation its features, its proportions, are nonetheless recognizable. The nose sits in the middle of the face directly between the eyes, directly about the mouth, and so forth. In a landscape, the artist must order the trees and the buildings such that the painting is as balanced and legible as the shapes which make up a face. Any casual museumgoer can tell immediately when this balance is lacking. It is difficult to maintain even the basic level of internal consistency which viewers take for granted when they visit a gallery.

A good painting must be orderly, and it must be interesting. All these musts: am I being obnoxiously prescriptive? Haven't we outgrown formulas and definitions? Are the painterly standards that I have just listed only an apology for traditionalism? I grant that these canons are hardly the only canons. The history of painting is a long parade of old and new rules. Modernism, too, had its rules, though it prided itself on its rule-breaking — the orthodoxies of the heterodox. I would like to dwell on one of its rules. Certain artists and critics since the nineteenth century have argued for an additional standard for artistic quality. It is that, in order for a work to be considered worthwhile, it must be new, and even revolutionary.

The requirement of newness promoted by these aestheticians meant that the work has to usher art into the future. A painting may be nice to look at, but if it does not contribute meaningfully towards the advancement of art then it is a lesser kind of art, or even an obstacle to art. The painter is an agent of history. The story of art is governed by a progressive motion

forward and upward towards the realization of an ideal. For the moderns, this ideal was the elimination of the third dimension, of illusionism, from the canvas, and the recovery of the primacy of the picture plane. It was this school that defended the movement towards abstraction and away from figuration. The shift into abstract art was, as all teleological thinkers like to say, no accident. Rather, as Alfred Barr, the formidable first director of the Museum of Modern Art instructed in an exhibition catalog in 1936, abstraction was "the logical and inevitable conclusion toward which art was moving."

Paintings, Barr argued, were not interesting because of the narratives or the objects portrayed, but because of the beauty of the relations of the forms within them. A painting, whatever it showed, was chiefly an arrangement of its own elements. Verisimilitude and optical observation were abandoned in favor of pictorial logic. Painting from life, Barr ruled, had been "exhausted." He declared that "the more adventurous and original artists had grown bored with painting facts. By a common and powerful impulse they were driven to abandon the imitation of natural appearances." For Barr and his fellow teleologists, this development, ironically enough, was not new. In fact, the drive towards abstraction had been central to developed understandings of art for millennia. They were not overthrowing the tradition, but fulfilling it. Members of this school often cited Socrates, in the following passage from Plato's *Philebus*:

> What I am saying is not indeed directly obvious. I must
> therefore try to make it clear. I will try to speak of the
> beauty of shapes, and I do not mean, as most people
> would think, the shapes of living figures, or their imita-
> tions in paintings, but I mean straight lines and curves

and the shapes made from them, flat or solid, by the lathe, ruler, and square, if you see what I mean. These are not beautiful for any particular reason or purpose, as other things are, but are always by their very nature beautiful, and give pleasure of their own quite free from the itch of desire; and colors of this kind are beautiful, too, and give a similar pleasure.

Why depend on models in order to paint the shapes and the colors that are what make representative paintings aesthetically valuable? If the essence of art can be distilled so that painting can be made totally independent of the external world, then the resultant art would be purer and higher than the sort of art that artists had thus far been producing, for which empirical observation had been a kind of crutch. The value of abstract art, Barr insisted, "is based upon the assumption that a work of art... is worth looking at primarily because it presents a composition or organization of color, line, light and shade." *Those* are the qualities worth painting. "Resemblance to natural objects," he continued, "while it does not necessarily destroy these esthetic values, may easily adulterate their purity. Therefore, since resemblance to nature is at best superfluous and at worst distracting, it might as well be eliminated."

Moreover, while nature can offer a painter models and objects worth painting, there is something cheap about copying forms instead of inventing them. (As if no invention was ever involved in artistic mimesis.) Naturalism, and its rich past, was overthrown: in the new dispensation, a painter should not imitate nature, but should instead conceive of a subject that can fully exist only within the ecosystem of the canvas. Otherwise, the original would always be preferable to

the painting. *Ceci n'est pas une pipe*, alas. Representation is an embarrassing endeavor since it can only result in an adulteration, in the compression of a three-dimensional object into the flatness of the picture plane. And, Barr argued, "in his art the abstract artist prefers impoverishment to adulteration." Abstract art was not just another kind of art: it was the only kind, the only real kind. Everything else was an anachronism, an error.

The greatest theologian in the church of abstraction was Clement Greenberg, a brilliant and despotic critic who presided over New York's art world in the second half of the twentieth-century. The rise and fall of his scepter ignited or foreclosed myriad artistic careers. He defended his favorites vociferously, and endeavored to condemn all others to obscurity. In 1944, Greenberg decreed that "the future of American painting depends on what [Motherwell], Baziotes, Pollock, and only a comparatively few others do from now on." Baziotes! Morandi, by contrast, he dismissed as "just a bottle painter." But who among the figurative painters delighted more in the relations of shapes and hues, and carried representation further to the brink of abstraction, than Morandi?

Greenberg's conception of modern art formed the basis of an art-world orthodoxy which still holds sway in certain precincts today. A flurry of recent biographies and reevaluations testify to his continued influence. Greenberg decreed that art history reached its apex with abstraction, that "modern figurative art" was oxymoronic, that contemporary representational painting was tantamount to an aesthetic devolution. He theorized that modernism itself was the "the intensification, almost the exacerbation, of this self-critical tendency that began with the philosopher Kant." After Kant, every discipline was forced to justify itself on its own terms:

The essence of modernism lies, as I see it, in the use of characteristic methods of a discipline to criticize the discipline itself, not in order to subvert it but in order to entrench it more firmly in its area of competence. Kant used logic to establish the limits of logic, and while he withdrew much from its old jurisdiction, logic was left all the more secure in what there remained to it.

Greenberg's grasp of Kant on logic was a little shaky, but his point was this: just as logic should restrict itself only to subjects which can be properly understood using logic, so art should concern itself only with what naturally and totally falls within its jurisdiction. A painting cannot breathe or move, so it should not reproduce living things. Do not imprison a bird in a fish bowl and do not compress a human figure onto a canvas. "Realistic, naturalistic art had dissembled the medium, using art to conceal art; Modernism used art to call attention to art."

Slowly, beginning with Manet, painters in Greenberg's account began to respect the properties of their medium, and allowed their paintings to celebrate those properties rather than conceal them. The many isms that overflowed from the cornucopia of modern art — Cubism, Orphism, Futurism, Constructivism, and so on —were all a result of this inward-looking self-critical impulse. Greenberg hastily added that, for the most part, these artists were not consciously adhering to a theory of history when they stood before their canvases. It was an ache to paint more expressively and powerfully that led them towards abstraction, and they inadvertently fulfilled an historical imperative without noticing that this is what they were doing. Greenberg repeated often that "all artists are bores." It is galling but not surprising that he viewed them as blind pawns in the grip of historical forces that they obeyed

without comprehension. His superior *ex cathedra* attitude to artists was deliciously captured by Jeffrey Tambor, who played Greenberg in the movie *Pollock*, when he turns to the lost and struggling painter and in his condescending baritone chastises him: "You're retreating into imagery, Jackson!"

Rather than working in service to an artistic ideal, Greenberg and Barr believed that contemporary artists have always grown weary of, and then overthrown, the dominant style of the day. Art history, as they tell it, is a tale of endless revolution — a permanent revolution, to borrow Trotsky's phrase. Viewed on a small scale, it appears as if every reigning style is the bastard child of the previous one, and that artists whored after the new, always hoping above all to topple the old. But the new decayed and became antiquated as soon as the most recent revolution succeeded and the rebels calcified into the establishment. (Corporations swiftly began to buy abstract and abstract expressionist art.) Somehow, some providential power shepherded all of these revolutions towards abstraction, as if a Hegelian demi-urge was pulling the strings. As Meyer Schapiro acidly summarized the idea:

> The theory of imminent exhaustion and reaction is inadequate not only because it reduces human activity to a simple mechanical movement, like a bouncing ball, but because in neglecting the sources of energy and the condition of the field, it does not even do justice to its own limited mechanical conception... And a final goal, an unexplained but inevitable trend, a destiny rooted in the race or the spirit of the culture or the inherent nature of art, has to be smuggled in to explain the large unity of a development that embraces so many reacting generations.

For all his intellectual rigor, Greenberg was, like all prophets of history, something of a mystic. He operated as if he had a privileged perception of the esoteric workings of art's destiny. His theory of art history is stupendously dogmatic and, as regards the extraordinary variety of art that was produced in his own time, it makes little sense. It omits, or expels, all the artists that disrupt its smooth linear narrative — most unfortunately, those modern painters whose accomplishment was precisely to throw into doubt the distinction between representation and abstraction because their work contained both.

Greenberg's theory of art, when taken to its conclusion, becomes absurd. Greenberg argues, as Schapiro puts it, "that representation is a passive mirroring of things and therefore essentially non-artistic, and that abstract art, on the other hand, is a purely aesthetic activity, unconditioned by objects and based on its own eternal laws." (It is true that Schapiro was in his early orientation a Marxist, but his Marxism certainly never blinded him to form.) Let us consider both propositions. First, "that representation is a passive mirroring of things and therefore essentially non-artistic." It certainly is the case that there is a kind of virtuosic academic style, stultified by study and devoid of originality. Many excellent painters who started out in academies tracing gypsum skulls painted in this way and their objective was verisimilitude. Most students never develop away from it, and there are still legions of artists who make a career producing what laymen consider "real art" because it looks like a photograph. Artists as original and exciting as Titian, Rembrandt, Cezanne, Degas, Matisse, Derain, Soutine, and Balthus began their careers producing realistic drawings and canvases. But all of them turned away from that early academic style and created figurative paintings

that were radical and singular — not reproductions of reality but interpretations of reality, and exceedingly painterly ones. "A passive mirroring of things?" Hardly. Not a single stroke on the weakest paintings of any of those artists is passive or essentially non-artistic.

And second, "that abstract art, on the other hand, is a purely aesthetic activity, unconditioned by objects and based on its own eternal laws." There is no way to produce any kind of art that is unconditioned by objects. There is no way to view any kind of art that is not informed by the objects that we are familiar with, and that constitute reality. Every aesthetic is developed through an interaction with the world. Color and form are all that painters have to create an aesthetically pleasing work, but color and form can only be studied in experience. This does not mean that they should be used only mimetically, to copy the world. But abstraction emerged out of the discoveries of representation, as in Kandinsky's crinolines, or in Cubism's still lifes, or in Brancusi's *Bird in Space*. And many abstract painters believed that their rejection of representation was not a rejection of the world, but a deeper grasp of it. They were right, which is one of the reasons that we linger before them. Joan Mitchell's paintings are vivified by a fantastic energy. They convey movement, though canvases cannot move. Even Jackson Pollock was simulating sensations and rhythms that he knew only through experience. If we can "read" such paintings, if they are coherent to us, it is because we have an eye for order that was learned from existing shapes and incidents in the world of material forms and living things.

The balance, the fittedness, and the rhythmic consistency that we find, say, in *Blue Poles* are taken from the cognitive experience of both the painter and the viewer. An abstract painting must be as cohesive, complicated, and brilliantly

315

ordered as a skeleton. Conversely, you don't need *putti* or apples to capture the lived world. The problem with "a purely aesthetic activity" is not its aspiration to high art but its aspiration away from life. Greenberg's Platonism bears little relation to what artists actually do. He once said that the first mark of paint on a canvas was an adulteration, since it disrupted the perfect two-dimensionality of the canvas. It would be impossible to produce an art that conformed exactly to what Greenberg wanted and was not sterile. Greenberg, Barr, and the other teleologists shrunk art in the name of its own climax. The future they demanded was anorexic rather than expansive.

And yet: for all his dogmatism and all his bullying, reading Greenberg now is nonetheless a relief. Even when he is wrong he is formidable, and even when he inserted what he saw into a dubious framework, his writings are a masterclass in how to pay attention to a painting. It is exhilarating to grapple with an art criticism steeped in learning and vitally invested in the quality of the art it was considering, even if its qualitative ideals were absurd. Today there are almost no art critics who are remotely analogous to Greenberg in intellectual seriousness or influence. Contemporary critics, far too often, are beholden to the art market. They pay too much attention to money. They do not champion unknown artists but lazily find their subjects in the system of established dealers and collectors and curators (which, in an age in which Instagram is full of the work of obscure but formidable artists, is sinful). The artists who win the attention of the art system fulfill two antithetical criteria: a thematic obsession with progressive politics, and an aesthetic

in thrall to the sleek soullessness of capitalism. (There is a bit of good news in that these political preoccupations have licensed galleries to take a new interest in figurative painting, since it is easier to champion the downtrodden if you depict them.) There are serious and rigorous artists painting today who do not concern themselves with identity and do not produce paintings fitted for atriums on Fifth Avenue. The serious critics should find them.

Kehinde Wiley is the perfect hero of our grim art system. Every one of his paintings is made in the Wiley brand image. The technical triumph for which Wiley is so admired — his sedulously detailed and decorative backgrounds against which he stages luxuriously rendered people of color — is in truth that he has succeeded in producing paintings, or in ordering a factory of assistants to assist him in producing paintings, that look as if they were generated by artificial intelligence. The meticulously rendered people in his canvasses do not look hyper-realistic; they look like crass digital art. And they look expensive. The backgrounds of a Wiley painting are intricate but digestible in precisely the same way that psychedelic wallpapers are. He is technically ostentatious and artistically bloodless.

Julian Lucas' recent profile of Kehinde Wiley in The New Yorker is a useful caricature of the new orthodoxy. The title, itself devoid of irony, betrays the overwhelming concern of both the interviewer and his subject: "How The Artist Kehinde Wiley Went from Picturing Power to Building It: His portrait of Obama sparked a nationwide pilgrimage. Now he's establishing an arts empire of his own." Power, by which Lucas means money, is the ultimate subject. "I wouldn't even say that art is the greatest thing that Kehinde will accomplish before the Lord promotes him," Wiley's mother told Lucas. "I see

317

him as a great entrepreneur." Like court painters throughout history, Wiley has savvily capitalized on his slickness. The Obama portrait is only the most familiar example. He has collaborated eagerly with luxury brands such as Grey Goose and American Express, and he paints celebrity-porn portraits of figures such as LL Cool J and Michael Jackson. His portraits of pedestrians identified on the street and invited into his studio are no less rhetorical and formulaic; unlike the great portraitists, Wiley captures only a surface. Roberta Smith once compared him to the French painter William-Adolphe Bouguereau. The comparison is apposite: like Bougereau, Wiley produces highly finished kitsch. Warhol would have been just as apt a comparison. It is no sin to be a businessman, of course, or to use painting as a means of making money. But we must not mistake a genius for marketing for artistic prowess. The problem with Wiley is not that he is corrupting the pure tradition of great art. The problem is that he is uninteresting, in the way that brands are always uninteresting.

Brand development is not the same as artistic develop-ment, and an artist can develop a style or a tone or a unique voice without devolving into a logo or a look. A Rothko and a Warhol are both immediately recognizable, but after one has recognized a Rothko, one must reckon with it and this takes time. Warhol, on the other hand, is designed to be the sort of thing that one can slurp down and forget. Many years ago John Updike referred to Warhol's art as "art for busy people." (He meant it as praise!) The same is true of Wiley. Warhol's art demands no more than a glance. He made products that happened to be paintings. Similarly, Wiley produces designs that one can print on an AmEx card without the least bit of aesthetic distortion.

Blackness, of course, is central to Wiley's portraiture and

318

to his success. As Julian Lucas says, the art world recently started "buying Black art like indulgences," a remark that captures the mercenary quality of such racial solidarity. From the standpoint of art, however, the important point is that the paintings are not good because they are of black bodies and they are not bad because they are of black bodies. Compare the flesh in one of Lynette Yiadom-Boakye's gripping portraits to the flesh in a Wiley painting. The subjects are the same race, but take a close look at the lusciousness of Yiadom-Boakye's oils. There is nothing slick about her canvases. Her paintings are consistently intelligent. As Zadie Smith noted in a commendable profile of the painter, which appeared in *The New Yorker* five years before Lucas' profile of Wiley, "the colors are generally muted: greens and grays and blacks and an extraordinary variety of browns. Amid this sober coloration splashes of yellow and pink abound, and vivid values and emerald greens, all tempered by the many snowdrop gaps of unpainted canvas, like floral accents in an English garden."

A melancholy inwardness permeates Yiadom-Boakye's painting. They offer weather for quiet contemplation. Her painterliness, the thick wetness of the paints, adds a genuine sensuousness to the canvas which is markedly different from the sterile shininess of Wiley's people. Since she paints quickly, usually finishing a canvas in a single day before her oils have a chance to dry, the facture of her surfaces dance with incident. No surface is purely flat, no surface is devoid of motion. The swiftness of her brush juxtaposes astonishingly with the delicacy of her touch. In her portrait "Highpower," from 2008, the head of a man is rendered with many sweeping strokes. There is a glimmer of light in the high point of the temple plane, just above and behind the eyebrow, which is mesmerizing. Each painting is the fruition of a visual obsession.

319

Good Painting

"A color, a composition, a gesture, a particular direction of the light," Yiadom-Boakye has said. "My starting points are usually formal ones." Delight, an infectious delight in paint, vivifies her work. Yiadom-Boakye's subject is not what makes her a fine artist, though her love for her people is affectingly evident and certainly enriches her work. If she were fascinated instead by furniture, landscapes, or people of varying hues, her paintings of those subjects would be no less fine.

A painting is good because of the colors and the forms that make it up. This is as obvious as it is shocking. And it is not "formalism" to say so. For a lover of paintings, for someone who has achieved an occasional moment of transcendence before a canvas, it may seem heretical or idiotic to point this out, the way that it is heretical or idiotic to point out that a book is simply a mass of typed pages or that a person is merely a mass of cells. But respect for the tactility and the materials of paintings is essential to a substantive appreciation of them. If there is soulfulness in a painting, it was put there by a paintbrush. This is so regardless of its subject or its subjectlessness. Can Rembrandt's Biblical etchings, or Poussin's mythological paintings, or Hals' group portraits, be appreciated without reference to the narrative that they present? I think so. Such a distillation of attention must be possible, if they are to be viewed as art. Extra-aesthetic meanings may abound in a picture, but they have no bearing on the painting's artistic quality.

A painting can be devoid of narrative and still be good, but it cannot be devoid of some measure of freshness or originality. I do not mean the newness that was fetishized by the modernists and the historicists. The newness that I have

in mind cannot be prescribed, it cannot be copied down in a lecture hall and spat out onto a canvas, and it does not have to fit neatly or at all into a theory of art history. The best way to understand and admire a painting by Cezanne is certainly not to view it as a precursor of Picasso and Braque. Cubism, after all, was not Cezanne's intended end. Moreover, a painting can be great without having the slightest cultural effect. Soutine was an original; no one had ever painted like him before and no one ever will again. His influence endures regardless of the fact that he did not catalyze a movement. The same is true of many great painters who were obsessed with and dedicated to art, not to the arc of history. And, conversely, an artwork or a style that inspires a movement can still be artistically uninteresting or unaccomplished. Even works that are historically consequential must be judged first for their merit and only then for their impact. *Les Demoiselles d'Avignon* is a formidable painting before it is a revolutionary act, and so is *Woman I*. In this regard, a work of vanguard art is exactly like a work of classical art: it must be evaluated for its quality. And who is to say what the vanguard is? The Barr-Greenberg teleology is not the only teleology that has been proposed as a means of plotting the trajectory of Western art.

Every artist will paint freshly, will create something that is new, if they have the courage of their own creativity. I will give an example. In *Woman's Back*, painted last year by Yuval Yosifov, a naked woman is limned in a field of muted greens and blues which are subtly reflected in her flesh. Her back is modeled with gentle, luscious detail. The artist has scraped the paint so that no strokes are visible, but still the body appears soft. The metal of the black chair on which she sits cuts harshly against the woman's supple flesh. The juxtaposition of the cool, rough metal against the woman's body

is enigmatic. This brazen choice, this lyrical oxymoron, grounds the composition, and it is the reason I often return to this painting.

As in many of her paintings, Yosifov straddles the chasm between abstraction and figuration. The shapes and colors that make up the body are rendered with the same authority and precision as the space in which they are materialized. Background and foreground feed into one another. Yosifov is a precocious young painter based in Tel Aviv who has already achieved some international recognition. I found her on Instagram, where she shares her paintings and her muses and mercifully betrays nothing about her political leanings. Her influences are evident: Degas, Ingres, and Corot whisper in her ear while she paints, but she does not repeat them. They inform but do not dominate her work. Her colors and compositions are consistently interesting, authoritative, and beautiful. I have syncopated myself to the rhythm of her posts, expecting at distant but regular intervals to be enlightened by whatever she has most recently produced. Each painting is an internally fulfilled event, not one in a great chain of historical significance. Yosifov's works are not revolutionary but revelatory. All good paintings are.

LEON WIESELTIER

The Troubles of the Jews

The mind operates by means of emphasis, especially the mind 323
in the grip of fear or anger. When it brings order to the welter
of experience, the mind sometimes exceeds the requirements
of coherence and proceeds to exercises in simplification. Out
of our many identities, we select one; out of our many loves, we
select one; out of our many threats, we select one. Life is more
easily managed this way. And we fit in more easily this way: such
choices are determined chiefly by how we wish to be known
by others, and by what others demand of us in the way of
personal validity in our time. And so we choose single symbols
of ourselves, and the rest, which may include some of our

strongest capacities, is left to languish, undetected and undeveloped. Complexity is *never* trending. It is true that the appeal to complexity can become complacent and ponderous and an alibi for mental inaction; but surely nothing of consequence is ever simple. Surely the truth about us is that we are many things, we have many commitments, and we suffer many troubles. We take our pleasures in many places. We fight on many fronts.

Perhaps nothing is more responsible for our myopias than our politics. Identify friend or foe, to borrow the naval code, is the rule. Those appear to be the only kinds of other people in existence. The Schmittians among us should take heart: we are living in the dystopia that their sordid hero described. Consider the question of our security. Our future depends significantly on how we conceive of the "foe." If we misdescribe the danger we face, our powers will fail us. But in keeping with our pathologically synchronized political culture, or, to put it another way, in keeping with the growing repudiation of the liberal mentality, we are losing our mental dexterity in the confrontation with what threatens us. "Precarity" is the shibboleth of the day, and there is certainly a basis in reality for the popularity of the term; but "precarities" would be more accurate. The weakening of our sense of multiplicity has become one of our most significant vulnerabilities. Ideology is a method for seeing less than is there. We elect to see less, in exchange for the confidence that what we have seen we have mastered. It is a satisfying contraction.

Even if we cannot proceed without frameworks with which to interpret experience, frameworks are blinders. That is why we are so often surprised, and ambushed; why crisis always finds us catching up. I remember when I first learned this lesson. I was a young student of modern Jewish history, and in the study of Zionism and the creation of the Jewish

324

state I came upon the famous pronouncement by David Ben Gurion in 1939: "We will fight the White Paper as if there were no Hitler and we will fight Hitler as if there were no White Paper." The White Paper, an act of supreme callousness that would be right at home in our era of scorn for the stateless, was an instrument of the British government that severely curtailed Jewish emigration from Europe to Palestine, with the aim of eventually banning it altogether. In 1939! I took away a larger point from Ben Gurion's strategy *in extremis*. It is that there is never only a single danger. The challenges are always multiple and simultaneous. This is not as obvious as it sounds, because it requires certain mental adjustments that do not comport well with simple pictures, with intellectual italics, with "systemic" analysis, with holistic explanations. In the Jewish community in Palestine, there were many Jews who overcame their opposition to the British occupiers to fight alongside them against the Nazis, and there were even some Jews who overcame their opposition to fascism to fight the British occupiers (the history of Jewish fascism did not begin with Kahane and Ben Gvir); but Ben Gurion was insisting upon a double struggle, because history had afflicted the Jews with more than a single enemy, more than a single cruelty. And sometimes the challenges are not all external: I was schooled in the art of the double struggle, the fight on many fronts, by some of my teachers, who were in the valiant minority of American intellectuals in the 1950s who denounced Joseph Stalin and Joseph McCarthy with equal vehemence. No excuses were accepted and no extenuations were made. And if the double struggle made no sense according to the politics of the day, so much the worse for the politics of the day.

The contemporary Jewish community is now faced with the prospect of a double struggle, but so far it has

325

demonstrated only a skill for singleness. The Jewish left wants to know only one thing, the Jewish right wants to know only another thing. Right now it should be the duty of American Jews to fight the anti-Semitism outside the Jewish world and the anti-democratic decay inside the Jewish world, and on the basis of the same principles.

One of the most impressive accomplishments of the fight against anti-Semitism is the literature — scholarly and philosophical — that has been created about it and against it. There is very little new to say about it, except to insist upon its eternal recurrence and to document its recent manifestations. But a succinct characterization of the malignancy is useful, and the finest one I know was recently written by Anthony Julius, the British Jewish intellectual and lawyer who is an authority on the terrible subject.

> Antisemitism consists of false and hostile beliefs about Jews, the Jewish religion, Jewish institutions or Jewish projects; these beliefs often lead to injurious things being said or done to Jews or their projects, or said about them. It has several modes of existence. Principally: it is a family of discourses; it conditions or deforms institutions and institutional practices; it is a choice made by individual men and women. Antisemitism variously threatens Jewish lives, Jewish security, and Jewish morale. It would deny to Jews rights others enjoy; it would withhold from them equality of treatment and regard. Antisemitism does not just injure Jews. It also encourages misconceptions about the causes of social

conflicts, and of human suffering and social deprivation, thereby prolonging their existence, to general disadvantage. By denying Jews the opportunity of making contributions to society, it injures all society's members. It corrupts political discourse; it taints political life; its injustices towards Jews are precedent-establishing. It even injures antisemites, degrading them and making them stupid.

By now it should not be controversial to say that no party or ideology or community or movement is immune to anti-Semitism. The Jews have been despised by universalists and by particularists, by cosmopolitans and by nationalists, by communists and by fascists, by socialists and by capitalists, by progressives and by reactionaries, by the secular and by the religious, by white people and by people of color, by intellectuals and by populists, by monarchs and by republicans, by philosophers and by farmers, by monsters and by nice people, in a multitude of languages and in a multitude of cultures, and in places where there were no Jews. The absence of the object of a prejudice does not weaken it, and sometimes strengthens it. (Anti-Semitism in German universities between the wars was highest in the universities where there were no Jewish students.) That is because a prejudice is not caused by its object, and the notion that it is caused by its object, a commonplace notion, is itself a repetition of the prejudice.

It is racist to seek the cause of racism in black people. It is misogynist to seek the cause of misogyny in women. It is homophobic to seek the cause of homophobia in gay people. And it is anti-Semitic to seek the cause of anti-Semitism in Jews. Prejudice is an expression of the prejudiced individual, of his or her inner turmoil, which is the result of his or her education

and experience; or of a society with its own inner wounds and needs, most notably its desperate desire for scapegoats for its failures. Nobody ever went looking for a scapegoat without finding one. Bigotry is an internal disfiguration, not an empirical inference or a conclusion warranted by facts from the outside. Its essentially subjective and fantastic character, its invincible indifference to evidence, is what accounts for its tenacity and its durability. Hallucinations cannot be refuted; they can only be delegitimated and disarmed.

All this, as I say, should be uncontroversial; but it is not. Almost nobody acknowledges the politically non-partisan nature of anti-Semitism, its infernal ubiquity. In the United States, for example, many Jews are certain that anti-Semitism is mainly or solely a phenomenon of the right. The Trump years certainly gave them abundant reasons to think so. (Trump himself pioneered a new type of villain in this tale: the pro-Israel anti-Semite.) The massacre at the Tree of Life synagogue in Pittsburgh, the torch-lit Nurembergish march in Charlottes-ville, the dramatic statistical spike in incidents of anti-Semitic violence around the country, the mainstreaming of politicians who believe in Jewish space lasers — the anti-Semitism that has characterized the American right for a century and longer has finally been allowed to come out from under its rock and leap onto our platforms and take its seats in Congress. This remains a national disgrace, and no amount of trade between Israel and the Emirates, which was the Trump administration's most significant contribution to the well-being of the Jewish state, can mitigate or erase the stain. (If we did have a space laser, who does Marjorie Taylor Greene think would be its first target?)

These awful developments have left Jewish progressives with the warm feeling that the spread of anti-Semitism has little to do with them, that the fight against anti-Semitism

328

is a progressive fight against the forces of reaction, which it partly is. Riveted by the bigot without, they overlook the bigot within. They are strangely unemphatic about the fight, for political reasons: the sane right, the saving remnant of American conservatism, and of course the Jewish right, has taken it up, and who would want to march with them? After all, some otherwise odious Republicans have been laudably exercised by Jew-hatred in America. Christian evangelicals have also risen to protest. Myself, I am grateful to them for their attention to the perils that beset my people, even if I cannot share their politics and their theological grounds for it. In times of trouble, friends are friends.

Jewish progressives have spoken only softly, if at all, about the Judeophobia in their own midst. What has anti-Semitism to do with them? They appear to believe that they have clean hands in this matter. Jean Améry, writing in 1969 about earlier manifestation of righteous intolerance on the New Left, called this "virtuous anti-Semitism." But now it turns out that some of the most glittering Congressional tribunes of the people, some of the stellar leftists in American politics, have required remedial training in respect for Jews. I am not especially moved by Ilhan Omar's or Rashida Tlaib's learning curve, because a lack of bigotry should be an elementary expectation in a decent society. They had no good reason to say anti-Semitic things in the first place. Were they ignorant? All racists are ignorant.

I am not arguing against forgiveness; like you, I have needed it myself. But I have for a long time believed that the test of a person's probity is his willingness to criticize his own community and to suffer unpopularity in his own congregation. Solidarity can sometimes make people stupid. The response of the progressives to the embarrassing revela-

tions of their comrades' bigotry was mainly to denounce the critics as racists and Islamophobes. They behaved like a sect. But my favorite example of progressivism's tolerance of its internecine anti-Semitism is the somewhat hapless case of Trayvon White. He is a progressive politician, a young African American who represents underserved and disadvantaged neighborhoods on the city council in Washington, D.C.. In 2018, on a fine morning in March when the city was startled by snow flurries, the councilman posted this: "Y'all better pay attention to this climate control, man, this climate manipulation ... And that's a model based off the Rothschilds controlling the climate to create natural disasters they can pay for to own the cities, man. Be careful." The Jewish community was offended, he met with a group of rabbis and lay leaders, he apologized, and he was sentenced to a visit to the Holocaust Museum. The tour of the museum was ninety minutes long. He left early. Everybody seemed satisfied by his promise to develop "a deeper understanding" of anti-Semitism. It was an admirable pledge. But how satisfied would he and his supporters be by the promise of a white supremacist to develop a deeper understanding of racism? Would the left leave it at that? White was reelected two years later with sixty percent of the vote.

The *sotto voce* of the American left about anti-Semitism (there are exceptions) is owed also to its bizarre notion that the Jews are a race — more specifically, that they are white, and so the color of their skin invalidates their claim on empathy and enrolls them permanently in the ranks of the essentially privileged. Anybody who knows anything about Jewish history will acknowledge that this is meretricious nonsense. We come in many colors and no color has protected us. One afternoon I sat with Yehuda Amichai in a hummus joint in the

330

central market in Jerusalem, and as we watched the polychromatic spectacle of the Jewish shoppers he turned to me and said: "Anybody who thinks that the Jews are a race should have some hummus here."

Which brings us, inevitably, to Israel. The diffidence of the American left about anti-Semitism is owed mostly to its diffidence about Israel. Well, not diffidence, exactly; hostility. Omar's and Tlaib's ugly comments about Jews were extenuated by their supporters as sympathy for the Palestinians. This, it was felt, pardoned their antipathy to — what? Israel? But they were not slandering Israel. They were slandering Jews. Tlaib is a Palestinian American. If you were Palestinian, wouldn't you have mean things to say about Jews? Is this hard to understand? Actually, it is easy to understand: Jews, too, have been wounded and angry, and political expressions of Jewish rage are befouling Israeli politics and society. No, the Judeophobia of Palestinians is not hard to understand; but it is hard to tolerate. Are some bigotries more acceptable than others? The progressive patience with Palestinian anti-Semitism, like the progressive patience with the ruinous state of Palestinian politics generally, is an insult to the moral intelligence of Palestinians. It is rank Corbynism. A left-wing American Jewish writer, whose commitment to a better world carried him all the way to condemning the campaign against anti-Semitism (or "'anti-Semitism'") as "a threat to freedom," helpfully explained that "Palestinians do not grow more tolerant of Jews when brutalized by a Jewish state." Of course they don't. But so what? The Islamophobia of the Israeli right is similarly absolved by reference to Palestinian violence. Or so they think. The misdeeds of the other cannot absolve one of the misdeeds of one's own. It is not hard-hearted to denounce the racism of victims.

The Troubles of the Jews

The defense of criticism of Israeli behavior seems to have become a prohibition against criticism of Palestinian behavior. This, as Salam Fayyad once remarked, is no favor to the Palestinians. (And where exactly are the critics of Israel who are being muzzled? Criticism of Israel, right or wrong, is everywhere; it is the *bon ton*; a good career move. At least on the campuses, it is pro-Israeli speech that is mortally uncool, that struggles to be heard and even permitted.) Anti-Semitism, if this needs to be repeated, is a grave and primary sin. The occupation of the West Bank is not a sufficient reason to retweet the work of an anti-Semitic cartoonist, which Tlaib and Omar did after they were idiotically banned by the Israeli government from visiting Israel. There is never a sufficient reason to proliferate anti-Semitism. Tlaib's anti-Zionism may be fueled by her family's experience, but with her talk of American Jews' double loyalty (are Israel's supporters in Congress any more ardent in their support for Israel than she is in her support for Palestine?) and in her "from the river to the sea" language she went beyond anti-Zionism. She confirmed the view of those who believe that anti-Zionism is anti-Semitism.

332

So is anti-Zionism the same as anti-Semitism? No, but anti-Semitism helps. If, by anti-Zionism, you mean that the Jews have no right to a state of their own, or are not a people with the same privileges and entitlements as other peoples in the era of nationalism and the nation-state; or that the Jewish state merits greater punishment than other states receive for the same, or greater, abuses and crimes; or that every Jew, and every Israeli Jew, is representative of all Jews and the entirety of the Jewish people, then you cannot be spared the most severe judgement: you are an anti-Semite. Go straight to the Holocaust Museum. Even though Israeli policies in the

occupied territories are often indefensible, and even though Israel is partially responsible for the apparently indefinite deferral of a solution to the conflict, thereby preparing the ground for a historical catastrophe, the intensity of the hatred of Israel on this blood-soaked and nauseatingly unjust planet is psychotic — which is to say, it has morphed in many places from criticism into prejudice.

Maligning Jews will do nothing to improve the lot of the Palestinians. While the history of anti-Semitism should not bar anybody from criticizing Israel, even ferociously, if you are going to criticize Israel, mind the line. (While the history of racism should not bar anybody from criticizing the African American community, even ferociously, if you are going to criticize the black community, mind the line.) I recommend this wariness not to suppress argument but to encourage humaneness. The distinction between anti-Zionism and anti-Semitism may seem analytically sound, but this is historically inflamed territory, there have been too many injurious consequences of sloppy thinking, and suspicion is justified. The border between the critique of Israel's policies and the critique of Israel's existence has too often been transgressed. And the criticism of Israeli policies is hardly made more persuasive when it is accompanied by hatred — or perhaps it is, in certain quarters and factions. (Though some of us, it should be noted, chastise Israel out of love.)

In his book *Outsiders*, the German literary scholar Hans Mayer, a Jewish socialist who fled to France in 1933 and after the war wandered homelessly between the two Germanies, wrote that "whoever attacks Zionism, but by no means wishes to say anything against the Jews, is fooling himself or others. The state of Israel is a Jewish state. Whoever wants to destroy it, avowedly or by means of a policy which cannot but result

333

in its annihilation, is dealing in the anti-Jewish hatred that has been with us since time immemorial." This, I'm afraid, is the burden that anti-Zionism must bear — its occupational hazard, if you will. The policy of annihilation against which Mayer warns, moreover, need not be violent; there are peaceful ways, demographic and political ways, to erase the Jewish state. The moral onus is on the haters. And, again, if you wish to understand their hatred of Jews, do not study Jews. They are not the anti-Semites. The notion that anything that Israel does is in any way a warrant for anti-Semitism is simply disgusting.

Synagogues across America are now giving classes in how to respond to an active shooter. Where on the left is the outrage? Surely this is no less outrageous than the grotesque composition of the Israeli government. Everybody has their favorite victims, of course, but this is nothing to be proud of. The expansion of empathy is the duty of every person and every party, but I know of none who have so far acquitted themselves completely of their duty. This ethical malfeasance is especially embarrassing in universalists. In 1917, in a letter to a friend, Rosa Luxemburg wrote these infamous sentences: "What do you want with this theme of the 'special suffering of the Jews'? I am just as much concerned with the poor victims on the rubber plantations of Putumayo, the blacks in Africa with whose corpses the Europeans play catch... They resound with me so strongly that I have no special place in my heart for the ghetto. I feel at home in the entire world, wherever there are clouds and birds and human tears." As it happens, in her political agitation Luxemburg was not as indifferent to anti-Semitism as she boasted here. But what sort of a boast is this?

There are historical circumstances, I suppose, in which the universal must be most forcefully asserted, and historical

circumstances in which the particular must take pride of place
— but the goal of all these avowals must be the establishment
of an equilibrium among our magnitudes, a truce between our
generality and our specificity. We must try to be as moved by
the plight of the far as by the plight of the near, by the misfor-
tune of others as by the misfortune of our own. Yet the defense
of one's own is not a mark of smallness. It is not "tribal" to fight
for your own existence. It is a sacred obligation and a rudimen-
tary sign of self-respect. Nor does it foreclose "clouds and birds
and human tears." There are universal grounds for the defense
of the particular, for the simple reason that there are no victims
who are not humans. Indeed, dehumanization is the very
condition of victimization. Luxemburg (and her spiritual heirs)
never recognized the irony of her position: since one's own
origins are also contained in "the entire world," the rejection of
one's origins, whatever else it is, is a flaw in one's universalism.
So there are no excuses for any of the orientations. A feral
response to anti-Semitism should be a matter of honor, and not
only for Jews. Like black lives, Jewish lives matter.

The Jewish right has been more vocal about the anti-Semitic
resurgence, which is admirable, though it teaches that all the
anti-Semitism in America is the work of the woke left. Like
the Jewish left, the Jewish right is partially right and partially
wrong. It appears that nobody has an interest in the whole
truth about anti-Semitism, because it is politically and philo-
sophically inconvenient. Yet it should be recalled that the
massacre at the Tree of Life was not perpetrated by the ACLU,
nor were the attacks at Poway and Colleyville and Kansas City.
Jewish Trumpists (the phrase itself is what is known in Judaism

as a desecration of God's name) must reckon with the incontrovertible historical fact that the alt-right, from Steve Bannon in 2016 to the Proud Boys in 2021, along with its white supremacism and its anti-Semitism, was regarded by the forty-fifth president as a political asset, as a part of his base. (His very base base.) At least Omar and Tlaib never killed anybody.

The problem with the Jewish right's efforts against anti-Semitism is that they are premised on the assumption that they are the best Jews. This self-congratulation, and its attendant condescension toward Jews who do not think or live as they do, runs through everything they say. (If Orthodox Jewry loved itself any more than it already does, it would violate the commandment against idolatry.) A sterling illustration of this was a piece in *The New York Times,* excerpted from a best-selling book, by the enterprising Bari Weiss, called "To Fight Anti-Semitism, Be a Proud Jew." This is high school uplift; I wrote it in high school. It is also somewhat baffling as an analysis of the problem. Are the Hasidic men who are regularly beaten on the streets of New York ashamed of their Jewishness? Or the shuls in New Jersey that hold services under police protection? Weiss, like other Jewish right-wingers, commits the cardinal mistake of explaining anti-Semitism in terms of Jewish behavior. She poses a choice: "Does safety come from contorting ourselves to look more like everybody else? Or does it come from drilling down into the wellspring of what made us special to begin with?" In fact, safety comes from physical bravery and security systems and law enforcement and community discipline and political engagement and the support of government. (And in the Jewish state, an army.) Even Jews who may be wavering in their beliefs and their practices, whose pride may be mixed with ambivalence, even Jewish "nones," deserve to be safe.

Weiss contends that there are two arguments about the sources of safety. "The first line of argument insists that safety for Jews comes by accommodating ourselves to the demands of our surrounding society. If we can just show that we are perfect Greeks, patriotic Germans, and so on, then they'd love us." And patriotic Americans, too? The Jewish right's equivalence of Americanism and Judaism — to the absurd extent of having persuaded themselves that the American Founders were inspired primarily by Jewish sources — is reminiscent of nothing so much as German Jewry's equivalence of *Deutschtum* and *Judentum*. "To the opposing side," she continues, "this political and cultural strategy was only a recipe for delayed humiliation and pain. Lasting security for Jews, the counter-argument goes, was always saved by leaders and movements, from the Maccabees to the Zionists, that urged us to be our fullest, freest selves — even if doing so made us deeply unpopular and despised." Never mind that lasting security was precisely not what the Maccabees, or the Hasmoneans, achieved. Weiss has not thought very deeply about assimilation, integration, separation, and appropriation in Jewish history.

"In these trying times," the sermon continues, "our best strategy is to build, without shame, a Judaism and a Jewish people and a Jewish state that are not only safe and resilient but also generative, humane, joyful, and life-affirming. A Judaism capable of lighting a fire in every Jewish soul — and in the souls of everyone who throws in his or her lot with ours." Amen, sister. Such a radiant Jewish civilization should be our objective even in times of perfect security, if there is such a time. But who, in this account, are the Jewish children of light and who are the Jewish children of darkness? The shameful thing about Weiss' rhapsodic pride is that it holds other Jews responsible

for their own imperilment. It repeats the old canard that Jewish self-hatred or Jewish inauthenticity or Jewish assimilation brought anti-Semitism upon us. Thus she taunts those Jews who insist that the "the real problem are those with their *kippot.*" She thinks they are spineless. This is very nasty. Pride takes many forms, especially in ethnicity-mad America. As far as I know, the young Jewish men who are removing their *kippot* on various campuses and in various cities are doing so not out of shame but out of fear. Should they be martyred for a yarmulke? (Judaism says not.) They are certainly not like "the Israelite slaves [who] chose to remain in Egypt," as Weiss obnoxiously describes the millions of American Jews who are less noisy about their heritage than she is.

Or is the problem really that so many of them do not wear *kippot* in the first place? But that is an entirely different question, having to do with the rise of secularism, the modern rupture of Judaism into the denominations, and individual freedom. A Jew has a right not to cover his head if a covering does not represent the character of his Jewish identity. The greatest Jewish leaders in modern history, the greatest leaders in Zionist history, were bare-headed heroes. Anyway, anti-Semites do not distinguish between types of Jews, or interest themselves in the dialectics of Jewish identity. For them, we are all the same. They vandalize synagogues and communal institutions of every stripe; they assault Jews with *kippot* and without *kippot,* our secular brethren and our religious brethren. We owe solidarity, therefore, to *all* our brethren. In the Jewish tradition this is called *ahavat yisrael,* the love of the Jewish people. Many Jews who proclaim it fall short of it; maybe we all do. But do not denounce Jews as a way of defending them. In 1939, in an essay called "When Facing Danger," one of his profound studies of Jews under pressure,

338

the social psychologist Kurt Lewin wisely observed that "it is not similarity or dissimilarity of individuals that constitutes a group, but interdependence of fate."

For Jews, the times are rich in tribulations. Even as we witness the resurgence of anti-Semitism and its sickening role in American politics, we behold also the ascendancy of chauvinism, xenophobia, intolerance, homophobia, Islamophobia, and theocratic hubris in the political success of the new Israeli right. In America, ethno-nationalism was in power for four years, and seeks to return to power; in Israel, it is in power now. I leave for another day the significant matter of ethno-nationalism as a deformation of nationalism, and more specifically of the liberal nationalism that established both the United States and Israel. Here I am more concerned with the descent of the Jewish right into the post-liberal swamp, with its apologetics for the Orbanization of Benjamin Netanyahu and his government, with its miserable indifference to millions of Jews in Israel and the world over. The Jewish right has an *ahavat yisrael* problem, even if no suggestion could offend it more.

There is nothing incendiary about my characterization of the Israeli government. All the traits that I have listed are accurate, based on a plain reading of the pronouncements of National Security Minister Itamar Ben Gvir, Finance Minister Bezalel Smotrich (who once described himself as "a fascist homophobe") , and other members of the unholy union of their extremist parties Otzma Yehudit (Jewish Power) and Religious Zionism, and Deputy Minister Avi Maoz, and a variety of ultra-Orthodox and haredi figures (Sephardi and Ashkenazi), and some Likud hacks, and their leader Benjamin

The Troubles of the Jews

Netanyahu, who has undergone a transformation for the worse, if that was possible. He is exactly as opportunistic and ruthlessly self-aggrandizing as he always was, but he is no longer the "liberal conservative" whose years in America imbued him with a reverence for democratic principles and procedures. Netanyahu has become the patron of intolerance and corruption. He is the king of the rot. The strikingly large demonstrations against his government were provoked by more than partisanship. A kind of shock animated them, a horror beyond politics, a panicked feeling that in his pursuit of office Netanyahu was betraying the foundational values of the state; and also a kind of shame that it has come to this, that there are fascists in the halls of Jewish power. Many Israeli centrists and also some conservatives have participated in the mass indignation. Their objective is to prevent a crisis from becoming a turning point.

In the view of Elliott Abrams, however, all this was "Jewish hysterics." Writing in *Commentary*, Abrams begins by sensitively remarking that the "firebrands" Ben Gvir and Smotrich "have taken many highly incendiary positions. Not only are there doubts and concerns to be expected; opposition to them and criticism of them will be entirely an appropriate feature of the new Israeli political moment." And having gotten his to-be-sure sentences out of the way, he goes to work. He is angry about the criticism, the "extreme rhetoric and extreme positions," of American Jews in their strictures against the new Israeli government. These dissents originate, he writes ominously, in "deeper reasons than mere parroting of Israeli voices." They express "long and deeply held positions." What are those compromising positions? Be patient. Abrams cites the open letter that three hundred and thirty American rabbis signed declaring that representa-

tives of Ben Gvir's, Smotrich's and Maoz's parties would no longer be welcome in their synagogues, because they "deny our rights, our heritage, and the rights of the most vulnerable among us." Every one of those allegations is verified by the policy proposals and the contemptuous language of Religious Zionism and Otzmah Yehudit (Jewish Power), the parties of the "firebrands"; but what strikes Abrams about this protest is that "not one Orthodox rabbi signed the petition." We are getting warmer.

The issue, in a word, is religion. Abrams disparagingly cites a remarkable essay by Hillel Halkin, one of the most formidable Jewish intellectuals of our day, in which he despairingly broke ranks (a neoconservative specialty in days gone by) with his right-wing Jewish comrades on the question of the new Israeli government, and (these are Halkin's words about himself) "put [the blame] on Judaism, of whose fantasies and delusions Zionism sought to cure us only to become infected with them itself." Halkin's sin is secularism, or loyalty to the spirit in which the state was established. I would not myself dismiss Judaism as "fantasies and delusions," not at all; but the truth or falsehood of Judaism should have no bearing upon the question of its place in an open Zionist order. Israel was founded as a secular state with freedom of religion. But "Halkin's line," Abrams writes, "is simply not a winner in Israeli elections," in utter indifference to any integrity that Halkin's Zionism might possess. Not a winner? In a war over identity, the primary consideration should not be expedience. In support of his operative's view of the situation, Abrams cites Yossi Klein Halevi's observation that Netanyahu's voters wished "to save Israel as a Jewish state." "While a majority of Israeli Jews are committed to maintaining Israel as both a Jewish and democratic state," Klein Halevi explained, "if

forced to choose between them, most would almost certainly opt for its Jewish identity." (Abrams composed his essay before Klein Halevi came out against the Netanyahu government and implored American Jews to do the same.)

Now, the only existing threat to the Jewish identity of the Jewish state is the one-state solution. But this is not what Netanyahu and his apologists have in mind when they seek to alarm Jews about the Jewishness of the state. They endorse not only a Jewish state, but a specific kind of Jewish state. "This is the struggle, if you will," Abrams writes in a particularly imperishable sentence, "between those who go to the beach on Shabbat and those who go to synagogues." A *Kulturkampf* in flip-flops! Abrams writes like a truant officer. The splendid pluralism of Israeli Jewish life, the coexistence of beachballs and kiddush cups, is not pleasing to him, just as it has never been pleasing to Israel's ultra-Orthodox and haredi communities. Like them, he believes that we are witnessing a "Judaism/Zionism debate," as if it must be one or the other, as if there have not been many interpenetrations of Judaism and Zionism in the years of Israel's existence and before, as if the possibility that Judaism should have no political connection to Zionism is not worth considering. "Israel's Jewish identity is the issue," he writes, "and centrist voters, or voters on the left, must convince their fellow citizens they do not view Judaism and halakha as outmoded tribal customs that should be jettisoned as soon as public opinion permits."

Halakha! My blood ran cold when I read that word, and my tefillin are never far from me. Why on earth do Israeli centrists have to say nice things about halakha? It is not the law of the land. Let those who wish to observe Jewish law observe it. Let them build their yeshivas and their shuls and flourish within them, even if their neighbors dislike their way of life. The

dislike anyway runs both ways. As far as I can see, nobody is preventing pious Jews from living according to their idea of Jewish piety. If they cannot bear to see other Jews living differently, then they were born two hundred years too late. As for Netanyahu, he has admitted that he fasted on Yom Kippur for the first time in his life before the recent election, thereby placing himself in the long line of Machiavellian conservatives for whom religion is of merely political utility.

Abrams' argument is that Israel is changing and that we, American Jews, must accept the changes. Needless to say, the Jewish right has demonstrated no such acquiescence to political facts when an Israeli government has pursued policies of which it disapproves, such as attempting to make peace. Hysterics, indeed. "The 1950s or 1960s Israel of Labor socialism may have resembled the Upper West Side," Abrams continues,

> but the Israel that is developing before our eyes does not. It is truly a Jewish state, increasingly peopled — and in part now governed — by Jews who believe in the God of the Hebrew Bible and for whom the practice of the religion of Judaism is the most important aspect of their lives. Can American Jews accept this Israel, or will it alienate all but the Orthodox — who practice that same religion?

343

Where to begin? For a start, there is no way in which the Upper West Side substantially resembled the Israel of the 1950s and 1960s — nobody made the desert bloom on Broadway; and I hasten to add that in those decades, the Orthodox Jews of Brooklyn, with not a single subscriber to *Dissent* among them, learned to admire the sun-tanned, beach-going, Torah-neglecting, collectivist Jews in Israel. Moreover, there is no

reason to fear that, on the dark day when Hezbollah unleashes its arsenal of missiles on Tel Aviv, Israel will find American Jewish support only in the Orthodox community. (Abrams knows this.) But it is rattling to infer that in 1967 and in 1973, and in all of Israel's campaigns in its defense, what was being defended was a deficient Jewish state, not "truly a Jewish state." Where in the founding documents of Israel was it decreed that the Jewishness of the Jewish state was to be defined religiously? Zionism, again, is compatible with all kinds of Jewishnesses, religious and secular, because it defines the Jews as a people or a nation. Its capaciousness was one of the secrets of its success (though its spirit of welcome sometimes disappeared when Jews of non-European origin found refuge in the state).

Abrams defines Israel's Jewishness in terms of Judaism, which is bad enough. What is worse is that he defines it in terms of only a part, a small part, of Judaism. In his sectarian way, he cares only about Orthodox Jews; and his essay is an extended insult to all the Conservative and Reform Jews in America whose support for Israel, even when they criticize it, is beyond reproach. An insult, that is, to the overwhelming majority of American Jews. According to the Pew survey in 2020, Orthodox Jews comprised nine percent of American Jewish adults, and seventeen percent of Jews between the ages of eighteen and twenty-nine identify as Orthodox. The fecundity of the Orthodox community is enormous, and mazel tov to them all, so let us for the sake of argument double the Pew figures and say that the Orthodox represent twenty percent of the American Jewish community. Is Abrams prepared, like Netanyahu's government and like the haredim, to write off three quarters or so of his community? This is what I mean by an *ahavat yisrael* problem. Or does he not even regard them as his community? But they are our brothers

and our sisters! They, too, deserve to be recognized as "Jews who believe in the God of the Hebrew Bible and for whom the practice of the religion of Judaism is the most important aspect of their lives," because the defining feature of modern Judaism, like it or not, is that there is more than one way to believe in that God and to practice that religion. I confess that I have my own qualms about the spiritual and intellectual quality of some of the Conservative and Reform congregations that I have visited, but I do not have the temerity to expel them, on those grounds or on any grounds, from my conception of my people.

There is freedom of religion in Israel, but there is not freedom of Jewish religion. American Jews, Abrams remarks, "denounce restrictions on non-Orthodox worship that most Israeli Jews find to be second-tier issues at most." When did questions of rights come to be decided by polls? Most Israelis find the Palestinian question, too, to be a second-tier issue, but it is not an act of friendship to encourage them in that delusion. Abrams says that "if one thinks of the leaders of major American Jewish organizations, and of the Reform, Conservative, and Reconstructionist rabbinate, is there any question which coalition they favored in the Israeli election — the one led by Lapid or the one led by Netanyahu?" But there is no mystery here. The coalition led by Lapid treated Reform, Conservative, and Reconstructionist Jews with dignity and the coalition led by Netanyahu did not. Do the Orthodox, too, not support Israeli parties that look favorably upon them? Or is everything they do for the sake of heaven? Their enforcer is the Chief Rabbinate of Israel, the most poisonous institution in contemporary Jewish life, which years ago was taken over by the least enlightened and least humane elements in the Israeli ultra-Orthodox community. The Chief Rabbinate

was not created by God at Sinai. It was created in 1920 by an ordinance of the British Mandatory authorities in Palestine. It is a pontifical office in a religion that has no pope. The basis of its authority is not halakhic but political. It is an engine of exclusion, a pitiless enemy of Jewish unity. Why should Reform, Constructive, and Reconstructionist Jews passively accept its rulings, or the contempt that its political supporters have shown for them? And why should the state endorse halakhic notions of identity and membership? Was the state created by God at Sinai, or by His sages?

The most disturbing sentence in Abrams' diatribe is this one: "It is an obvious principle to American Jews that all people should be treated alike, while most Israelis would find it simple madness to apply that principle to Israelis and Palestinians." If that is so, it is an occasion for sorrow; but I detect no sorrow in Abrams' words. Make the appropriate translations and you will have the worldview of Donald Trump, in whose administration Abrams served. As for "most Israelis": both blocs in the recent election emerged with 49.5 percent of the vote. Since the Lapid bloc included also Arab votes, it seems correct to say that a plurality of Jews supported the Netanyahu bloc, but this was hardly a mandate-conferring majority. A fight is on. And it is a fight over first principles. The anti-democratic view to which Abrams would have us accommodate ourselves represents nothing less than a rejection of the Israeli Declaration of Independence, which was a milestone in the reconciliation of the universal and the particular, and one of the glories of modernity. This is Article 13: "[The State of Israel] will ensure complete equality of social and political rights to all its inhabitants irrespective of religion, race or sex; it will guarantee freedom of religion, conscience, language, education and culture." Could it be more ringing?

From a fine recent study of the historical and philosophical origins of the document by Neil Rogachevsky and Dov Sigler, I learn that its first drafter relied heavily on the American Declaration of Independence and the English Bill of Rights, and that it was Ben Gurion himself who, at the last minute, added the word "sex" to that wondrous inventory of rights. The Zionist founders were serious about democracy. (The Zionist state has practiced it imperfectly.) And along comes Abrams to tell us that most Israelis care more about security than about human rights, and that's that. When governments in other countries adopt an anti-democratic ethos, when other peoples turn against liberalism and its ideal of equality, we — many American Jews — *Commentary* too, I believe — assail them and wage a war of ideas. Why should Israel be different? The Torah and the Talmud are full of injunctions to reprove and remonstrate with your own kind.

But now some of the same American Jewish patriots who are hoarse with proud reminders that on the Liberty Bell there appears a verse from Leviticus — "proclaim liberty throughout the land unto all the inhabitants thereof" — these same people, Zionists all, appear to deny the relevance of this verse, this Hebrew verse, to the state of the people whose ancestors introduced its idea to the world. And appeals to security will not settle the matter, because it has been one of the controlling assumptions of the Jewish state since its inception that there should be no contradiction between safety and justice. The Declaration of Independence championed human rights in 1948, at the hour of Israel's greatest vulnerability. The imminent invasion of seven Arab armies did not impede or impair its liberalism. Nor did its political liberalism abridge its national pride, or its proclamation of natural rights mitigate its proclamation of historical rights. In

this way the Declaration of Independence, with its weak religiosity, was ironically consistent with a remarkable legacy of the Jews in exile: they never used their adversity as an alibi for a relaxation of their own ethical standards for themselves. The enmity that surrounded them was never taken up as an excuse for laxness about right and wrong.

The opposition to Netanyahu's shameful government is an expression of that old ideal of Jewish self-rigor in times of crisis. Abrams, by contrast, prefers that we make exceptions for ourselves. And finally he resorts to the cheapest argument of all. American Jews, he scolds, "do not live with the threats to safety and even life that face Israelis." But neither does he! What if he is wrong, and the incitements of Ben Gvir and Smotrich, and the settler vigilantism that they have already provoked, lead to an intifada, and the Iranians instruct Hezbollah to launch? What if he is wrong, and the Netanyahu government enacts a revision of the Law of Return under the guidance of the ultra-Orthodox rabbinical establishment, so that Jews in flight from persecution will not be admitted into the country and Zionism will be thereby vanquished? What if he is wrong, and the judicial reform that Netanyahu seeks (and not exactly for reasons of philosophy) leaves Israel — a state without a constitution or a bicameral legislature or a federal system — with even fewer checks and balances than it already has, and at the mercy of executive power and even of authoritarian rule? None of these bleak scenarios are implausible, and if they come to pass Abrams will not be there to experience the consequences of his erroneous views. Which is not say, of course, that he should silence himself. It is to say only that he should desist from intimidating people with other opinions by suggesting that they are playing fast and loose with Jewish lives. Insofar as any of our opinions will be responsible for

348

outcomes in Israel, we all run this risk. How, really, could he, or anyone in the American Jewish community, be silent? We criticize Russia when we do not live in Russia; we criticize China when we do not live in China; we criticize Venezuela when we do not live in Venezuela; but we criticize Israel, as Abrams too has done, even though we do not live there, because we are mingled with it, because we share a peoplehood with it, because our hearts easily defy our distance from it, because (as Kurt Lewin said) we are interdependent in fate.

As with the great debate about America, there is nothing wrong with the great debate about Israel that would not be somewhat ameliorated if everybody were to locate their discomfort zones and learn to exist within them. Discomfort zones are the detox centers of identity. They cripple sectarian politics. They shake the walls. They introduce a therapeutic awareness of complexity and an invigorating sense of humility about the overwhelming reality of other people and their perspectives. They are the antithesis of anxiety, because they quicken. If the Jewish left and the Jewish right could only find their discomfort zones, if they could be made to feel uncomfortable about their smugness and their settledness, we might all be more comfortable, and therefore more courageous, in rising together to meet yet another century that will not leave the Jews alone.

349

CONTRIBUTORS

ANDREW DELBANCO is the Alexander Hamilton Professor of American Studies at Columbia University and the president of the Teagle Foundation. A version of this essay was delivered as the Jefferson Lecture in Washington, DC last fall.

JAMES KIRCHICK is the author of *Secret City: The Hidden History of Gay Washington*.

MICHAEL WALZER is professor emeritus at the Institute for Advanced Study in Princeton and the author most recently of *The Struggle for a Decent Politics: On "Liberal" as an Adjective*.

OLÚFẸ́MI TÁÍWÒ is Professor of African Political Thought at Cornell University and the author, among other books, of *Against Decolonisation: Taking African Agency Seriously*.

DECLAN RYAN's collection of poems *Crisis Actor* will be published this summer.

TAMAR JACOBY is the director of the New Ukraine Project at the Progressive Policy Institute and the author of *Displaced: The Ukrainian Refugee Experience*.

ALFRED BRENDEL, the pianist, is the author most recently of *The Lady from Arezzo: My Musical Life and Other Matters*.

MELVYN P. LEFFLER is the Edward Stettinius Emeritus Professor of American History at the University of Virginia and the author of *Confronting Saddam Hussein: George W. Bush and the Invasion of Iraq*.

ALASTAIR MACAULAY is a critic and historian of the performing arts who was the chief dance critic of the *New York Times* and the chief theater critic of *The Financial Times*.

ISHION HUTCHINSON's next book, *School of Instructions*, will appear in the fall.

JENNIE LIGHTWEIS-GOFF is a professor of English at the University of Mississippi and the author of *Captive Cities: Urban Slavery in Four Movements*.

MARK LILLA's book *Ignorance and Bliss: On Wanting Not to Know* will be published next year.

MITCHELL ABIDOR is a writer and translator. His translation of Claude Anet's *Ariane, A Russian Girl* will be published by NYRB Classics later this year.

JOHN PSAROPOULOS is an independent journalist based in Athens who ran the *Athens News*, Greece's English-language newspaper, from 1999 to 2009.

CELESTE MARCUS is the managing editor of *Liberties*. She is writing a biography of Chaim Soutine.

LEON WIESELTIER is the editor of *Liberties*.

As a matter of principle, *Liberties Journal* does not accept advertising or other funding sources that might influence our independence.

We look to our readers and those individuals and institutions that believe in our mission for contributions — large and small — to support this not-for-profit publication.

If you are interested in making a donation to *Liberties*, please contact Bill Reichblum, publisher, by email at bill@libertiesjournal.com or by phone: 202-891-7159.

Liberties — A Journal of Culture and Politics is distributed to
booksellers in the United States by Publishers Group West;
in Canada by Publishers Group Canada; and, internationally
by Ingram Publisher Services International.

LIBERTIES, LIBERTIES: A JOURNAL OF CULTURE
AND POLITICS, is published quarterly in Fall, Winter,
Spring, and Summer by Liberties Journal Foundation.

ISBN 979-8-9854302-0-2
ISSN 2692-3904

The insignia that appears throughout
Liberties is derived from details in
Botticelli's drawings for Dante's
Divine Comedy, which were executed
between 1480 and 1495.